Harvard University Art Museums

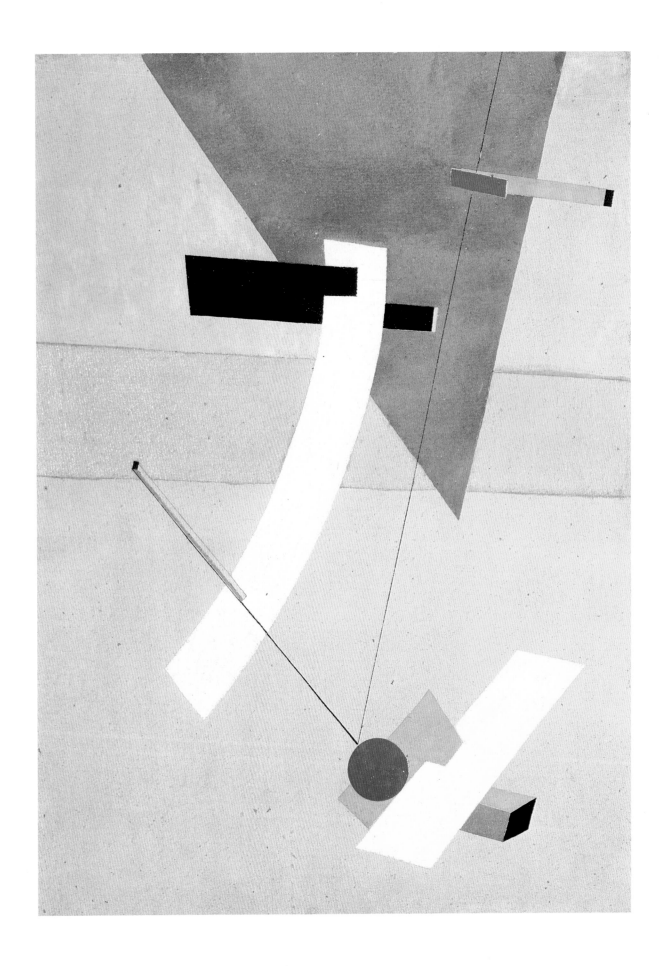

Harvard University Art Museums
A Guide to the Collections

Arthur M. Sackler Museum

William Hayes Fogg Art Museum

Busch-Reisinger Museum

Kristin A. Mortimer
With contributions by William G. Klingelhofer

Harvard University Art Museums · Cambridge · Massachusetts
Abbeville Press · Publishers · New York

Front illustration: Jean-Auguste-Dominique Ingres, **Raphael and the Fornarina** (see no. 198)
Back illustration: Kleophrades Painter, **Red-Figure Calyx Krater** (see no. 112)
Frontispiece: El (Lasar Markovitch) Lissitzky, **Proun 12E** (see no. 377)

Art director: James Wageman

Designer: Jean Brueggenjohann

Editor: Alan Axelrod

Production manager: Dana Cole

Library of Congress Cataloging-in-Publication Data

Arthur M. Sackler Museum.
 Harvard University Art Museums.

 Bibliography: p.
 Includes index.
 1. Harvard University. Art Museums—Guide-books.
 I. Mortimer, Kristin A. II. Klingelhofer, William. III. Fogg Art Museum. IV. Busch-Reisinger Museum of Central and Northern European Art. V. Harvard University. Art Museums. VI. Title.
 N526.A78 1986 708.144′4
 85-22910
 ISBN 0-89659-600-1
 ISBN 0-89659-601-X (pbk.)

CONTENTS

PREFACE

Harvard's art collections, like those of the much older universities of Oxford and Cambridge in England, have been a natural product of the institution's long intellectual and social history. Included among its vast treasures are portraits of local dignitaries by John Singleton Copley; European master prints collected before the Civil War by Francis Calley Gray; the Pre-Raphaelite drawings and paintings acquired under the influence of Charles Eliot Norton, Harvard's first art historian; and the rich holdings of modern German material which accompanied the architect Walter Gropius when he left Germany to become dean of the Graduate School of Design in 1937.

It is not our purpose to recount the history of the collections or of the personalities who formed them, nor are we attempting to provide definitive accounts of the objects illustrated here. The four hundred objects shown in this *Guide* have been selected as outstanding representatives of the great and varied holdings which have grown steadily since the University's founding 350 years ago. Some of our collections are unrivaled by any other museum in this country—early Chinese jade carvings, for example, or French drawings from the 15th through the 19th centuries; others are exceedingly strong—Greek vases and coins, Romanesque sculptures from France and Spain, and Japanese prints. Even those parts of the collections which are not unusually rich play a meaningful role in teaching and research, the primary mission of both the Museums and the University.

The staff of the Museums is closely integrated with that of Harvard's Department of Fine Arts. Curators and conservators have academic appointments, and the collections are used continually by teachers and students. Galleries are installed as material for analysis and discussion in Harvard College's general education program. Works from the collections are brought into classrooms for the department's art history survey courses; advanced, highly specialized seminars are often focused on museum objects and are enhanced by scientific analysis in the Museums' distinguished Center for Conservation and Technical Studies. Finally, the intellectual life of the Harvard community is greatly enriched by scholarly visitors from all over the world, attracted by the collections and the research facilities of the Fine Arts Library.

Rarely have the Museums bought works on the open market, and indeed purchase funds are miniscule. Four generations of museum directors and curators have solicited gifts from patrons, often helping them to form private collections with the understanding that certain items would eventually come to the Museums. Other patrons, without any formal connection to the University, have given generously to the Museums simply to support their work. The credit lines of the illustrations of this *Guide* give the names of many of the great collectors to whom we owe so much—Grenville Winthrop, for example, or Paul Sachs, Maurice Wertheim, Frederick Watkins, Philip Hofer, Joseph Pulitzer, Jr., Ian Woodner, or Melvin Seiden.

Over a century has passed since the University appointed Charles Eliot Norton as Lecturer, and then Professor of the History of Art as Connected with Literature. From Norton's tutelage came such scholars as Bernard Berenson in the Italian field and Ernest Fenollosa in Chinese and Japanese art; subsequent generations of Harvard-trained persons have become leaders in art history as well as museum professionals, trustees, art critics, and private collectors. The unusual environment for the visual arts created at Harvard University has resulted in the magnificent objects seen in this *Guide*; equally important are the historical and spiritual insights that have grown from the study and care of these collections.

This guide to the Harvard University Art Museums' collections was produced in part to celebrate the October 1985 opening of the Arthur M. Sackler Museum. Designed by the British architect James Stirling to house the departments of Ancient, Islamic, and Oriental art, the Sackler Museum joins the Fogg and the Busch-Reisinger to form a new and unified institution, the Harvard University Art Museums.

The *Guide* was written by Dr. Kristin Mortimer, now Curator at the Isabella Stewart Gardner Museum in Boston and a distinguished specialist in medieval art and architecture. She was ably assisted in all aspects of the project by Dr. William Klingelhofer, who recently completed his Ph.D. at Harvard in Indo-Islamic art and architecture, and who wrote entries for all the Islamic and all of the Oriental objects except Chinese bronzes, jades, and ceramics. They were aided by almost every member of the Museums' curatorial and administrative staffs in providing a coherent summary of our diverse collections. To those who assisted in this project, I wish to express the Museums' profound gratitude.

Our debt is unusually great to Leonie Gordon, who served loyally as coordinator and editor of the project and to Porter Mansfield for editorial assistance in addition to flawless typing of the manuscript, to Lisa Flanagan and Peter Walsh who handled the vital details of finance and publication, and to Michael Nedzweski and Richard Stafford of the Museums' Photographic Services department. We were delighted to secure the services of Jean Brueggenjohann as designer and are deeply grateful to Abbeville Press for its help in bringing this project to fruition.

John M. Rosenfield

Abby Aldrich Rockefeller
Professor of Oriental Art

Acting Director, 1982–85

A Note on the Entries

Measurements are given height before width before depth, unless otherwise noted. A single measurement denotes height, two measurements denote height by width, three measurements denote height by width by depth, unless otherwise noted.

ARTHUR M. SACKLER MUSEUM

PRE-COLUMBIAN

1

YOKE

ca. A.D. 300–900
Mexican, Classic Veracruz
Dark green basalt (?), 40.6 x 36.8 cm
Bequest—Grenville L. Winthrop,
1943.1246

This is one of four horseshoe-shaped
yokes bequeathed by Grenville Winthrop.
Although their precise purpose still eludes
us, the yokes, which number in the hun-
dreds, evidently were connected with the
Mexican ball-court game where they may
have had a religious–ceremonial signifi-
cance; weighing from 40 to 60 pounds,
they also could have served as goal-
markers in the game. But regardless of
their actual use, it is clear that they played
some important ritualistic role. Working
with certain hard stones to take advan-
tage of coloration and textural quality,
the sculptors painstakingly chipped and
polished with stone implements and buff-
ers, each object probably requiring years
of effort. Furthermore, although style, de-
gree of elaboration and details vary, shape
and dimensions, as well as basic patterns
and motifs with obvious symbolic im-
port, are treated consistently. In this
example, characteristic of a relatively
elementary and humanoid type, an intim-
idating feline–human creature, whose
head appears at the center, has arms and
sandaled legs twisted onto the curving
sides. Scrollwork from his mouth inter-
twines with his body and also continues
onto the top.

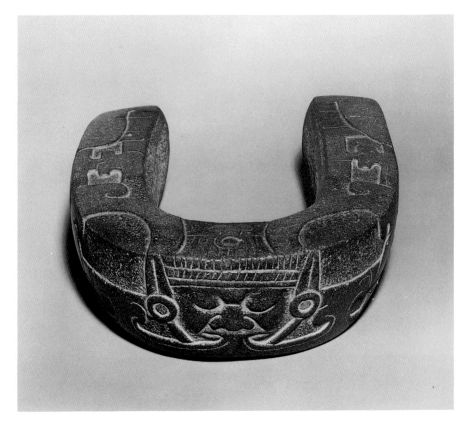

References
A. Kidder II, "Mexican Stone Yokes," *Bulletin
of the Fogg Museum of Art* XI/1 (Jan. 1949),
3–9; Hanfmann and Rowland, 1954, 137;
T. Proskouriakoff, "Varieties of Classic Central
Veracruz Sculpture," *Contributions to Ameri-
can Anthropology and History*, Carnegie
Institution of Washington XII/58 (1960),
72–78, no. 21; *Winthrop Retrospective*,
1969, no. 126.

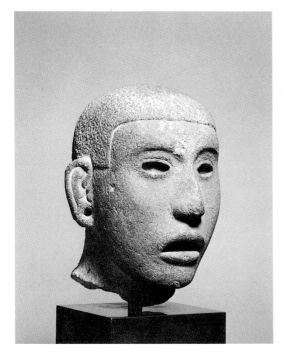

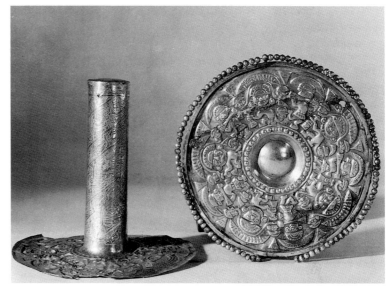

2

LIFE-SIZE HEAD

ca. 14th century A.D.
Mexican, Aztec (A.D. 1200–1519)
Dark grey lava stone, 21 x 17.1 cm
Bequest—Grenville L. Winthrop,
1943.1051

This *Head*, probably once attached to a
kneeling or sitting figure, may well record
a human sacrifice, the key religious prac-
tice in Aztec rituals. Provincial in style
compared to examples from the heart of
the Aztec Empire in the central valleys of
Mexico, it has a close counterpart (Mu-
seo Nacional de Antropologia) whose
eyes and teeth still have their original
shell inlay. The holes in the ears of the
head illustrated here also imply missing
ear plugs or feather pendants, and evi-
dently the face was once plastered and
tinted. Even without these adornments,
the piece retains a discarnate, soporific
pathos.

References
Hanfmann and Rowland, 1954, 137;
Winthrop Retrospective, 1969, no. 128.

3

PAIR OF HAMMERED EAR PLUGS

ca. 14th–15th century A.D.
Peruvian, Chimu Culture (A.D. 1000–
ca. 1476)
Gold, 12.7 x Diam. 14 cm
Bequest—Grenville L. Winthrop,
1943.1072a–b

Like the Aztecs (no. 2), the Peruvian
Chimu, precursors of the Incas, lived
within a rigid class system where the size
of the wearer's ear plugs was apparently a
manifestation of his rank; this grand pair
must then have belonged to a person of
status. Typical of Chimu art is the re-
petitive ornament of the gold work, in
which five warriors in profile, weapons
hoisted over their shoulders, alternate
with five frontal feline–human figures,
whose savage visages are made more
threatening by their fearsome headgear
and by the war-trophy heads appended
to their tails.

References
Hanfmann and Rowland, 1954, 137; *Winthrop
Retrospective*, 1969, no. 127.

CHINESE

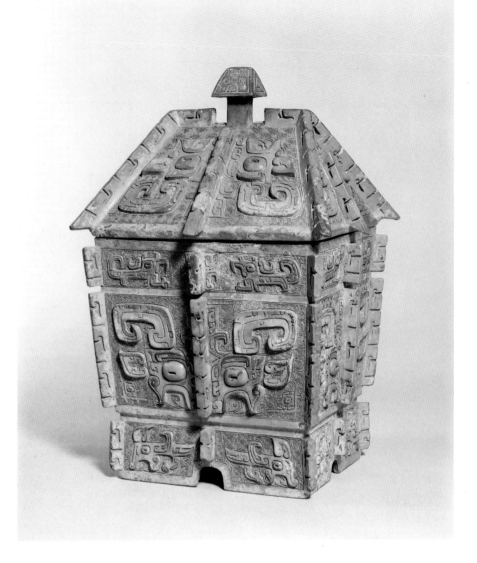

FANG-I (RITUAL WINE CONTAINER)

12th century B.C.
China, Shang Dynasty (Anyang period,
ca. late 13th–early 12th century B.C.)
Bronze with grey patina, 30.2 cm
Bequest—Grenville L. Winthrop,
1943.52.109

The Museums' celebrated collection of
Chinese ritual bronze vessels is based pri-
marily on the 1943 bequest of Grenville
Winthrop, who favored works of excep-
tional finesse in execution and in a good
state of preservation. His high aesthetic
standards are reflected in this magnificent
storage vessel, which manifests the tech-
nical and artistic virtuosity of late Shang
craftsmen. Working with complex assem-
blies of ceramic piece-molds, bronze
founders produced a variety of such ves-
sels for the preparation and serving of
food and drink in rituals whose exact
nature and purpose are little understood
today. In this covered container, the strong
architectural shape is divided into dis-
tinctly defined areas marked by projecting
flanges and by plain horizontal bands
that cut across them. The exquisitely cast
decoration is eminently suited to this
structure. Against a *lei-wen* (rectangular
spiral) background, the stylized zoo-
morphic motifs stand out in bold relief,
their arrangement governed by the
bilateral symmetry of the container.
Characterized by large eyes and C-shaped
horns, *t'ao-t'ieh* faces (the precise icono-
graphic significance of which remains a
mystery) appear on the main zone of the
body and again on the lid; complement-
ing these large masks are pairs of small
dragons in the narrow zones at the top of
the body and on the foot. Far different is
the early Western Chou *fang-i* (no. 7),
one of a small group of flamboyant ves-
sels with protruding curled and hooked
flanges whose bold projections tend to
negate the architectural fabric of the ves-
sel proper.

References
Winthrop Retrospective, 1969, no. 36; R. W.
Bagley, *Shang Ritual Bronzes in the Arthur M.
Sackler Collections*, Cambridge, Mass., forth-
coming, no. 79. For a similar *fang-i* in the
Cincinnati Art Museum see Loehr, 1968, no.
38; for another similar *fang-i* see D. H. Del-
banco, *Art from Ritual: Ancient Chinese
Bronzes from the Arthur M. Sackler Collec-
tions*, Fogg Art Museum, Cambridge, Mass.,
1983, no. 23.

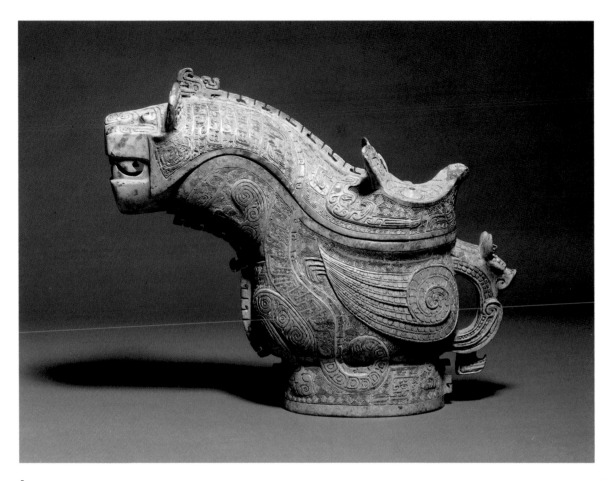

5

KUANG (RITUAL WINE SERVER)

China, Shang Dynasty (Anyang period, ca. late 13th–early 12th century B.C.) Bronze with pale green patina, 24.7 cm Bequest—Grenville L. Winthrop, 1943.52.103

One of the most finely wrought and beautifully preserved of the bronze vessels in the Winthrop collection, this *kuang* served as a ritual pouring vessel. Shaped like a covered gravy boat, its curving form is worked into a design of a tiger's head and body. The head is strongly three-dimensional while the body has been represented more abstractly on the vessel's sides. Moreover, the tiger's anatomy is conflated with that of an owl, whose head forms the rear end of the lid

and whose wings appear below. Another bird form is seen on the handle. The surface decor contains many other small animals and *lei-wen* patterns, forming a swirling composite of geometric and zoomorphic motifs. A closely related pair of *kuang* was uncovered in 1976 at Anyang in the tomb of Fu Hao, the only complete royal Shang burial site found so far; those vessels confirm a late 13th–early 12th century B.C. date for the Museums' example.

References
Winthrop Retrospective, 1969, no. 35; R. W. Bagley, *Shang Ritual Bronzes in the Arthur M. Sackler Collections,* Fogg Art Museum, Cambridge, Mass., forthcoming, no. 73.

YU (RITUAL WINE BUCKET)

10th century B.C.
China, early Western Chou Dynasty
(ca. 1049–771 B.C.)
Bronze, blackish patina with thicker
incrustations of green patina, 25.7 cm
(without handle)
Bequest—Grenville L. Winthrop,
1943.52.107

Known as the *Keng Ying yu* from its in-
scription—which relates that Keng Ying
commissioned the bucket in appreciation
for favors bestowed on her by the king—
the vessel was made in the 10th century
B.C. and demonstrates some of the impor-
tant changes that occurred in bronze
decoration after the Chou dynasty came
to power. Superseding the fierce beasts
and *t'ao-t'ieh* masks of the Shang period,
for instance, are the curvilinear bird
motifs that appear on the body and lid.
These paired creatures face each other
but turn their heads back; beaks, plumes
and tails are sinuous and voluted forms
echoed by the smaller birds in profile on
the narrow concave bands surrounding
the belly. Frontal beasts' heads in high
relief punctuate the centers of the back
and front and the ends of the swing
handle, and all the relief forms are still
depicted against the *lei-wen* ground. In
its rhythmic patterns, the decor has an
exuberant, unified ornamentality setting
it apart from the more stately, hieratic seg-
mentations of the Shang *fang-i* (no. 4).

References
Loehr, 1968, no. 51; *Winthrop Retrospective*,
1969, no. 37. For L. Huber's translation of the
inscription see Loehr, 1978, 414–15.

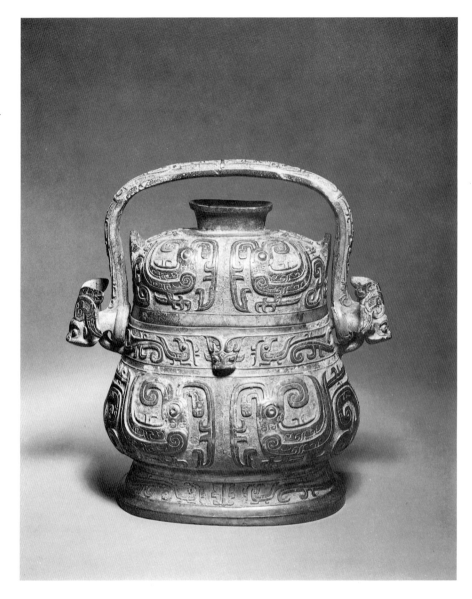

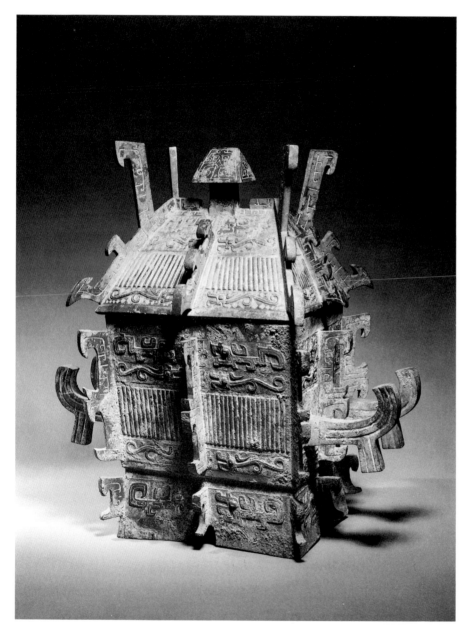

FANG-I (RITUAL WINE CONTAINER)

Late 11th century B.C.
China, early Western Chou Dynasty
(ca. 1049–771 B.C.)
Bronze, 50.8 cm
Gift—Anonymous, 1944.57.37

References
J. K. Murray, "Object of the Month—Early
Western Zhou Bronze *Fang Yi,*" *Orientations*
XVI/10 (1985), 42–44. For discussion of re-
lated pieces see Loehr, 1968, no. 41, and R. W.
Bagley in W. Fong (ed.), 1980, no. 48.

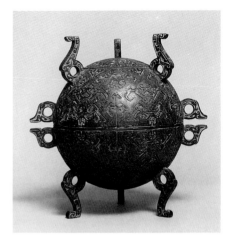

9

TUI (RITUAL FOOD VESSEL)

First half of the 4th century B.C.
China, late Eastern Chou Dynasty
(475−221 B.C.)
Bronze, dark brown and dark green patina. Original malachite (and copper?) inlay almost entirely lost, 27.6 x Diam. 20.6 cm (without handles)
Bequest—Grenville L. Winthrop,
1943.52.115

A relatively late and rare form, the *tui* is a spherical container that opens to form a pair of three-legged serving dishes. The shape offers a congenial surface to the abstract, geometric design motifs popular in the late Eastern Chou period. At that time, traditional ritual vessels were being used for secular purposes, and new forms of decoration were evolving, including the highly formalized birds and repeat patterns found here. Along with changes in motifs and style came the use of inlaid minerals and metals, reflecting an emerging taste for resplendent, luxurious surfaces, possibly influenced by contact with northern nomad art. Although most of the inlay of the Museums' piece has been lost, the precision and subtlety of its design and execution remain undiminished.

References
Winthrop Retrospective, 1969, no. 40. For similar ornament with its inlay remaining see J. F. So in Fong (ed.), 1980, no. 73, and T. Lawton, *Chinese Art of the Warring States Period*, Freer Gallery of Art, Washington, D.C., 1982, 38.

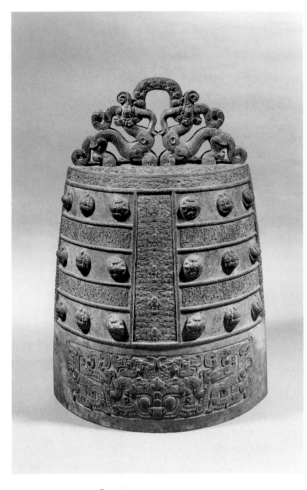

8

CHUNG (RITUAL BELL)

China, late Eastern Chou Dynasty
(475−221 B.C.)
Bronze, 66.4 cm
Bequest—Grenville L. Winthrop,
1943.52.178

References
S. Umehara, *Shina kodo seika*, Osaka, 1933, I/3, 224; idem, *Etude des bronzes des Royaumes Combattants*, Kyoto, 1936, pl. XCIX.

MIRROR

China, late Eastern Chou Dynasty
(475–221 B.C.)
Bronze, Diam. 30.3 cm
Bequest—Grenville L. Winthrop,
1943.52.147

References
S. Umehara, *L'Etude sur le miroir antérieur à la dynastie des 'Han,'* Kyoto, 1935, pl. 8, no. 2; idem, *Shina kodo seika*, Osaka, 1933, 4, pl. 19; B. Karlgren, "Huai and Han," *Bulletin of The Museum of Far Eastern Antiquities* 13 (1941), 18; *Winthrop Retrospective*, 1969, no. 57.

11

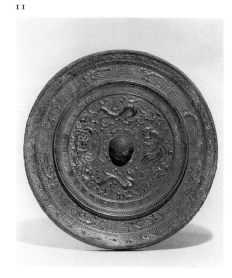

10

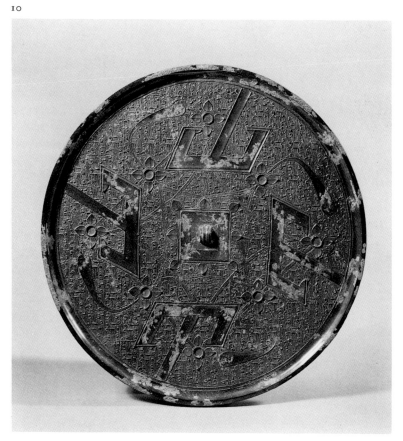

11

MIRROR

China, Sui Dynasty (581–618)
Bronze of silvery appearance. Reflecting surface covered with green patina; reverse, with light blue patina, Diam. 24.76 cm
Bequest—Grenville L. Winthrop,
1943.52.164

The date of this handsome mirror, ca. A.D. 600, takes us several hundred years past the age of ritual bronze vessels, and shows us the incorporation of Buddhist and western elements in Chinese decoration. The latter are to be seen in the half-palmette band on the outer rim; the former appear in the music-playing *apsarases* of the outer figural zone, in the lotus-blossoms surrounding the central knob, and in the small being at the edge of the main zone who possibly represents a Buddhist demon. The remainder of the decor is traditional and cosmological: the graceful animals of the Four Directions in the main zone, and the *pa kua* (eight trigrams) and *pa yin* (eight characters symbolizing musical instruments) that separate the flying angels. The elegantly proportioned decorative scheme includes an inscription, surrounding the central field, that describes the properties of the mirror and its ornament, and ends with appropriate advice:

> Focused on objects, it gives images
> from the distance;
> Use it for mirroring the inner self, and
> lucidity comes within reach.

Reference
Winthrop Retrospective, 1969, no. 60 (inscription translated by H. W. Huber).

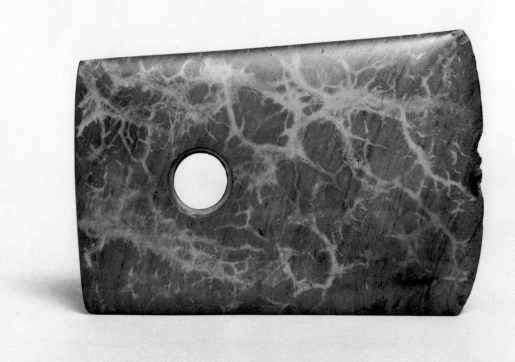

12

HEAVY AXE

China, Neolithic Period (3rd millennium
B.C.)
Greyish green stone, 128 x 84 mm
Bequest—Grenville L. Winthrop,
1943.50.112

Reference
Loehr, 1975, no. 3.

DISK-AXE

China, Shang Dynasty (ca. 1500–
ca. 1030 B.C.)
Opaque, ivory-colored jade,
Diam. 181 mm
Bequest—Grenville L. Winthrop,
1943.50.527

The rigorous art of jade carving (actually
grinding with abrasives) had reached a
high level of sophistication by the time
bronzes were first made. Already in the
Neolithic period (no. 12), jade equiva-
lents of stone tools, weapons, and other
objects were being fashioned for ritual
and mortuary purposes; by the Shang dy-
nasty, articles such as this rare disk-axe
were exquisitely wrought from stones
chosen for their color, grain, and luster
when polished. Important in the aesthetic
standards of the carvers were the purity
and elegance of the outer profile—the sil-
houette—of these jade implements. This
disk-axe was a ceremonial object whose
perimeter was partly flattened and ser-
rated to simulate the sides of an axe-
blade.

References
Loehr, 1975, no. 22; R. W. Bagley in Fong
(ed.), 1980, no. 7.

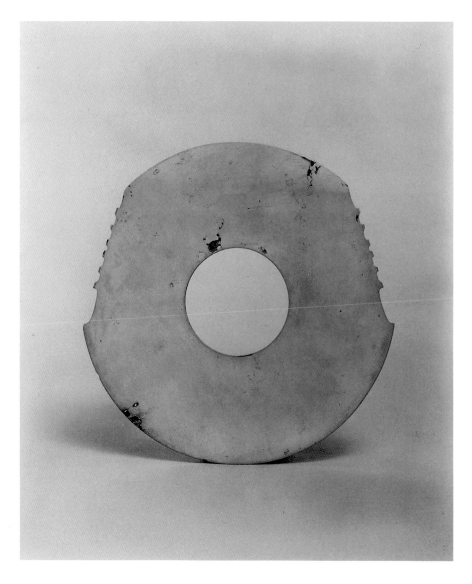

14

NOTCHED TABLET WITH
INCISED BIRD FIGURE

10th century B.C.
China, early Western Chou Dynasty
(ca. 1049–771 B.C.)
Light yellowish brown jade, 84 x 32 mm
Bequest—Grenville L. Winthrop,
1943.50.232

The angular contour of this jade tablet
presents a contrast to the curving forms
of the birds, accomplished with double
incisions, that decorate both surfaces of
the piece. These creatures, in their fluid,
rhythmic vitality that seems to deny the
hardness of the medium, have close coun-
terparts in the birds of the *Keng Ying yu*
(no. 6) of the same period (10th century
B.C.).

Reference
Loehr, 1975, no. 331.

15

CONFIGURATION OF DRAGON,
BIRD, AND SNAKE

China, late Eastern Chou Dynasty
(475–221 B.C.)
Highly polished, translucent, brown and
honey-colored jade, 130 x 78 mm
Bequest—Grenville L. Winthrop,
1943.50.468

The consummate technical skill and
design sense achieved by jade carvers
during the Warring States period (475–
221 B.C.) are strikingly combined in this
pendant. The serpentine ribbon form ter-
minates at one end in a bird holding a
snake in its beak and, at the other, in a
dragon head. The sweeping rhythm of
the main contour is accentuated by the
smaller curves and countercurves of the
wing and talon of the hybrid creature,
while the surface has been meticulously
textured with raised borders, cross-hatch-
ing, striations, and raised spiral curls.
This last motif was a particularly vital
part of Eastern Chou design.

Reference
Loehr, 1975, no. 427.

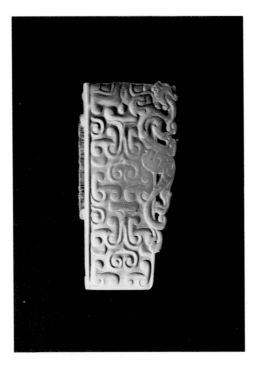

SCABBARD BUCKLE

2nd or 1st century B.C.
China, Western Han Dynasty
(206 B.C.–A.D. 8)
Translucent, pale greenish jade with
cream-colored areas, 62 x 32 mm
Bequest—Grenville L. Winthrop,
1943.50.398

The undulant dragon, partly executed in
openwork, that crawls along the right
edge of this scabbard buckle is typical of
Han design in its three-dimensionality
and its semi-autonomy from the rest of
the fitting. Although the beast is clearly
related to late Eastern Chou precursors,
its position (with the head seen from
above) and its lively convolutions place it
in the Western Han dynasty that fol-
lowed. An animal mask at the top and
scrollwork on the front complete the dec-
oration of the piece, which has a belt-slot
at the back.

Reference
Loehr, 1975, no. 570.

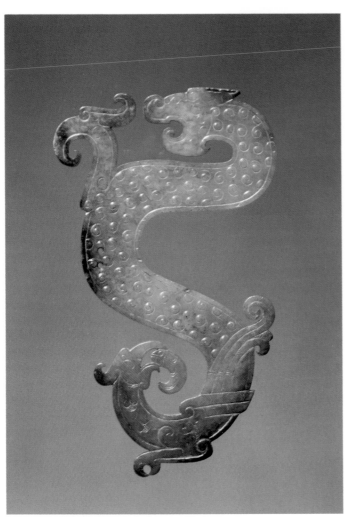

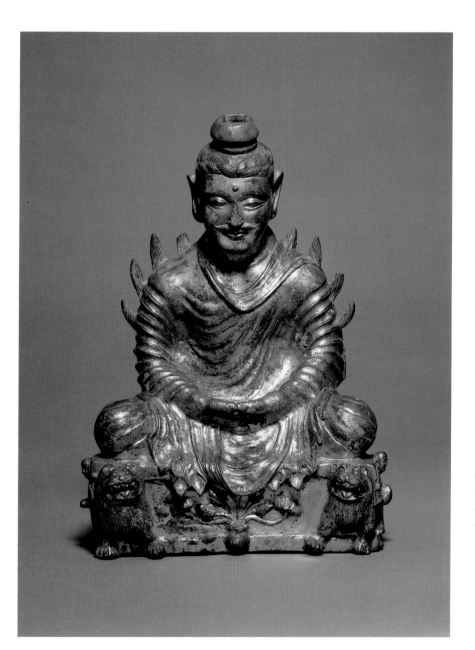

SEATED BUDDHA WITH FLAMING SHOULDERS

ca. late 4th or 5th century
China, Northern Wei Dynasty (386–534)
Gilt bronze, 32.8 x 24.2 cm
Bequest—Grenville L. Winthrop,
1943.53.80

The impress of Gandharan art on early Chinese Buddhist sculpture is strikingly evident in this unusual bronze image of the meditating Sakyamuni with eight flames emerging from his shoulders. The flames are an outward manifestation of the inner wisdom and luminosity of the historical Buddha. In its facial features and heavy drapery folds, this statue is clearly the result of the direct copying of Gandharan forms. The paired lions and small donor figures that flank the throne are, however, rendered in a Chinese style. Although the composite quality of this work has led to some uncertainty over its origins and date, specialists now generally agree that it is among the earliest examples of Chinese Buddhist art, dating it to the early years of the Northern Wei dynasty.

References
B. Rowland, Jr., "Indian Images in Chinese Sculpture," *Artibus Asiae* X/1 (1947), 12, fig. 8; H. Munsterberg, *Chinese Buddhist Bronzes*, Rutland, 1967, 26, pl. 3; *Winthrop Retrospective*, 1969, 72–73, no. 63; Loehr, 1978, 418.

BUDDHA

Dated 484
China, Northern Wei Dynasty (386–534)
Gilt bronze, 36.5 x 15.7 cm (at base)
Bequest—Grenville L. Winthrop,
1943.53.59

An inscription on the back of this image dates it in accordance with 484, a date fully consistent with stone sculptures of the Yun-kang caves and elsewhere, created in the second half of the fifth century. While the stylistic influences from Gandharan and Central Asian prototypes are still evident, the developing Chinese idiom is clearly revealed in the more complex patterns of the robe and in the slimmer, more graceful handling of the figure. A similar evolution may be traced in the sandstone sculpture of the Yun-kang caves with their colossal Buddha images dating from the second half of the fifth century. The high elevation of the Buddha's throne, adorned with attendant bodhisattvas and royal lions, contributes to the commanding yet compassionate presence of this figure, his hand raised in the *abhaya mudra* that inspires fearlessness in the mind of the devotee. Probably representing Maitreya, the Future Buddha, this bronze may have been the sole image of a small household shrine.

References
H. Munsterberg, "Buddhist Bronzes of the Six Dynasties," *Artibus Asiae* IX/4 (1946), 296, pl. 7; *Winthrop Retrospective*, 1969, 74, no. 64.

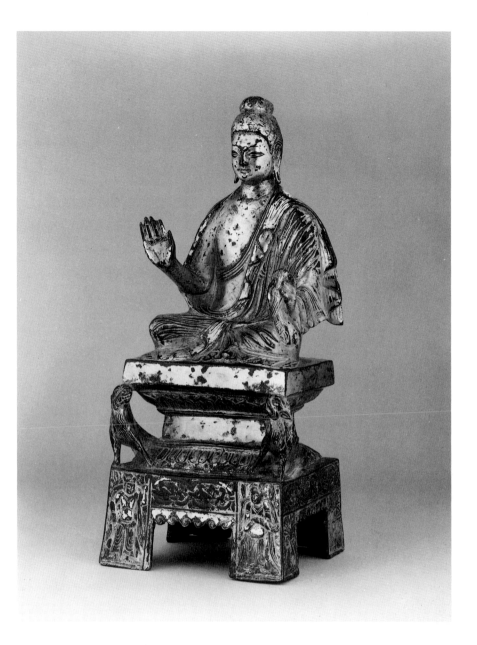

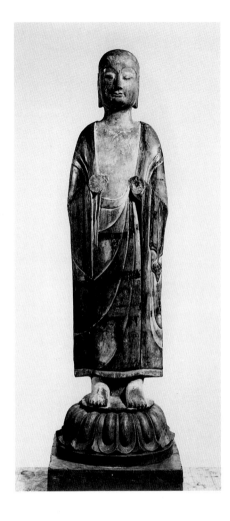

19

BHIKṢU

560–70
Ting-chou School
China, Northern Chi Dynasty (550–577)
White marble with polychrome, 85.6 cm
Bequest—Grenville L. Winthrop,
1943.53.31

The style of the Ting-chou School of
Northern Chi sculpture is characterized
by a sensitive, highly accomplished tech-
nique of marble carving and cylindrical
body modeling. This youthful monk's
(*bhikṣu*) figure is an idealized abstraction
appropriate to the subject and to the
piece's original function as an attendant
to the Buddha. The monastic robes
painted in a patchwork design without
regard to the drapery folds still retain
some of their original coloration.

Reference
O. Sirén, "Chinese Marble Sculptures of the
Transition Period," *Bulletin of the Museum
of Far Eastern Antiquities* 12 (1940), 493,
pl. VIIb.

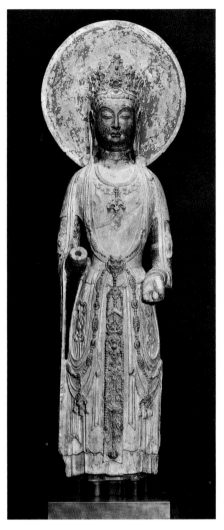

20

AVALOKITEŚVARA

China, Sui Dynasty (581–618)
Limestone with traces of gilding and
pigment, 158 x 34.3 cm
Bequest—Grenville L. Winthrop,
1943.53.43

Reference
M. M. Rhie, "Late Sui Buddhist Sculpture in
Chronology and Regional Analysis," *Archives
of Asian Art* 35 (1982), 27–54, figs. 22–23.

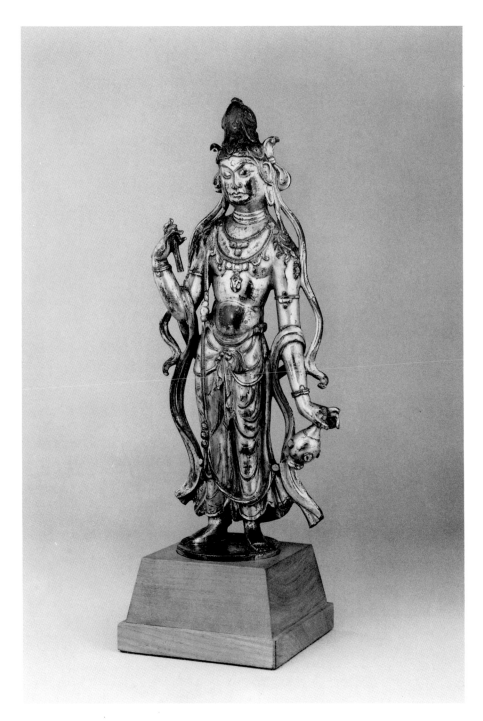

21

AVALOKITEŚVARA

Early 8th century
China, T'ang Dynasty (618–907)
Gilt bronze, 37.2 x 15.2 cm
Bequest—Grenville L. Winthrop,
1943.53.61

Reference
S. Mizuno, *Bronze and Stone Sculpture of China*, Tokyo, 1960, 129.

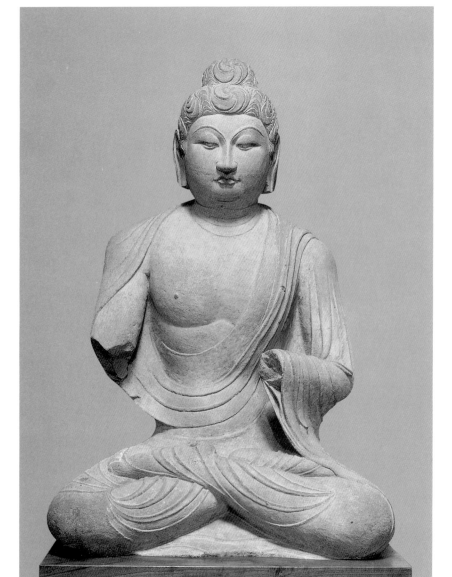

ŚĀKYAMUNI BUDDHA

ca. 715
China, T'ien-lung-shan, Shansi,
T'ang Dynasty (618–907)
Sandstone with traces of polychrome,
109.5 cm
Bequest—Grenville L. Winthrop,
1943.53.22

This sandstone Śākyamuni was originally the central image of a Buddhist triad sculpted in the north wall of Cave 21 at T'ien-lung-shan. The tightly ordered, rhythmic lines and taut, swelling volumes of the figure are characteristic of the developing T'ang style of the early 8th century. Although missing its right arm and left hand, this figure is among the best preserved of the sculptures removed from T'ien-lung-shan. Other images from Cave 21 may be found in the Museum of Fine Arts in Boston and the Brundage Collection of the Asian Art Museum in San Francisco; The Metropolitan Museum of Art in New York possesses the head of one of the bodhisattvas originally flanking the Harvard piece.

References
Sickman and Soper, 1956, 72, fig. 55B; H. Vanderstappen and M. Rhie, "The Sculpture of T'ien-lung-shan: Reconstruction and Dating," *Artibus Asiae* XXVII/3 (1965), 208–10, 217–18, fig. 72; M. M. Rhie, "A T'ang Period Stele Inscription and Cave XXI at T'ien-lung Shan," *Archives of Asian Art* 28 (1974–75), 6–33, figs. 1, 11.

AVALOKITEŚVARA

China, Sung or Chin Dynasty
(960–1279)
Wood with gilt and polychrome,
123.8 x 117.5 cm
Gift—Friends of the Fogg, 1928.110

Originally gessoed and painted, this massive yet fluently disposed Avalokiteśvara (Chinese: Kuan-yin) is fashioned from several wooden blocks attached by mortise and tenon joinery. Compared to the somewhat androgynous bodhisattva type of earlier portrayals, this figure is more distinctly feminine in character and is identified as Avalokiteśvara by the small seated Amitabha Buddha in the gilded crown. Richly attired in princely robes and ornaments, and seated in a posture of royal ease, the image of the bodhisattva found constant expression in sculpture and painting after the T'ang dynasty. Similar works are now preserved in numerous European and American collections, notable examples being found in the Nelson Art Gallery of Kansas City and the City Art Museum in St. Louis.

References
Loehr, 1978, 418–19, fig. 4. See in general, Sickman and Soper, 1956, 97–100.

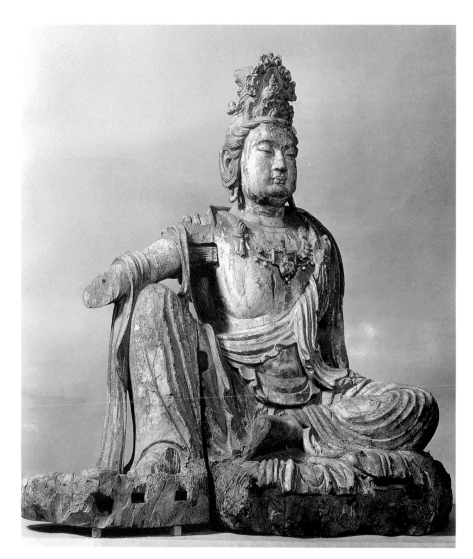

ELEVEN-HEADED KUAN-YIN

Dated 985
China, Tun-huang, Northern Sung
Dynasty (960–1127)
Hanging scroll, ink and colors on silk,
97.3 cm
Bequest—Grenville L. Winthrop,
1943.57.14

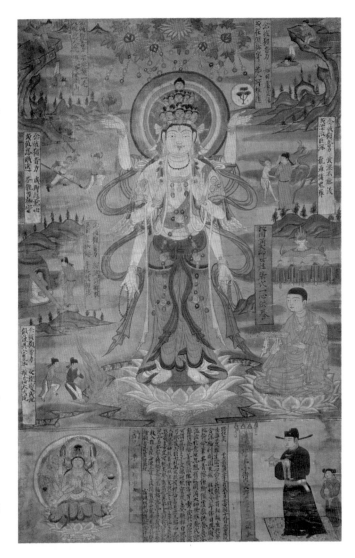

The Art Museums possess paintings and one sculpture from the Buddhist cave sanctuary at Tun-huang in Kansu Province of western China. The Chinese gateway to the ancient Silk Road, Tun-huang was an important artistic center where traditions from India and Central Asia mingled with those from Tibet and China itself. In 1923, the Fogg Museum dispatched an expedition, headed by Langdon Warner, to the Tun-huang area. The dangerous, even chaotic conditions prevailing at the site are described in Warner's *Long Old Road to China*, together with an account of the painstaking process involved in the removal and transport of extremely fragile wall painting fragments and the large stucco sculpture.

The graceful painted clay figure from Cave 328 was originally one of eight attendant bodhisattvas grouped around a central image. Somewhat elongated and youthful in shape, it reflects T'ang Chinese sculpture at the threshold of its development into the more massive, opulent forms seen in the seated Buddha from T'ien-lung-shan (no. 22). The fragment of a wall painting from Cave 320 depicts the head of a bodhisattva in a sensitive manner reflecting the skills of the metropolitan Chinese painting ateliers; it has many similarities with the celebrated Japanese wall paintings of the same date at Hōryū-ji near Nara.

A dated banner painting from the early years of the Sung dynasty adds a further dimension to the Museums' collection of Buddhist art from Tun-huang. Painted in vivid colors and strong outlines, the central figure of the *Eleven-headed Kuan-yin* is surrounded by scenes which illustrate the accompanying quotations from Chapter twenty-five of the Lotus Sutra (*Saddharma Pundarika Sūtra*). The inscription below identifies the donor at the lower right as Tsung-shou, a son of the principal official at Tun-huang, who dedicated the painting to the monk Yuan-man.

References
For information on the 1923 Fogg Museum expedition see L. Warner, *The Long Old Road to China*, New York, 1926, 138 ff.; *idem*, "An Eighth Century Statue from Tun-huang," *Art Studies* IV (1926), 29–37. Sickman and Soper, 1956, pl. 57B (pl. 65A publishes another fragment of a wall painting from Tun-huang in the Museums' collection). For a brief general discussion of Tun-huang see Terukazu Akiyama, *Arts of China: Buddhist Cave Temples*, Tokyo, 1969. For comparative material in the British Museum and the National Museum, New Delhi see also A. Waley, *Catalogue of the Paintings Recovered from Tun-huang by Sir Aurel Stein*, London, 1931, and R. Whitfield (ed.), *The Art of Central Asia, the Stein Collection in the British Museum*, 3 vols., Tokyo, 1982–83.

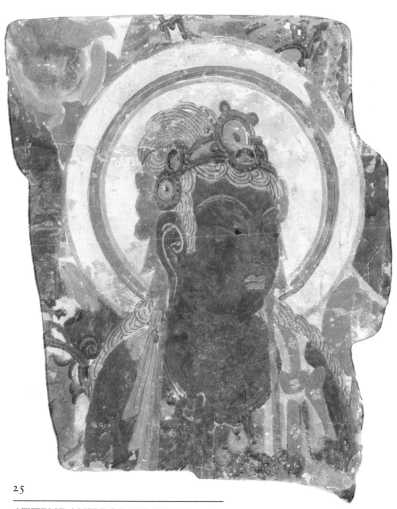

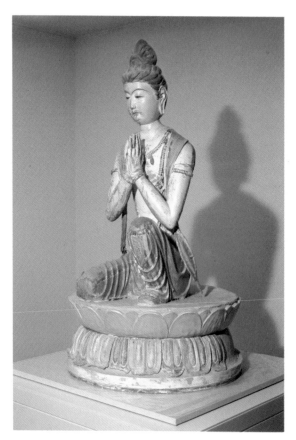

26

ATTENDANT BODHISATTVA

ca. 700
China, Cave 328, Tun-huang
T'ang Dynasty (618–907)
Polychromed unbaked clay,
220 cm
China Expedition, 1923, 1924.70

25

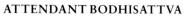

ATTENDANT BODHISATTVA

Early to mid-8th century
China, Cave 320, Tun-huang
T'ang Dynasty (618–907)
Fragment of a wall painting, colors on
clay ground, 73.5 x 58.6 cm (framed)
China Expedition, 1923, 1924.43

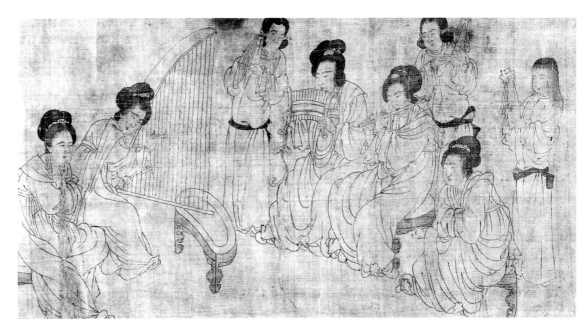

27

LADIES OF THE PALACE

Datable to 1140
After Chou Wen-chü (active ca. 970)
China, Southern Sung Dynasty
(1127–1279)
Handscroll, ink and slight color on silk,
25.7 cm
Purchase—Francis H. Burr Memorial,
1945.28

Originally part of a longer scroll copied from a lost work by the Five Dynasties painter Chou Wen-chü, this scroll is an important relic of Chinese court figure painting. Executed in the *pai-miao* or outline mode with touches of color only in their red hair ribbons and lips, the women and children of these intimate scenes are brought vividly to life by the sensitive brushwork of the artist. Additional scrolls preserving the other sections of Chou Wen-chü's composition are found in The Metropolitan Museum of Art, the Cleveland Museum of Art, and at Villa I Tatti, Florence. A colophon dated 1140 and preserved with the Cleveland portion states that this copy of Chou Wen-chü's scroll was made for the scholar and critic Chang Ch'eng.

References
Y. Yashiro, "Again on the Sung Copy of the Scroll 'Ladies of the Court' by Chou Wen-chü," *Bijutsu Kenkyū* 169 (May 1952), 157–62; *Eight Dynasties of Chinese Painting*, 1980, no. 16, 27–29; Suzuki, 1982, I, A10–026.

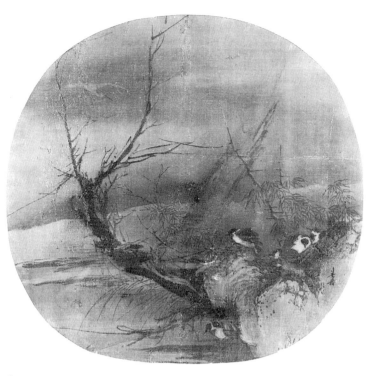

28

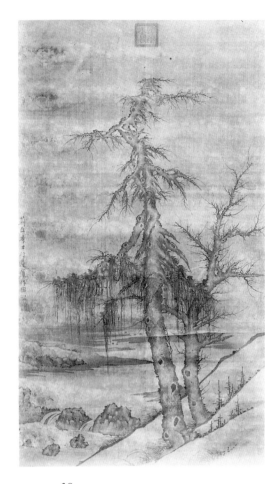

29

WINTER BIRDS

Signed Liang K'ai (active early
13th century)
China, Southern Sung Dynasty
(1127–1279)
Ink and slight colors on silk,
24.1 x 25.4 cm
Gift—Dr. D. W. Ross, 1924.88

After a brief career as a painter in the
Southern Sung Academy during the first
years of the 13th century, Liang K'ai is
said to have left the court and spent the
latter part of his life in a Ch'an (Zen)
monastery. It is from this period that
most of his known works date, those
which later earned him such reverence in
Japan. Best noted for his figural paint-
ings, Liang K'ai also painted landscapes,
many of which show a personal and
introspective interpretation of winter
themes. Since his signature was some-
times added to later copies and imitations
of his work, some scholars, such as Sirén,
have questioned the attribution of this
painting to Liang K'ai; however, the style
closely matches that of this artist and has
been accepted as genuine by many.

References
A. Waley, *Introduction to the Study of Chinese
Painting*, London, 1923, pl. XLV; Sirén, 1956,
II, 133–38 (text), 66 (annotated lists); J.
Cahill, *The Art of Southern Sung China*, New
York, 1962, no. 25; Suzuki, 1982, A10–050.

GUARDIAN OF THE VALLEY

Li Shih-hsing (1282–1328)
China, Yuan Dynasty (1279–1367)
Ink and color on silk, 172.8 x 98.2 cm
Gift—Galen L. Stone, 1923.211

References
S. E. Lee, *Chinese Landscape Painting*,
Cleveland Museum of Art, 1954, 48, pl. 28;
S. E. Lee and W. K. Ho, *Chinese Art Under the
Mongols: The Yuan Dynasty (1279–1368)*,
Cleveland Museum of Art, 1968, 42, pl. 225;
Suzuki, 1982, A10–001.

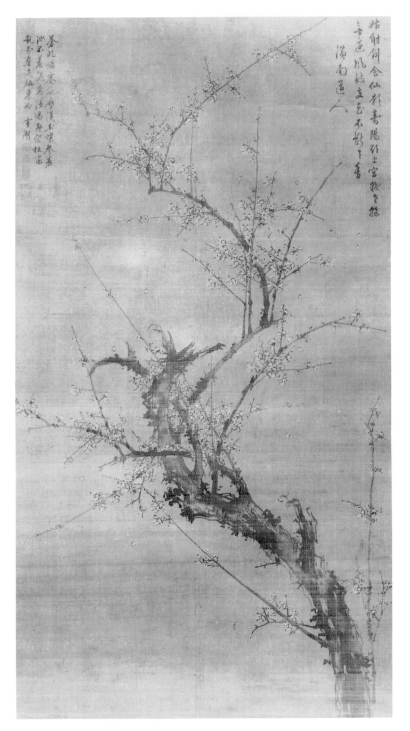

30

PLUM BLOSSOMS

16th century
Liu Shih-ju (1497–after 1581)
China, Ming Dynasty (1368–1644)
Ink on silk, 180 x 98 cm
Gift—Galen L. Stone, 1923.191

As a boy, Liu Shih-ju was, reputedly,
deeply impressed by the work of a re-
nowned 14th-century plum blossom
painter, Wang Mien, and determined to
devote his life to mastering the subject
painted by this mentor. Not content with
merely copying, Liu Shih-ju is said to
have wandered the hills of his district
studying plum trees to enrich his under-
standing of the subject. Working all his
life to perfect his style, he imbued his
brushwork with a vigorous rhythm
supported by the elegantly controlled
tonalities of his ink wash and was thereby
able to capture both the strength and
delicacy of this ancient symbol of life re-
newed. Although few of Liu Shih-ju's
paintings survive, woodblock-printed
copies of his plum manual, *Hsueh-hu
mei-p'u*, suggest the range of his work.

References
Sirén, 1958, IV, 225–26 (text); VI, pl. 254,
and VII, 212 (annotated list); Loehr, 1978,
420; M. Bickford, *Bones of Jade, Soul of Ice*,
Indiana University Press, 1985, no. 23. For an
example of Wang Mien's work see *Eight Dy-
nasties of Chinese Painting*, 1980, no. 89.

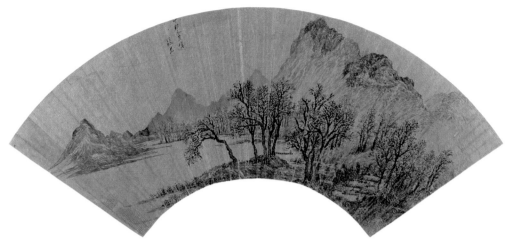

AUTUMN LANDSCAPE

Dated 1627
Chang Hung (1557–ca. 1652)
China, Ming Dynasty (1368–1644)
Folding fan mounted as album leaf, ink
and slight color on gold treated paper,
17.6 x 57.6 cm
Purchase—The Ernest B. and Helen Pratt
Dane Fund, 1984.1

References
See in general J. Cahill, *The Distant Moun-
tains*, New York, 1982, 39–59, and idem, *The
Compelling Image*, Harvard University Press,
1982, 1–35.

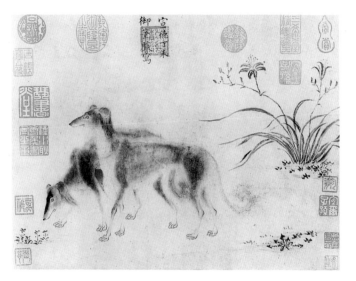

SALUKI DOGS

Dated 1427
Emperor Hsuan-tsung (1399–1435;
reigned 1426–1435)
China, Ming Dynasty (1368–1644)
Ink and slight color on paper,
26.2 x 34.6 cm
Gift—Charles A. Coolidge, 1931.20

The fifth Ming emperor Hsuan-tsung was
the most influential Ming imperial patron
of the arts, and he actively modeled his
patronage on that of the Northern Sung
(960–1127) rulers. He was himself an
accomplished painter, and most works at-
tributed to him are of carefully observed
animal subjects, set in simplified land-
scapes. He was especially known for the
refined and skillful brushwork with
which he rendered the soft coats of his
subjects. The hounds in this work have
been identified as Salukis, a breed orig-
inating in the ancient Near East.

References
Suzuki, 1982, A10–045. See in general Sirén,
1958, IV, 113 (text), and VII, 196 (annotated
lists). For a comparative work see the Nelson
Gallery of Art's "Dog and Bamboo," published
in *Eight Dynasties of Chinese Painting*, 1980,
no. 120.

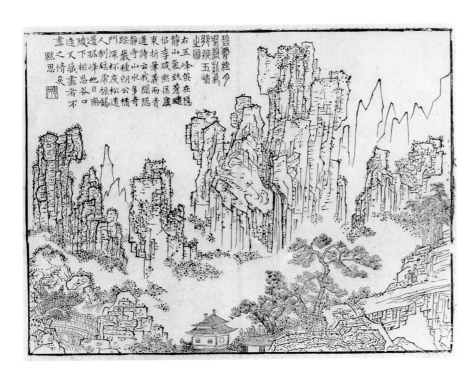

T'AI-P'ING SHAN-SHUI T'U

Dated 1648
Hsiao Yun-ts'ung (1596–1673)
China, Ch'ing Dynasty (1644–1912)
Printed book, ink on paper,
24.3 x 31.1 cm
Purchase—Hofer Collection, with the
assistance of the Dane Fund, 1981.36

With the advent of the alien Ch'ing dynasty in 1644, Hsiao Yun-ts'ung, like many of his loyalist contemporaries, retired from official service and made his living through his artistic activities. A leading master of the Anhui school of painting, he was also a prominent designer of woodblock illustrations. Hsiao's *T'ai-p'ing shan-shui t'u* depicts forty-three scenes of the T'ai-p'ing district in Anhui, all of them designed with artistic reference to compositions of earlier masters. Three master woodcarvers of Anhui—Liu Lung, T'ang Shang, and T'ang I—executed the blocks for this book, capturing the original rhythm and texture of Hsiao's brushwork. The Museums' edition, an exceptionally fine impression, contains thirty-nine of the original forty-three prints and is among the most illustrious copies of the work, having passed through the hands of many prominent Japanese literati of the 18th and 19th centuries. It was to the *T'ai-p'ing shan-shui t'u* and similar works that many Japanese painters of the Nanga school looked for landscape models.

Reference
J. Cahill (ed.), *Shadows of Mt. Huang*, University Art Museum, Berkeley, Cal., 1981, 30–32.

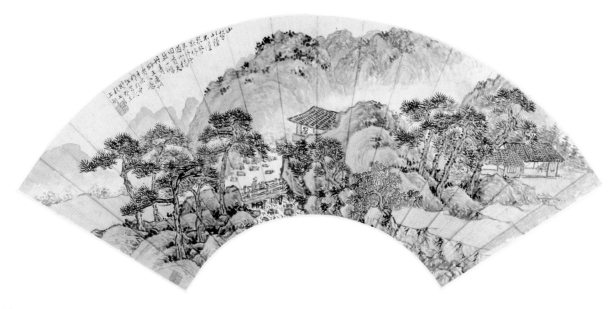

34

SMALL BRIDGE OVER FLOWING STREAM

Dated 1733
Fang Shih-shu (1692–1751)
China, Ch'ing Dynasty (1644–1912)
Folding fan mounted as album leaf, ink and light color on mica-coated paper, 17.45 x 53 cm
Purchase—Oriental Objects Fund, 1978.89

Highly regarded in his own lifetime, Fang Shih-shu was a prominent scholar-gentleman painter at the important artistic center of Yang-chou in the 18th century. Basing his style on a careful study of the Sung and Yuan masters, he became a leading figure in the orthodox as opposed to the eccentric tradition. Known for the refined sensitivity of his brush-work, apparent in this fan painting, Fang was also an accomplished poet and calligrapher. The delicate handling of color and texture found in this fan, which imitates the manner of the painter Wang Chien (1598–1677), distinguishes the polished approach of Fang Shih-shu at this rather early stage of his development.

Reference
See in general Sirén, 1958, V, 218 (text), and VII, 330 (annotated lists).

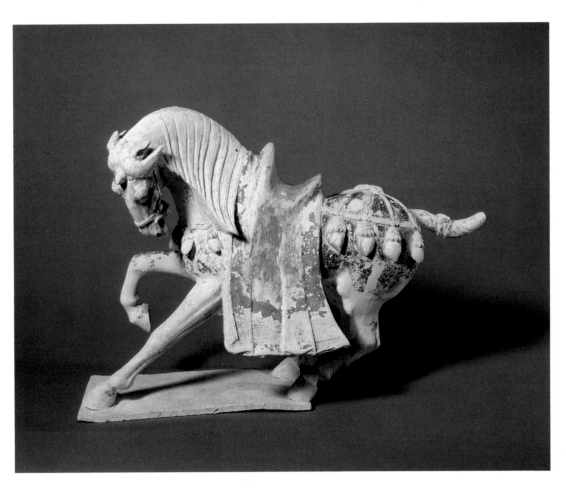

35

**PRANCING HORSE
(TOMB FIGURINE)**

China, T'ang Dynasty (618–907)
Earthenware with traces of white slip and
mineral pigments (grey, green, red),
37.5 x 52 cm
Bequest—Mrs. Nicholas Brown, 1950.86

This magnificent steed most likely would
have joined a large retinue of earthenware
animals, human figures, and serving ves-
sels meant to equip the tomb of a T'ang
aristocrat. Although much of the surface
paint has flaked away, the dynamism of

the horse remains. T'ang tomb sculptures
tell us much about the customs, cos-
tumes, and culture of a sophisticated
society that took pleasure in flaunting
worldly possessions.

Reference
See in general Medley, 1976, 77–82.

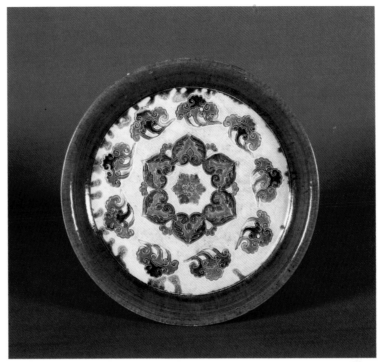

37

SHALLOW DISH ON THREE FEET (SAN-TS'AI WARE)

China, T'ang Dynasty (618–907)
Earthenware with impressed design
under *san-ts'ai* (three-color) lead glaze,
Diam. 29.9 cm
Gift—Dr. Arnold Knapp, 1954.122

San-ts'ai ware is an exuberantly colored
variety of T'ang ceramics, represented
here by a dish on which green, blue, and
amber lead glazes appear against a creamy
white ground. The design fans out from a
central hexagonal rosette to a band of six
linked heart-shaped palmettes and culmi-
nates in a circle of nine fluffy cloud forms
(auspicious motifs), each subtly varied in
color arrangement. The bright green
glaze of the lip contrasts with the amber
of the exterior, and the vessel is sup-
ported by three short cabriole feet. Also
found in other media of the period, the
floral motifs point to influence from the
Near East, reflecting the cosmopolitan
spirit of T'ang culture.

References
H. Trubner, *The Arts of the T'ang Dynasty,*
Los Angeles County Museum, 1957, 22 and
no. 209; M. Loehr, *Chinese Art: Symbols and
Images*, Wellesley College, Wellesley, Mass.,
1967, no. 15; *idem*, 1978, pl. VII.

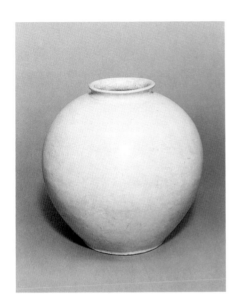

36

JAR

China, T'ang Dynasty (618–907)
Porcelaneous stoneware with cream
white glaze, 23.49 x Diam. 24.13 cm
Gift—In memory of Anne Scott
Thomson by her Friends, 1951.15

The elegantly understated form of this
fully rounded jar demonstrates the grow-
ing sophistication of the Chinese potter.
It was from technical advancements in
the making of such white-bodied earthen-
ware and stoneware that true porcelain
evolved during the T'ang period.

References
See in general H. Trubner, *The Arts of the
T'ang Dynasty*, Los Angeles County Museum,
1957, 22–23, and Medley, 1976, 97–102.

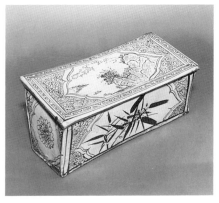

39

PILLOW (TZ'U-CHOU WARE)

13th century
China, Chin Dynasty (1115–1234)
Buff stoneware with wash of white slip,
painted designs in dark brown under a
cream white glaze, L. 30.48 cm
Gift—C. Adrian Rübel, 1950.156

Among the most significant of the highly
diverse *tz'u-chou* wares (sturdy stoneware
made for everyday use) are pillows such
as this one produced by the Chang family
of potters in the district of Tz'u-hsien.
This rectangular example represents one
of two main classes characterized by
shapes used for pillows, which in turn
influenced the nature of the ornamenta-
tion. Here a landscape scene typical of
contemporary painting styles appears on
top within an ogival compartment. On
the four vertical sides, similar ogival
fields contain large bamboo sprays and
lotus or chrysanthemum blossoms, and
freely brushed floral scrolls serve as fillers
in all the spandrels.

References
See in general R. Whitfield, "Tz'u-chou Pillows
with Painted Decoration," in M. Medley (ed.),
Chinese Painting and Decorative Style (Collo-
quies on Art and Archaeology in Asia, no. 5),
London, 1975, 74–94; Medley, 1976, 128–
29 (and fig. 92 for another example of a rec-
tangular Chang family pillow); and M. Tregear,
Sung Ceramics, New York, 1982, 82–84.

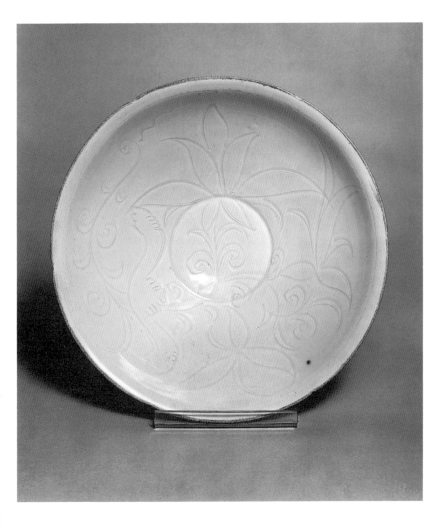

38

DISH (TING WARE)

Early 12th century
China, Sung Dynasty (960–1279)
White porcelaneous stoneware with
carved and incised floral decor under
ivory glaze, Diam. 22.22 cm
Bequest—Dr. Arnold Knapp, 1956.116

Large amounts of fine pottery were
bought from the Ting kilns by agents of
the Sung court at Kaifeng. The combina-
tion of a hard, thin-walled, very white

stoneware body with a transparent glaze
of ivory tone gave the best products of
the Ting kilns the luster and delicacy of
porcelain and set it apart from other
white stoneware and earthenware of the
period. The ethereal blossoms and floral
scrolls that were carved and incised in
this bowl match the quality and handling
of the materials in finesse and restrained
elegance.

References
See in general Medley, 1976, 106–14, and
M. Tregear, *Sung Ceramics*, New York, 1982,
50–62.

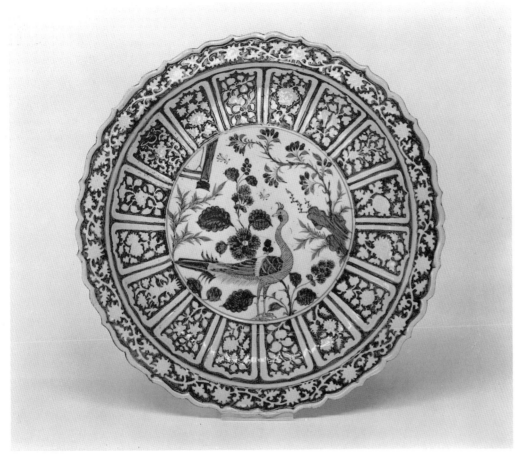

LARGE PLATE WITH ARABIC INSCRIPTION

Mid-14th century
China, Yuan Dynasty (1279–1367)
Porcelain with underglaze blue
decoration, Diam. 48.8 cm
Gift—Richard C. Hobart, 1961.112

The importation in the 14th century of
the mineral cobalt blue, long employed
for Persian faience, dramatically affected
the course of Chinese ceramic pro-
duction. Brought in by Near Eastern
merchants, the mineral was used by Yuan
potters to ornament vessels made pri-
marily for the flourishing export trade;
thus not only the technique, but also
the shapes and decoration reflect non-
Chinese tastes. This plate, then, incorpo-
rates Near Eastern decorative elements,
such as the radiating ogival panels of the
cavetto (the one at ten o'clock enclosing
an illegible Arabic inscription), that are
based on metalwork models. The vessel
as a whole has a distinctive lavishness
that results from the combination of the
ordered, ornamental outer bands, exe-
cuted in low relief and reserved in white
on a blue ground, with the more in-
formal painting of the blue-on-white
gardenscape.

References
J. Ayers, "Early Chinese Blue-and-White in the
Museum of Eastern Art, Oxford," *Oriental
Art* 3 (1951), 137, fig. 11; *idem*, "Some
Characteristic Wares of the Yüan Dynasty,"
Transactions of the Oriental Ceramic Society
29 (1954–55), 69–86, reproduced in pl. 43,
fig. 37; S. E. Lee, *Chinese Art Under the
Mongols*, Cleveland, 1968, no. 150. For a
general discussion of early blue-and-white por-
celain see Medley, 1976, 178–86, and Lion-
Goldschmidt, 1978, 56–60.

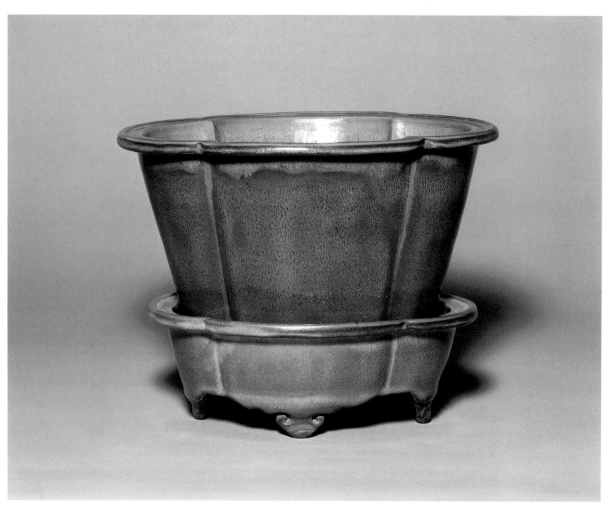

41

FLOWER POT AND STAND

China, Chin Dynasty (1115–1234)
Chün ware, pot 16.5, stand 8.2 cm
Gift—Ernest B. Dane, Class of 1892, and
Helen P. Dane, 1942.185.56a–b

Reference
See in general Medley, 1976, 118–22.

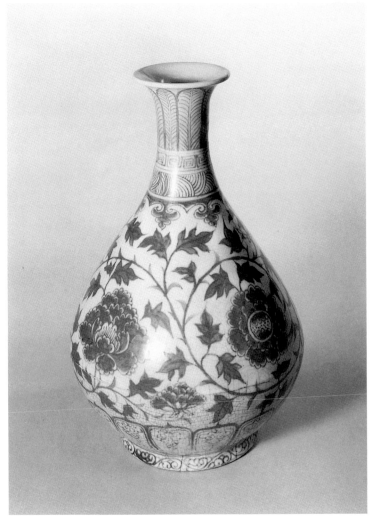

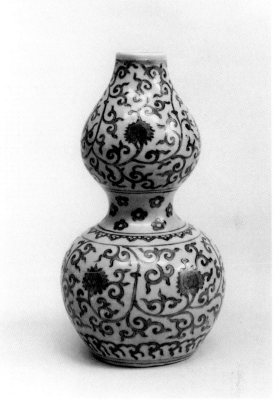

42

43

BOTTLE-SHAPED VASE

Late 14th century
China, Ming Dynasty (1368–1644)
White porcelain with painting in copper
red under transparent glaze, 33 cm
Gift—Richard C. Hobart in memory of
Langdon Warner, 1961.113

In its transition to the superb achieve-
ments of the 15th-century Ming kilns,
the ceramics industry was influenced by
economic and political developments.

The use of underglaze copper red to dec-
orate this vase, for instance, reflects the
temporary decrease in blue-and-white
production due to the scarcity of cobalt
blue during the brief closure of the Chi-
nese ports in the late 14th century. The
designs on the vase suggest the attempt—
as the domestic market grew—to create a
vocabulary of ceramic ornament more
suited to Chinese tastes. In this example,
an imposing peony scroll runs continu-
ously around the belly of the vase.

References
See in general Medley, 1976, 195–200, and
fig. 144 for a very similar vase in the National
Museum, Tokyo; also see Lion-Goldschmidt,
1978, 61–64.

DOUBLE-GOURD VASE

Chia-ching reign (1522–66)
China, Ming Dynasty (1368–1644)
Mark on base: *Ta Ming Chia Ching
Nien Chih*
Porcelain decorated in underglaze blue
and overglaze enamels, 22.2 cm
Bequest—Samuel C. Davis, Class of
1893, 1944.254

References
See in general Medley, 1976, 221–22, and
Lion-Goldschmidt, 1978, 140–41, 162–63.

KOREAN

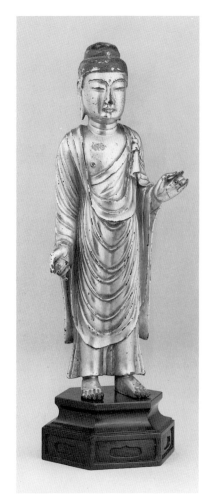

BUDDHA

ca. late 8th–early 9th century
Korea, Unified Silla Dynasty (668–935)
Gilt bronze, 16.2 cm
Bequest—Grenville L. Winthrop,
1943.53.72

Contemporaries of the T'ang court of China, the rulers of the Unified Silla kingdom presided over a period of unparalleled peace, prosperity, and cultural advancement in Korea. At its height, Kyongju, the capital, was one of the largest and most beautiful cities in the Eastern world. Korean Buddhist sculpture in both stone and bronze developed rapidly, revealing the strong influence of T'ang models in its rendition of fluent drapery and bodily proportions. With the decline of official sponsorship and the lessening impact of Chinese tastes in the later 8th century came more distinctly Korean features in sculptural style, such as the flattening of body and garments; the depiction of folds by incisions; and the introduction of a broader, squarer facial type. The generic iconography of these two figures precludes their precise identification: they were probably installed in small household shrines like that in number 46.

Reference
C. Kim and L. K. Lee, *Arts of Korea*, Tokyo, 1974, 62, 75, pls. 78, 109.

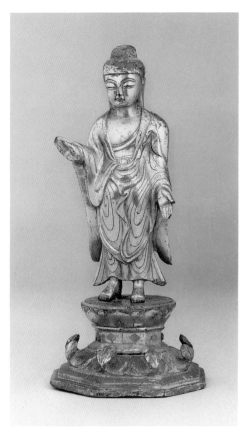

44

BUDDHA

ca. 700
Korea, Unified Silla Dynasty (668–935)
Gilt bronze, 19.9 cm
Bequest—Grenville L. Winthrop,
1943.53.73

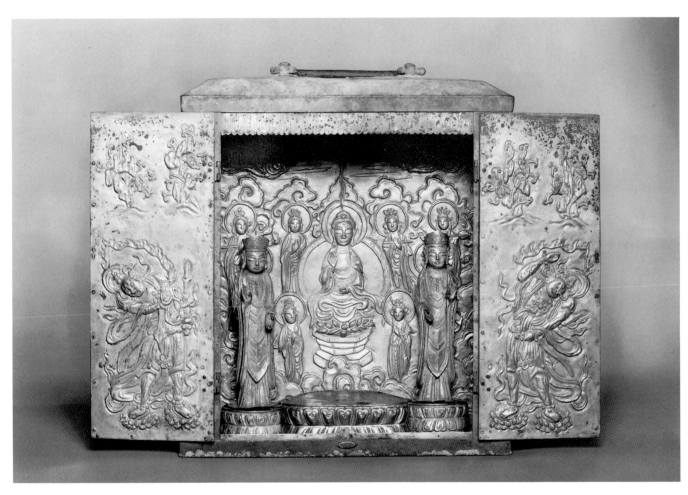

46

BUDDHIST SHRINE WITH
BODHISATTVAS

ca. 11th–12th century
Korea, Koryŏ Dynasty (918–1392)
Silver alloy, gilt bronze,
24 x 22.2 x 11.2 cm
Bequest—Grenville L. Winthrop,
1943.53.71

Reference
C. Kim and L. K. Lee, *Arts of Korea*, Tokyo,
1974, 80, pl. 123.

JAPANESE

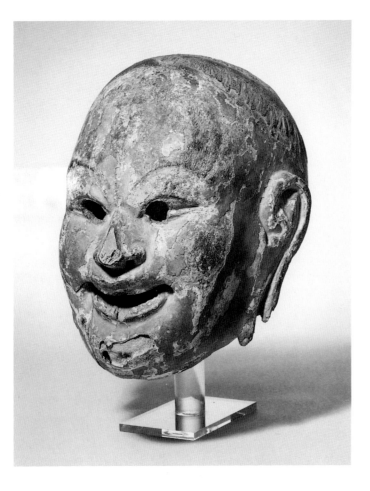

GIGAKU MASK

ca. 754
Japan, Tempyō Period (710–94)
Wood with traces of polychrome
and hair, 28.5 x 21.6 cm
Bequest—Grenville L. Winthrop,
1943.56.11

Handsome, realistic masks that covered
most of the head were employed in
Gigaku, a dance-drama performed in
Japanese temples during the Nara period
(645–794). Originating in China and
Central Asia, the Gigaku dances were
performed during grand ceremonial occa-
sions. Many of the masks were highly
descriptive in style; some represented
exotic Western types. After the ninth cen-
tury, Gigaku was replaced by other forms
of dance, and the masks were stored
away. The largest collections of them
were preserved at the large Nara temples
of Hōryū-ji and Tōdai-ji. This mask, de-
picting a youthful smiling boy, came from
the latter temple, where there is a very
similar one dated 752 and inscribed with
the name Ki'ei, an otherwise unknown
sculptor.

References
Mainichi Shimbunsha (ed.), *Zaigai Nihon no
Shiho* (Japanese Art: Selections from Western
Collections), Tokyo, 1980, VIII, no. 91. See in
general L. Warner, *Japanese Sculpture of the
Tempyō Period*, Cambridge, Mass., 1959, and
P. Kleinschmidt, *Die Masken der Gigaku der
altesten Theaterform Japans*, Wiesbaden,
1966.

ZŌCHŌ-TEN, GUARDIAN OF THE SOUTH

Late 13th or 14th century
Japan, Kamakura Period (1185–1336)
Wood with polychrome, 109.22 cm
(without base)
Gift—Mrs. George R. Agassiz in
memory of Dr. Russell Agassiz, 1951.108

The Kamakura period witnessed the
popularizing of Buddhism throughout all
levels of Japanese society as well as a shift
of political authority away from the
Kyoto aristocracy to the Kamakura head-
quarters of the militant Minamoto clan.
Both factors were influential in the de-
velopment of works characterized by
a new vigor and dramatic appeal during
this last great period of Japanese Bud-
dhist sculpture. The extraordinary skill
achieved by the wood sculptors of this
period is fully displayed in this figure of
Zōchō-ten, derived from Indian Buddhist
mythology in which he serves as one of
the guardians of the four cardinal direc-
tions, whose placement on the temple
altars served to ward off evil. The model-
ing of the robust figure in elaborate
warrior's garb evinces the anonymous
sculptor's obvious delight in the threat-
ening demeanor of his subject. The
beautifully crafted carving, especially evi-
dent in the carefully worked girdle knot
and demon's head biting a cord around
the figure's waist, is enhanced by the
painted decoration of floral and geo-
metric patterns, now much abraded,
which adorns the surface.

Reference
Mainichi Shimbunsha (ed.), *Zaigai Nihon no
Shiho* (Japanese Art: Selections from Western
Collections), Tokyo, 1980, VIII, no. 67.

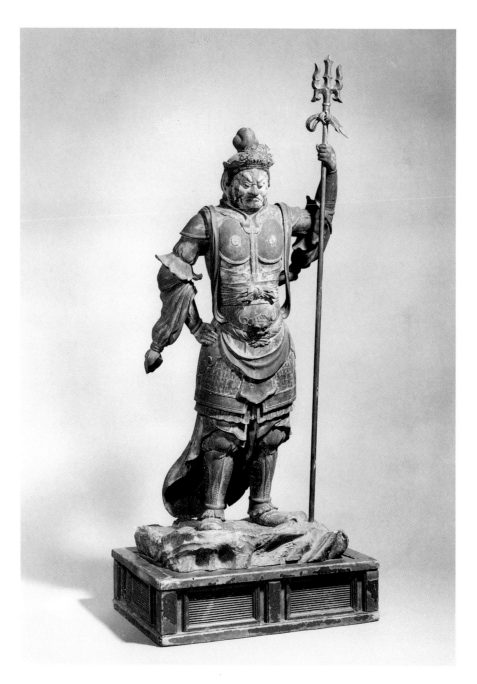

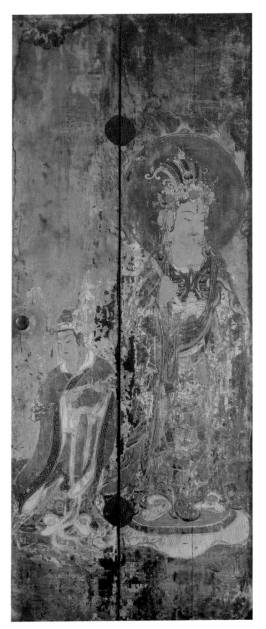
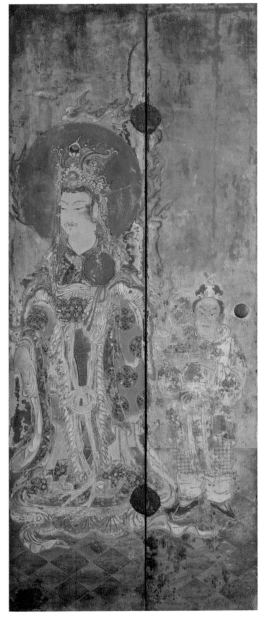

49

SHRINE DOORS WITH BONTEN AND TAISHAKUTEN

14th century
Japan, Muromachi Period (1392–1568)
Color on black lacquer panels,
127 x 105.4 cm
Gift—C. B. Hoyt, 1928.184

Reference
S. Shimada, *Zagai hiho* (Japanese Paintings in
Western Collections), Tokyo, 1969, II, 29
(text), pl. 14.

WOODEN CORE OF HAND DRUM

Japan, Momoyama Period (1568–1603)
Lacquered wood with gold powder
(*maki-e*), 25.4 x Diam. 11 cm
Purchase—The Ernest B. and Helen Pratt
Dane Fund, 1983.39

This small hand drum of lacquered wood is decorated with a design of morning glories drawn in clear lacquer over which gold dust has been sprinkled. It is an exquisite example of the lacquer work associated with the Kyoto temple of Kōdai-ji. Founded in 1606 by the wife of Toyotomi Hideyoshi (1536–98), Kōdai-ji was the funeral shrine for her husband, who was one of the greatest military rulers in Japanese history. The temple served also as the repository for many of their most prized personal possessions, which included numerous lacquer works in this characteristic style. Unlike most *Kōdai-ji* painted lacquer ware, this drum core employs only one motif, the morning glory, which is shown in various stages of its life, lending variety and interest to the design. Drum cores like this, to which leather heads were attached on the ends, were used in the Noh drama. The Museums' drum is among the earliest extant examples of such instruments decorated with *maki-e*.

Reference
Y. Motou, *Kōdai-ji Maki-e*, Kyoto, 1971, 47, illus., no. 54.

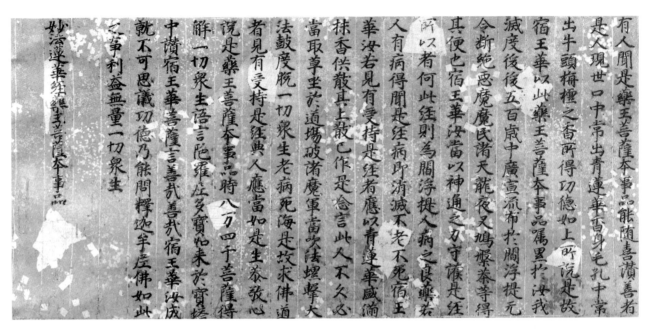

51

SECTION OF THE HOKKE-KYŌ (LOTUS SUTRA)

ca. 1150
Japan, Late Heian Period (897–1185)
Section of a handscroll, mounted as a
hanging scroll, ink on paper decorated
with gold and silver leaf, 25 x 44 cm
Gift—Mrs. Donald F. Hyde, 1977.202

Buddhist texts of the late Heian period
were sumptuous creations commissioned
by the aristocracy. Richly ornamented pa-
pers, embellished with gold and silver
leaf with delicately colored lotus flowers
painted in the margins, were given over to
master calligraphers who wrote the text
in the dignified and disciplined *kaisho*
("regular script") used for the transcrip-
tion of Buddhist texts. This section of the
Lotus Sutra, one of the most revered
scriptures of East Asian Buddhism, was
taken from an original set of eight scrolls
made in the middle of the 12th century.

References
Rosenfield, Cranston, and Cranston, 1973,
52–53; Y. Shimizu and J. M. Rosenfield,
*Masters of Japanese Calligraphy 8th–19th
Century*, Asia Society Galleries and Japan
House Gallery, New York, 1984, 45.

52

DIARY OF THE BRIGHT MOON

Dated the ninth month of 1226
Fujiwara Teika (1162–1241)
Japan, Kamakura Period (1185–1336)
Mounted as a handscroll, ink on paper,
30 cm
Gift—Mrs. Donald F. Hyde, 1977.203

The *Diary of the Bright Moon* (*Mei-getsuki*) is the personal journal of the courtier and important poet and critic Fujiwara Teika, whose life spanned the beginning of the Kamakura military regime (1192–1333). Although intended as a private record and not as a work of art, Teika's diary became a stylistic model of artless beauty for later calligraphers. Restored in 1632, the 110 scrolls of the *Meigetsuki* have since been dispersed in various fragments; the Museums' work is the only one preserved in an American collection.

Reference
Rosenfield, Cranston, and Cranston, 1973, 151–53.

53

EARTHQUAKE SCENE
FRAGMENT FROM THE
ILLUSTRATED LEGEND OF JIN'O-JI

ca. 1350–1400
Japan, Nambokuchō Period (1336–92)
Section of a handscroll, mounted as a
hanging scroll, ink, color, and gold on
paper, 34.4 x 61 cm
Gift—Hofer Collection, given in honor
of Professor and Mrs. Edwin A.
Cranston, 1973.64

The handscroll from which this scene
was taken was originally one of two, de-
picting the semi-legendary–semi-factual
history of Jin'o-ji, a Buddhist temple
south of Osaka. The first scroll, which
recounts the temple's foundation in the
seventh century, tells of the resident de-
ity's wrath at the temple's later neglect
and his revenge by causing the earth-
quake depicted in this scene (the small
blue labels attached to the scroll help to
reconstruct the story). The second scroll

depicts the restoration of the temple in
the eighth century by a Korean monk,
Kōnin. These scrolls combine the more
studied, disciplined style of earlier im-
perial works with the freer, more popu-
larizing elements of local idioms then
emerging in Japanese narrative painting
(*yamato-e*). At the same time they pre-
serve the refined and masterful color
tonalities characteristic of the genre. Two
other fragments from the set are now
owned by the Museums.

References
Rosenfield, Cranston, and Cranston, 1973,
273–75; Mainichi Shimbunsha (ed.), *Zaigai
Nihon no Shiho* (Japanese Art: Selections
from Western Collections), Tokyo, 1980, II,
nos. 90, 91.

六親眷屬乃至一切有情群類同じく安養の

AN ILLUSTRATED HISTORY OF THE YŪZŪ NEMBUTSU SECT

Dated 1471
Painted by the monk Musashi Hōgen
Japan, Muromachi Period (1392–1568)
Two handscrolls, ink and color on paper,
height varies from 25.2 to 30.4 cm
Gift—Hofer Collection, given in honor
of Mr. Mathias Komor, 1973.68

The Yūzū nembutsu sect of Buddhism
was one of several in Japan whose doc-
trine and practice relied primarily on
devotion to Amitābha Buddha, Lord of
the Western Paradise. Central to its wor-
ship was the recitation of the Amidist
prayer "Namu Amida Butsu" ("I accept
the Buddha Amitābha"), which was be-
lieved to increase the believer's chances of
rebirth in the Paradise of the West. At
times the recitation was accompanied by

gongs and dancing; this is shown in the
scroll by the two monks performing on
the platform near the center of a temple
scene. The strong colors, uneven line
quality, and almost caricature-like faces
in this scroll represent a marked depar-
ture from the more professional style of
earlier *yamato-e*, a trend already noted in
reference to *Earthquake Scene* (no. 53).
Comparison with other versions of the
scroll now in American collections such
as those at the Cleveland Museum of Art,

Chicago Art Institute, and Freer Gallery,
reveals an obvious affinity in composition
and detail, suggesting that the artists
worked from an older, well-known model.
A study by Margaret Kanada has shown
that the artist belonged to the Shiba guild
of Buddhist painters in Nara and that the
Museums' scrolls originally belonged to
the Raikō-ji temple in the Kawachi dis-
trict near Osaka.

References
Rosenfield, Cranston, and Cranston, 1973,
276–78. M. M. Kanada, "A Study of the Yūzū
nembutsu engi," *Kokka* 1713 (1985), 7–36.

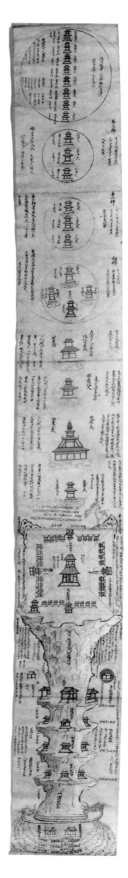

SECTION FROM A BUDDHIST COSMOLOGY

Dated 1402
Illustrated by the monk Ryūyu; text
copied by the monk Ryūi
Japan, Muromachi Period (1392–1568)
Handscroll, ink and color on paper,
28.9 cm
Gift—Hofer Collection, given in honor
of Professor and Mrs. John M.
Rosenfield, 1973.66

Indian cosmology, along with the Buddhist faith, was transmitted to Japan via China. This handscroll, containing five maps of the world as seen from a Japanese perspective, is among the most complete renderings of the Buddhist view of both Asia's geography and spheres of spiritual attainment. Beginning with an extremely simplified map of Japan, the scroll proceeds with maps—more metaphysical than geographical in character—of India, the Four Great Rivers, and the Four Continents of the World. It ends with a listing of the Eight Hells and a pictorial diagram of the various levels of earth and the heavens, turned sideways to fit the scroll's format. Such maps, fabulous and abstract as they seem, exerted a profound influence on Japanese culture and on that society's view of itself in the larger Buddhist world.

Reference
Rosenfield, Cranston, and Cranston, 1973, 104–7.

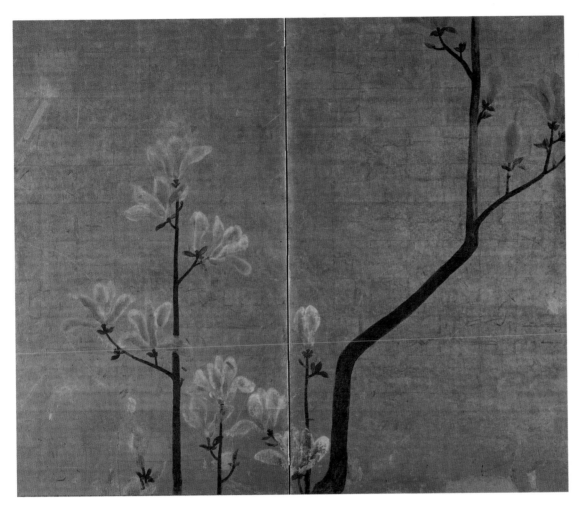

56

TWO-FOLD SCREEN: MAGNOLIA BLOSSOMS ON GOLD GROUND

Early to mid-17th century
Attributed to the School of Tawaraya
Sōtatsu (?–1643?)
Japan, Edo Period (1603–1868)
Color and gold on paper,
137.7 x 183.3 cm
Purchase—Museum Funds, 1962.89

Reference
Loehr, 1978, 419–20.

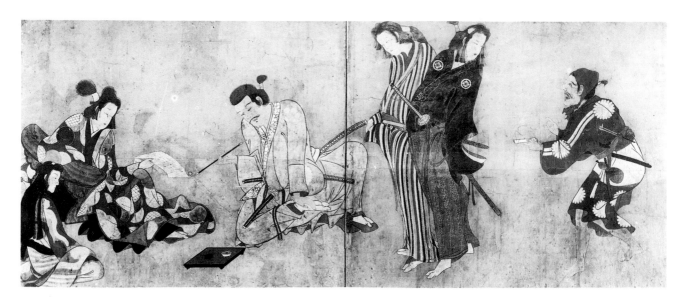

57

TWO-FOLD SCREEN: SCENE IN A GEISHA HOUSE

Early 17th century
Attributed to the School of Matabei
(1578–1650)
Japan, Edo Period (1603–1868)
Color on paper, each panel
84.3 x 73.1 cm
Gift—Dr. Denman W. Ross, 1921.14

References
Bulletin of the Fogg Art Museum, Harvard
University (Nov. 1935), 4; S. E. Lee, *Japanese
Decorative Style*, Cleveland Museum of Art,
1961, 99, 146, no. 98; W. H. Coaldrake,
"Discussion and Disruption in a House of En-
tertainment: A Japanese Fūzoku Painting of
the 17th Century," *Fogg Museum Annual Re-
port*, 1976–78, 58–72.

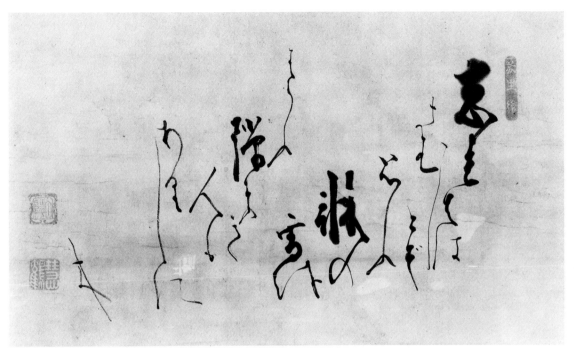

58

POEM ON MEDITATION

Mid-18th century
Hakuin Ekaku (1685–1768)
Japan, Edo Period (1603–1868)
Hanging scroll, ink on paper, 27 x 46 cm
Purchase—Museum Funds, 1964.165

Hakuin remained throughout his life a humble country priest unattached to the seats of political power. He was, nonetheless, instrumental in the 18th-century revival of the Rinzai sect of Buddhism, and through his teaching and writing he became one of the most revered and influential figures in the history of Japanese religion. His painting and calligraphy are prized for their spontaneous, dynamic, and often enigmatic quality. Seen as immediate expressions of the artist's spiritual attainment, their creation was part of Hakuin's own religious discipline. In this poem, using *kanji* (Chinese characters) and *hiragana* (Japanese phonetic script), the middle-aged Hakuin describes the time when he became so engrossed in meditation that he did not even stop to sweep the snow from the floor beside him. The seals to the left read *Hakuin* and *Ekaku*; the one to the right, *Hōjō-e* ("the picture that sets living [beings] free").

References
Loehr, 1978, 420–21; Y. Shimizu and J. M. Rosenfield, *Masters of Japanese Calligraphy 8th–19th Century,* Asia Society Galleries and Japan House Gallery, New York, 1984, 172.

WOMAN RUNNING TO ESCAPE A SUDDEN SHOWER

Suzuki Harunobu (ca. 1725?–70)
Japan, Edo Period (1603–1868)
Polychrome woodblock print,
20.6 x 27 cm
Gift—J. T. and W. S. Spaulding,
F. Warburg, A. Porter, and P. Sachs,
1923.24

Harunobu was a pioneer in the develop-
ment of the color print in Japan. Working
for private connoisseurs whose generous
patronage enabled the rapid refinement of
the printing process in the mid-1760's, he
produced a large number of images in-
tended for personal gifts and calendars,
which were later used in the expanding
commercial market for such prints.
Harunobu was distinct in his selection
and placement of complex color designs
and was renowned for his sensitive, gen-
teel compositions. Invoking his own
poetic and highly personal vision of
idealized womanhood, he placed this fig-
ure amid driving sheets of dark rain
beneath ominously heavy clouds and em-
blems of thunder and lightning.

References
Ukiyo-e Shūka (Collection of the Masterpieces
of *Ukiyo-e* Prints in Museums), Tokyo, 1980,
VIII, 16–17. See also D. B. Waterhouse,
Harunobu and his Age, British Museum, Lon-
don, 1964.

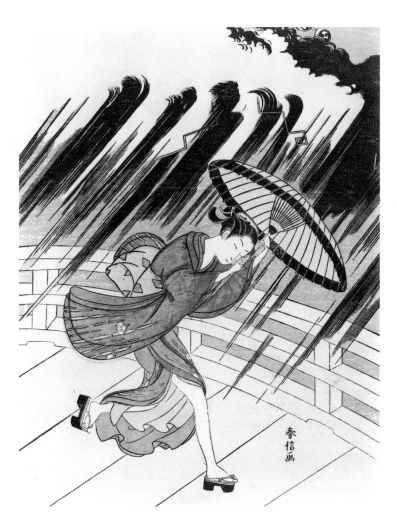

60

THE ACTOR MATSUMOTO KOSHIRO

ca. 1795
Tōshūsai Sharaku (active 1794–95)
Japan, Edo Period (1603–1868)
Polychrome woodblock print with mica-dust background, 37.46 x 25.4 cm
Duel Collection, Gift—Anonymous Donors, 1933.4.510

Despite intensive research, Sharaku remains the most historically elusive of the major *ukiyo-e* printmakers. Little is known with certainty of his life beyond what can be discerned from his surviving prints, some 160 in number, all produced in the remarkably short span of nine months from 1794 to 1795. Most depict actors from the popular dramas of the revived and flourishing Kabuki theater; in this work the actor Matsumoto Koshiro is portrayed in the role of Sakanaya Gorobei from the play *Katakiuchi Noriaibanashi*. Sharaku skillfully exploited and extended the naturalizing trends introduced by Katsukawa Shunshō (1726–92). Through a stylized but sensitive realism frequently verging on caricature, Sharaku captured not only the characteristic physical features but also the forceful personality of his subject, bringing a new psychological dimension to *ukiyo-e*.

References
J. Suzuki, *Sharaku*, Tokyo, 1968, 50, pl. 18;
Ukiyo-e Shūka (Collection of the Masterpieces of *Ukiyo-e* Prints in Museums), Tokyo, 1980, VIII, 24–25.

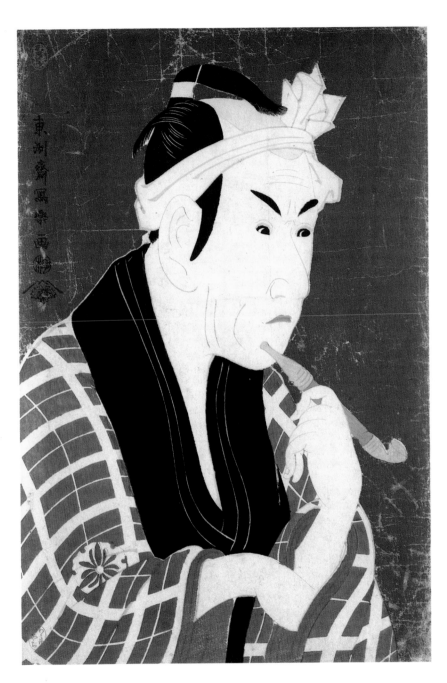

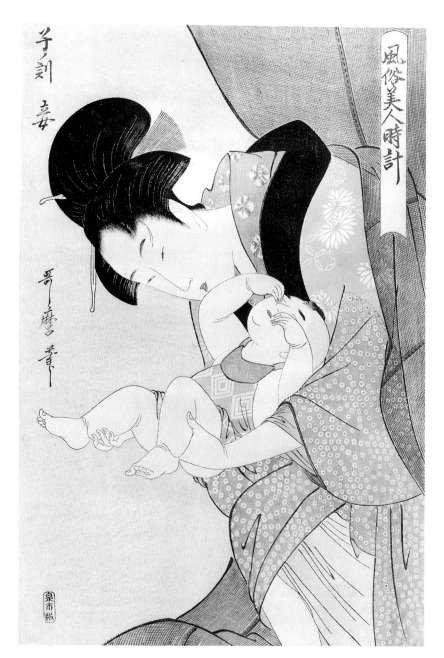

A CONCUBINE AND HER CHILD AT NOON
FROM THE SERIES
FŪZOKU BIJIN TOKEI, 1801(?)

Kitagawa Utamaro (1753–1806)
Japan, Edo Period (1603–1868)
Polychrome woodblock print,
38.8 x 26.4 cm
Duel Collection, Gift—Anonymous
Donors, 1933.4.589

At the end of the 18th century, Utamaro
dominated the popular genre of por-
trayals of beautiful women. Influenced
early in his career by Harunobu's prints
and by contemporary artists such as
Kiyonaga (1752–1815), Utamaro went
on to create a new image of the ideal
woman, subtly sensual and languorous in
her appeal, yet refined and graceful in her
manner. At the same time, Utamaro took
great care to invest his idealized women
with an emotional presence. In this print
the artist portrays a concubine relaxing
with her child at midday; a draped mos-
quito net lends depth to the decorative
surface of the print.

Reference
See in general M. Narazaki and S. Kikuchi,
Utamaro, Tokyo, 1968.

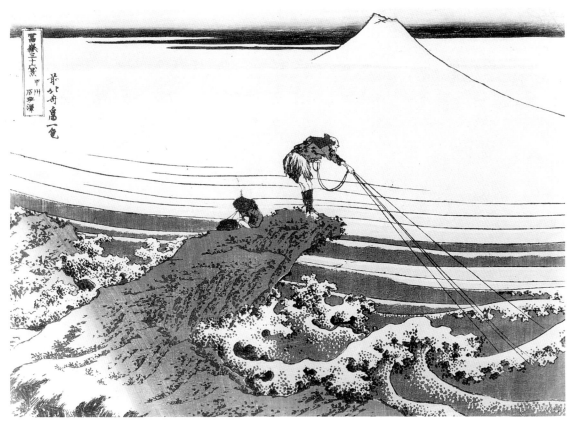

FUJI FROM KAJIKAZAWA
FROM THE SERIES
THIRTY-SIX VIEWS OF MT. FUJI

Katsushiki Hokusai (1780–1849)
Japan, Edo Period (1603–1868)
Polychrome woodblock print,
26 x 38.3 cm
Duel Collection, Gift—Anonymous
Donors, 1933.4.2693

Hokusai's *Thirty-Six Views of Mt. Fuji*
(*Fugaku san-jū-rokkei*), published in a se-
ries from about 1823 to 1831, are among
the Japanese prints best known to West-
ern audiences. Depicting the sacred
mountain from many viewpoints, the se-
ries conveys the spectacle of everyday
country and city life presided over by
Fuji's brooding presence. In favoring
landscape over the traditional *ukiyo-e*
subjects of actors and courtesans, Hoku-
sai opened up an entirely new range of
subject matter for the print medium.
Landscape prints were taken up with

great enthusiasm, although with different
results, by such younger contemporaries
as Hiroshige. This powerful image cap-
tures both the elemental fury of the
foaming waves and the quiet dignity of
the fisherman and small boy on their pre-
carious perch.

Reference
M. Narazaki, *Hokusai "The Thirty-six Views
of Mt. Fuji,"* Tokyo, 1968, 40–41.

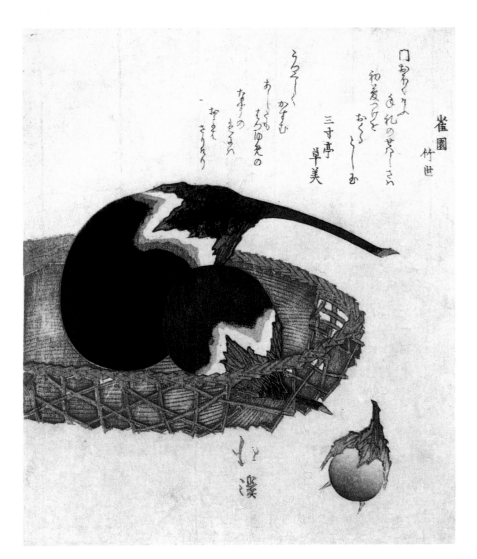

EGGPLANTS

Totoya Hokkei (1780–1851), with
poems by Jakuen Chikusei and associate
Japan, Edo Period (1603–1868)
Polychrome woodblock print,
18.7 x 17.2 cm
Duel Collection, Gift—Anonymous
Donors, 1933.4.1884

Hokkei, a prominent follower of Hokusai,
was among the most prolific exponents of
surimono, deluxe prints privately com-
missioned for personal exchanges and
usually accompanied by verses. Using the
most costly of materials, both the de-
signer and printer had the opportunity to
exercise great technical virtuosity even in
so simple a composition as this still life
with eggplants. The eggplant as subject
presumably was chosen to symbolize
abundance, for it was one of the three
auspicious dreams to be hoped for at the
New Year. The Museums' collection of
surimono is one of the largest in the
world.

Reference
See in general T. Bowie, *Art of the Surimono*,
Indiana University Art Museum, 1979.

64

SPROUT D

Shinoda Toko (1913–)
Japan
Lithograph, numbered 16/50,
59.69 x 45.08 cm
Gift—Art/Asia, 1971.154

Reference
F. Blakemore, *Who's Who in Modern Japanese Prints*, New York, 1975, 185–87.

SOUTH AND SOUTHEAST ASIAN

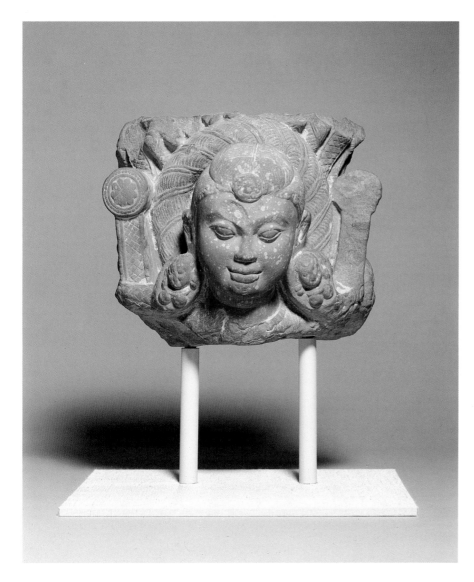

HEAD OF A SERPENT QUEEN

1st century A.D.
India, Mathura
Red Sikri sandstone, 20 x 23 cm
Purchase—The Ernest B. and Helen Pratt
Dane Fund, 1982.61

The Mathura region in northern India
was the center of one of the most vig-
orous and influential sculptural traditions
of the Indian subcontinent. This head of
a *Naginī* or snake deity, carved in the re-
gion's characteristic red sandstone, is an
outstanding example of popular religious
imagery emerging in the first century A.D.
The long coils of the *Naginī's* hair,
surmounted originally by a spreading
canopy of serpents' heads, wrap around
halo-like to outline her face. Her large
earrings are in fact snakes adorned with
humanoid faces, their serpentine bodies
winding around behind. Very similar in
style to this work is a well preserved rail-
ing pillar from Faizabad near Mathura
and now in the Bharat Kala Bhavan in
Varanasi, which may indicate the original
format of this piece.

References
For an illustration of the Faizabad Yaksi see
J. P. Vogel, *La Sculpture de Mathura*, Paris,
1930, pl. L. The Cleveland Museum of Art
Nagini (CMA 68.104) also shares traits with
the Museums' piece; see S. Czuma, "Mathura
Sculpture in the Cleveland Museum Collec-
tion," *The Bulletin of the Cleveland Museum
of Art* LXIV (March 1977), 89, fig. 8.

MALE AND FEMALE DEVOTEES

3rd–4th century A.D.
Said to come from Hadda, Afghanistan
Stucco, Male, 37 x 13.5 cm,
Female, 36 x 10 cm
Purchase—The Ernest B. and Helen Pratt
Dane Fund in memory of Benjamin
Rowland, Jr., 1981.23, 24

These small stucco figures of Buddhist lay
worshipers derive from a larger sculp-
tural ensemble, probably focused on a
central Buddha image; similar images
often have formed part of the decorative
program of the basements of stupas or
monastic structures. The male figure rep-
resents a person of non-Indian origin, for
beneath the heavy scarf of a Buddhist
monk he wears the Iranian or Central
Asian tunic and trousers; the woman,
too, wears a tailored garment beneath her
scarf. Works such as these two figures
clearly reveal the strong Hellenic in-
fluences disseminated in the wake of
Alexander's conquest in the 3rd century
B.C. Over the succeeding centuries, these
influences interacted with artistic styles
from India proper to produce the charac-
teristic traits of the Gandharan school,
named after the region near Peshawar in
Pakistan where works in this style were
first discovered. Extending from Taxila in
the east to the northern tributaries of the
Oxus in the Soviet Union, the Gandharan
school became a major force in the
spread of Buddhist art to Central and
East Asia. Stucco played an important
role in the decorative traditions of the
school, with noted centers such as Hadda
producing some of the finest examples of
Gandharan art in this medium.

References
For examples of the context of such images see
J. Marshall, *Taxila*, Cambridge, England,
1951, III, pls. 58b, 99b. For similar works see
J. Barthoux, *Les Fouilles de Hadda*, Paris,
1930.

TURBANED HEAD OF A ROYAL FIGURE OR BODHISATTVA

3rd–5th century A.D.
Gandharan school
Stucco, 23.6 x 20 cm
Gift—C. Adrian Rübel, 1947.23

Reference
J. Strzygowsky, *The Afghan Stuccos of the
N. R. F. Collection*, New York, 1931, fig. 26.

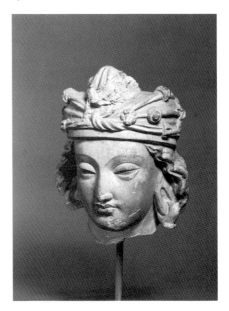

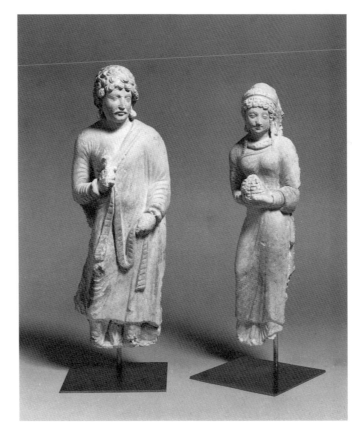

66

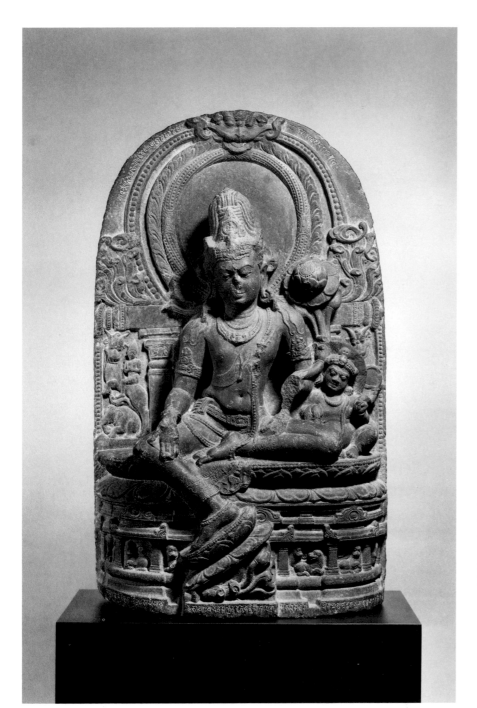

AVALOKITEŚVARA WITH YAMA

10th century
India, Bihar
Grey-brown schist, 78.5 x 47 cm
Gift—Earl Morse, Law School Class of
1930, 1965.48

This statue represents the compassionate
bodhisattva Avalokiteśvara as evidenced
by the now barely discernible effigy of the
Buddha Amitābha in the center of his
elaborate coiffure. He is accompanied by
the dwarf figure of Yama, Vedic god of
death, who is more often associated with
Mañjuśrī. The stele is an outstanding
example of the prolific sculptural work-
shops of Bihar during the reign of the
Pāla kings of Bengal and Eastern India
(8th–12th centuries). Often attached to
the large monastic universities of the re-
gion, such as Nalanda and Vikramaśila
in Bihar, these were the last great centers
of Buddhist art in its native India. It was
from these centers that the Pāla style was
transmitted to Nepal and Tibet, where it
survived after the Muslim conquest of
India proper.

References
P. Chandra, *Indian Sculpture from the Collec-
tion of Mr. and Mrs. Earl Morse*, Cambridge,
Mass., 1963, no. 9; R. Newman, *The Stone
Sculpture of India: A Study of the Materials
Used by Indian Sculptors from ca. 2nd Cen-
tury B.C. to the 16th Century*, Cambridge,
Mass., 1984, fig. 27.

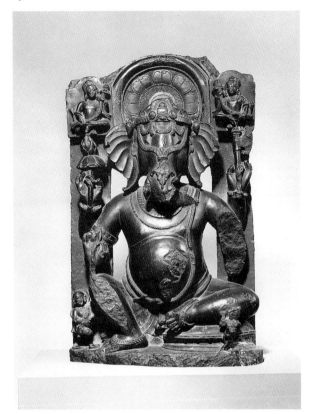

69

GANEŚA

ca. A.D. 900
India, Rajasthan
Carbonaceous matasiltstone,
71.5 x 49 cm
Gift—Mr. and Mrs. Howard E. Houston,
1974.55

The deity who removes all obstacles, the benevolent Ganeśa, is most often shown seated and with four arms. According to Hindu myth, Ganeśa received the elephant's head as compensation after his own had been destroyed in a conflict with Śiva, with whom Ganeśa is intimately linked; he is, in fact, often depicted as Śiva's son. This figure's sculptural style and material suggest it came from the Mewar region of southwestern Rajasthan; similar examples have been recovered from sites at Bansi, Kalyanpur, and Chhota-Bedala and are now housed in the Udaipur Museum.

References
For examples of this school see R. C. Agrawala, "Some Unpublished Sculptures from Southwestern Rajasthan," *Lalit Kala* 6 (Oct. 1959), 63–71, and *Sculpture from Udaipur Museum*, Jaipur, 1960; R. Newman, *The Stone Sculpture of India: A Study of the Materials Used by Indian Sculptors from ca. 2nd Century B.C. to the 16th Century*, Cambridge, Mass., 1984.

70

SEATED VIṢṆU

Early 13th century
India, Tamil Nadu
Bronze, 32.7 x 10.9 cm
Purchase—The Ernest B. and Helen Pratt Dane Fund, 1982.32

With his right hand extended in the *varada* or gift-bestowing gesture and his left delicately holding a flower (now missing), this image embodies the graceful vision of the compassionate and ever-youthful deity typical of the South Indian tradition. The slender elongation of the body with its smooth and softly modeled planes is typical of the late Chola period (10th–12th centuries), which witnessed the acme of bronze casting in the region. A date at the end of this period is suggested by the tall and conical treatment of the crown, the rendering of the face, and the extremely low relief of the decoration.

70

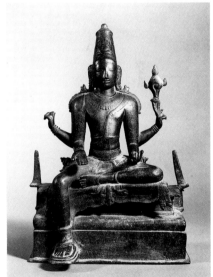

References
Master Bronzes of India, Chicago Institute of Art, 1965, no. 60; S. Czuma in *Indian Art from the George P. Bickford Collection*, Cleveland, 1975, no. 21. For comparative works see P. R. Srinavasan, *Bronzes of South India*, Madras, 1963, figs. 237 and 260.

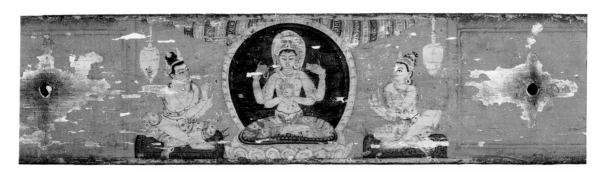

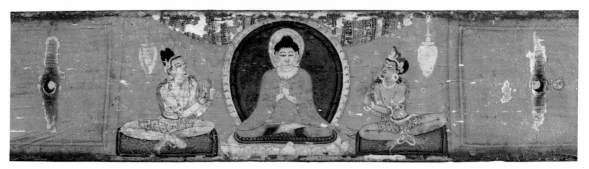

71

GREATER SUTRA OF THE PERFECT WISDOM (ASTASAHASRIKA PRAJÑĀPĀRAMITĀ)

ca. 1100
Nepal or Eastern India
Polychromed wood and palm leaves,
L. 56.7 x 5.6 cm
Gift—Hofer Collection, in honor of
Mr. and Mrs. Stuart Cary Welch,
1973.90

References
Similar dated works may be found in the
Cleveland Museum of Art (38.301, dated
1112), the Victoria and Albert Museum, London (15.1958, dated 1112), and the Bodleian
Library, Oxford (MS Sansk. a 7(R.), dated
1097).

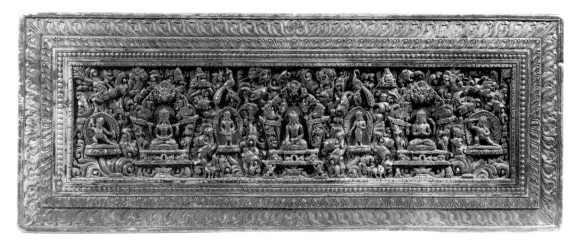

72

SUTRA COVER

ca. 15th century
Nepal or Tibet
Wood with traces of polychromy and
gilding, 26.5 x 69.8 cm
Purchase—Hofer Collection, 1978.515

Traces of red polychromy and gilding re-
main on this expertly carved sutra cover,
which, as on number 71, served to pro-
tect a manuscript copy of one of the
Buddhist scriptures, most likely the Pra-
jñāpāramitā. One of the finest examples
of its type, it richly exemplifies the skill of
the Newari wood-carving traditions of
Nepal during the Malla period (1200–
1769). Set against a background of dense
foliage are seven Buddhist deities; at the
center is Akṣobhya, the Fully Enlightened
Buddha embodying the steadfast, imper-
turbable calm of one who has subdued all
raging passion. Although carrying a Ti-
betan inscription on the inside cover, this
work is characteristically Nepalese in

style, and its date, probably the 15th
century, can be determined through com-
parison to Nepalese bronzes of the
period. Similar carved covers, though
probably of a later date, are owned by the
Newark Museum Collection of Tibetan
Art and Ethnography and the Ashmolean
Museum, Oxford.

References
See in general R. M. Bernier, "Wooden Win-
dows of Nepal," *Artibus Asiae* XXXIX/3–4
(1977), 251–67. For comparison to Nepalese
bronzes see U. von Schroeder, *Indo-Tibetan
Bronzes*, Hong Kong, 1981, 331 ff.

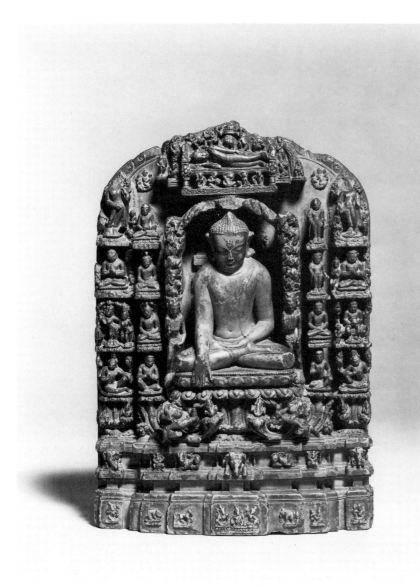

73

PLAQUE WITH SCENES FROM THE LIFE OF THE BUDDHA

12th–13th century
Burma
Alabaster, 18.7 x 13 cm
Purchase—The Louis Sydney Thierry
Memorial Fund, 1979.328

This tiny Burmese stone plaque depicts events in the life of the historical Buddha. Of central import is the portrayal of his moment of Enlightenment, symbolized by his touching the earth with his hand, calling it to witness his steadfastness at the time of temptation. Prominently displayed at the top of the stele and along the sides are the other events of his life, including birth, first sermon, and death. Emaciated figures on the sides of the central image support the schematically rendered host of demons—Mara's army— in their fruitless attempt to distract the Buddha from his path. Other Buddhas, followers, and divinities crowd the tablet, which is sculpted with remarkable detail and finesse considering its extremely small scale. Indebted stylistically to eastern Indian models of the Pāla period (8th–12th centuries), works of this particular type have also been found in Tibet, Ceylon, and India; the majority, however, are found in Burma, which is most likely their place of origin. A very similar work is found in the Mr. and Mrs. John D. Rockefeller III Collection in The Asia Society, New York.

Reference
For similar examples see G. H. Luce, *Old Burma–Early Pagan*, New York, 1970, III, pls. 400–5; I, 148–53, and II, 171–75.

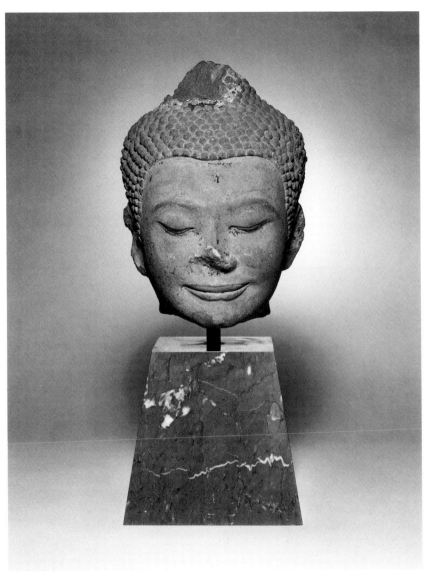

74

HEAD OF BUDDHA

Early 13th century
Cambodia
Stone, 23.5 cm
Gift—Paul J. Sachs, "A testimonial to my friends the Hon. and Mrs. Robert Woods Bliss," 1928.165

A superb example of the Bayon school of Khmer sculpture, the sculptural handling of this head reveals the increasingly naturalistic treatment often found in carvings of the Jayavarman VII period (ca. 1181–1215/19). In its supple treatment of hair and facial features, the work reflects the súrprisingly descriptive traits of con-

temporary royal portraiture, which characteristically blurs the distinction between sacred and secular imagery. Its publication shortly after its arrival at Harvard in 1922 appears to have had a profound impact on the French author and art historian André Malraux and to have influenced his decision to journey to Southeast Asia.

References
D. Ross, "An Example of Cambodian Sculpture," *Fogg Art Museum Notes*, 1922, 2–13; *The Evolution of the Buddha Image*, Asia House, New York, 1963, no. 29; S. E. Lee, *Ancient Cambodian Sculpture*, Asia House, New York, 1969, no. 47; J. Lacouture, *André Malraux* (Eng. trans. A. Sheridan), New York, 1975, 51.

ISLAMIC AND LATER INDIAN

75

**BAHRAM GUR AND THE
MONSTER WOLF (KARG)
MINIATURE FROM
THE "DEMOTTE"
SHAHNAMA** ("BOOK OF KINGS")

ca. 1330–40
Iran, Tabriz, Mongol, Ilkhanid Period
(1256–1353)
Opaque watercolor on paper,
21.1 x 29.9 cm (folio size)
Bequest—Estate of Abby Aldrich
Rockefeller, 1960.190

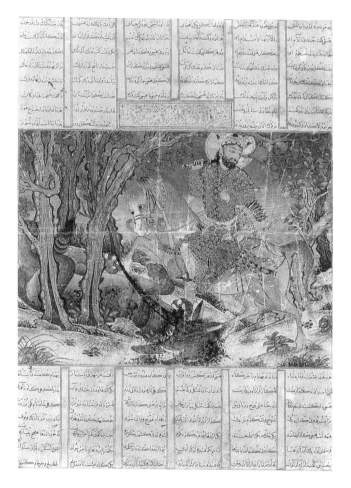

Few Iranian miniatures are more dramatic or visually compelling than this folio from a renowned 14th-century manuscript, one of the earliest copies of the Iranian national epic "The Book of Kings," which was put into verse by Firdausi of Tus during the early years of the 11th century. The miniatures from this manuscript bring together the aesthetic finesse, poignant expressiveness, and vibrant power characteristic of much Iranian painting. In this episode Bahram Gur, the great pre-Islamic ruler and hero of the Sassanian empire, turns his spirited horse away from the scene of his triumph over the vanquished yet still fiercesome Karg.

Fourteenth-century Tabriz, where this manuscript was likely produced, was a center of trade with China from whose art such motifs as the trees and prancing horse of this work were adapted. The greater naturalism of the setting and individualized figures in this and similar paintings illustrates an innovative departure from earlier Iranian works. The Museums are fortunate to own six of the better pages from the "Demotte" *Shahnama*, named ironically after the French art dealer who scattered its miniatures.

References
Simpson, 1980, 28, no. 6; O. Grabar and S. Blair, *Epic Images and Contemporary History, The Illustrations of the Great Mongol Shahnama*, Chicago and London, 1980, no. 53.

TAHMINA COMES TO RUSTAM'S CHAMBER
MINIATURE FROM A SHAHNAMA ("BOOK OF KINGS")

First half of the 15th century
Iran, Timurid Period (1370–1506)
Opaque watercolor on paper,
20.9 x 10.5 cm (miniature)
Gift—Mrs. Elsie Cabot Forbes, Mrs. Eric
Schroeder, and the Annie S. Coburn
Fund, 1939.225

This lyrical and romantic work perfectly
represents the classic restraint of Iranian
painting during the Timurid period. The
calligraphic, minutely detailed lines and
the intricate, colorfully decorated surface
patterns in this picture present a vivid
contrast to the striking boldness of the
Mongol *Bahram Gur and the Monster
Wolf* (no. 75). Illustrating another story
from the *Shahnama*, the famous hero
and warrior Rustam awaits in his bed-
chamber late one night as a slave ushers
in the beautiful and alluring princess Tah-
mina of Samangan, who was to bear him
his only son. A sharp poignancy is added
to the tale by the knowledge that years
later, father and son would meet, neither
recognizing the other, in a fight to the
death.

From the inscription above the door,
the work has been associated with the
important Timurid patron of the arts
Jalal-al-Dawla wa'l Din Iskander, Timur's
grandson and governor of Shiraz (1409–
15); recently a slightly later date has been
suggested.

References
E. Schroeder, *Persian Miniatures in the Fogg
Art Museum*, Cambridge, Mass., 1942,
51–74; Simpson, 1980, 36, no. 8.

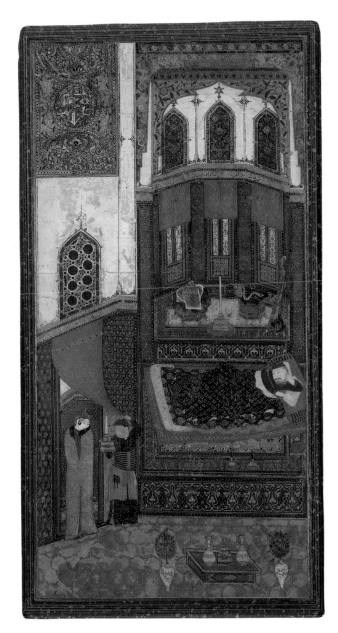

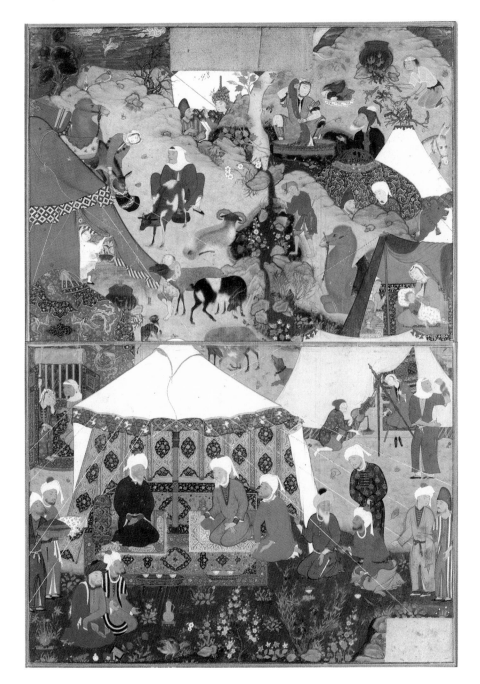

NOMADIC ENCAMPMENT
FROM SHAH TAHMASP'S **KHAMSA**
("QUINTET") OF NIZAMI

Dated 1539–43
Reliably inscribed in a later hand as the
work of Mir Sayyid-ʿAli
Iran, Safavid Period (1501–1736)
Opaque watercolor on paper,
27.8 x 19.3 cm (miniature)
Gift—John Goelet, formerly in the
collection of Louis J. Cartier, 1958.75

Produced under Shah Tahmasp Safavi
(1524–76), one of Iran's most discerning
and devoted patrons of painting, this min-
iature is a major work by Mir Sayyid-ʿAli.
A reclusive, moody, and compulsive art-
ist, he was a passionate sketcher from
life, incorporating studies of animals,
flowers, people, and objects into his
finished works. Rarely equaled in either
his brilliantly intricate technique or
inventively conceived and decorative
compositions, his paintings are also accu-
rate sources of information on Safavid
material culture. He was one of the Safa-
vid artists invited by Humayun (reigned
1530–56) to join the Mughal atelier in
India where his sensitive naturalism was
greatly admired and became an impor-
tant factor in the early formulation of the
Mughal school.

Removed from its manuscript (now in
the British Museum) during the later
17th century, this painting along with a
companion piece (*Night-time in a Palace*,
also in the Museums' collection) was cut
in half and remounted in an album. The
pieces have now been reunited in their
original format by the Museums' paper
conservators.

References
S. C. Welch, *The Art of Mughal India*, The
Asia Society, New York, 1963, no. 1; idem,
*Wonders of the Age, Masterpieces of Early
Safavid Painting, 1501–1576*, Fogg Art Mu-
seum, Cambridge, Mass., 1979, no. 67;
Simpson, 1980, 58–60, no. 17; M. B. Dickson
and S. C. Welch, *The Houghton Shahnameh*,
Cambridge, Mass., 1981, fig. 238.

79

DAYDREAMING YOUTH

ca. 1590
Signed by Riza
Iran, Qazvin, Safavid Period
(1501–1736)
Black ink on paper, 12 x 6.7 cm (without border)
Purchase—Alpheus Hyatt Fund, 1952.7

This painting represents the earlier work of Riza, the outstanding Safavid artist of the later 16th and early 17th centuries, and reveals the influence of such earlier artists as Mirza-ʿAli (no. 78) and his colleague Shaykh-Muhammad on Riza's developing style. That the painter was also a leading calligrapher in a society which venerated the art form is clearly evident in the vibrant linear rhythms achieved in this drawing. Its dashing, rapidly changing lines, resembling the *nastaʿliq* script seen in the artist's signature, appeal as abstract forms at the same time as they characterize the sitter and establish his pose. Riza's pictures, frequently representing popular themes such as musicians, wrestlers, and mountebanks, were eagerly collected by connoisseurs who gathered such drawings to be mounted in albums facing specimens of artful calligraphy.

Reference
Simpson, 1980, 84, no. 30.

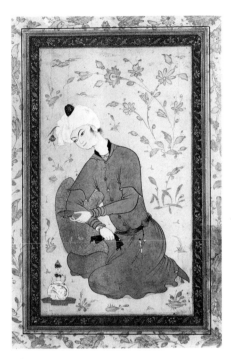

78

YOUTH WITH A GOLDEN PILLOW

ca. 1560
Attributed to Mirza-ʿAli
Iran, Mashhad, Safavid Period
(1501–1736)
Opaque watercolor on paper,
17.6 x 10.1 cm (miniature)
Gift—John Goelet, formerly in the collection of Louis J. Cartier, 1958.61

Shah Tahmasp's growing disaffection with the arts prompted his nephew Sultan Ibrahim Mirza, an avid poet, musician, inventor, and polo player, to gather under his patronage at Mashhad in the later 1550's many of the artists formerly employed at his uncle's court in Qazvin. Among these was Mirza-ʿAli who concentrated in his later works on exploring the atmosphere and sophisticated affectations of the Safavid court, which are exquisitely captured in the sensuous ambiguity of this *Youth with a Golden Pillow*. Effectively contrasting the light, floral-adorned background with the bright blue and orange embroidered garments, Mirza-ʿAli also reveals his mastery of anatomy in the perfectly balanced limbs of this mysterious youth. Remaining loyal to his young patron even after the latter's exile to the remote town of Sabzivar, Mirza-ʿAli later returned to the Safavid capital with the reconciliation of Shah Tahmasp and his nephew: under the direction of these two great patrons, he and his colleagues painted their culminating masterpieces.

References
S. C. Welch, "Pictures from the Hindu and Muslim World," *Apollo* 107/195 (1978), 423; idem, *Wonders of the Age, Masterpieces of Early Safavid Painting, 1501–1576*, Fogg Art Museum, Cambridge, Mass., 1979, 200, no. 78; Simpson, 1980, 64, no. 20.

MYSTICAL JOURNEY

ca. 1650
Probably Iran, Safavid Period
(1501–1736)
Black ink and watercolor on paper, with
gold rulings, 24.8 x 12.5 cm
Purchase—Grace Nichols Strong, Francis
H. Burr Memorial, and Friends of the
Fogg Museum Fund, 1950.135

During the 17th century Muslim artists
became increasingly international, a
circumstance aptly reflected in this ex-
traordinary tinted drawing which, by
nature of its visionary, otherworldly
quality, defies a specific geographical lo-
cation. A "Turko-Iranian" work whose
provenance may have been one of the
Deccani sultanates of India, Safavid Iran,
or perhaps Ottoman Turkey, it reflects
not only the fact that many artists were
Sufis (mystics) but also that their careers
often took them across temporal as well
as spiritual borders. Caught up in a swirl-
ing pattern reminiscent of marbleized
paper, ascetics of all degrees and sizes are
swept magically through the air, sur-
rounded by birds, insects, and animals in
this teeming cosmic dance. One bearded
sage is actually transformed into an ele-
phant. The mystical allusions mirrored
in the dreamlike intensity of this image
have been related to those found in such
literary works as Farid al-Din 'Attar's
Conference of the Birds. Despite
trimming, this strikingly original yet
anonymous drawing has lost none of its
dramatic appeal.

References
A. Welch, *Shah 'Abbas and the Arts of Isfahan*,
New York, 1973, 99, no. 59; Simpson, 1980,
98, no. 37.

81

DRAGON CAVORTING

16th century
Turkish, Ottoman Period (1281–1922)
Ink heightened with color, gold, and
silver, on paper, 17.5 x 10.6 cm (opening)
Gift—Mr. and Mrs. John Dolliver
MacDonald in memory of Eric
Schroeder, 1974.101

82

FOLIO FROM A BLUE VELLUM QUR'AN

ca. 9th century
Tunisia, Qairawan, Aghlabid Period (800–909)
Gold ink on blue vellum, 28.6 x 37.5 cm
Purchase—Francis H. Burr Memorial, 1967.23

This folio from one of the most admired copies of the *Qur'an*, executed in gold ink on blue vellum perhaps after Byzantine models, is one among only three or four similar examples in the Islamic tradition. It was commissioned at the Great Mosque of Qairawan for the mosque at Mashhad by the Abbasid Caliph al-Ma'mun (ruled A.D. 813–33). Unaccountably it was not delivered, and although many of its pages have been dispersed, much of the manuscript remains in the National Library in Tunis.

The script employed is a highly stylized Kufic, considered the most noble vehicle for God's word. Clearly based on a design aesthetic, it stresses the linear quality of a calligraphy that achieves striking visual effects by freely lengthening or compressing individual words. This device, along with the minimal use of vowel and diacritical signs, makes the reading of this luxury manuscript difficult. The folio is from the "Surah al' Baqarah" (the Cow), one of the most familiar chapters of the *Qur'an*.

Reference
A. Welch, 1979, 48–49, no. 4.

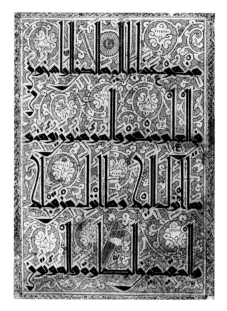

83

FOLIO FROM A QUR'AN

11th–early 12th century
Iran, Seljuk Period (1038–1194)
Ink and color on paper, 31.3 x 21.4 cm
Purchase—Discretionary Fund of the
Islamic Department, 1982.40

References
See A. Welch, 1979, 64, no. 13, and *idem* and
S. C. Welch, *Arts of the Islamic Book, The
Collection of Prince Sadruddin Aga Khan*,
Ithaca, N.Y., and London, 1982, no. 11, for
folios from the same manuscript.

84

TUGHRA OF MAHMUD I
(1730–54) WITH AN IRIS

Turkey, Ottoman Period (1281–1922)
Ink and watercolor on paper,
25.4 x 38.3 cm (sight)
Purchase—Alpheus Hyatt Fund,
1958.123

The Ottoman *tughra*—imperial ciphers
or seals based on the characters of the
sultan's names—are among the most
dynamic and refined reflections of the
Turkish aesthetic. Devised by court
calligraphers (*tughrakesh*) who took
pleasure in the challenge of composing
infinite variations on this striking theme,
they vary greatly in both complexity and
scale, some being six feet long while
others are as small as the head of a pin.
Enriched with illuminated passages, Sultan Mahmud's *tughra* also expresses the
Ottomans' preoccupation with flowers. In
this case, rather than the tulip for which
the Ottomans were justly famed, a lone
iris complements and balances the composition and calligraphic flourish of the
sultan's name. Its naturalism stems from
European botanical illustrations and the
natural history studies of Mughal India.

References
See in general E. Kuhnel, "Die osmanische
Tughra," *Kunst des Orients*, 1955, II, 69–82;
F. Babinger, *Die grossherrliche Tughra*, Istanbul, 1975; and Suha Umur, *Osmanli Padishah
Tugralari*, Istanbul, 1980.

BOWL

10th–early 11th century
Iran, Samanid Period (819–ca. 1005)
Ceramic, 4.5 x Diam. 14.5 cm
Gift—John Goelet, 1960.28

Characteristic of a type of ware produced at Nishapur in northeastern Iran during the period of Samanid rule, this small bowl carries a simple calligraphic ornament in rich, black Kufic script. In their artful yet unassuming composition of decorative scheme against white glazed ground, such vessels achieve a stunning, starkly elegant effect. The calligraphic ornament usually consists of short moralizing or folk aphorisms, invariably delightful in design if not always accurate in transcription and likely intended more for the edification of merchants than of the royal household.

Reference
See in general C. K. Wilkinson, *Nishapur Pottery of the Early Islamic Period*, The Metropolitan Museum of Art, New York, 1973.

86

BOWL

ca. 14th century
Iran, "Sultanabad" ware, Ilkhanid Period
(1256–1353)
Glazed ceramic, 12.4 x Diam. 27.4 cm
Gift—Mrs. Carleton S. Coon, 1962.154

References
See in general A. Lane, *Later Islamic Pottery*,
London, 1957, 10–13, and E. Grube, *Islamic
Pottery of the Eighth to the Fifteenth Century
in the Keir Collection*, London, 1976,
261–68.

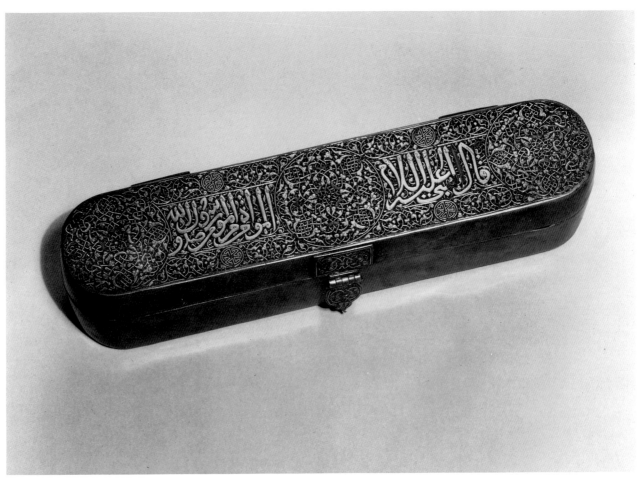

87

PEN BOX (QALAMDAN)

Late 14th–early 15th century
Iran, Timurid Period (1370–1506)
Bronze inlaid with silver and gold,
4.5 x 5.4 x L. 24.8 cm
Bequest—Frances L. Hofer, 1979.352

This superbly inlaid Timurid pen box, of
a type developed in the 12th century, re-
veals the same decorative finesse, discrete
inventiveness of arabesque design, and
proportional balance as encountered in
the miniature paintings of the period

(no. 76). A thoroughly princely object, it
could well be imagined in one of the pal-
ace scenes that often form the backdrop
for Timurid illustrations or in the hands
of the artists who created them. The
prominent inscription on its face is ap-
propriate for such a use, reading: "The
Prophet, upon whom be peace, said: 'The
believer is the mirror of the believer. The
Prophet of God has spoken the truth!'"

Reference
See in general A. U. Pope (ed.), *A Survey of
Persian Art*, London and New York, 1938–39,
section on metalwork by R. Harari.

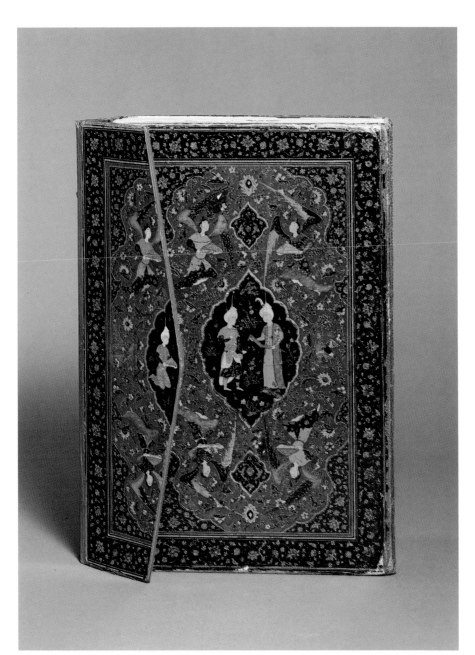

BINDING OF A MANUSCRIPT: THE DIVAN (POETICAL WORKS) OF HAFIZ

ca. 1530
Iran, Safavid Period (1501–1736)
Lacquer, 19 x 29 cm
Gift—Stuart Cary Welch, 1964.149

One of the finest surviving examples of early Safavid lacquer, this binding was made in the atelier of Shah Tahmasp to protect one of his most remarkable manuscripts, *The Divan of Hafiz*, illustrated by Sultan-Muhammad and Shaykh-Zadeh. Sultan-Muhammad, who like many of the court painters also worked in the medium of lacquer, is probably responsible for the angels flying against the rich floral arabesque background of this cover. The inner flap is of a lustrous black, enriched by drawings in gold and enlivened by a bounding fox, which may also be assigned to the same hand (as may the set of playing cards in the Stadt- und Landesbibliothek, Vienna, attributed to Sultan-Muhammad through relation to this binding). Originally a Chinese technique, lacquer had already been employed in Iran for some time; its use for bookbindings is known there in the 15th century.

References
See in general A. U. Pope (ed.), *A Survey of Persian Art*, London and New York, 1938–39, V, 1984–86, and IX, pls. 972, 977a. For the playing cards see R. von Leyden, D. Duda, and M. Roschanzamir, *Spielkarten-Bilder in Persischen Lackmalereien der Osterreichischen National-Bibliothek*, Vienna, n.d. (1981?).

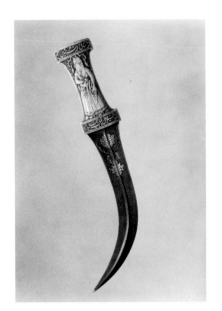

89

IVORY HILTED DAGGER

Blade 1800–01, handle 1834–38
Iran, Qajar Period (1779–1925)
Length of blade 20 cm, of hilt 11.6 cm
Purchase—Alpheus Hyatt Fund,
1958.1.31

The inscriptions adorning the carved
ivory hilt of this dagger identify the fig-
ure on one side as Muhammad Shah
(reigned 1834–48), third ruler of the Qa-
jar Dynasty in Iran, and that on the other
as Sayyid ʿAli Khan, first Aga Khan of the
Ismaili Moslem Sect. Commissioned ap-
parently as a gift for the latter by one of
his followers, this dagger reflects the
close personal and political ties between
the two men. Their friendship ended,
however, in 1838 after an abortive revolt
and subsequent flight to India by the Aga
Khan. The hilt is attached to an earlier
blade, the craftsmanship of which reveals
the work of a master swordsmith; an
inscription forming part of the gilt deco-
ration on the blade notes its manufacture
in the Hijra year 1215 (1800–01) by
one Muhammad Hadi by order of Aga
Qadalu.

Reference
A. Welch, 1979, 158–59, no. 60.

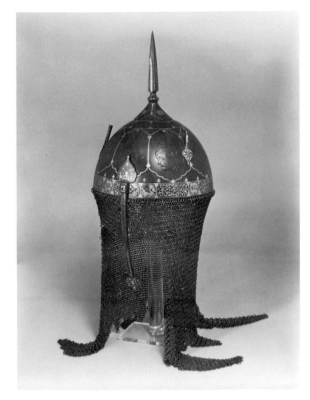

90

HELMET WITH CHAIN MAIL

17th century
Iran, Isfahan, Safavid Period (1501–1736)
Steel with hunting scenes worked in relief
inlaid with gold, encomiastic inscriptions
with the names of heroes from the
Shahnama, 27 cm (without chain mail),
L. of chain mail 40 cm
Gift—John Goelet, 1960.39

Reference
A. Welch, *Shah ʾAbbas and the Arts of Isfahan*,
New York, 1973, 60, no. 46.

PILGRIMS' BANNER

Dated 1094 A.H. (1683)
North Africa
Silk, 337.9 x 194.5 cm
Gift—John Goelet, 1958.20

Banners such as this large brocaded ex-
ample from North Africa were often
borne aloft at the head of religious and
military processions; sometimes, as in
this case, they were meant to be carried
before a pilgrimage cortege to the holy
city of Mecca. Reference to the 12th-
century North African mystic ʿAbd al-
Qadir in the lavish epigraphic decoration
identifies this work as belonging to fol-
lowers of his Qadiriyya religious order.
The close relationship between this work
and Ottoman banners woven in Istanbul
has also been noted.

References
W. B. Denny, "A Group of Silk Islamic Ban-
ners," *Textile Museum Journal* IV/1 (Dec.
1974), 67–81; A. Welch, 1979, 76–77,
no. 20.

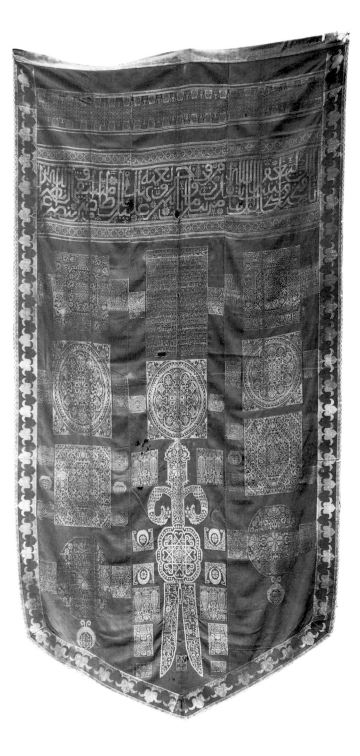

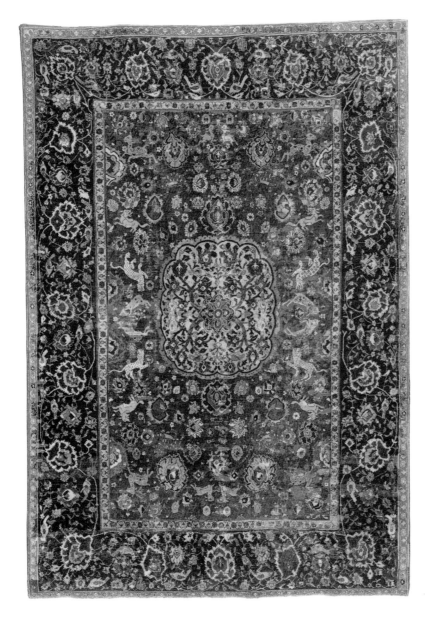

MEDALLION AND HUNTING CARPET

16th century
Iran, Safavid Period (1501–1736)
Wool, 235.6 x 160 cm
Bequest—Joseph V. McMullan, 1974.57

The artists of the Safavid shahs often provided the designs for carpets and other textiles; their influence is beautifully apparent in the lively and highly pictorial rendering of animal and floral motifs in this sumptuous carpet. Its design relates closely to similar works depicting the royal hunt, but, in the words of the carpet specialist Joseph V. McMullan who bequeathed this carpet to the Museums, "[it] has all the indications of a hunting scene, only the hunters are missing." From the royal workshops the patterns and motifs of such imperial carpets migrated to the humbler ateliers of the bazaars from Qazvin and Isfahan to Turkey and India, exerting a profound and far-reaching influence and often undergoing remarkable transformations in the process.

Reference
J. V. McMullan, *Islamic Carpets*, New York, 1965, 76, no. 15.

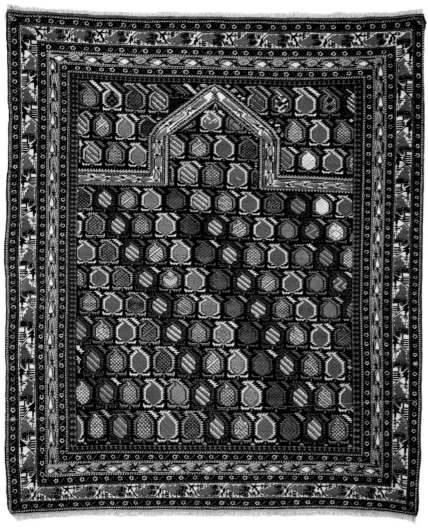

93

MARASALI PRAYER RUG

19th century
Caucasus (U.S.S.R.)
Wool with silk, 132 x 115 cm
Gift—Elizabeth Gowing, Harborne W.
Stuart, Peggy Coolidge, and the estate of
W. I. Stuart in memory of Mr. and Mrs.
Willoughby H. Stuart, Jr., 1977.166

This small pile prayer rug from the east-
ern Caucasus is among the most superb
and rare examples of its type. The weave
is exceptionally fine with almost 300
knots to the square inch; silk fibers added
to the wool at irregular intervals provide
lambent sheen. The *boteh* or small leaf-
like designs that dominate the field are a
motif of Persian origin and are employed
here in a color scheme and pattern of ex-
traordinary vitality. While the exact
provenance and date of this carpet are
not known, Marasali in the Shirvan dis-
trict of the Caucasus has been suggested
as the probable place of origin for this
and similar pieces.

Reference
W. B. Denny, *Oriental Rugs*, Washington,
D.C., 1979, 59, 68.

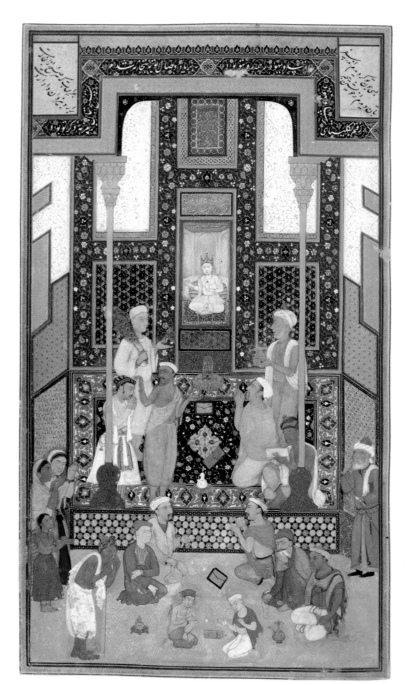

THE POET'S VISIT TO AN INDIAN TEMPLE FROM A BUSTAN OF SA'DI MANUSCRIPT

ca. 1540
Bukhara
Repainting attributed to the Mughal
artist Bishandas, ca. 1620
Opaque watercolor and gold on paper,
28.5 x 17.5 cm
Gift—Philip Hofer in honor of Stuart
Cary Welch, 1979.20

This miniature was one of three included
in a copy of the 13th-century Iranian
poem, the *Bustan* of Sa'di, created for the
discerning Uzbek Sultan 'Abd al-'Aziz of
Bukhara (reigned 1540–49). The episode
illustrated here recounts one of Sa'di's ad-
ventures in India when he was shocked to
discover that a miraculously moving im-
age in a temple was in fact manipulated
by hidden strings pulled by priests. The
original painting can be attributed to
Shaykh-Sadeh, an outstanding pupil of
Bihzad; the precisely detailed architec-
tural setting still reveals his remarkable
skill. The figures, however, were com-
pletely reworked by the Indian artist
Bishandas upon acquisition of the manu-
script by the Mughal emperor Jahangir
(reigned 1605–27); the former's hand
and the latter's natural interests are re-
sponsible for these superb characteriza-
tions as they now appear, certainly among
the most enticing features of the work.

References
S. C. Welch, *The Art of Mughal India*, New
York, 1963, 70–71, pl. 23; M. C. Beach, *The
Grand Mogul: Imperial Painting in India
1600–1660*, Williamstown, Mass., 1978, 110.

SLAUGHTER ON THE RAMPARTS
FOLIO FROM THE **DASTAN-I AMIR HAMZA** ("TALES OF AMIR HAMZA")

ca. 1570
India, Mughal Period (1526–1857)
Opaque watercolor on cotton,
67 x 51.5 cm
Purchase—Francis H. Burr Memorial,
1941.292

This remarkable folio from a manuscript
of the *Dastan-i Amir Hamza* vividly
expresses the dynamic personality of
the Mughal emperor Akbar (reigned
1556–1605) and his impact on contem-
porary painting. Serving as a virtual
training ground for Akbar's developing
atelier, under the guidance both of the
emperor and the Safavid artists imported
by his father Humayun, this project is
said to have employed some one hundred
artists who together produced about
1400 original illustrations for this work
alone during the fifteen years needed
for its completion; from these about
150 paintings remain. Mir Sayyid-ʿAli
(no. 77) may have provided the design
and supervised the painting of this
graphic and dynamically narrative scene,
which exemplifies the early and at times
uneasy synthesis of Indian and Iranian
pictorial traditions.

Reference
G. Egger, *Hamza-Nama*, Graz, 1974; S. C.
Welch, "Pictures from the Hindu and Muslim
World," *Apollo* 107/195 (1978), 425–27,
pl. X.

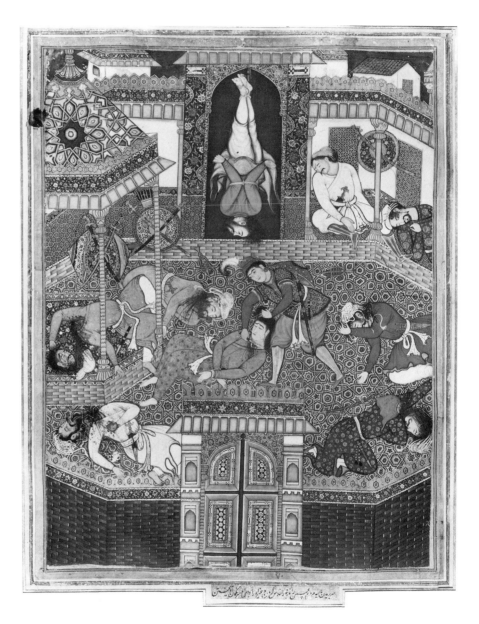

96

ANVARI ENTERTAINS IN A SUMMER HOUSE
FOLIO FROM A DIVAN (POETICAL WORKS) OF ANVARI

Manuscript dated 1588
Attributed to Basawan
India, Mughal Period (1526–1857)
Opaque watercolor on paper, 14 x 7.7 cm
Gift—John Goelet, 1960.117.2

The maturation of Akbar's atelier and of his own personal interests and ambitions finds an appropriate response in the later paintings of his reign. One of these, an illustration from a "pocketbook" copy of Anvari's *Divan* created for the emperor in 1588 when the court was in Lahore, reveals the delicacy and subtlety characteristic of such artists as the Hindu painter Basawan to whom this work is attributed. The nuances of human personality and the sensitive, gently descriptive treatment of natural forms, as seen in this meeting of two friends over poetry and wine in their sylvan retreat, characterize many of Akbar's later commissioned works. It is these qualities in particular, seen to such advantage in the fifteen miniatures adorning this manuscript, that were to receive an even greater emphasis and scrutiny under the patronage of his son, Emperor Jahangir.

Reference
A. Schimmel and S. C. Welch, *Anvari's Divan: A Pocket Book for Akbar*, New York, 1983.

97

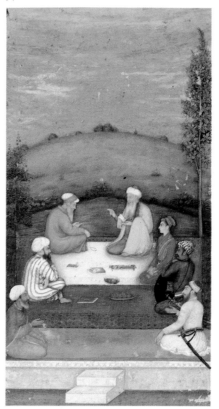

97

PRINCE DARA SHIKOH CONVERSING WITH SAGES

ca. 1630
India, Mughal Period (1526–1857)
Opaque watercolor on paper,
17.8 x 9.9 cm
Gift—Eric Schroeder in honor of John Coolidge, 1968.47

The gathering of Muslim theologians pictured here is characteristic of those often convened by the young prince Dara Shikoh (1615–59), the son of Shah Jahan (reigned 1627–58). Like his great-grandfather Akbar, he encouraged religious unity and displayed a great fondness for philosophical discussions with Muslim and Hindu followers alike, although these inclinations were to cost him the throne and eventually his life. This theme frequently surfaces in the paintings associated with him, which are often extraordinarily expressive and penetrating in their observations—physical and psychological alike—of the figures who so intrigued him. The atmospheric landscapes in which his world unfolds often display a similar intensity and beauty, receiving some of their finest and most haunting treatments in the Mughal paintings of this period.

Reference
M. C. Beach, *The Grand Mogul: Imperial Painting in India 1600–1660*, Williamstown, Mass., 1978, 167, no. 63.

AN ENCOUNTER AT A WELL

ca. 1740–50
Attributed to Nihal Chand
India, Kishangarh
Opaque watercolor on paper,
29.5 x 18 cm (sight)
Gift—John Kenneth Galbraith, 1972.350

With the gradual waning of Mughal power from 1700 onwards, the Rajasthani courts were quick to develop not only a political but also an artistic autonomy. Encouraged by the enthusiastic patronage of such rulers as Raja Raj Singh (reigned 1706–48) of Kishangarh, many artists formerly employed by the Mughals found new resources and rewards for their talents in these burgeoning Rajput ateliers. This lyrically evocative rendition of a traditional Indian theme—a prince flirting with village girls at a well—receives an exquisite, delicately detailed treatment at the hands of Nihal Chand to whom it has been attributed, revealing him as both a master draftsman and accomplished colorist. The flowering of the Rajasthani tradition in paintings such as this during the 18th century owes much to the remarkably successful integration of indigenous local styles with assimilated Mughal influences, a process that produced equally brilliant results in other regional centers such as Bundi (no. 99).

Reference
S. C. Welch and Beach, 1965, 121, no. 33.

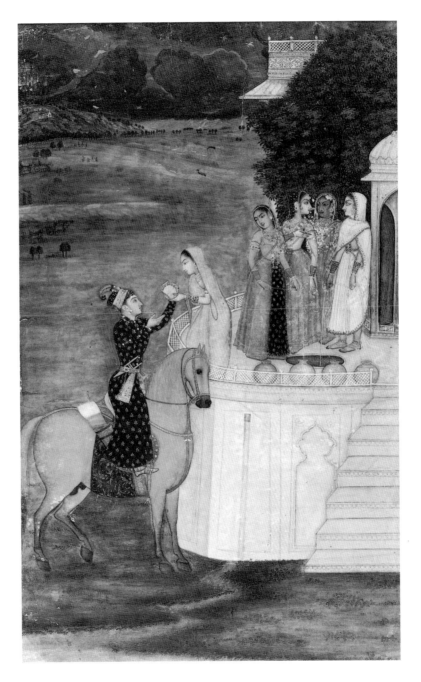

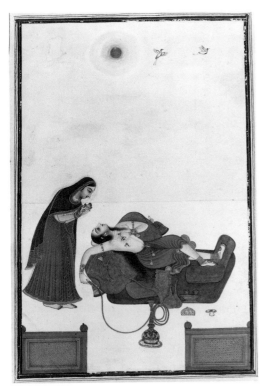

99

A LADY YEARNING FOR HER LOVER

ca. 1775
India, Bundi
Opaque watercolor on paper,
28 x 19.5 cm (sight)
Gift—John Kenneth Galbraith, 1972.352

References
M. S. Randhawa and J. K. Galbraith, *Indian Painting: The Scene, Themes, and Legends*, Boston, 1960, pl. 15; S. C. Welch and Beach, 1965, 125, no. 56.

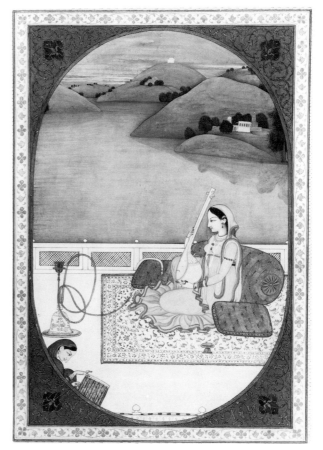

100

CHITRINI NAYIKA FROM A **RASIKAPRIYA SERIES** (CLASSIFICATION OF HEROINES AND HEROES)

ca. 1780
India, Kangra
Opaque watercolor on paper,
27.3 x 19.4 cm
Gift—John Kenneth Galbraith, 1971.126

References
S. C. Welch and Beach, 1965, pl. 53; W. G. Archer, *Indian Painting from the Punjab Hills*, London and New York, 1973, I, 52.

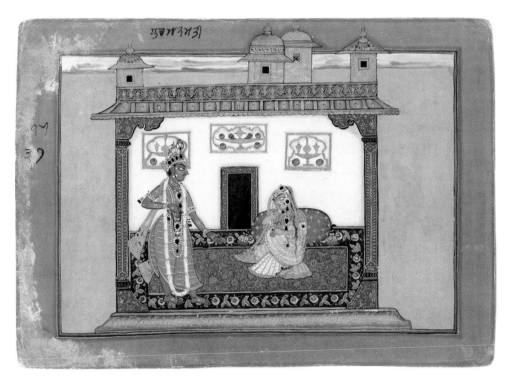

101

A NAYIKA AND HER LOVER
FROM A **RASAMANJARI SERIES**

ca. 1670–80
India, Basohli
Gouache and opaque watercolor on
paper, 23.5 x 33.1 cm
Gift—John Kenneth Galbraith, 1972.74

This work is one of a series of paintings
illustrating Bhanu Datta's 14th-century
Sanskrit poem, the *Rasamanjari*. While
essentially courtly and secular in tone,
the poem celebrates the nature of divine
love as fulfilled by Krishna and Radha.
This theme formed the basis of the paint-
ing traditions of the hill states, which
habitually cast Krishna as the amorous
gallant. Basohli was among the earliest of
these Pahari or hill state schools of paint-
ing to develop. Remaining relatively

indifferent during the 17th century to
influence from either the Mughal or
Rajasthani idioms, its own style was
characterized by dazzling colors, precise
if simple compositions, and the frequent
use of small pieces of emerald green
beetle wings. This particular work comes
from the earliest of three *Rasamanjari* se-
ries, which form an important sequence
in the development of the Basohli style.

References
S. C. Welch and Beach, 1965, 119, no. 21;
W. G. Archer, *Indian Painting from the Punjab
Hills*, London and New York, 1973, I, 39,
no. 32.

EGYPTIAN, NEAR EASTERN, BRONZE AGE AEGEAN, ETRUSCAN

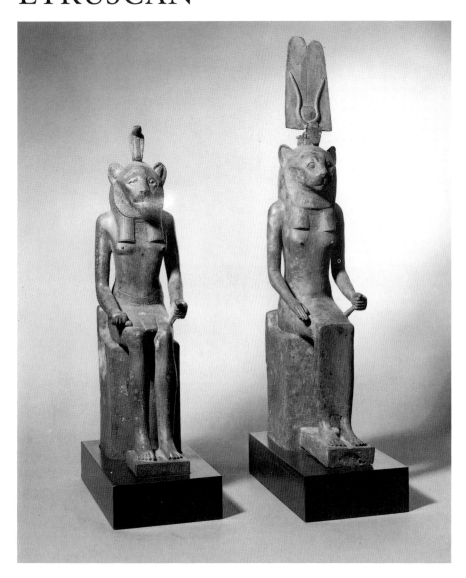

102

LION-HEADED GOD AND GODDESS (SEKHMET)

Egypt, Late Period (712–525 B.C.)
Bronze, Female 67.75, Male 53 cm
Bequest—Grenville L. Winthrop,
1943.1121a–b

Reference
J. Vandier, "Ouadjet et L'horus léontocephale
de Bouto," *Fondation Eugène Piot. Monuments et Mémoires* 55 (1967), 17–21.

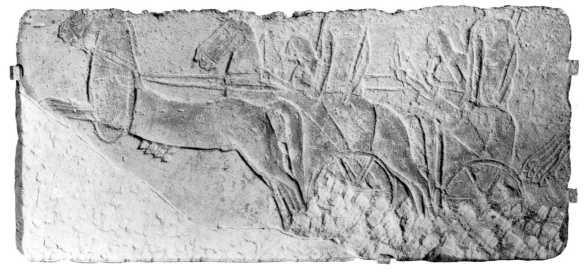

103

CHARIOTEERS WITH LADIES-IN-WAITING IN A ROYAL PROCESSION

ca. 1352–33 B.C.
Egypt, Dynasty XVIII (1557–1304 B.C.)
Limestone, 23 x 53.3 cm
Gift—New Hermes Foundation,
1960.170

Originally part of a wall decoration at the palace-temple complex of Tell-el-Amarna, this sunken relief shows a portion of a royal procession of two-horse chariots, each with a driver and two ladies-in-waiting. It has the vitality and distorted realism that characterize the revolutionary shift away from age-old style conventions, effected under the rule of the unorthodox pharaoh Akhenaton (reigned 1372–58 B.C.). Along with hundreds of other such fragments from the deserted capital, the *Charioteers* probably was carried across the Nile about a century later, to be reused in the foundations of a building at Hermopolis Magna, during the reign of Rameses II (1292–32 B.C.).

References
J. D. Cooney, *Amarna Reliefs from Hermopolis in American Collections*, The Brooklyn Museum, New York, 1965, no. 34; Hanfmann and Mitten, 1978, 364.

104

HEAD OF A MAN

2300–2000 B.C.
Akkadian (2340–2180 B.C.) or Neo-Sumerian
Dark stone, 7.8 cm
Purchase—Harvard-Baghdad School
Expedition Fund, 1929.228

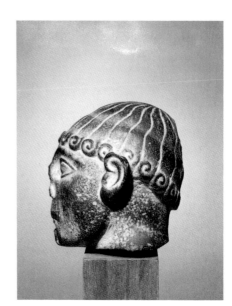

The extremely rare *Head of a Man* is all that remains of an Akkadian sculpture dating most likely from the time of King Sargon. The underlying geometric structure combined with the severe, mesmerizing expression gives this piece an austere strength relieved only by ornamental patterning, seen especially in the carefully arranged corkscrew curls. Despite its damaged condition and small dimensions, the *Head* still manages to project a powerful presence.

References
Hanfmann and Rowland, 1954, 130; G. M. A. Hanfmann, "Acquisitions of the Fogg Art Museum: Sculpture and Figurines," *American Journal of Archaeology* 58/3 (1954), 224; E. L. Terrace, *The Art of the Ancient Near East in Boston*, Museum of Fine Arts, Boston, 1962, no. 5.

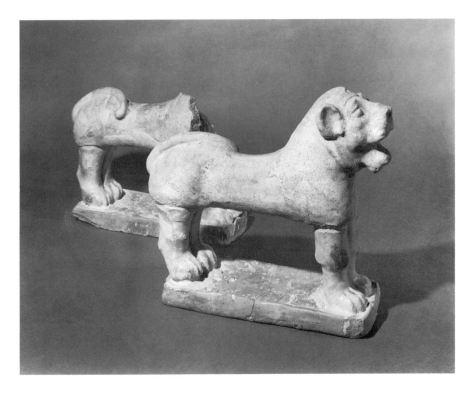

PAIR OF LIONS
FROM THE TEMPLE OF ISHTAR, NUZI

1500–1350 B.C.
Mesopotamia, Hurrian
Glazed terracotta, 38.8 cm (to top of head)
Gift—Harvard-Baghdad School of Expedition, 1931.162

Harvard participated in the excavations of the Hurrian city of Nuzi (in the oil fields of Iraq), which was ruled in the mid-2nd millennium B.C. by the Indo-European kings of Mitanni. Among the finds were the *Lions* from the temple of Ishtar, goddess of fertility and of battle, "a lioness before whom heaven and earth tremble." Her shrine, which included a life-sized statue of "the Lady of Battle," was elaborately decorated. The *Lions*, originally glazed a deep blue-green (now faded to a light green), apparently flanked the pedestal; another crouching pair in red and yellow sat at Ishtar's feet. Assembled from five pieces of clay whose glaze, when fired, served to fuse the whole together, the intact *Lion* affirms the high level of craftsmanship of the Nuzians, a populace who came in contact with the Hebrews of the patriarchal era.

References
Hanfmann and Rowland, 1954, 130; Hanfmann and Mitten, 1978, 363.

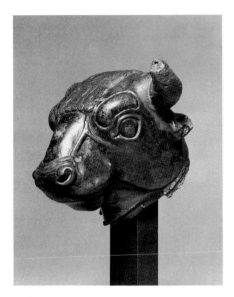

106

BULL PROTOME
FROM A CAULDRON

8th–7th century B.C.
East Anatolia, Urartian
Bronze, 9.5 x 12.2 cm (including one
horn)
Bequest—Grenville L. Winthrop,
1943.1321

Reference
G. M. A. Hanfmann, "Four Urartian Bulls'
Heads," *Anatolian Studies* 6 (1956), 205–13.

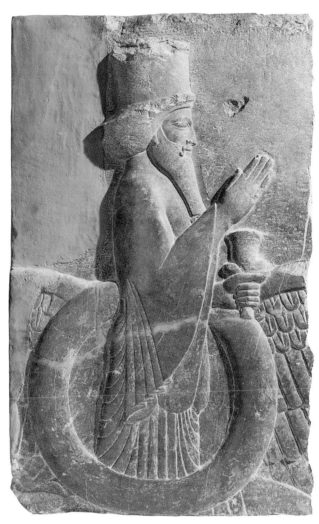

107

WINGED BEING PROTECTING
THE KING

ca. 485–460 B.C.
Persian, Achaemenid (539–331 B.C.)
Dark limestone, 73 x 44.3 cm
Bequest—Grenville L. Winthrop,
1943.1062

This relief figure once appeared above
that of an enthroned king—Xerxes I
(reigned 485–65 B.C.), or more probably
Artaxerxes I (reigned 465–25 B.C.)—on
the jamb of a door to the Hall of a Hun-
dred Columns (Throne Hall) at
Persepolis. Its wings and tail broken off,
the being stands in a sun disk and holds
a lotus in one hand while seeming to
bless with the other. The figure was
found during cleaning to have significant
traces of the red, green, and blue pig-
ments that once covered the carved
decoration of the ceremonial buildings
of the Achaemenid capital. Since the
color has disappeared almost entirely
from the standing sculptural remains,
this piece, one of a group of Achaemenid
relief fragments bequeathed by Grenville
Winthrop, provides invaluable evidence
for the original lavish polychromy of the
great imperial court complex.

References
For the piece's original setting, as well as for its
color reconstruction and an explanation of its
unfinished state, see J. Lerner, "A Painted Re-
lief from Persepolis," *Archaeology* 26/2
(1973), 116–22; see also Hanfmann and Mit-
ten, 1978, 363–64.

97

FEMALE STATUETTE

ca. 1600–1450 B.C.
Crete, Minoan
Bronze, 6.7 cm
Purchase—David M. Robinson Fund and
Gift of Mr. and Mrs. Edwin L. Weisl, Jr.,
1975.60

Of approximately the same date as the
Lions from Nuzi (no. 105) is this *Statuette* from Crete. The figure wears a
typical Minoan costume of bell-shaped

skirt with sashes tied below the waist and
an open-breasted jacket with short
sleeves; unusual for a piece of this size
are details such as the bracelet and elegantly styled hair. In general the forms
are simplified, but the rendering is subtly
organic and the effect graceful and vivacious. The woman stands in a lithe but
relaxed manner, seeming to support her
weight on her left leg, slightly bending
her knees and leaning a little backward
from the waist. Like many of these figures, ranging in size from smaller to over
three times taller, she raises her right
hand to her forehead in an apparent gesture of deference or adoration. Although
we have little specific knowledge of Minoan cult practices, it is likely that this
bronze served as a votive offering in one
of the numerous sanctuaries that have
been discovered in the island's grottoes
and on its mountaintops.

References
D. G. Mitten, "A Minoan Bronze Statuette at
the Fogg Art Museum," *Fogg Art Museum
Annual Report*, 1974–76, 48–55; Hanfmann
and Mitten, 1978, 363.

FIGURE OF A WOMAN WITH A POMEGRANATE (PROBABLY THE GODDESS TURAN)

ca. 400 B.C.
Etruscan
Bronze, 20.3 cm
Purchase—Alpheus Hyatt Fund and
Contributions of 24 Friends of the Fogg,
1956.43

This figure has been identified as Turan, a
preeminent Etruscan goddess, partly
from her crown of metal leaves (*ampyx*).
As the goddess of love, who became the
equivalent of the Greek Aphrodite, she
holds an appropriate fertility symbol, the
pomegranate. Her costume, with thick
beaded necklace and boots with curling
toes, is characteristically Etruscan, as are
her somewhat weighty proportions and
linear, decorative drapery. These "native"
elements excepted, the bronze is imbued
with the ethos of early Greek Classicism.
Standing in a pliant contrapposto, the
figure conveys an introspective firmness
of will perfectly suited to her divine
nature.

References
G. M. A. Hanfmann, "An Etruscan Goddess,"
Archaeology 9/4 (1956), 230–32; Mitten and
Doeringer, 1967, no. 168. See also R. S. Teitz,
Masterpieces of Etruscan Art, Worcester Art
Museum, Worcester, Mass., 1967, no. 59, in
which the author questions the positive identi-
fication of the goddess as Turan.

110

FUNERARY JUG (PITCHER-OLPE)

ca. 700 B.C.
Greek (Attic), The Lion Painter
Ceramic, 58.2 x Diam. 35.2 cm
Purchase—Francis H. Burr Memorial,
1950.64

The Lion Painter, a Late Geometric Athenian vase painter, received his title from his most distinguishing mannerism, namely the animals he portrayed in strict profile with bulging fore- and hindquarters joined by wasplike waists. Also characteristic of his work are the friezes of metope-like panels that organize the overall design. Flanked by meander and smaller bands of geometric decoration, the friezes punctuate the belly, shoulder, and neck of the pitcher; the metopal pan-els frame the stylized animals as well as swastikas and other large ornamental motifs, while the triglyphs contain central fields with zigzag.

References
P. Kahane, "Die Entwicklungsphasen der attisch-geometrischen Keramik," *American Journal of Archaeology* 44 (1940), 480, pl. 27, 3; J. M. Cook, "Athenian Workshops around 700," *Annual of the British School of Athens* 42 (1947), 143–44; J. Coldstream, *Greek Geometric Pottery*, London, 1968, 73–74.

BLACK-FIGURE COLUMN KRATER

ca. 565 B.C.
Greek (Attic), attributed to Lydos
(A) Chariot and Warriors, (B) Sphinx and Lions
Ceramic, 33.4 x Diam. 35.6 cm
Bequest—Joseph Clark Hoppin,
1925.30.125

This column krater fully realizes the potential of the black-figure technique. The bold silhouettes that rhythmically contrapose frontal and profile views; the fine discriminations, as in the two pairs of fighting warriors, that enliven the controlling symmetry; the individual ornamental motifs, such as the sinuous lotus buds and lions' tails that balance one another; and the details, painted in red or incised, that create the strong surface texture, coalesce into a powerful and decoratively satisfying whole. From the Robinson Bequest, the Museums have a fine plate with two winged figures (1959.127) also attributed to Lydos, whose name we know from two signed vases now in the Louvre and in Athens.

References
J. D. Beazley, *Attic Black-Figure Vase Painters*, Oxford, 1956, 108, no. 9; D. M. Buitron, *Attic Vase Painting in New England Collections*, Fogg Art Museum, Cambridge, Mass., 1972, no. 8.

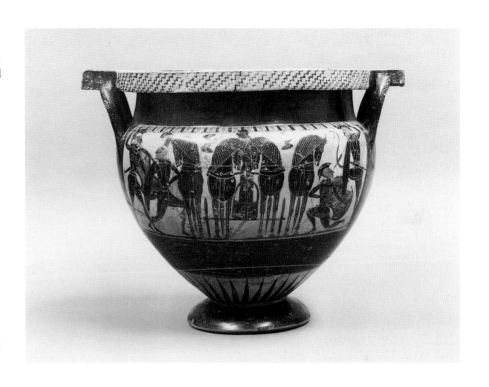

RED-FIGURE CALYX KRATER

ca. 500 B.C.
Greek (Attic), Kleophrades Painter
(Epiktetos II)
Ceramic, 43.8 x Diam. 51.5 cm (at
mouth)
Gift—Frederick M. Watkins, 1960.236

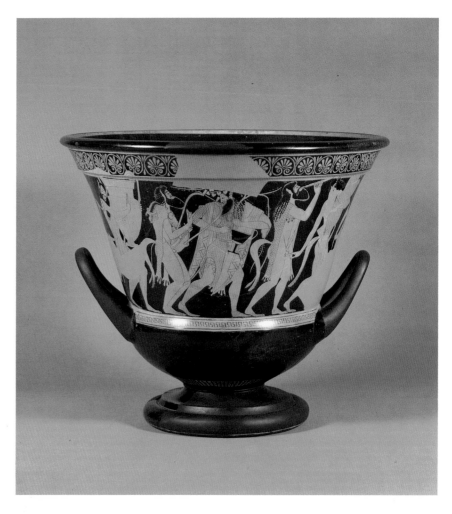

From the bold monumentality and deco-
rative unity of the design to the precise
handling of the tiniest detail, this early
work by the Kleophrades Painter demon-
strates his superior talents. The scene
shown is from the story of Hephaistos.
Having been cast to earth by Hera for
being born lame, the god of crafts took
revenge on his mother by fashioning and
sending her a trick throne that bound her
with invisible fetters. Only Dionysos suc-
ceeded in persuading Hephaistos to
return to Olympus and release Hera; the
god of wine accomplished this task with
the aid of his satyr-companions and a
good deal of the inebriating beverage.
What we actually see is the drunken and
noisy procession homeward, the moment
chosen thus being particularly appropri-
ate both to the ample field provided by
the shape of the calyx krater and to its
function as a vessel for diluting wine
with water. The two deities—Hephaistos
on muleback, Dionysos in his distinctive
attire and holding a kantharos—domi-
nate the group and take their rightful
places at the center of the two main sides,
amidst the complex poses and varied ac-
tions of the satyrs. This is the earliest
calyx krater to take full advantage of this

shape for presenting a continuous frieze.
Subtleties of composition are matched by
the high level of draftsmanship through-
out. This proficiency is evident not only
in the firm outlines of the figures, but
also in the adept exploitation of the red-
figure technique to portray a wide range
of textures and materials (e.g., in the sen-
sitive use of dilute glaze to delineate rib
cages and muscles, of yellow and red
washes to describe leopard skins and to
pick out ivy wreaths and parts of musical
instruments, and of incised lines to artic-
ulate curly hair and bushy beards). Both
in quality of conception and execution,
this calyx krater ranks as the very finest
of the Museums' Greek vases.

References
A. Ashmead, in the *Watkins Collection*, 1973,
no. 20; D. Soren, "The Fogg Kleophrades Vase
Under Ultra Violet Light," *Bulletin of the
American Schools of Oriental Research* 228
(Dec. 1977), 29–46; Hanfmann and Mitten,
1978, 365.

RED-FIGURE HYDRIA (KALPIS)

ca. 510–500 B.C.
Greek (Attic)
Ceramic, 38.1 x Diam. 15.5 cm
(at handles)
Bequest—Frederick M. Watkins, 1972.40

A seldom portrayed, culminating scene of the *Iliad*—the Ransom of Hector—is represented on the shoulder panel of this three-handled hydria. In the depiction, the wound-covered, lifeless Hector lies beneath the couch of the reclining Achilles, who boorishly cuts at a piece of meat that drips blood onto the corpse. It is the dramatic moment when Priam comes to beg for the release of his son's body, catching "the knees of Achilles in his arms." The Greek hero's helmet and shield provide a static complement to the supplicating figure. Assigned to the Pioneer Group, whose principal artists were Euphronios, Euthymides, and Phintias, the piece is typical of their progressiveness early in the development of the red-figure technique. The drawing is curiously awkward in some details (e.g., Priam's ear and hand), but the predominating high quality—as in Hector's monumental form, enlarged to accommodate the longer bottom border—declares the hand of a master.

References
D. M. Buitron, *Attic Vase Painting in New England Collections*, Fogg Art Museum, Cambridge, Mass., 1972, no. 37; A. Ashmead, in the *Watkins Collection*, 1973, no. 19; Hanfmann and Mitten, 1978, 365.

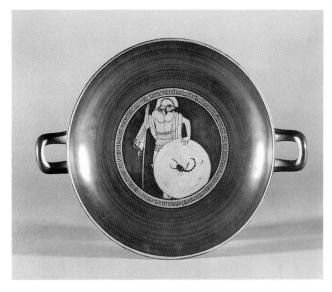

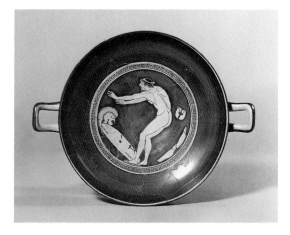

114

RED-FIGURE KYLIX

ca. 490–480 B.C.
Greek (Attic), Foundry Painter
Ceramic, 9.7 x Diam. 23.3 (with handles
30.4) cm
Gift—E. P. Warren, 1927.149

References
Hanfmann and Rowland, 1954, 132; J. D.
Beazley, *Attic Red-Figure Vase Painters*, Ox-
ford, 1963 (2nd ed.), 402, no. 16; J. Boardman,
*Athenian Red-Figure Vases: The Archaic Pe-
riod*, London, 1975, 137, fig. 266.

115

RED-FIGURE KYLIX

ca. 490–480 B.C.
Greek (Attic), Onesimos
(A) Trainer and Two Athletes, (B) Three
Armed Runners, (Int.) *Hoplitodromos*
Ceramic, 9.9 x Diam. 23.9 cm
Bequest—Frederick M. Watkins, 1972.39

The interior and sides of this kylix present
the motif of the armed runner, or *hop-
litodromos*. Inside the cup, an older,
bearded athlete practices the start of the
race, having rested his helmet, shield, and
greaves against the meander border. The
scene is skillfully designed in accordance
with the circular shape, and is especially
sensitive in detailing and characterization.
On one side of the vessel, two runners
exercise under the eye of a young trainer,
who demonstrates proper execution with
his forked wand; on the other side, three
more runners take various active atti-
tudes. Jumping weights and a discus
highlight the athletic theme, and the run-

ners' shields all bear the device of a leaf
with six or seven lobes, as if to indicate
their membership in a single gymnasium.
Another kylix by Onesimos depicting
hoplitodromoi (formerly in the Schweizer
Collection, Arlesheim) could have been a
companion to this piece, the pair perhaps
ordered by someone who himself partici-
pated in the sport.

References
J. D. Beazley, *Attic Red-Figure Vase Painters*,
Oxford, 1963 (2d ed.), 323, no. 55; A. Ash-
mead, in the *Watkins Collection*, 1973, no.
22; U. Hausmann (ed.), *Der Tübingen Waf-
fenläufer*, *Tübinger Studien zur Archäologie
und Kunstgeschichte*, 4, Tübingen, 1977, 42.

BLACK-FIGURE PANATHENAIC PRIZE AMPHORA

Dated to the archonship of Theophrastos,
340–339 B.C.
Greek (Attic)
Ceramic, 80 x Diam. 39 cm
Bequest—Joseph Clark Hoppin,
1925.30.124

Two stocky boxers, heeding a referee and
under the watchful gaze of Olympias,
stand ready to compete in the vase paint-
ing illustrated here. The other side of the
vessel has a large Athena, poised with
shield and spear and flanked by pillars
with statues of herself and Zeus and the
following inscriptions: "I am a prize
from Athens" and "Theophrastos was
archon" (the official whose tenure pro-
vides the date). The amphora, made to
contain oil from consecrated olives, would
have been awarded to a winner in the
Panathenaic games held every four years
on the birthday of Athena. By tradition,
these prize amphorae were decorated in
the archaizing black-figure technique, but
in style—as these decidedly late Classical
figures show—they were completely up-
to-date.

References
J. D. Beazley, *The Development of Attic Black-
Figure*, Berkeley, Cal., 1951, 98–99; Hanf-
mann and Rowland, 1954, 133; Hanfmann
and Mitten, 1978, 365.

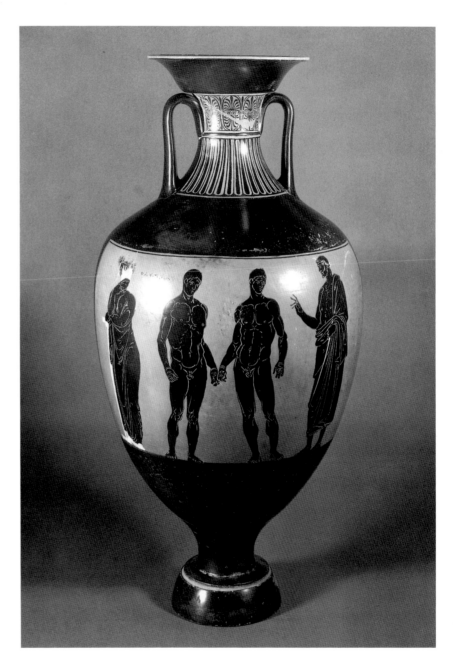

GREEK AND ROMAN

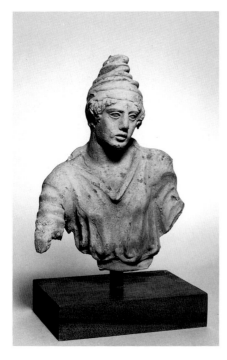

117

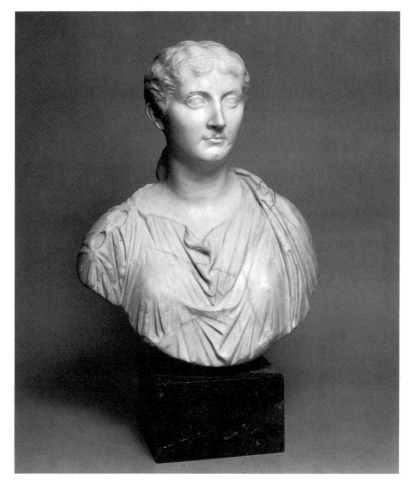

118

BUST OF A YOUTH (ATTIS OR ORPHEUS?)

ca. 325–300 B.C.
Greek, Tarentine
Terracotta, 28.5 cm
Bequest—Grenville L. Winthrop,
1943.1085

References
For comparative pieces see L. D. Caskey,
"Greek Terra-Cottas from Tarentum," *Bulletin
of the Museum of Fine Arts, Boston* 29 (April
1931), 17–21; P. Wuilleumier, "Tarente des
origines à la conquête Romaine," *Bibliothèque
des Écoles Françaises d'Athènes et de Rome*
148 (1939), 406, pl. xxxi, 2; *Münzen und
Medallien, 210 Antiken Terrakotten*, Basel,
Sonderliste, Aug. 1962, 23–24, no. 55;
H. Herdejürgen, *Die tarentinischen Terrakot-
ten des 6. bis 4. Jahrhunderts v. Chr. im
Antikenmuseum Basel*, Mainz, 1971; and
B. Kingsley, Stevenson College, University of
California, Santa Cruz, forthcoming article.

PORTRAIT BUST OF ANTONIA MINOR

ca. A.D. 50 or later
Roman
Marble, 53.4 cm
Purchase—John Randolph Coleman
Memorial Fund, 1972.306

Frequently called the "Wilton House An-
tonia" because of its famous provenance
(collection of the Earl of Pembroke), this
marble bust portrays Antonia Minor (36
B.C.–A.D. 39), who was niece of Au-
gustus, daughter of Octavia and Marc
Antony, wife of Drusus the Elder, and a
woman honored for her beauty and in-
tegrity. Of her many portraits—sculpted,
on coins, and on gems—this one shows
her the most advanced in years. Bearing a
fundamental similarity to images of her

on coins that her son Claudius (reigned
A.D. 41–54) had struck, the bust very
possibly is posthumous. It may in fact re-
late to the commemorative likeness that
Claudius ordered to be borne, according
to Suetonius, in a carriage through the
Roman Circus.

References
K. P. Erhart, "A Portrait of Antonia Minor in
the Fogg Art Museum and Its Iconographical
Tradition," *American Journal of Archaeology*
82 (1978), 193–212; Hanfmann and Mitten,
1978, 366; Vermeule, forthcoming. On the
condition of the bust see also N. Herz and
D. B. Wenner, "Tracing the Origins of Marble,"
Archaeology 34/5 (1981), 14–21.

STATUE OF MELEAGER

ca. A.D. 100
Roman copy after a Greek original of
ca. 340 B.C.
Attributed to Skopas
Parian marble, 117 to 122 cm
Bequest—Mrs. K. G. T. Webster,
1926.48

This statue of Meleager, the tragic hero who succeeded in killing the fierce Kalydonian boar only to meet his own demise at the instigation of his mother, is the most renowned object of classical antiquity in the Museums. It is conceivably the finest of many Roman copies after a lost Greek masterpiece, probably of bronze and usually attributed to Skopas. Various of the more complete replicas depict Meleager with a *chlamys* or light cloak, a spear, and his dog and the head of the slain boar at his feet; quite possibly both the original and the Museums' piece included these attributes. In all the replicas, the hunter stands with his right hand on his buttock, putting weight on his right leg and drawing his left leg back. This pose sets up a rhythmic curving motion, best seen from an oblique angle, that is perfectly discernible in the shoulders, torso, and hips of the Museums' version. But it is the sensitively copied head that captures the essence of the late Classical model, and summarizes the story and character of Meleager. It discloses him not as the victorious hero in a moment of triumph, but as the "dynamic embodiment of defiant courage, ready to defend his trophy against all comers," as if cognizant of the further dangers fate has in store.

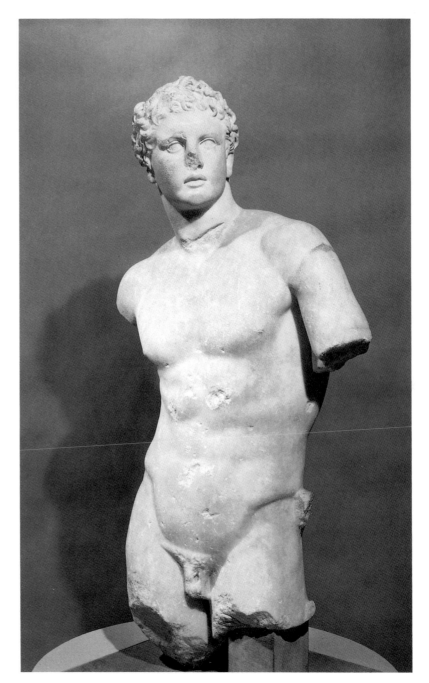

References

The quotation is from Hanfmann and Rowland, 1954, 133. For iconographical evidence provided by remaining struts and by fragments found with the Museums' *Meleager*, as well as for an overall analysis, see G. M. A. Hanfmann and J. G. Pedley, "The Statue of Meleager," in W. H. Schuchhardt (ed.), *Antike Plastik*, 1964, III, 61–65; see also S. Lattimore, "Meleager: New Replicas, Old Problems," *Opuscula Romana* 9 (1973), 157–66; Hanfmann and Mitten, 1978, 363; and Vermeule, forthcoming.

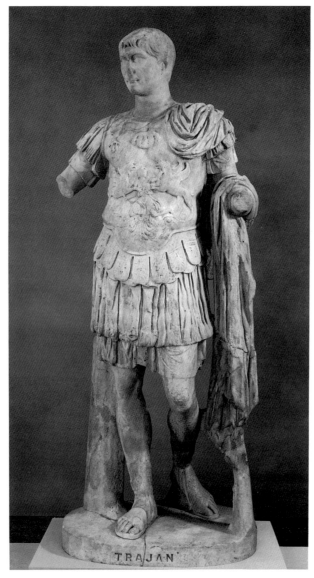

120

STATUE OF TRAJAN

ca. A.D. 120
Roman
Pentelic marble, 1.91 m
Purchase—Alpheus Hyatt Fund, 1954.71

It is likely that this marble statue of Trajan (reigned A.D. 99–117) once showed the emperor holding a short sword or a scepter in his left hand and raising his right hand to give an imperial salutation, order, or address. In gesture as well as in stance, the work thus would have mimicked the Polykleitan-derived rhythms of the *Prima Porta Augustus*, a parallel drawn even closer by the costume. Like the *Augustus*, Trajan is shown with a magnificent parade cuirass, decorated with motifs that add a specific message to the general heroic–military theme. Below an apotropaic Gorgoneion, a young female figure tries to ward off two attacking griffins. The beasts would have been understood as emblems of Apollo, the special patron divinity of emperors; their victim is an Arimaspe, one of a mythical race who would have been seen as symbolizing the inhabitants of the eastern frontiers of the Roman Empire. The allegorical reference, then, is to Trajan's military campaigns that finally settled the problem of the eastern borders (Parthia and Armenia).

Another carved ornament helps reveal the approximate time of the commission. On the leather lappets suspended from the metal breastplate are bovine skulls (*bucrania*), a funerary motif suggesting, in conjunction with the careworn and elderly features of the head, that the work is posthumous. Like the *Antonia Minor* (no. 118), it would be commemorative and would date from the early years of Hadrian's reign (A.D. 117–38), a time when, by honoring Trajan's memory and alluding to his victories, the new emperor could hope to solidify his own position as *Optimus Princeps*.

References

G. M. A. Hanfmann and C. C. Vermeule, "A New Trajan," *American Journal of Archaeology* 61 (1957), 223–53; C. C. Vermeule, *Greek and Roman Sculpture in America*, J. Paul Getty Museum, Malibu, Cal., 1981, no. 258; *idem*, forthcoming.

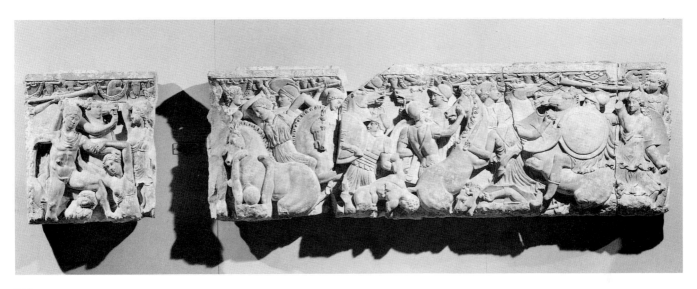

121

AMAZON SARCOPHAGUS

Late 2nd century A.D.
Roman (made at Athens)
Marble, 1932.49a: 63 x 51 cm;
1932.49b: 63 x 23 cm; 1899.9a: 63 x 59
cm; 1899.9b: 63 x 91 cm; 1899.9c:
63 x 58 cm
Bequest—Charles W. Gould,
1932.49a–b, and Gift—Edward Forbes,
1899.9a–c

The battle between the Greeks and the
Amazons is carved on the five fragments,
four from the front and one from the left
end, of this Roman sarcophagus that was
probably sculpted in an Athenian work-
shop. Divided into a standard three sec-
tions, the scene on the front is crowned
by a tendril border above a garland swag
that is draped around bulls' heads and
contains trophies. Straining figures and
horses are crammed together in three
tiers beneath the ornament, the spatial
structure revealing the transitional style
of the piece. Figures overlap and the most
distant rank is carved in lower relief, but
the nearer two are compressed into a
single foreground plane; this last device
has the effect of an optical illusion, as
occurs when viewing a crowd from afar.
Furthermore, the deeply undercut fore-
ground figures throw part of the back-
ground into shadow, but in other places
the conspicuous background plane con-
tradicts the sense of recession. This
squeezing of space, along with the sharply
incised contours and flattened forms,
shows that the sculptor was moving away
from naturalistic illusionism toward a late
antique aesthetic.

References
A. W. Ellis, "Reliefs from a Sarcophagus, Dec-
orated with an Amazonomachy, in the Fogg
Museum," *Harvard Studies in Classical Philol-
ogy* 47 (1936), 216–18; Hanfmann and
Mitten, 1978, 366; Vermeule, forthcoming.
See also A. Giuliano and B. Palma, *La maniera
ateniese di età Romana. I maestri dei sarcofagi
attici* (*Studi Miscellanei*, 24), Rome, 1978,
30–33, no. 7, in which the work is attributed
to the "Agrigento Master," ca. A.D. 190.

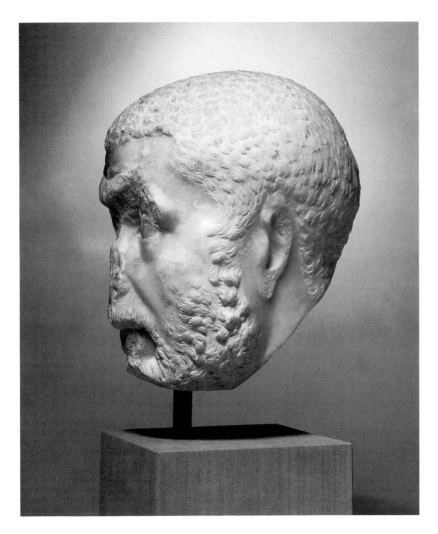

BEARDED MALE HEAD

Mid-3rd century A.D.
Roman
Luna marble, 28 cm
Purchase—Alpheus Hyatt Fund,
1949.47.138

Even in its mutilated state, this portrait head has a compelling magnetism. Sensitively modulated, pellucid flesh tones; closely observed idiosyncracies such as the high cheekbones and slight overbite; and precisely rendered patterns and textures of hair allow us to recognize an individual, but not to read his mind. However, it is his inner concentration, if not his actual thoughts, that the sculptor sought most to convey, by emphasizing selective features—the furrowed brow; the pensive, deeply shadowed mouth; the unwavering, deeply drilled, inwardly searching eyes. In its fine balance between organic description and expressive abstraction, the piece represents a critical moment in the development of late Roman portraiture.

Recent research has shown that two marble heads in Rome, and possibly a bronze head in Belgrade, may well portray the same person as the Museums' example. The pieces in Rome, more conservatively naturalistic, thus would demonstrate the concurrence of divergent styles in the first half of the 3rd century. Although the sitter has yet to be identified, he conceivably was the emperor Macrinus (reigned A.D. 217–18).

References
G. M. A. Hanfmann, "Observations on Roman Portraiture," *Latomus* 11 (1952), 209–15. For the relation of the three marble heads, all of which seemingly were defaced in antiquity, see S. Wood, "A Too-Successful *Damnatio Memoriae*: Problems in Third Century Roman Portraiture," *American Journal of Archaeology* 87 (1983), 489–96. See also *Spätantike und frühes Christentum*, Liebighaus Museum antiker Plastik, Frankfurt-am-Main, 1983, 384–85, no. 4, and Vermeule, forthcoming.

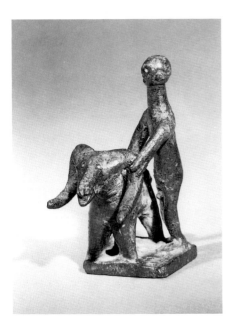

123

MAN LEADING A RAM BY THE HORN

8th—7th century B.C.
Greek
Bronze, 6.2 cm
Purchase—David M. Robinson Fund,
1970.26

References
Sams, 1976, no. 5; D. G. Mitten, "Man and Ram: A Bronze Group of Geometric Style in the Fogg Art Museum," *The Journal of the Walters Art Gallery* 36 (1977), 31–36.

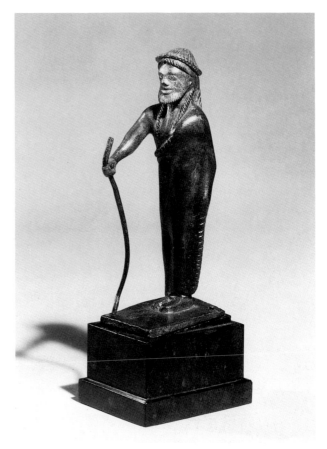

124

BEARDED MAN WITH A STAFF

ca. 525–500 B.C.
Greek (Arcadian)
Bronze, 12.2 cm
Gift—Frederick M. Watkins, 1965.533

The fine detailing of incised beard, mustache, and braided locks of hair, and the skillful suggestion of robust physique and erect posture beneath the cloak proclaim the ability of the Archaic sculptor who made this figure. Whom the figure represents, however, has yet to be established. The staff could belong to a shepherd, but the garland and the mantle with its fringed border are not customary shepherd's attire. This last article, worn over the left shoulder, could be the costume of an Arcadian ruler-hero or a god, but the lack of a definitive attribute makes at least the latter designation questionable.

Two other possibilities are that the figure portrays an athletic trainer or a poet. First, the bronze closely resembles the depictions of trainers on early red-figure vases, such as that with wreath, staff, and cloak on the cup by Onesimos in the Museums (no. 115). Second, the figure's alert expression and sprightly carriage, in addition to his garb, could identify him as a declaiming bard.

References
Mitten and Doeringer, 1967, no. 48; *Watkins Collection*, 1973, no. 4; Sams, 1976, no. 15; Hanfmann and Mitten, 1978, 364.

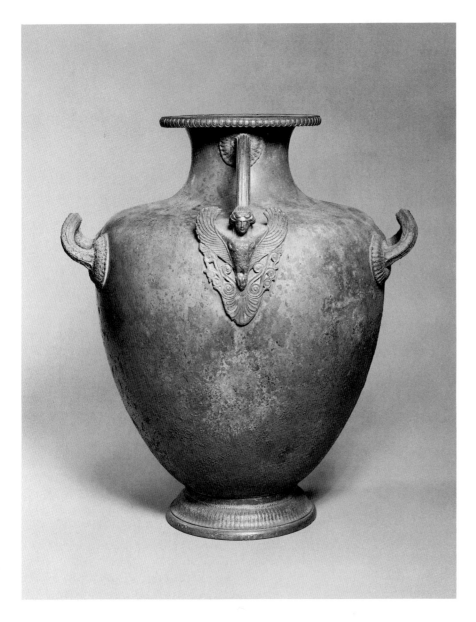

125

HYDRIA

ca. 425–400 B.C.
Greek
Bronze, 40 cm
Purchase—Grace Nichols Strong
Memorial Fund, 1949.89

Valuable bronze hydriai were most likely
used for ceremonial events rather than
for carrying water (no. 113); they served,
for instance, as cinerary vessels and as
receptacles for drawing lots, and were
given as trophies to athletes. This ex-
ample, which has an almost identical
twin in the British Museum, belongs to a
large 5th-century B.C. group character-
ized by siren-decorated vertical handles.
Set off by the smooth hammered body,
and the restrained fluting, tongue, and
egg-and-dart motifs of the lip, foot, and
side handles, the cast siren, with incised
feathers and elaborate hairstyle, is framed
by a refined volute and palmette design.

References
E. Diehl, *Die Hydria*, Mainz, 1964, 35ff., 219,
no. B147; Mitten and Doeringer, 1967,
no. 108.

126

APHRODITE HOLDING A DOVE

ca. 450 B.C.
Greek
Bronze, 10.7 cm
Gift—Frederick M. Watkins, 1960.666

This *Aphrodite* may well replicate a lost full-size votive figure by an unidentified but important sculptor of the early Classical style. As Hanfmann has demonstrated, the Museums' piece, with its distinctive hairdo and haughty expression, is closely associated with the so-called "Budapest group," comprised of Roman copies that presumably followed a Greek prototype of ca. 470–460 B.C. As reflected in the figurine shown here, the prototype deviated from mid-5th-century practice in portraying the goddess of love clothed only in a *himation* that left her right breast bare. Another rare and particularly delightful feature is the slow spiral torsion of the arms, whose rhythm is matched by the diagonal sweep of massive drapery folds from the left shoulder down the right hip and up the back. Reportedly found at Epidauros, this stately and rather formidable image may not only reflect a masterpiece, but also indicate the establishment of a shrine in her honor well before the 4th-century temple of Aphrodite known to have been built at that place.

References
For discussion of related pieces and stylistic affiliations see G. M. A. Hanfmann, "An Early Classical Aphrodite," *American Journal of Archaeology* 66/3 (1962), 281–84; Mitten and Doeringer, 1967, no. 93; and *Watkins Collection*, 1973, no. 6.

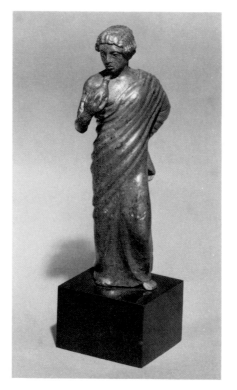

127

STATUETTE OF HEPHAISTOS

2nd century A.D.
Greek (Athens?)
Bronze, 9.4 cm
Gift—Mr. and Mrs. Norbert Schimmel in honor of Professor George M. A. Hanfmann, 1982.35

This piece is a fine miniature version of Alkamenes' bronze cult statue of Hephaistos (late 5th century B.C.), which stood in the Temple of Athena and Hephaistos at Athens.

References
D. G. Mitten in O. W. Muscarella (ed.), *Ancient Art. The Norbert Schimmel Collection*, Mainz, 1974, no. 35; Sams, 1976, no. 32; F. Brommer, *Hephaistos. Der Schmiedgott in der Antiken Kunst*, Mainz, 1978, 53, 148, 213, pl. 22, 4.

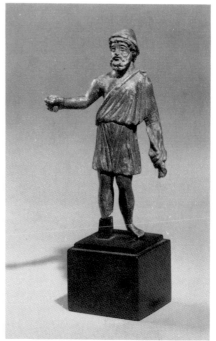

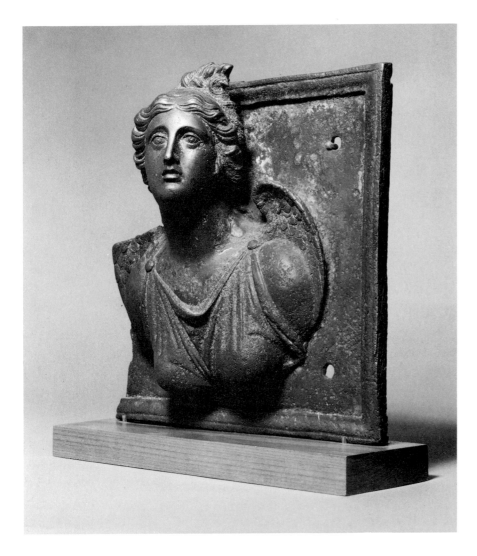

PLAQUE WITH A BUST OF VICTORY

2nd century A.D.
Roman
Bronze, 27.7 cm
Purchase—Louise Haskell Daly Fund, Francis H. Burr Memorial, William M. Prichard Fund, and Alpheus Hyatt Fund, 1966.12

In all probability this bronze plaque is an *insigne*—very few of which have survived—from a Roman ship named the *Victory*. Representations and written descriptions of Hellenistic and Roman vessels give various locations for these plaques; the Museums' piece could have been attached directly to the prow or to the starboard or bow end of an outrigger. Certainly the winged figure was designed to be viewed from a particular angle. Victory looks her best seen from the side and below, as she stares forward vigilantly, her chin set and her lips slightly parted. In selecting the vantage point and in giving the figure its vitalized quality, the Roman sculptor understood his Hellenistic model well; at the same time, he interpreted it according to a more classical taste, typical of the time of Hadrian.

References
Mitten and Doeringer, 1967, no. 262; E. Williams, *Gods and Heroes: Baroque Images of Antiquity*, New York, 1968, no. 60; G. M. A. Hanfmann, "A Roman Victory," *Opus Nobile. Festschrift zum 60. Gebürtstag von Ulf Jantzen*, Wiesbaden, 1969, 63–67.

129

PORTRAIT HEAD OF JULIA DOMNA

A.D. 193–217 or later
Roman (Syrian)
Bronze, 36 cm
Gift—C. Ruxton Love, Jr., 1956.19

Found on the site of a Roman military
outpost not far from Julia Domna's
(reigned A.D. 193–217) birthplace at
Emesa in Syria, this portrait of her,
although damaged, still shows the distin-
guishing features that appear on other
likenesses—painted, sculpted, and
numismatic: waved hair framing a face
with large, wideset eyes, high cheek-
bones, small mouth, and rather promi-
nent nose. We must imagine, however, the
opulent effect of the piece in its original
gilded and probably bejeweled state, set
into a statue or bust. It would have been
a befitting portrayal of this powerful and
intelligent woman, who played a most ac-
tive role in the affairs of the empire as
consort of Septimus Severus and mother
of Caracalla. She also took great interest
in the arts, a side of her character that is
suggested in this quiescent, reflective
image.

References
U. Hiesinger, "Julia Domna: Two Portraits in
Bronze," *American Journal of Archaeology* 73
(1969), 39–44; C. C. Vermeule, *Greek and
Roman Sculpture in America*, J. Paul Getty
Museum, Malibu, Cal., 1981, no. 299.

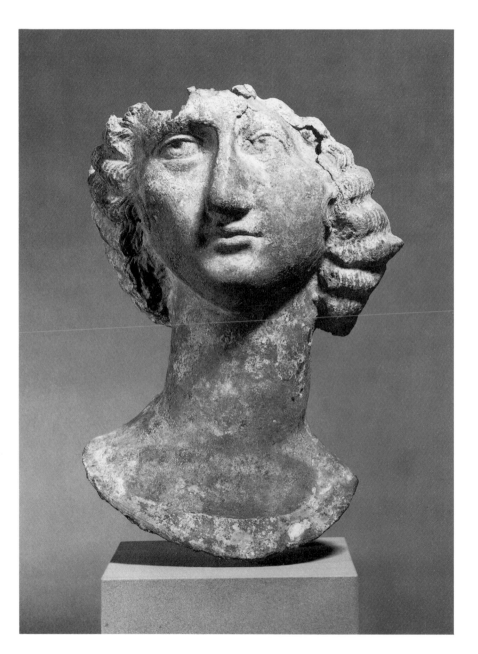

PROVINCIAL ROMAN AND COPTIC

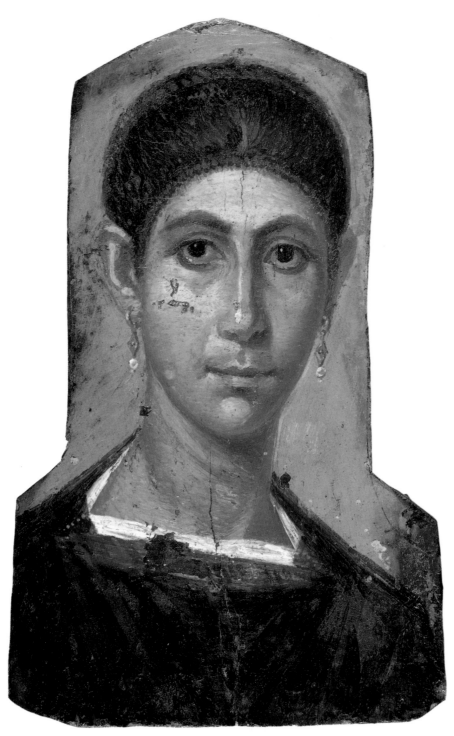

PORTRAIT OF A LADY WITH EARRINGS

ca. A.D. 130–40
Egypt (Fayum)
Encaustic on wood, 22.5 x 35.3 cm
Gift—Denman W. Ross, 1923.60

This Fayum portrait is particularly well preserved, its colors still fresh and glowing. The medium, in which wax serves as the binder, has the luminous and fluid potential of oil, and the artist availed himself accordingly. In soft and graduated modeling, with the light source envisioned to the sitter's right, he built up his tangible image. The woman is young but of uncertain age; her individual features have been recorded but also generalized. Linked to Hellenistic tradition in these aspects of method and style, the painting nevertheless had a thoroughly Egyptian purpose, being destined for incorporation into her mummy wrappings. As portrayed, her liquid and typically magnified eyes already seem to gaze soberly into the afterworld.

References
G. M. A. Hanfmann, *Roman Art*, New York, 1975, 306, no. XLVI; D. L. Thompson, *Mummy Portraits in the J. Paul Getty Museum*, Malibu, Cal., 1982, 5, fig. 6.

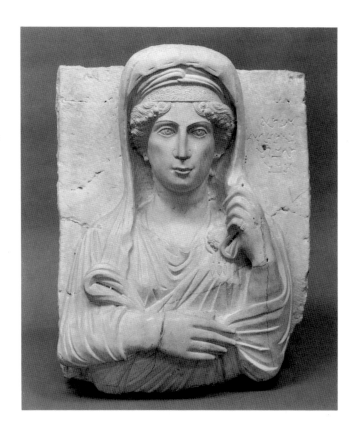

131

FUNERARY RELIEF OF A WOMAN

ca. A.D. 200
Roman, Syria (Palmyra)
Limestone, 61 x 45.5 cm
Gift—The Hagop Kevorkian Foundation
in memory of Hagop Kevorkian,
1975.41.116

Reference
Vermeule, forthcoming.

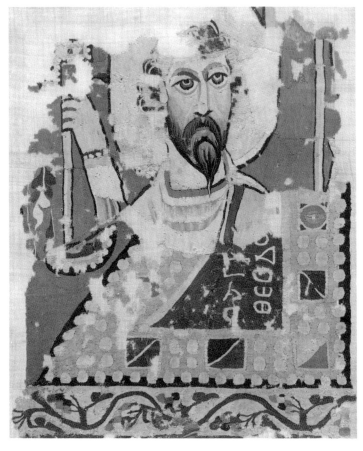

132

ST. THEODORE

5th–6th century A.D.
Coptic
Textile fragment, wool and linen,
44.1 x 31.8 cm
Gift—Denman W. Ross, 1939.112.1

Reference
K. Weitzmann (ed.), *The Age of Spirituality*,
The Metropolitan Museum of Art, New York,
1979, 549–50.

ANCIENT COINS

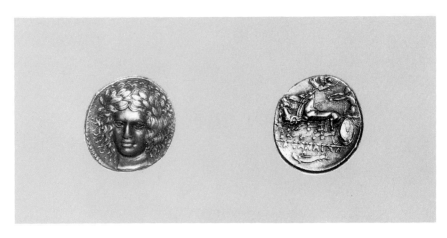

133

SILVER TETRADRACHM

ca. 405 B.C.
Greek, Sicily (Katane)
Obv. Head of Apollo. ΗΡΑΚΛΕΙΔΑΣ
(at r.)
Rev. ΚΑΤΑΝΑΙΩΝ. Quadriga crowned
by Victory. Fish
Wt. 17.51 gm (↘)
Bequest—Frederick M. Watkins,
1972.134

The imposing Apollo on the obverse of
this coin from Katane (north of Syracuse)
is a fine and early example of a head that
was accurately foreshortened and three-
dimensionally modeled in an almost fully
frontal view. Executed in high relief, with
its mane of waving and curling hair
crowned by a laurel wreath, this image of
the sun god radiates an intense aura of
divine composure and beauty. The die-
engraver, Herakleidas, was one of the first
to sign his name to a coin with such a
facing head design. The reverse has the
lively racing chariot motif, with a Victory
descending to crown the driver; it too
shows the highly creative "sculptural" ac-
complishments of the Sicilian mints at the
end of the 5th century B.C.

References
G. K. Jenkins, *Ancient Greek Coins*, New
York, 1972, 169–70, no. 429; *Watkins Col-
lection*, 1973, no. 27; K. P. Erhart, *The
Development of the Facing Head Motif on
Greek Coins and Its Relation to Classical Art*,
New York (Garland Series of Outstanding Dis-
sertations in the Fine Arts), 1979, 152–59.

SILVER DENARIUS

43–42 B.C.
Roman
Obv. L·PLAET·CEST BRVT IMP. Bust of
Brutus.
Rev. EID·MAR. Liberty cap between two
daggers.
Wt. 3.76 gm (↑)
Bequest—Frederick M. Watkins,
1972.244

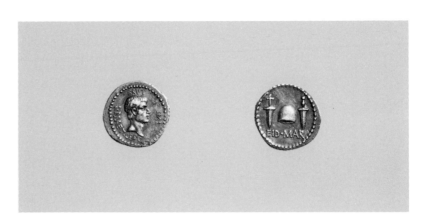

Just as the Katane tetradrachm (no. 133) demonstrates an important stylistic innovation in Greek numismatics, this denarius with Brutus on the obverse exemplifies a crucial iconographical development in Roman Republican coinage, namely the portrait of a living ruler. Julius Caesar had been the first to have his own likeness shown (44 B.C.), and here we see an image of one of his assassins, struck just one or two years after the murder. In the political upheaval following Caesar's demise, Brutus, as one of the "Liberators" from the tyranny, was even able to flaunt his deed on the reverse, the two daggers and the *pileus* (cap of liberty) celebrating, as the legend reads, the Ides of March. The deaths of Brutus and Cassius at the Battle of Philippi (42 B.C.) put an abrupt end to such propaganda. Five or six years later the young Octavian, though a member of the Triumvirate, was striking coins with his portrait only (no. 135), and was on his way, as Caesar's heir and grand-nephew, to eventual control of the state as Augustus (27 B.C.–A.D. 14).

References
Watkins Collection, 1973, no. 149; M. H. Crawford, *Roman Republican Coinage*, London and New York, 1974, I, no. 508/3; Sutherland, 1974, 102.

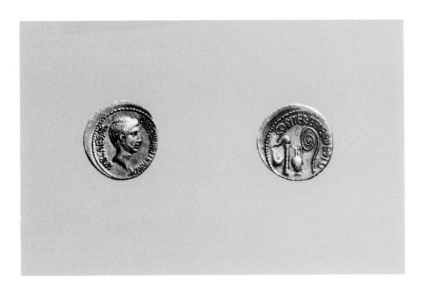

SILVER DENARIUS

ca. 37 B.C.
Roman (Gaul)
Obv. IMP·CAESAR·DIVI·F·III·VIR·ITER·
R·P·C Head of Octavian. Dotted rim.
Rev. COS·ITER·ET·TER·DESIG.
Simpulum, aspergillum, capis and *lituus.*
Dotted rim.
Wt. 3.695 gm
Gift—J. Randall Thompson, 1979.267

References
M. H. Crawford, *Roman Republican Coinage*, London and New York, 1974, I, no. 538/1; Sutherland, 1974, 112.

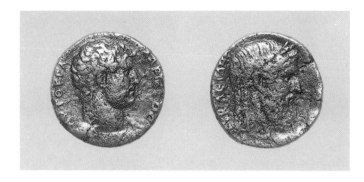

BRONZE MEDALLION

2nd century A.D.
Roman (Elis)
Obv. Head of Hadrian, right, ΑΥΤΟΚΡΑ
ΑΔΡΙΑΝΟC
Rev. Laureate head of Zeus, right,
ΕΥΚΛΕΙΔΗC (retooled to read
Eukleides)
Wt. 27.04 gm
Gift—H. Bartlett Wells, 1979.314

In contrast to the preceding monetary pieces (nos. 133–36) is this bronze medallion, a souvenir commemorating one of the seven wonders of the classical world, the huge chryselephantine statue of Zeus made by Pheidias for the god's temple at Olympia. Having vanished in antiquity as did the rest of the single statues by the renowned sculptor who oversaw the decoration of the Parthenon, the Zeus is conserved for us solely in such small numismatic copies, a few of which show the entire enthroned composition. Although the sumptuousness and scale of the original gold and ivory masterpiece have to be imagined, this fine Hadrianic medallion records the magisterial features of the supreme deity. It is one of only four surviving examples in good condition; the others are in the Bibliothèque Nationale, Paris, the Staatliche Museum, Berlin, and the Fitzwilliam Museum, Cambridge, England. In answer to the question of what his model had been, Pheidias allegedly quoted Homer's lines from the *Iliad* (I.527–30):

> Thus spoke the son of Kronos and nodded his dark brow and the ambrosial locks flowed down from the lord's immortal head, and he made great Olympus quake.

References
B. V. Head, *Historia Numorum. A Manual of Greek Numismatics*, Oxford, 1911, 426; S. Lesser, "Pheidias at the Fogg," *Fogg Art Museum Newsletter* (Fall 1979), 5, 10; P. R. Franke, "ΗΛΙΑΚΑ-ΟΛΥΜΠΙΑΚΑ (Heliaka-Olympiaka)," *Mitteilungen des Deutschen Archäologischen Instituts Athenische Abteilung* 99 (1984), 331, pl. 52.4.

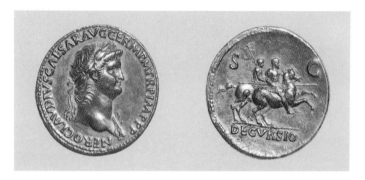

136

BRONZE SESTERTIUS

A.D. 64–66
Roman
Obv. NERO·CLAVDIVS·CAESAR·AVG·
GERM·P·M·TR·P·IMP·P·P. Bust of Nero.
Rev. S·C·DECVRSIO. Nero and squire
mounted.
Wt. 32.13 gm (↓)
Bequest—Frederick M. Watkins,
1972.225

This bronze sestertius is representative of the fine quality of bronze coins issued during the later reign of Nero (A.D. 54–68). It shows the fleshy and unattractive yet imperatorial features of the emperor, who wears the aegis and is surrounded by the sundry abbreviated titles symbolizing his absolute authority. Following his prerogative names as a member of the Julio-Claudian line (including that of Augustus, with the connotation of heroic or semi-divine status), are allusions to his leadership of the Roman religion (P[ontifex] M[aximus]), his tribunician power (Tr[ibunica] P[otestate]), and most importantly, his holding of the state's highest conferred honor (P[ater] P[atriae]). The handsomely designed reverse illustrates the Decursio, a tribute to the praetorian guards, in which the mounted emperor, outfitted with cuirass and spear, is accompanied by an equestrian soldier bearing a standard.

References
Watkins Collection, 1973, no. 152; Sutherland, 1974, 168–69, no. 311; H. Mattingly, *Coins of the Roman Empire in the British Museum*, London, 1976, I, 227, no. 146.

FOGG ART MUSEUM

WESTERN SCULPTURE

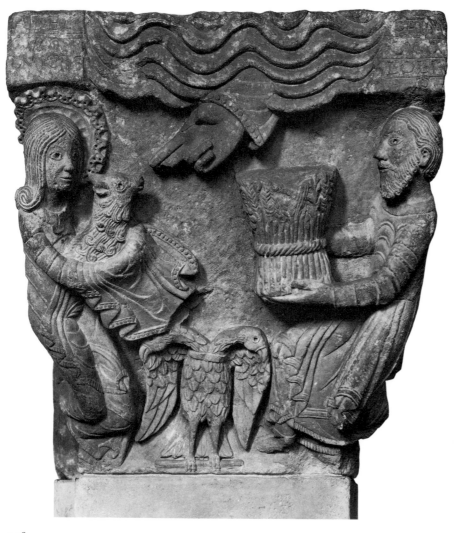

138

THE OFFERING OF CAIN AND ABEL

ca. 1125–30
Capital from the abbey church of
Moûtier-St-Jean, Burgundy
Limestone, 61 x 63.5 cm
Gift—Friends of the Fogg Museum,
1922.18

One of the Museums' treasures is the series of thirteen capitals (three narrative, ten foliate) from the Benedictine abbey of Moûtier-St-Jean, destroyed during the French Revolution. All but one were acquired by A. K. Porter for Harvard in

1922; *in situ* they had stood on pilasters or engaged columns in the nave and possibly the choir of the Burgundian church. The survival of these supports (and other pieces remaining in various locations) is significant in two principal respects. With the aid of a 17th-century engraving, the Museums' capitals have made it possible to reconstruct the elevation of the church and to determine its close ties to the great third church, begun in 1088, at the abbey of Cluny. Furthermore, the capitals have increased our knowledge of sculptural workshops active at Cluny and at related Burgundian sites such as Autun and Vézelay in the first quarter of the 12th century.

The narrative example illustrated here is notable both for its style, which is par-

ticularly close to that of extant pieces from Cluny, and for its content. With great economy of form, it imparts a lucid message of the triumph of good over evil, the sculptor having drawn on Christian and Hebrew commentators as well as the Bible. Cain and Abel, as the inscriptions above their heads specify, are presenting their offerings to the Lord, whose preferential acceptance is indicated by the fingers emerging from the clouds of heaven and pointing to Abel's first-born lamb. The youthful Abel, hands respectfully veiled and halo behind his head, maintains a gracefully weightless stance; behind him on the side of the capital is a foliate form that may represent the Tree of Life in Paradise. The older and bearded Cain bends his knees awkwardly as his offering (in which the chaff has not been removed from the wheat) is literally cut off by the hand of God; behind him the side scene depicts Samson or David subduing a lion, another symbol of victory over evil. By these distinctions, the didactic contrast is made manifest; Abel is seen as the good Christian and antetype of Christ, Cain as the heretic and instrument of the Devil.

References
Bergman, 1978, 372; Cahn and Seidel, 1979, I, no. 1. For information on other surviving pieces see N. Stratford, "Sculpture romane originaire de Moûtiers-St-Jean," *Mémoires de la Commission des Antiquités du Département de la Côte-d'Or* 32 (1980–81), 327–35.

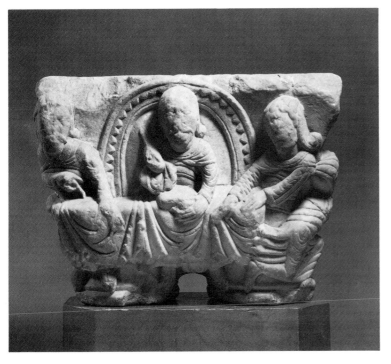

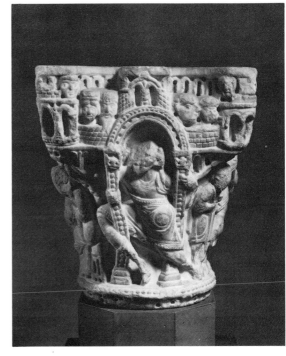

139

THE SUPPER AT EMMAUS

ca. 1140
Capital from St-Pons-de-Thomières, near
Narbonne
Marble, 38 x 51 cm
Gift—Arthur Kingsley Porter, 1922.67

References
L. Seidel, "Romanesque Capitals from the Vicinity of Narbonne," *Gesta* XI/1 (1972),
34–45; Bergman, 1978, 372–73; Cahn and
Seidel, 1979, I, no. 17.

140

SAMSON DESTROYING THE HOUSE OF THE PHILISTINES

3rd quarter of the 12th century
Capital from Notre-Dame-des-Doms,
Avignon
Marble, 31.5 x 26.5 cm
Gift—Meta and Paul J. Sachs, 1922.132

Carved in a lustrous white marble, the
Samson capital is unexcelled in quality
by any others surviving from the destroyed cloister of the Provençal abbey.
Two of the scenes on the other three sides
celebrate, as does this one, the prowess
and righteous deeds of the Biblical hero;
the remaining one presents his demise at
the hands of the treacherous Delilah. All
four events take place within a well-
defined architectural framework, in
which a decorated central arch is the uni-
fying motif. The final episode, after the
blinding, is illustrated here; the story is
brought to a climax as Samson, con-
torted into a pinwheel pose, strains every

muscle to buckle the arch, a feat that will
topple the entire arcaded, turreted struc-
ture and its occupants. The exuberant
style suggests that the artist was familiar
with the sculpture of Toulouse.

References
Bergman, 1978, 374; Cahn and Seidel, 1979,
I, no. 18. The Museums also have a foliate
capital from the Avignon cloister (1934.15).
For reference to other extant pieces in various
collections see J. Thirion, "Le décor sculpté du
cloître de la cathédrale d'Avignon," *Fondation
Eugène Piot. Monuments et Mémoires* 60
(1976), 87–164 (proposes date in the 1150's
or 1160's for the Samson capital; see especially
121–25, 151, 163).

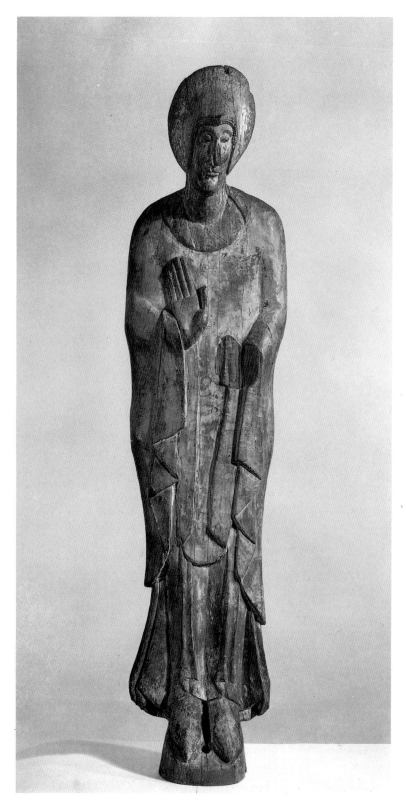

STATUE OF THE VIRGIN

ca. 1125
From Santa Maria de Tahull, Catalonia
Wood with traces of polychrome,
154.9 x 38.1 cm
Gift—Friends of the Fogg Art Museum,
1925.11

The original use of wooden figures such
as this Catalonian *Virgin* is not fully
understood, but Deposition groups found
in the same region indicate that they may
have been used in enactments of the
Easter liturgy. Although it has been sug-
gested that the Museums' piece comes
from a Deposition, the gesture is not in
keeping with that scene, in which the
Virgin reaches out to receive the body
of Christ. Holding both arms close to
the chest with the right palm raised is
instead appropriate to an Annunciation,
or less commonly to a Crucifixion. That
the *Virgin* more likely belonged to a
representation of the latter event is sub-
stantiated by the recent discovery by
H. Nieuwdeorp, director of the Art Mu-
seum of Antwerp, of a possibly pendant
St. John possessing the same style and
dimensions. But whatever role she for-
merly played, this abstracting, other-
worldly *Virgin* endures as a timeless
image of commanding yet restrained
spirituality.

References
About the work's possible origin as part of a
Deposition see Bergman, 1978, 375–76; for
further discussion of iconography and prove-
nance see Cahn and Seidel, 1979, I, no. 51.
Though citing the report of J. Puig y Cada-
falch that the *Virgin* had been found (in 1907)
with a *St. John*, Cahn and Seidel provisionally
opted for an Annunciation, since there had
been no further knowledge of such a piece.

COLUMNAR SUPPORT WITH THREE APOSTLES: MATTHIAS, JUDE AND SIMON

ca. 1125–50
Found in San Pelayo Antealtares,
Santiago de Compostela
Marble, 115 x 17.5 cm
Gift—Republic of Spain through the
Museo Arqueologico Nacional and
Arthur Kingsley Porter, 1933.100

With their weightless stances, their un-
derstated but embroidered robes, and
their subtle communicative divergences
from rigid symmetry and verticality,
the *Three Apostles* form an impressive
group. As in the case of the Tahull *Virgin*
(no. 141), the initial purpose of the col-
umnar support remains to be determined;
at least by the early 17th century, and
until removed in the 18th, it was one of
four under the altar at San Pelayo, a
Benedictine church just east of the cathe-
dral of Santiago, or St. James, whose
shrine in Compostela was the foremost
pilgrimage goal in the 12th century. Two
of the other columns are now in the
National Archaeological Museum in Ma-
drid; the fourth has been lost. Originally
they were most likely used as supports in
a cloister or for a substantial church
furnishing such as a lectern or pulpit.
Furthermore, the 12th-century *Pilgrim's
Guide* relates that four columns sustained
the ciborium over St. James' tomb itself.
Reconstruction at San Pelayo began in
1122, and operations in the cloister at
Santiago started two years later, so that
either foundation could have commis-
sioned and housed the *Three Apostles*
and their sculpted brethren.

References
Bergman, 1978, 374–75; for discussion of the
literature and the historical context see Cahn
and Seidel, 1979, I, no. 53.

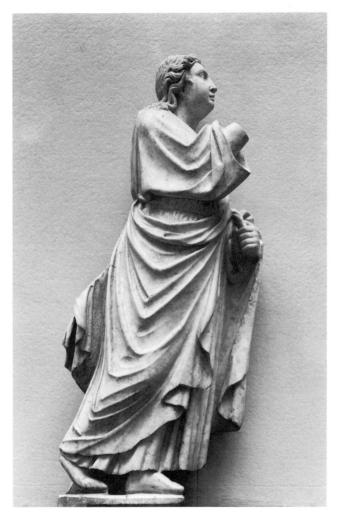

143

CENSING ANGEL

ca. 1295
Attributed to Arnolfo di Cambio
(active 1260–1302)
Marble, 115.6 x 50.5 x 25.5 cm
Gift—Mrs. Arthur Kingsley Porter in
memory of her husband, 1957.57

The only piece in the United States that
can be assigned to the workshop or hand
of Arnolfo di Cambio is this *Censing An-
gel*. Acquired by A. K. Porter in 1921
from a private collection in Florence, it
probably once flanked the seated Virgin
and Child (now in the Opera del Duomo)
of the central tympanum of the west fa-
çade of that city's cathedral. Arnolfo,
appointed to replace the old Sta. Rep-
arata with a new and more splendid

building, began his supervision with the
west end in 1296 and continued until his
death in 1302. Although his façade was
redesigned some fifty years later, much of
the sculpture presumably executed under
and/or by him was retained, remaining in
position until all of it was pulled down in
1587. Other extant façade carvings,
particularly those of the Virgin of the
Nativity (Opera del Duomo) and of the
Dormition (formerly in Berlin), bear
strong affinities to the *Angel*, and all have
characteristics distinctive to Arnolfo's
style. These are to be seen, for instance,
in the crisp, measured, V-shaped drapery
folds and in the mildly animated ex-
pressions and gestures, and are traits
identical to those parts of the Siena
Cathedral pulpit (1268) that Arnolfo
sculpted as a young assistant to Nicola
Pisano.

References
See F. Gibbons, "Arnolfo di Cambio Censing
Angel," *Fogg Art Museum Annual Report*,
1956–57, 18–24, for a convincing refutation
of its earlier designation as an Annunciate an-
gel; though the attribute and right hand of the
figure are missing, part of the rope from which
the thurible was suspended is still visible. Vi-
sual records of the 14th and 16th centuries
and a written description of 1586 give some
valuable evidence of Florence cathedral's
pre-1587 façade arrangements: see Gibbons,
18–24, and M. Weinberger, "The First Façade
of the Cathedral of Florence," *Journal of
the Warburg and Courtauld Institutes* IV
(1940–41), 67–79. For a full bibliography
see D. Gillerman, "Gothic Sculpture in Ameri-
can Collections. The Checklist: I. The New
England Museums," *Gesta* XIX/2 (1980),
129, no. 66.

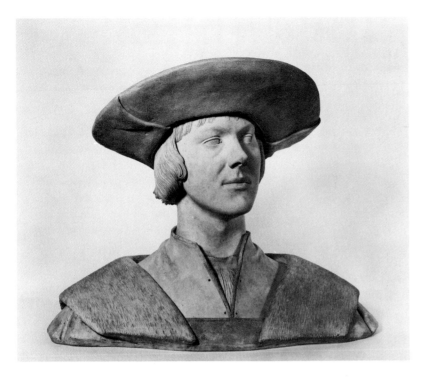

144

PAIR OF PORTRAIT BUSTS
(MAN AND WOMAN)

ca. 1515
Northern European (French?, Flemish?,
German?)
Terracotta, 43.6 x 54.6 x 23.5 cm (man),
41.2 x 51.4 x 21 cm (woman)
Gift—David Rockefeller in memory of
his mother, Abby Aldrich Rockefeller,
1981.188, 189

Reference
Catalogue of the David Rockefeller Collection, forthcoming.

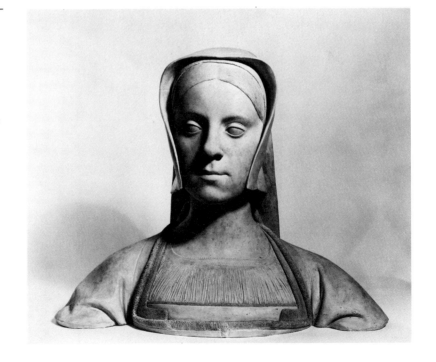

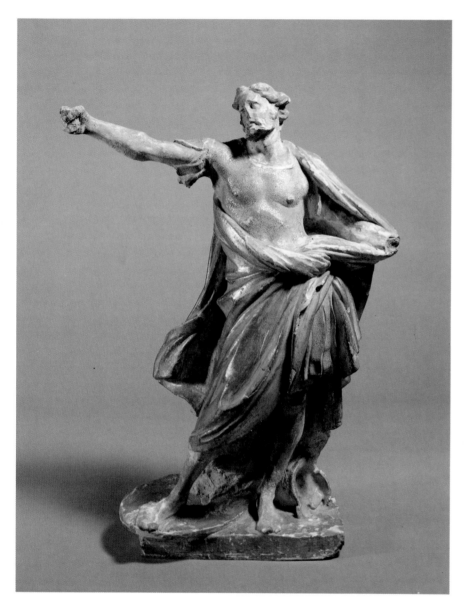

ST. LONGINUS

1630–31
Giovanni Lorenzo Bernini (1598–1680)
Terracotta with later gesso and gilding,
52.7 cm
Purchase—Alpheus Hyatt and Friends of
the Fogg Funds, 1937.51

Although Bernini probably modeled
countless small terracottas during his
long, productive career, only a little over
forty of them have come down to us. In
housing fifteen, the Museums have the
biggest single group, which also is the
most significant in both scope and co-
herence. It is possible, because of prove-
nance, that this group actually remained
as an intact lot from the master's studio.
One of the most important of all is the
Longinus, the only extant *bozzetto* of the
twenty-two that Bernini reportedly made
before carving the huge marble statue
(1638) in St. Peter's that stands in the
niche of the northwest crossing pier, one
of the four supports of the great dome.
Greatly daring in its pose, which is
repeated in the final work, the model por-
trays the saint in the sudden moment of
revelation, after he has pierced Christ's
side with his lance. His outflung arms
mimic the shape of an imaginary cross
and connote his own eventual martyr-
dom; in St. Peter's, the surge of ascending
energy of the marble figure directs atten-
tion to the actual cross atop the immense
baldacchino, also designed by Bernini,
that stands over the high altar.

References
For the provenance of the Museums' *bozzetti*
and for the *Longinus* see I. Lavin, "Calculated
Spontaneity: Bernini and the Terracotta
Sketch," *Apollo* 107/195 (1978), 398–99
and 401–2; see also idem, *Bernini and the
Crossing of St. Peter's*, New York, 1968,
35–37; and R. Wittkower, *Gian Lorenzo Ber-
nini*, London, 1966, no. 28.

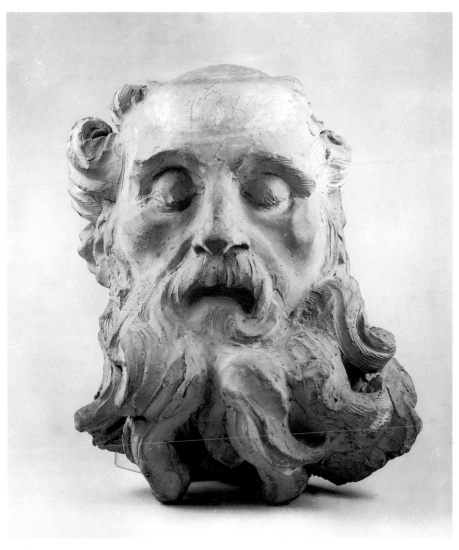

146

HEAD OF ST. JEROME

ca. 1661
Giovanni Lorenzo Bernini (1598–1680)
Terracotta, 35.7 cm
Purchase—Alpheus Hyatt and Friends of
the Fogg Funds, 1937.77

This life-sized head, a study for the marble
statue of St. Jerome in the Chigi Chapel
of Siena Cathedral, is thirty years later
than the *Longinus* (no. 145). All the deco-
ration of the chapel, which was commis-
sioned by Pope Alexander VII to honor
his family and to house a highly venerated
image of the Madonna, was designed and
overseen by Bernini. An important exist-
ing architectural element incorporated
into the new chapel was the Porta del
Perdono (Door of Forgiveness), and it was
in niches to either side of this door that

Bernini placed statues of Sts. Mary Mag-
dalene and Jerome. These two saints,
flanking the entrance, thus were meant to
exemplify the concept, important to the
Counter-Reformation, of redemption
through penitence (also no. 184). In the
finished work, Jerome seems about to
swoon from his impassioned visionary
experience of Christ's suffering on the
cross; a crucifix, pressed to his cheek,
seems to hover in his mind's eye rather
than to exist as a physical object. The
modello, with eyes closed and lips parted
to express mystical fervor, represents the
final working out of the idea. It is the
only instance known to us in which Ber-
nini made a separate study of a head for

an ideal as opposed to an actual portrait;
it magnifies the supple modeling and
sensitive texturing at which he was un-
surpassed with both tools and hands.

References
R. Wittkower, *Gian Lorenzo Bernini*, London,
1966, no. 63; I. Lavin, "Calculated Spon-
taneity: Bernini and the Terracotta Sketch,"
Apollo 107/195 (1978), 402–4; idem, *Draw-
ings by Gianlorenzo Bernini from the Museum
der bildenden Künste, Leipzig, German
Democratic Republic*, The Art Museum,
Princeton University, Princeton, 1981,
229–32.

BALLET DANCER, DRESSED

1880
Edgar Degas (1834–1917)
One of ten castings, probably 1922 by
A. A. Hébrard
Bronze, with tulle skirt and hair ribbon,
99.1 x 35.6 cm
Bequest—Grenville L. Winthrop,
1943.1128

The original wax model of the *Ballet Dancer* (now in the Louvre) is the one piece from among his tireless explorations of sculptural form that Degas chose to exhibit, and, as with every other piece that he modeled in clay or wax, this bronze was cast only after his death. When he showed the *Dancer* at the Impressionist exhibition of 1881, critical reaction ranged from praise to outright hostility; however, the reviews unanimously acknowledged the striking and innovative realism of the figure.

The portrayal of a fourteen-year-old ballet student, with her still awkwardly angular frame and her pose of adolescent impertinence, was indeed novel to the Parisians of 1881. The artist's inclusion of hair ribbon, linen bodice, muslin *tutu*, and (supposedly) satin dance slippers, in addition to details such as the tinting of the face and the tights bagging under her bony knees, lent such verisimilitude to the piece that, according to one reviewer, "the dancer . . . comes to life under one's gaze, and seems ready to leave her pedestal." The displayed work is the culmination of trial drawings and an unclothed wax study of the young model that show the beginning of the artist's developed sculptural essays on the motion of the human form in space.

References
J. Rewald, *Degas: Sculpture, the Complete Works*, London, 1957, 13, 16–20, 28, 29; C. W. Millard, *The Sculpture of Edgar Degas*, Princeton, 1976, passim; Jones, 1985, 55, fig. 48. On the complex history of the bronze casting by the foundry of A. A. Hébrard see P. Failing, "The Degas Bronzes Degas Never Knew," *Art News* 78/4 (1979), 38–41.

148

ST. JOHN THE BAPTIST

1878
Auguste Rodin (1840–1917)
Bronze, 79 x 30 cm
Bequest—Grenville L. Winthrop,
1943.1147

When Pignatelli, the Abruzzese peasant
who inspired this figure, knocked on
Rodin's studio door, the sculptor was so
struck by the stranger's "bearing and
physical strength" that he "thought im-
mediately of a St. John the Baptist: that
is, a man of nature, a visionary, a believer,
a forerunner come to announce one

greater than himself." Rodin further re-
lated the origin of the spirited stance:
the untrained, unselfconscious model
"planted himself, head up, torso straight,
at the same time supported on his two
legs, opened like a compass. The move-
ment was so right, so determined, and so
true that I cried: 'But it's a walking man!'
I immediately resolved to make what I
had seen."

Although the actual evolution of the
work is more complex than the story
implies—Rodin's trip to Italy in 1875
and his introduction above all to the
sculpture of Michelangelo no doubt also
affected his thinking—the artist's account
does address the two keys to the success
of the *St. John*. Pignatelli's planted legs
suggested the possibility of capturing in
one pose the progression in time and
space that defines walking, and one can
read the motion from the left foot, up the
left leg, and down again to the front right
foot; Rodin found this more "truthful"
than the time suspension of photography.
The kinetic energy created by this confla-
tion of movements in turn suffuses the
entire figure, uniting with the expressive
gestures and features to communicate an
air of divinely inspired oratory.

Reference
The Rodin quotations are from J. L. Tancock,
The Sculpture of Auguste Rodin, Philadelphia
Museum of Art, 1976, no. 65.

149

YOUNG CYCLIST

1907
Aristide Maillol (1861–1944)
One of the second edition of four (?), cast
ca. 1925 by A. Rudier and finished by
the artist
Bronze, 95.5 cm
Purchase—Friends of the Fogg Art
Museum and Alpheus Hyatt Funds,
1962.199

Maillol's *Young Cyclist* provides a pro-
vocative comparison with the mature,
muscular, individualized beauty of Rodin's
St. John (no. 148). This smooth-skinned,
sleek body, with its detailed modeling of

neck, shoulders, and chest, is reminiscent
of classical Greek statues of young ath-
letes; the model was the youthful Gaston
Colin, who frequently visited Maillol's
studio on his bicycle. Known chiefly for
his monumental studies of the female
form, Maillol was, by his own admission,
uncomfortable with interpreting the
male, and he sculpted only this one large-
scale male nude. On seeing the work at
the Autumn Salon of 1909, Rodin re-
acted with surprise: "I would not have
thought you capable of doing that!"

References
M. Bouvier, *Aristide Maillol*, Lausanne, 1945,
38–40; J. Wasserman, "The Young Cyclist by
Aristide Maillol," *Fogg Art Museum Acquisi-
tions*, 1962–63, 17–20; Jones, 1985, 27,
fig. 13.

150

THE PIANISTE

ca. 1917
Elie Nadelman (1882–1946)
Base made by J. Erhard Johnson, Inc.,
Watertown, Mass., 1958
Painted wood, 91.4 x 39.4 x 61 cm
Gift—Dr. and Mrs. John P. Spiegel,
1956.200

References
American Art At Harvard, 1972, no. 132;
Jones, 1985, 71, fig. 66. For the nearly identi-
cal piece in the Philip Goodwin Collection
(Museum of Modern Art, New York) see
L. Kirstein, *Elie Nadelman*, New York, 1973,
no. 121.

CARYATID II

1915
Constantin Brancusi (1876–1957)
Red oak (in four pieces), 166.7 cm
(originally 53.3 cm taller, cut down in
1926)
Gift in part—William A. Coolidge,
Hazen Foundation, and Mrs. Max
Wasserman, and Purchase in part—
Francis H. Burr and Alpheus Hyatt
Funds, 1968.2

This monumental wood carving is Brancusi's last work to take the discrete life-sized human figure as its point of departure. In a fusion of architectonic and organic forms, he contraposes the static load and support elements, abacus and plinth, with the undulant bearing members between them: feet, ankles, arched torso, head with grooved necklace and zigzag earrings (and grooved hairplait down the back), and rectangular headdress. The piece's immediate predecessor, *Caryatid I*, more overtly anthropomorphic, clearly embodies the sculptor's interest in African art. *Caryatid II*, at the same time more abstracting and more ornamented, also relates to the series (ca. 1912–15) of wooden cat caryatids (e.g., in the Musée Nationale de l'Art Moderne, Paris) in which Brancusi first explored the combination of architectural motifs with forms from nature. The rough-grained and planar *Caryatid II* shares only its tactility with the sculptor's earlier small-scale, glossy, ovoid objects, and anticipates his totemic constructions.

References
For information about *Caryatid I* see J. Coolidge, "Brancusi's *Caryatid II*," *Fogg Art Museum Acquisitions*, 1968, 21–32, esp. 27. See also S. Geist, *Brancusi, A Study of the Sculpture*, New York, 1968, 49–52, no. 90; *idem*, "Brancusi," in W. Rubin (ed.), *"Primitivism" in 20th Century Art*, II, *Affinity of the Tribal and the Modern*, New York, 1984, 345–67; and Jones, 1985, 58, fig. 49.

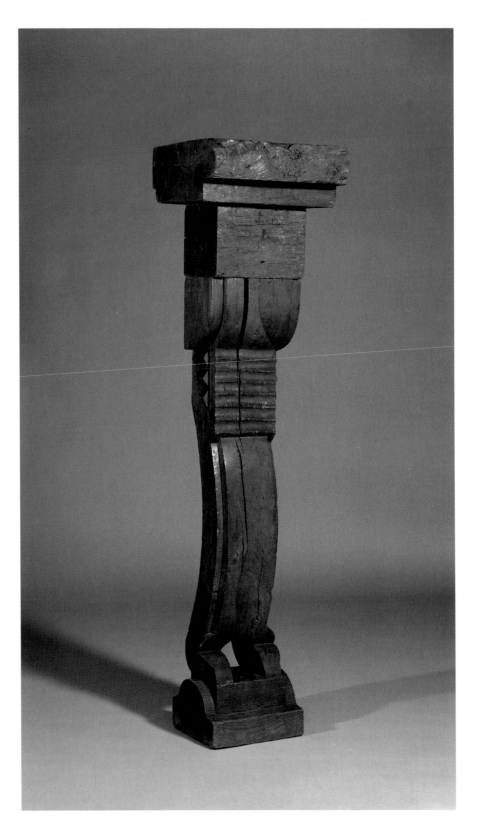

152

ACROBAT (UPSIDE-DOWN FIGURE)

1927
Gaston Lachaise (1882–1935)
Bronze, 27 cm
Bequest—Marian H. Phinney, 1962.78

The inflated female contours, so distinctive a feature of Lachaise's style, give this acrobatic figure a sense of monumentality considerably larger than its actual dimensions. Breasts, stomach, thighs, and buttocks have become voluminous but buoyant shapes celebrating femininity. The *Acrobat* also reflects Lachaise's enchantment with the circus and takes its place among a series of performers, culminating in the immense *Floating Figure* of 1927 in the Museum of Modern Art, who hover or twist backward or balance on hands or shoulders.

References
American Art at Harvard, 1972, no. 141; G. Nordland, *Gaston Lachaise, The Man and His Work*, New York, 1974, no. 70; J. Wasserman, *Three American Sculptors and the Female Nude*, Fogg Art Museum, Cambridge, Mass., 1980, no. 9 (suggests the influence of Nadelman; no. 150); Jones, 1985, 69, fig. 62.

153

BRANCH R

ca. 1951
Fernand Léger (1881–1955)
Bronze, 55.2 x 50.8 cm
Gift—Mr. and Mrs. Joseph H. Hazen,
1962.183

References
Fogg Art Museum Acquisitions, 1962–63
(illus.); Jones, 1985, 67, fig. 59.

UPRIGHT MOTIVE, NO. 8

1955–56
Henry Moore (1898–)
First of planned edition of seven
Bronze, 221 cm
Gift—G. David Thompson in memory of
his son G. David Thompson, Jr., 1959.42

About thirteen years later than the representational *Study for the Northampton Madonna and Child* (no. 306) is this abstracting but vaguely biomorphic bronze, stemming from a commission by the firm of Olivetti to decorate the courtyard of their newly erected Milan headquarters. Moore made a series of twelve small maquettes, in which the one preparative to the Museums' piece came late (the numbering not being consecutive). From this series, he personally chose to have some of the *Motives* cast in full size. In a letter of August 28, 1959, the sculptor stated that he himself thought the theme of *No. 8* was a crucifix.

References
Letter to Frederick B. Deknatel of Harvard in the Fogg Art Museum archives. See also A. Bowness (ed.), *Henry Moore, Sculpture and Drawings*, III, *Sculpture 1955–64*, New York, 1965, no. 388; Jones, 1985, 70, fig. 63.

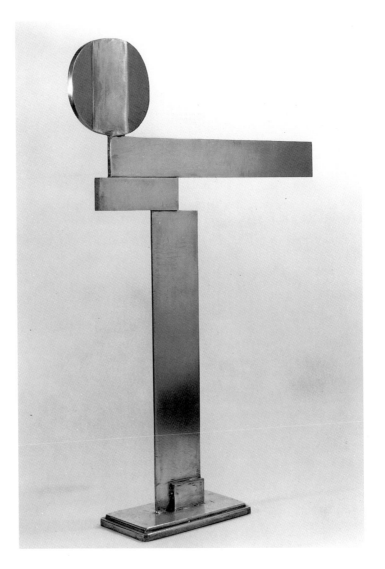

155

BOOKS AND APPLE

1957
David Smith (1906–65)
Silver, 76.2 x 51.4 cm
Gift—Lois Orswell, 1979.408

This two-and-a-half-foot-high sculpture, small in dimensions and precious in material, has an elegance of surface and a refinement of planar geometry that give it a special place in Smith's oeuvre. It belongs, along with another example in the Museums (*Bird*, also given by Lois Orswell, 1979.409), to the set of sculptures that the former metalworker carried out in sterling silver in 1957–58. Fry proposed that their mirroring capability may have helped generate the large-scale, highly burnished works in stainless steel that Smith showed for the first time in 1960. This latter group also was sparked by the stencil drawings, made from such objects as metal rods and cardboard rectangles, that the artist devised late in the 1950's. The Cubist-inspired *Books and Apple* has a particular affinity of form to the geometric steel constructions that accomplished an "optical fusing of surface and depth."

References
The quotation is from E. Fry, *David Smith*, The Solomon R. Guggenheim Museum, New York, 1969, 13. See also Wasserman, 1971, no. 42; R. E. Krauss, *The Sculpture of David Smith, A Catalogue Raisonné*, New York (Garland Reference Library of the Humanities, 73), 1977, 78, no. 415; and Jones, 1985, 111, fig. 108.

WESTERN PAINTINGS

156

ST. DOMINIC

Mid-13th century
Sienese School
Tempera and gold on panel,
116.3 x 61.8 cm
Purchase—Hervey E. Wetzel Bequest
Fund, 1920.20

This compelling image of a cowled monk
is possibly the earliest surviving likeness
of St. Dominic (d. 1221); the reddish hair
and beard tally with a contemporary
written description of him. The face,
however, is not the original, X-rays hav-
ing revealed it to be the third one painted
on the panel. The first, from about 1240,
was placed in the exact center of the
panel; the second, already shifted to the
left, was executed in about 1260 in the
manner of Coppo di Marcovaldo, a
Florentine. The face now visible, from
another twenty years later, was probably
painted by an assistant of Guido da
Siena. This artist, following the original
design, probably also repainted the hands.
A last enhancement, from the earlier part
of the 14th century, is the punched halo
by Ugolino da Siena or by someone who
borrowed his tools. The gold background
and most of the scapular are in their
original state.

The evidence of two early revisions
shows that the image must have been
highly venerated, an inference further jus-
tified by reconstruction of its original
form. Close examination of the panel has
demonstrated that the saint initially was
portrayed full-length and that he was
flanked by twelve scenes from his life. Al-
though the extant piece, then, is only a

fragment, the importance of the once
large dossal with its extensive narrative
cycle and lifelike representation of the
founder of the Dominican order is clear;
presumably it held a place of honor in the
church of S. Domenico in Siena.

References
For full discussion of the piece including the
X-ray examination and reconstruction see
C. Gómez-Moreno, E. Jones, A. Wheelock, Jr.,
M. Meiss, "A Sienese *St. Dominic* Modernized
Twice in the Thirteenth Century," *Art Bulletin*
51 (1969), 363–66. See also Fahy, 1978,
377–78.

THE MADONNA AND CHILD ENTHRONED

ca. 1270
The Master of Camerino (active third quarter of the 13th century)
Tempera and silver on panel,
107.9 x 44.7 cm
Gift—John Nicholas Brown, 1969.151

In the Museums' second rare Duecento painting, a sure sense of decorative patterning and a simple but strong color scheme of reds, blues, browns, and white predominate. The fixed, frontal form of the Madonna, set off against the striped cloth of honor, in turn provides a majestic backdrop for the more active pose of the blessing Christ Child. Recent research has uncovered a work by the same artist in the town of Camerino in the Marches.

Reference
Fahy, 1978, 378–79.

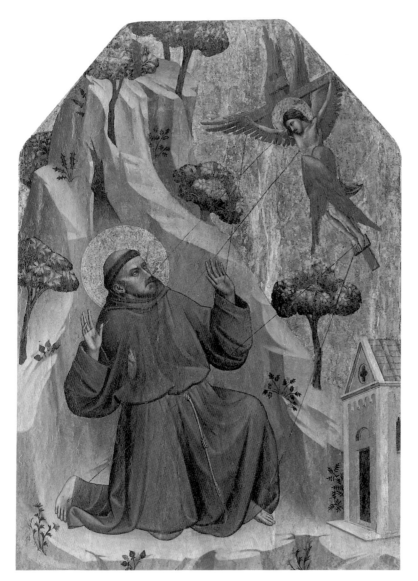

THE STIGMATIZATION OF ST. FRANCIS

ca. 1320
Attributed to the workshop of Giotto
(1266–1337)
Tempera and gold on panel,
212 x 150 cm
Purchase—Friends of the Fogg Museum
Fund, 1929.234

Complementing the *St. Dominic*
(no. 156) is an important painting of
Francis of Assisi, founder of the other
major new order of the 13th century.
Here we see a single event from the
saint's life, in which he receives the stig-
mata from a seraphic vision of the
crucified Christ. Even though this work
has been attributed to Giotto's godson
Taddeo Gaddi (ca. 1334–66), recent un-
published research at the Harvard
University Art Museums has shown that
it clearly precedes the painting (now in
the Louvre) of the same subject produced
in Giotto's workshop. In spite of surface
damage and retouching and the loss of
the top of the gable, the panel retains all
the characteristic qualities of Giotto's
early style, especially the frescoes in the
Upper Church in Assisi. Unlike the *St.
Dominic*, the *St. Francis* has always been
a single panel, yet its large scale pro-
claims that it, too, resulted from a com-
mission of consequence. And along with
the drawing of the *Visitation* (no. 246), it
is the Museums' best example of the
powerfully modeled human forms inhab-
iting equally powerful landscapes that
Giotto himself first created.

References
Fahy, 1978, 380–81; A. Ladis, *Taddeo Gaddi*,
Columbia, Mo., 1982, 86, no. 3.

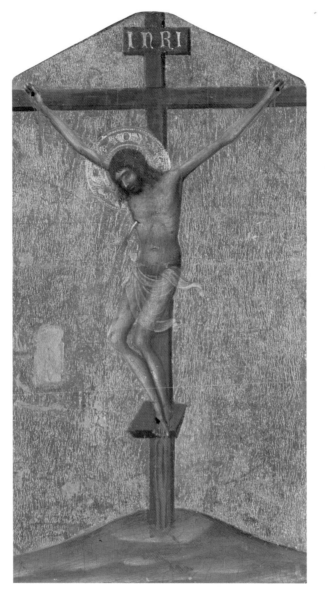

CHRIST ON THE CROSS

ca. 1320
Simone Martini (1280/85–1344)
Tempera and gold on panel, 25 x 13.4 cm
Purchase—Hervey E. Wetzel Bequest
Fund, 1919.51

The emaciated torso and attenuated
limbs, the graphically depicted flow of
blood, and the starkness of the lifeless
figure against the gold background give
this small painting an intense pathos, as
though the artist had sought to make
visible the one terrible concept of Christ's
forsakenness. Although Simone's emotive
power and typically gossamer brush-
strokes remain undiminished, the original
shape and context of his panel have been
lost. Fahy, however, has convincingly con-
nected it to a polyptych by the Sienese
master, the main segments of which are
in the Fitzwilliam and Wallraf–Richartz
Museums; he suggests that the Harvard
Museums' *Christ* formed the pinnacle of
the central panel with *The Madonna and
Child*.

Reference
Fahy, 1978, 382–83; the panel has been cut
down on all sides and reduced to extreme
thinness.

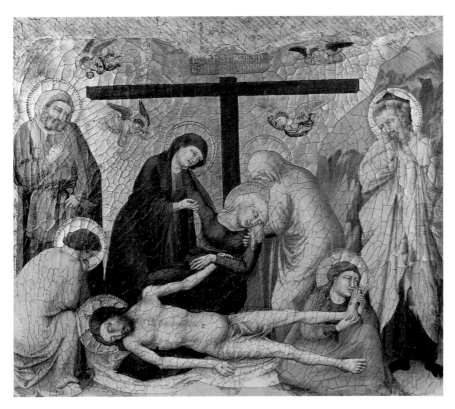

160

THE LAMENTATION OVER THE DEAD CHRIST

ca. 1330
Master of the Fogg Pietà (active first half of the 14th century)
Tempera and gold on panel, 42.3 x 50 cm
Gift—Meta and Paul J. Sachs, 1927.306

The inventiveness and unconventionality of the artist whom Offner named for this panel are evinced not only by individual daring poses—especially those of St. John and of Christ—but also by the group's dense yet unambiguous linear organization, in which strong diagonals emanate from a triangle within a rectangle. The resulting psychological power transmits an acute yet restrained sense of shock and mourning. Probably the work once was the central predella scene of a polyptych believed done for the Giugni Chapel of Santa Croce; other extant parts of the same altarpiece, as well as a large panel painting in Figline and frescoes in Florence and Assisi, have been identified as by the same Tuscan master, who was Giotto's contemporary.

References
Fahy, 1978, 381–82; on p. 382 the author states that "recent research identifies him with a painter from Assisi known as Giovanni di Bonino." For this identification see G. Marchini, "Il giottesco Giovanni di Bonino," *Giotto e il suo tempo: Atti del Congresso Internazionale per la celebrazione del vii Centenario della nascita di Giotto* (1967), Rome, 1971, 67–77. See also M. Boskovits, in R. Offner, *A Critical and Historical Corpus of Florentine Painting. The Fourteenth Century: The Painters of the Miniaturist Tendency*, Florence, 1984, IX, sec. III, 60–66, 317–34.

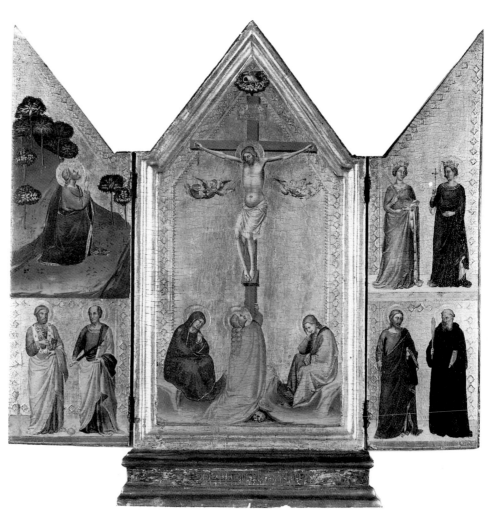

161

TABERNACLE: THE CRUCIFIXION, AGONY IN THE GARDEN AND SIX SAINTS

1334
Bernardo Daddi (documented 1312–48)
Tempera and gold on panel, center 62.3 x 28.5 cm, wings 45.4 x 13 cm
Purchase—Friends of the Fogg Museum and Prichard Funds, 1918.33

Compared to the *Lamentation* (no. 160), Bernardo's *Crucifixion* looks straightforward and traditionally Florentine. The vertical figure of the Magdalene preserves the strict balance of the Virgin and St. John on either side of the cross; the pairs of saints on the side wings, interrupted only by the depiction of Christ praying at Gethsemane, also conform to a symmetrical pattern. Most scholars have accepted the tabernacle as by Bernardo's own hand, and the 1334 inscription on the base makes it contemporary with his *Madonna of the Magnificat* in Florence Cathedral.

Reference
Fahy, 1978, 382.

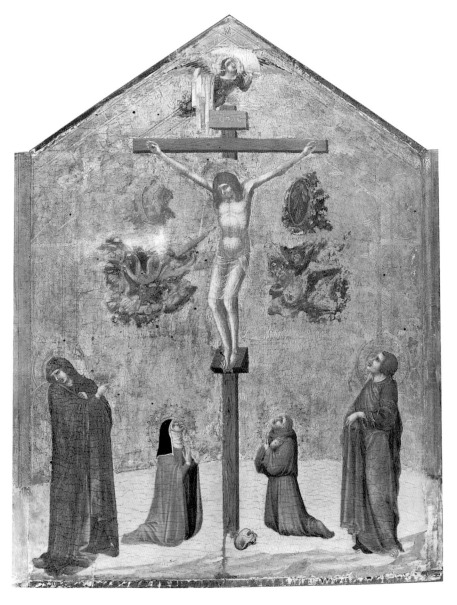

THE CRUCIFIXION WITH SAINTS CLARE AND FRANCIS

ca. 1320
Pietro Lorenzetti (active 1306?–48/49)
Tempera and gold on panel,
45.8 x 36.2 cm
Bequest—Grenville L. Winthrop,
1943.119

In addition to the Virgin and St. John, Pietro Lorenzetti's *Crucifixion* includes Sts. Clare and Francis, who appear as mystic witnesses. The angels and the figures of the sun and the moon flanking Christ further remove the scene from the realm of the biblical account and change the focus to one of timeless contemplation. The physical and mental distancing of the figures one from another, and the design that bends the upper bodies of the Virgin and St. John to parallel Christ's outstretched arms, contribute to the aura of formalized devotion. Both the ornament incised on the gold ground and the figure style relate the painting to Pietro's earliest phase; the work presumably once formed the central panel of a portable altarpiece with shutters.

References
Fahy, 1978, 383–85; H. B. J. Maginnis, "Pietro Lorenzetti: A Chronology," *Art Bulletin* LXVI (June 1984), 196–97.

PROCESSIONAL CRUCIFIX

ca. 1365
Luca di Tommè (active 1356–89)
Obverse: Crucified Christ with the
Virgin, Christ the Savior, St. John the
Evangelist, and St. Francis
Reverse: Crucified Christ with St. Paul,
the Archangel Michael, St. Peter, and
St. Louis of Toulouse
Tempera and gold on panel with glass
crystals, 44 x 31.5 cm
Bequest—Mrs. Jesse Isidor Straus,
1970.59

References
M. Meiss, "Notes on Three Linked Sienese
Styles," *Art Bulletin* 45 (1963), 47; he dates
the piece to before 1362 on the grounds that it
still reflects the style of the older Niccolò
Tegliacci. See also S. Fehm, *The Collaboration
of Niccolò Tegliacci and Luca di Tommè*, Los
Angeles, 1973, 30, n. 24.

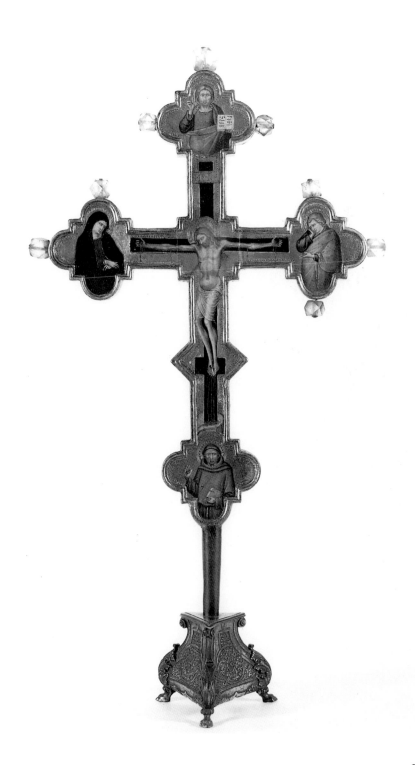

THE CRUCIFIXION

ca. 1348
Ambrogio Lorenzetti
(active 1319–48/49)
Tempera and gold on panel, 68 x 35 cm
Gift—Meta and Paul J. Sachs, 1939.113

This *Crucifixion*, which probably consti-
tuted half of a diptych, stands in marked
contrast both to the static, formalistic
Crucifixion of Ambrogio's older brother
Pietro and to the absolute isolation of Si-
mone's *Christ on the Cross* (nos. 162,
159). Ambrogio has packed his scene
with characters whose individual emo-
tional responses to the event charge the
painting with drama. Nevertheless, atten-
tion keeps returning to the central
character. For instance, the dramatically
innovative pose of the prostrate Virgin
forms a strong focus in the lower left
foreground, but her glance, as well as the
Magdalene's, return the observer to
Christ. The sophisticated composition
and the convincing placement of figures
in space are enhanced by the brilliant col-
ors and rich costumes and trappings;
Ambrogio has blended a Sienese taste for
the decorative and exotic with a Floren-
tine predilection for solidity of form and
human narrative.

Reference
See Fahy, 1978, 385–86 for discussion of a
possibly related panel by Pietro Lorenzetti and
for the dating of this one in relation to the
Black Death.

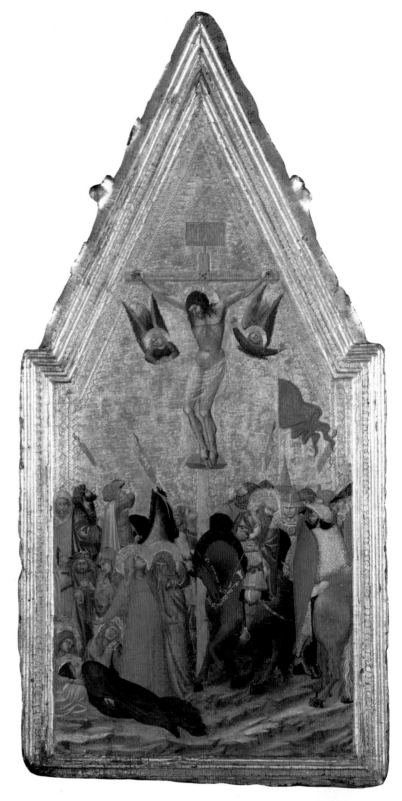

THE MADONNA ENTHRONED WITH ANGELS

ca. 1380
Spinello Aretino (active 1373–1410)
Tempera and gold on panel,
195.3 x 113 cm
Gift—Mrs. Edward M. Carey, 1905.1

References
Forbes Catalogue, 1971, 22; M. S. Frinta, "A seemingly Florentine yet not really Florentine Altar-piece," *Burlington Magazine* CXVII/869 (Aug. 1975), 532–35.

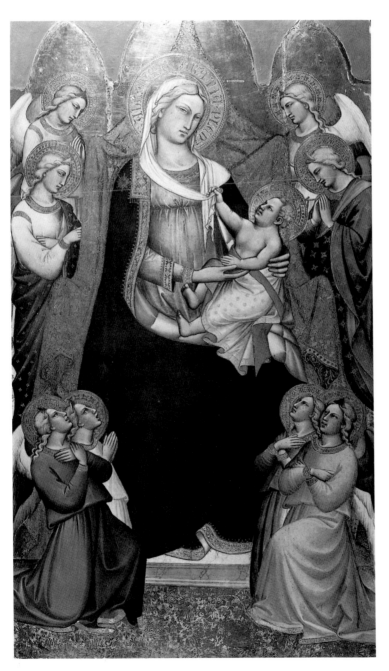

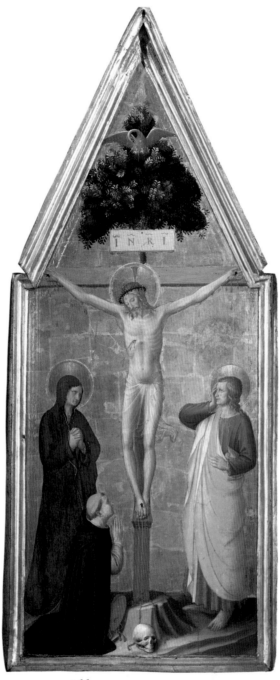

166

THE CRUCIFIXION

ca. 1446
Fra Angelico (active 1417–55)
Tempera and gold on panel, 96.6 x 42 cm
Purchase—Hervey E. Wetzel Bequest
Fund, 1921.34

According to Pope-Hennessy, "the most
impressive of the artist's late paintings" is
this *Crucifixion*, once in all likelihood
the center of a small triptych. Despite a

few reminiscences of the Trecento, such
as the gold ground and the slightly
hierarchical scale, the work belongs com-
pletely to the early Renaissance. The
monumentality of the figures; the care-
fully modeled and idealized body of
Christ; the consistent lighting from the
left that helps define the forms; the atten-
tion to realistic detail as in the flagella-
tion marks echoed symbolically by the
pelican piercing its own breast; all affirm
a thorough understanding of the prin-
ciples first laid down by Masaccio. The
figure style and the halo types specifically
anticipate Fra Angelico's silver chest pan-
els of the 1450's, but the most concrete
evidence for the dating and perhaps even
the key to the expressive content of the
painting are provided by the kneeling do-
nor figure. From his Dominican habit
and cardinal's hat, and from comparison
with a later portrait of him in Sta. Maria
sopra Minerva in Rome, he has been
identified as Juan de Torquemada
(1388–1468), the only friar of his order
to be made cardinal (1439) at the time.
This same Spaniard was one of a group of
Dominicans whose writings, generated by
a reform movement at the end of the 14th
century, influenced Fra Angelico; the
pensive quietude that prevails in the *Cru-
cifixion* may reflect their teachings.

References
The quotation is from J. Pope-Hennessy, *Fra
Angelico*, Ithaca, New York, 1974, 37. For
identification of the kneeling donor figure see
Fahy, 1978, 386–87; he notes a corroboration
of the dating in a *St. Sixtus* first identified by
Pope-Hennessy as one of the missing wings. If,
as is thought, the papal saint is a portrait of
Eugenius IV, then the triptych must have been
painted after Fra Angelico moved to Rome in
1445 and before the pope died in February
1447. For information about the late 14th-
century reform movement see C. Lloyd, *Fra
Angelico*, Oxford, 1979, 4.

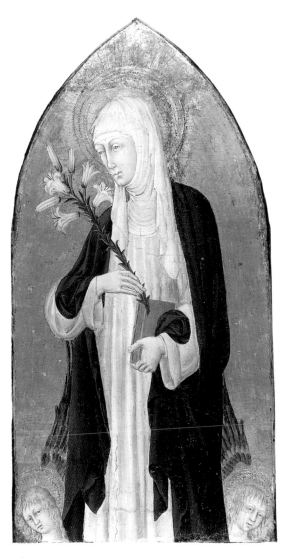

167

ST. CATHERINE OF SIENA

Giovanni di Paolo (1403?–after 1482)
Tempera and gold on panel,
108.6 x 53.3 cm
Gift—Lord Duveen of Millbank, 1921.13

Reference
H. W. van Os, "Giovanni di Paolo's Pizzi-
caiuolo Altarpiece," *Art Bulletin* 53 (1971),
289–302.

168

CHRIST IN LIMBO

ca. 1440
Sienese, Sano di Pietro, alias "Osservanza
Master" (1406–81)
Tempera on panel, 34.3 x 43.2 cm
Gift—Paul J. Sachs as a "testimonial to
my friend Edward W. Forbes," 1922.172

References
Sachs Collection Catalogue, 1965, no. 87;
Forbes Catalogue, 1971, 36; P. Torriti, *La
Pinacoteca Nazionale di Siena: i dipinti dal xii
al xv secolo*, Genoa, 1977, 248–51.

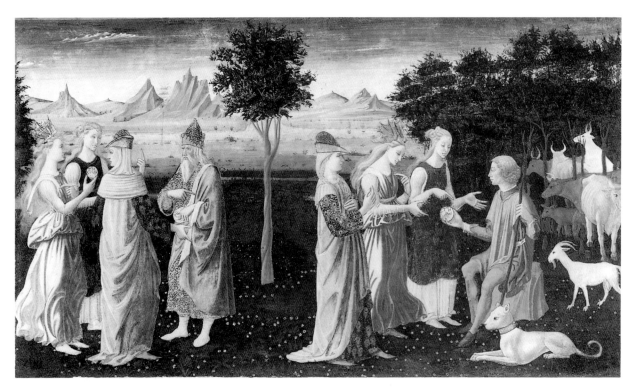

169

THE JUDGMENT OF PARIS

ca. 1480
Florentine, Master of the Argonaut
Panels (active last quarter of the 15th
century)
Tempera on panel, transferred to canvas,
65.1 x 110.9 cm
Gift—Meta and Paul J. Sachs, 1928.169

Reference
E. Fahy, "The Argonaut Master," *The Metropolitan Museum of Art Bulletin*, forthcoming.

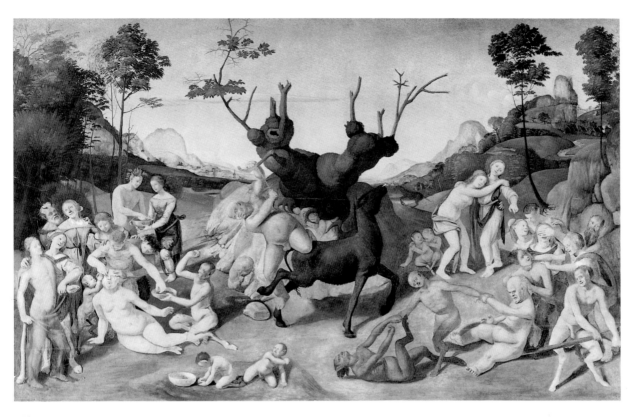

THE MISFORTUNES OF SILENUS

ca. 1500
Piero di Cosimo (1462–1521?)
Oil glazes over tempera? on panel,
76.2 x 126.3 cm
Purchase—Friends of Art, Archaeology
and Music, and Alpheus Hyatt Fund,
1940.85

As described admiringly by Vasari, this panel and the pendant *Discovery of Honey* in the Worcester Art Museum once adorned a room in the house bought by the Vespucci family in 1499. The Mu-seums' painting illustrates the later part of an episode taken from Ovid's *Fasti*: the greedy Silenus, in pursuit of another hive, is shown falling from his mule and being stung by the agitated bees, much to the amusement of the satyrs and maenads who then come to his aid. Although the design is unified, it actually comprises three separate moments, each with the aged and obese Silenus as the focus, and it typifies the kind of elaborate wall deco-ration, often with involved classical themes, that became fashionable among Florentine patrons. Because of the idio-syncracies of Piero's style and the dearth of firmly dated works by him, opinions have varied widely as to the place of the Vespucci panels in the artist's develop-ment. Fahy's proposal, however, remains the most plausible: finding the marriage of Giovanni Vespucci in 1500 a likely time for the commission, he also has ar-gued on stylistic grounds that the pieces, still quattrocentesque in conception, must have preceded the effect on Piero of Leonardo's 1505 *Battle of Anghiari* with its daringly foreshortened figures in frenzied action.

References
E. Fahy, "Some Later Works of Piero di Cos-imo," *Gazette des Beaux-Arts* 65 (1965), 201–12; as the author has maintained, the poor condition must have been due to a de-structive cleaning. See him also for discussion of two panels with Tritons and Nereids that probably hung with the others as a marine complement to the Bacchic *thiasos*. See M. Bacci, *Piero di Cosimo*, Milan, 1966, 92–93, no. 36, for the place of the Vespucci panels in Piero's development.

171

THE ADORATION OF THE MAGI

ca. 1480
Cosimo Tura (ca. 1430–95)
Tempera on panel, 38.8 x 38.6 cm
Gift—Mrs. Edward M. Cary, 1905.14

This small panel belongs to a set that includes the *Circumcision* at the Isabella Stewart Gardner Museum and the *Flight into Egypt* at The Metropolitan Museum of Art, and it has been suggested that all three come from the predella of the large altarpiece commissioned by the Roverella family and painted by Cosimo for S. Giorgio fuori le Mura, Ferrara (ca. 1474). Portions of that work are now dispersed, the principal one being the central *Madonna with Angels* in the National Gallery, London. Because of the uncommon references to Mosaic law in both the London and Gardner paintings, the attribution of the roundels to the altarpiece is inviting. Yet contradictory evidence is

given in an early 18th-century description of the S. Giorgio work before its dismantling; the writer claimed that the predella was composed of scenes from the lives of Sts. Bernard and Benedict. In any event, the *Adoration* epitomizes the accomplishments of the Ferrarese artist whose eerie boulder-strewn landscapes and sculpturesque figures confirm both Cosimo's idiosyncratic visions and the enduring influence of Mantegna.

References
P. Hendy, *European and American Paintings in the Isabella Stewart Gardner Museum*, Boston, 1974, 263–64; E. Fahy, "Italian Paintings at Fenway Court and Elsewhere," *The Connoisseur* 198/795 (May 1978), 37–39; and K. Christiansen, "Early Renaissance Narrative Painting in Italy," *The Metropolitan Museum of Art Bulletin*, Fall 1983, 36–37.

172

THE MADONNA AND CHILD ENTHRONED WITH ANGELS AND DONOR; ST. FRANCIS AND ST. SEBASTIAN

Niccolò da Foligno (ca. 1430–1502)
Tempera on panel, central panel:
148.4 x 83.8 cm; left wing: 147.6 x 45.1
cm; right wing: 148.2 x 41.3 cm
Gift—Edward W. Forbes in memory of
Charles Eliot Norton, 1927.207

References
B. Berenson, *Italian Pictures of the Renaissance, Central Italian and Northern Italian Schools*, London, 1968, I, 295; *Forbes Catalogue*, 1971, 14.

MYSTIC CRUCIFIXION

ca. 1500
Sandro Botticelli (1444/45–1510)
Tempera and oil on canvas,
73.5 x 50.8 cm
Purchase—Friends of the Fogg Museum
Fund, 1924.27

Harvard's pioneer role in the development of modern conservation techniques under the directorship of Edward Forbes is well represented by the *Mystic Crucifixion*. Until the work was cleaned in 1925, it was considered the effort of a pupil, but once the varnish and substantial repainting were removed, the true merits of the original became apparent. X-rays revealed design changes in the angel's limbs and a quality of drawing in the drapery that ruled out any but Botticelli's own hand. Even with its grave losses, the image remains powerful; moreover, along with the artist's *Mystic Nativity* (National Gallery, London), it documents the profound impact of Savonarola on late 15th-century Florence. Converted to Savonarola's teachings after the latter's death in 1498, Botticelli incorporated in the *Mystic Crucifixion* themes from the fiery Dominican's visionary sermons on the consequences of the corruption of the church and immorality of the city. To Christ's left side, black storm clouds, symbolizing the wrath of God, rain weapons and firebrands, and the angel of justice raises his sword to slay the *marzocco* or small lion, heraldic emblem of Florence. To Christ's right side, the purified city is bathed in light emanating from God the Father as white angels chase the clouds away; the Magdalene, standing for the penitent church, embraces the cross while the wolf of clerical vice flees her robe.

References
On the restoration see the *Forbes Catalogue*, 1971, 128–35. See also Fahy, 1978, 388, and R. Lightbown, *Sandro Botticelli*, Berkeley, Cal., 1978, II, 94.

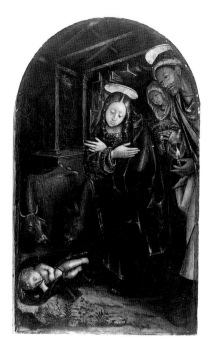

174

THE ADORATION OF THE CHRIST CHILD

Defendente Ferrari (ca. 1511–after 1535)
Oil on panel, 69.9 x 47 cm
Gift—Mrs. Felix M. Warburg in commemoration of the seventieth anniversary of Felix Warburg's birth, 1941.134

Probably from the early part of the painter's career and in style still linked to the 15th century, the *Adoration* has the strikingly novel feature of a nighttime setting, which the Piedmontese artist has used to stunning effect; unable to penetrate the gloom of the manger's rafters, the candles' glow illuminates the awed faces of Joseph and the maidservant, while a more unearthly light seems to radiate from and around the Madonna and Child. In his choice of setting as well as in the exactly notated details, Defendente discloses first-hand knowledge of northern, specifically Netherlandish, accomplishments.

References
V. Viale, "Schedule su Defendente Ferrari," *Studies in the History of Art dedicated to William F. Suida*, London, 1959, 231–33; Freedberg, 1978, 392–93.

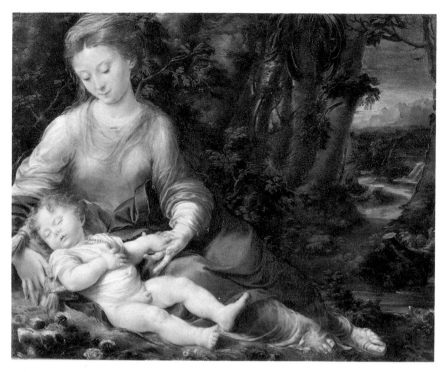

175

THE MADONNA WITH THE CHRIST CHILD IN A LANDSCAPE

ca. 1540
Girolamo Mazzola-Bedoli (1500–69)
Oil on panel, 35.6 x 47 cm
Gift in part—Barbara B. Paine, and Purchase in part—Mrs. Ernest Angell Trust Fund and Richard Norton Fund, 1972.22

A completely human bond between the gently protective Madonna and the sleeping Christ Child is established in this splendid small painting. Using the dark sheltering copse of oak trees as a foil, Bedoli has rendered gleaming flesh tones, diaphanous drapery, and shimmering accoutrements to give his figures a refined yet simple elegance and sweetness. Similarly, the inclusion of such disguised symbols as the thornless roses standing for the Immaculate Conception and the Child's coral beads signifying preservation from evil suggests a broader Christian import but does nothing to detract from the tender intimacy of the moment shown. Through this expressive vocabulary, Bedoli reveals the influence of the important Emilian painter Correggio; at the same time he manifests formal allegiance to the leading proponent of the mannerist style, his mentor and cousin-in-law Parmigianino.

References
Freedberg, 1978, 392; A. Milstein, *The Painting of Girolamo Mazzola-Bedoli*, New York (Garland Series of Outstanding Dissertations in the Fine Arts), 1978, 50–51. For discussion of related works, especially the documented *Betrothal of St. Catherine* of the San Niccolò Altarpiece of San Giovanni Evangelista, Parma (1536), see H. Cooksey, "*Madonna and Child in a Landscape* by Girolamo Mazzola-Bedoli," *Fogg Art Museum Annual Report*, 1972–74, 58–66.

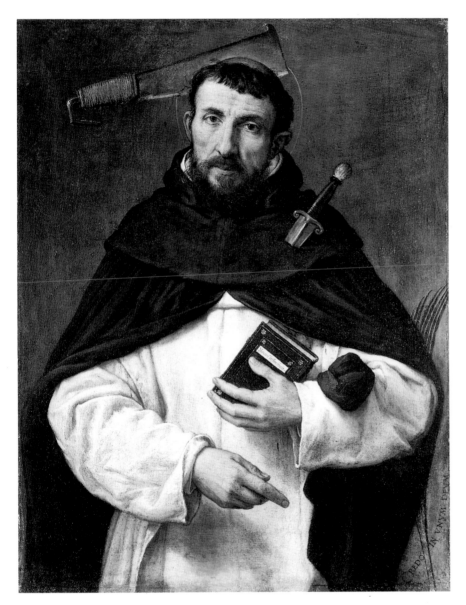

PORTRAIT OF A DOMINICAN FRIAR AS ST. PETER MARTYR

1549
Lorenzo Lotto (ca. 1480–1556)
Oil on canvas, 88.4 x 68 cm
Gift—Edward W. Forbes in memory of
Alice F. Cary, 1964.4

This portrait is dependably dated and the sitter identified by an entry in Lotto's own notebook: "September 1549. To Friar Angelo Farfatti of St. Dominic, a St. Peter Martyr as large as himself in his portrait." Two 20th-century restorations, however, were required to return the painting to its original state: the first, in 1923, reinstated a cleaver that had been squeamishly painted out, while the second, in 1953, recovered the artist's signature as well as the inscription, CREDO IN UNUM DEUM, to which the friar points. In the iconic religiosity of the work may be seen the "incipient mentality of the Counter-Reformation," and in the disquieting intensity of communication with the viewer, one of Lotto's express fortes.

References
The quotation is from S. J. Freedberg, *Painting in Italy 1500–1600*, Harmondsworth, 1971, 207. See also *idem*, 1978, 389–90, and F. Caroli, *Lorenzo Lotto*, Milan, 1980, 242–43.

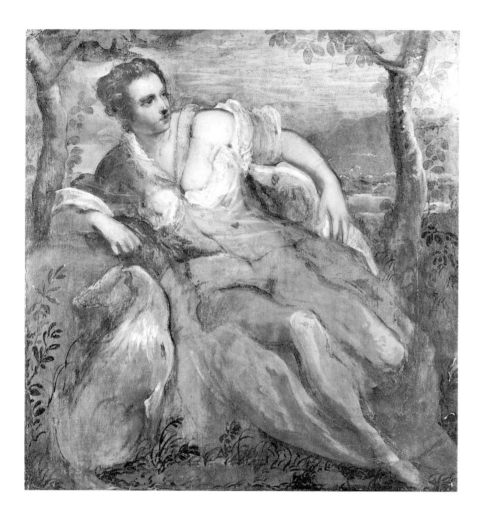

177

AN ALLEGORY OF FIDELITY

Domenico Tintoretto (1560–1635)
Oil on canvas, 109 x 106 cm
Gift—Mrs. Samuel Sachs in memory of
Mr. Samuel Sachs, 1942.165

Appearing on the market as a Veronese,
the uncompleted painting was bought by
Ruskin in 1852 after he saw the land-
scape elements that had been concealed
behind a frame; the finesse of the swiftly
executed sketch seen as a whole made
him assign it unhesitatingly to Jacopo
Robusti. In recent years, the attribution
has been changed once again, on the
basis of the *Allegory*'s connection to a set
of works with related themes and com-
positions that are accepted as by the
master's son Domenico. That Domenico
executed the piece in his youth, however,
is evident in the painterly handling of the
surface, a trait inherited from his father;
later on his style was to become harder
and more studied.

References
R. Hewison, *Ruskin and Venice*, J. B. Speed
Art Museum, Louisville, Ky., 1978, no. 55;
Freedberg, 1978, 390–91.

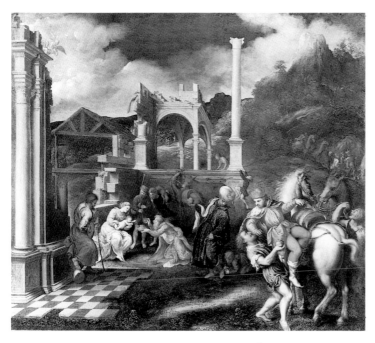

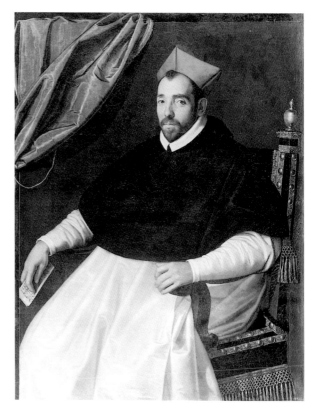

179

PORTRAIT OF A CARDINAL, MICHELE BONELLI, CALLED CARDINAL ALESSANDRINO

1586
Scipione Pulzone da Gaeta
(before 1550–98)
Oil on canvas, 134 x 105 cm
Gift—Edward W. Forbes, 1905.12

Reference
Freedberg, 1978, 393.

178

THE ADORATION OF THE MAGI

ca. 1550
Paris Bordone (1500–71)
Oil on canvas, 85.1 x 99.4 cm
Bequest—Grenville L. Winthrop,
1943.104

This signed *Adoration* by the pupil of
Titian who traveled to Fontainebleau
(no. 265) attests to the imprint of central
Italian mannerism on Venetian painting
of the middle of the Cinquecento. Char-
acteristic of Bordone's particular response
to the *maniera* are the stage-like architec-
tural setting and the theatrical effect of
the stormy sky, against which the figures,
from the prancing horses to the eager
Christ Child, play their varied and active
roles.

Reference
Freedberg, 1978, 391.

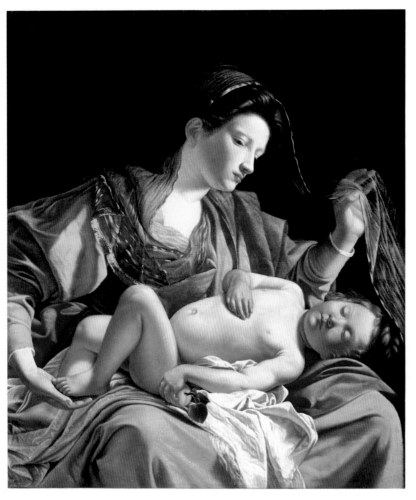

180

THE MADONNA WITH THE SLEEPING CHRIST CHILD

ca. 1610
Orazio Gentileschi (1563–1639)
Oil on lined canvas, 99.5 x 85 cm
Gift—through William A. Coolidge in memory of Lady Marian Bateman, 1976.10

As somber in mood as it is rich in texture and brilliant in color and lighting, Orazio Gentileschi's *Madonna* is an extremely important example of his personal development of the inventions of the young Caravaggio. Set against a dark void, the figures have an almost overpowering tangible presence; the vast lap of the

Madonna fills the entire picture plane to accommodate the outstretched form of the Christ Child. It is this intense physical reality, in which motion and emotion are newly integrated, that comes specifically from Caravaggio's early works. Absent instead is the dramatic chiaroscuro (so crucial for other artists [no. 184]) of Caravaggio's more mature style; the Madonna and Child are fully lighted, a feature enhanced by the high color tonalities, especially the golden yellow of the Madonna's dress, that are expressly Orazio's. Of equal potency with these formal properties is the spiritual message conveyed. Christ lies on a white cloth, a reminder of the shroud in which he will be buried, on the lap—altar of the Virgin who signifies the Church that he will found. Her stately gesture in turn evokes the humeral veil used to cover the Eucharistic vessels of the mass, and the sacramental allusions are brought full circle by the apricot Christ holds. Identified by Freedberg as an arcane substitute for the apple as the actual fruit of original sin, the apricot thus refers to the cause that made the sacrifice of God's Son man's only means to salvation. These two vividly corporeal beings, then, literally embody the celebration of the Eucharist, during which, on the altar, the bread and wine become the body and blood of the Redeemer.

References
Freedberg, 1978, 393; *idem*, "Gentileschi's Madonna with the Sleeping Christ Child," *A Dealer's Record*: *Agnew's 1967–81*, London, 1981, 45–49.

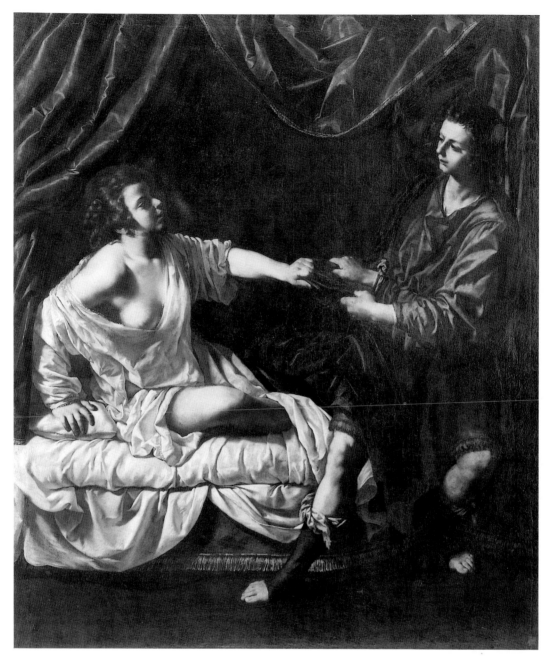

181

JOSEPH AND POTIPHAR'S WIFE

Attributed to Paolo Finoglia
(1590–1645)
Oil on canvas, 231.8 x 194.9 cm
Gift—Samuel H. Kress Foundation,
1962.163

Reference
Freedberg, 1978, 394–95.

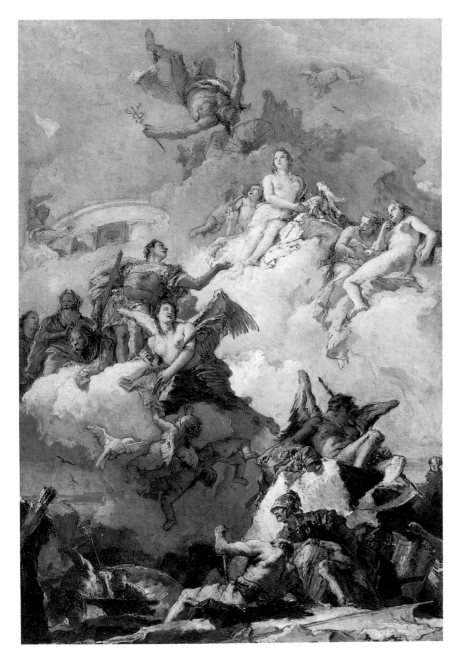

THE APOTHEOSIS OF AENEAS

ca. 1765
Giovanni Battista Tiepolo (1696–1770)
Oil on canvas, 72.2 x 51.1 cm
Purchase—Allston Burr Bequest Fund,
1949.76

A close but puzzling relation exists between one of the ceiling paintings executed in the years 1762–66 by the Tiepolo workshop for the Royal Palace in Madrid and this oil sketch. The main characters in the two works are the same: Aeneas, standing on a cloud borne by putti, ascends toward his mother Venus to be presented with armor she has ordered from Vulcan, whose forge appears below. Because the ceiling, however, differs both in its spatial ordering and in its inclusion of additional subsidiary figures, it has not been established with absolute certainty whether the sketch is a *modello* by Giambattista or a free variant by his assistant-son Domenico. Allowing for the occasionally tremulous drawing, typical of the last years of Giambattista's life, and the repainting to be found especially in the figures of Aeneas and the Victory beneath him, the sketch is of a quality to favor an attribution to the master himself.

References
W. Friedman, "A Tiepolo Attribution Problem," *Fogg Art Museum Acquisitions*, 1968, 52–64; Freedberg, 1978, 396.

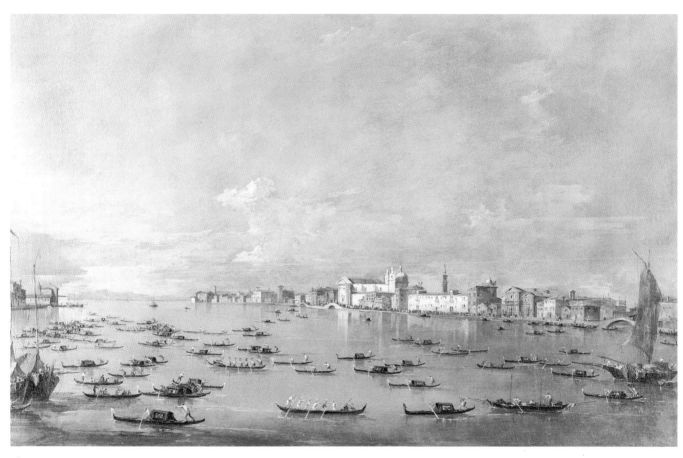

183

VENICE: FONDAMENTA DELLA ZATTERE

ca. 1785–90
Francesco Guardi (1712–93)
Oil on canvas, 47 x 75.5 cm
Bequest—Grenville L. Winthrop,
1943.113

References
A. Morassi, *Guardi: Antonio and Francesco
Guardi*, Venice, 1973, I, 427, no. 626; L. R.
Bortolatto, *L'opera completa di Francesco
Guardi*, Milan, 1974, no. 329.

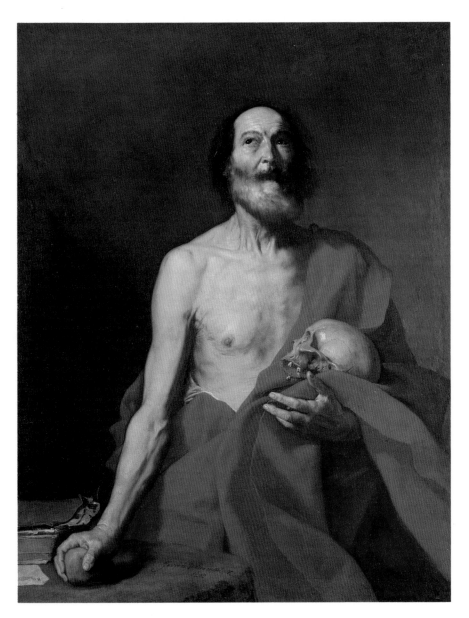

ST. JEROME

1640
Jusepe de Ribera (1591–1652)
Oil on canvas, 127 x 100.6 cm
Gift—Arthur Sachs, 1920.7

Ribera, who spent time in the north of
Italy as well as in Rome before settling in
Naples, painted St. Jerome more fre-
quently than any other subject. This
work, a particularly fine example, em-
phasizes the restrained bearing and inner
vitality of the early 5th-century scholar
and ascetic; shown only with the at-
tributes of skull, stone, and his own
writings, he prepares to beat his breast in
penitence as he contemplates the vanity
and ephemeral nature of earthly matters.
Through its dark tonality with the strik-
ing scarlet of the cloak as a foil, its ex-
pressive tenebrism, and its unrelenting
description of a vigorous but aging body,
the painting declares the Spaniard's pene-
trating response to the innovations of
Caravaggio.

References
Freedberg, 1978, 397; A. E. Pérez-Sánchez and
N. Spinosa, *L'opera completa del Ribera*,
Milan, 1978, no. 198; C. Felton and W. B.
Jordan (eds.), *Jusepe de Ribera*, Kimbell Art
Museum, Fort Worth, Texas, 1982, no. 32.

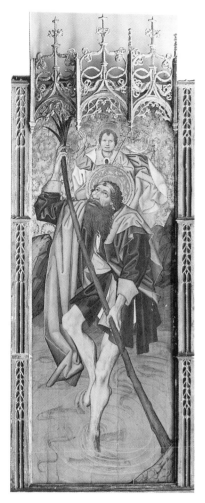

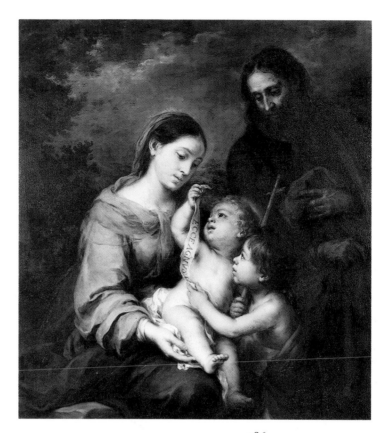

185

186

ST. CHRISTOPHER

Late 15th century
Attributed to the Master of St. Ildefonso
Tempera on panel, 177.2 x 67.6 cm
Gift—Edward W. Forbes, 1948.35

In purchasing this painting in 1920 for
the modest sum of 320 dollars, Edward
Forbes became one of the first American
collectors to acquire an early Spanish
painting. According to the Madrid dealer
who sold the piece, it came from the con-
vent church of Sta. Maria (founded in the
12th century) near Saldena in the prov-
ince of Palencia, and had formed part of
a lateral retable. Nothing more is known
of the panel's provenance, but it has been
assigned to the Master of St. Ildefonso
because of similarities to other works
given to the same artist, whose name was
coined from a painting of St. Ildefonso
receiving the chasuble from the Virgin
(now in the Louvre). The *St. Christopher*,
with its crisp, energetic angularity and

its bright array of colors—the saint's
blue tunic and green mantle lined in
red, and the pink drapery of the Christ
Child—shows the uncommon talent of
this anonymous master who worked in
an Hispano-Flemish mode.

References
C. R. Post, *A History of Spanish Painting*,
Cambridge, Mass., 1933, IV, pt. 1, 193–98
and 1938, VII, pt. 2, 862, 864; *Forbes Cata-
logue*, 1971, 42.

THE HOLY FAMILY

ca. 1670
Bartolomé Esteban Murillo (1617?–82)
Oil on canvas, 120 x 110 cm
Bequest—Nettie G. Naumburg,
1930.189

The Holy Family, which found its way
into a British collection in the early 19th
century, eventually came to the Museums
through the Naumburg bequest. Along
with a similar work now in the Wallace
Collection in London, this picture, with
its soft but directed illumination and its
muted brown, silver, and pastel hues,
demonstrates the accomplished technique
of this Andalusian artist.

References
Freedberg, 1978, 397; J. A. Gaya Nuño,
L'opera completa di Murillo, Milan, 1978,
no. 154; D. A. Iniguez, *Murillo*, Madrid,
1981, II, no. 198.

187

"QUOS EGO" (NEPTUNE CALMING THE TEMPEST)

ca. 1635
Peter Paul Rubens (1577–1640)
Oil on panel, 49 x 64 cm
Purchase—Alpheus Hyatt Fund,
1942.174

The painting (now in Dresden) based on this oil sketch constituted part of the elaborate decorative scheme of triumphal arches and stages commissioned by Antwerp for the city's reception in 1635 of the Cardinal-Infant Ferdinand, newly appointed governor of Flanders and brother of King Philip IV of Spain. Together with two other historical–allegorical representations, it formed the vast backdrop to the Stage of Welcome on the processional route. In the oil sketch, we see Neptune—accompanied by Nereids, heralded by a Triton, and assisted by Auster and Zephyr (the south and west winds)—rising from the sea to quell the fierce north wind (Boreas) that had threatened and immobilized Ferdinand's fleet during a voyage from Barcelona to Genoa. The "*Quos Ego*" in the title comes from Virgil's *Aeneid* (I.135). In order to safeguard Aeneas' passage to the African coast, Neptune castigated the rebellious winds, storming "Quos ego . . ." ("Whom I . . ."), stopping short for high rhetorical effect, without uttering the implied "will punish." Thus the artist compared Ferdinand with the Trojan hero and alluded to the divine protection of sovereigns. In the fluid brushwork, ranging from thick impasto highlights to areas just barely touched, and in the subtle color effects of warm, golden tones set off against cooler passages of silver-grey and picked up by brilliant touches of red, we see Rubens at the height of his technical and expressive powers.

References
J. Rosenberg, "Rubens' Sketch for *The Wrath of Neptune*," *Fogg Art Museum Bulletin* 10/1 (Nov. 1942), 5–14; J. R. Martin, *The Decorations for the Pompa Introitus Ferdinand*, London, 1972, no. 3a; J. S. Held, *The Oil Sketches of Peter Paul Rubens*, Princeton, 1980, I, no. 146.

188

PORTRAIT OF A PREACHER

ca. 1625
Frans Hals (1580–1666)
Oil on canvas, 62 x 51.5 cm
Bequest—Nettie G. Naumburg,
1930.186

The sitter for this portrait has been called
a preacher because of his black skullcap.
Although depictions of men of other pro-
fessions wearing the same headgear are
known, the rather stern dignity presented
here certainly would have befitted a man
of the cloth. The painting has been dated
by Slive on the basis of its relation to
several others, including The Metro-
politan Museum's *Portrait of a Man* of
1625. Once in the collection of Stanislaus
August Poniatowski, King of Poland

(d. 1798), the work is in excellent condi-
tion, save for apparently having been
slightly cropped on all four sides.

References
C. Grimm and E. C. Montagni, *L'opera com-
pleta di Frans Hals*, Milan, 1974, no. 144;
S. Slive, *Frans Hals*, London, 1974, III, no. 41.

189

A SEACOAST SCENE

1663
Salomon van Ruysdael (1600?–70)
Oil on panel, 33 x 26.5 cm
Gift—Grenville L. Winthrop, 1935.29

References
W. Stechow, *Salomon van Ruysdael*, Berlin,
1938, 73, no. 36, fig. 49. A second panel
(1935.28), also the gift of Grenville L.
Winthrop, is a companion to this piece; see
idem, no. 35, fig. 48.

190

A RIVER SCENE

1634
Jan van Goyen (1596–1656)
Oil on canvas, 88 x 131.5 cm
Bequest—James P. Warburg, 1969.55

References
J. Rosenberg, S. Slive, and E. H. Ter Kuile,
Dutch Art and Architecture, Harmondsworth,
1966, 150, pl. 124a; H. U. Beck, *Jan van
Goyen (1596–1656)*, Amsterdam, 1973, II,
220, no. 457. See W. Stechow, *Dutch Land-
scape Painting of the Seventeenth Century*,
London, 1966, 55, pl. 99 for another van
Goyen landscape from the Warburg bequest
(1969.54).

191

HEAD OF CHRIST

ca. 1648–52
Rembrandt van Rijn (1606–69)
Oil on panel (oak), 25.3 x 19.9 cm
Gift—William A. Coolidge, 1964.172

Radically departing from traditional idealized portrayals of Christ, Rembrandt in the late 1640's and early 1650's used a specific Jewish model from contemporary Amsterdam to explore various characteristics of the humanity and suffering of the Redeemer. One of seven such studies having almost identical dimensions, the Museums' piece is the closest of all to the head of Christ in the famous *Hundred Guilder Print*. In this oil sketch we see the maturity of Rembrandt's emerging late style: the sheer ingenuity of technique to build up anatomical forms, as in the lines scratched into wet paint that connote the texture of the beard and yet reveal the jaw's bony structure, and the mellow color consonances and soft chiaroscuro that so perfectly evoke the intangible subject of Christ's inner thoughts. That the nature of Christ, both human and divine, was a particular preoccupation of the artist at this time in his life is attested by the 1656 inventory of his property, made prior to its liquidation in order to forestall bankruptcy; the list included two *Heads of Christ* in his bedroom and a third in his small studio, "done from life," as was the painting shown here.

References
S. Slive, "An Unpublished *Head of Christ* by Rembrandt," *Art Bulletin* 47 (1965), 407–17; *idem*, "Rembrandt at Harvard," *Apollo* 107/196 (1978), 458.

192

A WATERFALL

ca. 1665
Jacob van Ruisdael (ca. 1630–82)
Oil on canvas, 99.7 x 86.3 cm
Gift—Miss Helen Clay Frick, 1953.2

So seemingly true to nature is this painting that it is hard to believe that Ruisdael never traveled to Scandinavia. Instead he based his many nordic landscapes, which he began in the early 1660's, on the popular works of a fellow artist, Allart van Everdingen (1621–75), who had visited Sweden and Norway in 1644. Ruisdael had been only to the relatively rugged border region between Holland and Germany, and memories of those trips no doubt tempered his own selection of motifs (as in the half-timbered cottage included here). In any case, Ruisdael undeniably had an inspired feeling for the wilderness; the imaginary scene is romantic, but utterly non-rhetorical in its equipoise between the disposition of light and dark and of mass and void.

References
W. Stechow, *Dutch Landscape Painting of the Seventeenth Century*, London, 1966, 145; S. Slive and H. R. Hoetink, *Jacob van Ruisdael*, New York, 1981, 103.

193

VIEW OF A CITY

Gerrit Adriaenz Berckhyde (1638–98)
Oil on canvas, 61.3 x 71.1 cm
Gift—Mr. and Mrs. Samuel B. Grimson
(from the Paul M. Warburg Collection),
1968.65

Reference
C. Hofstede de Groot, *A Catalogue Raisonné
of the Works of the Most Eminent Dutch
Painters*, London, 1927, VIII, 340–41, no. 37
(attributed there to Jan van der Heyden).

194

THE HOLY FAMILY IN A
LANDSCAPE

ca. 1650–51
Nicolas Poussin (1594–1665)
Oil on canvas, 98 x 129.5 cm
Gift—Mrs. Samuel Sachs in memory of
her husband Samuel Sachs, 1942.168

In the sophisticated construction of this painting, Poussin used the Holy Family to create an allegory of purification and salvation through Christ's sacrifice. All eyes focus on the Virgin in the center, as she in turn looks toward her son; assisted by the young St. John, she prepares to bathe the Christ Child. Not only does the scene clearly allude to the later baptism, but also the Child's anxious expression connotes his awareness of events to come. Inspired by High Renaissance models to create an image of classical rigor and beauty, Poussin portrayed the action in a frieze-like manner across the picture plane. The mysterious sibyl or prophetess and the lake in the middle distance enhance the foreshadowing symbolism, while the flowers offered by the putti are another reference to the Passion. Poussin also may have intended to draw a parallel with the classical theme of the bathing of the infant Bacchus, who, because he was born twice (nos. 195, 275), was seen as prefiguring Christ and the Resurrection.

References
Sachs Collection Catalogue, 1965, no. 91; D. Wild, *Nicolas Poussin*, Zurich, 1980, II, no. 167; P. Rosenberg, *France in the Golden Age: 17th-Century French Paintings in American Collections*, The Metropolitan Museum of Art, New York, 1982, no. 93.

195

THE INFANT BACCHUS
ENTRUSTED TO THE NYMPHS

1657
Nicolas Poussin (1594–1665)
Oil on canvas, 123 x 179 cm
Gift—Mrs. Samuel Sachs in memory of
her husband Samuel Sachs, 1942.167

This painting, commissioned by his friend
Jacques Stella, an artist and dealer in
Rome (no. 196), reflects both Poussin's
own seriousness of purpose and his intel-
lectual ambience. Basically, two distinct
myths have been juxtaposed: on the left
Mercury presents the new-born Bac-
chus—who had been carried to term in
his father Zeus's thigh after the untimely
death of his mother—to the nymphs who
will care for him, while on the right the
drowned Narcissus lies dead from pining
after his own image mirrored in the water
and Echo turns to stone from yearning
after him. Poussin drew on the writings
of his contemporaries as well as on Ovid
and Philostratus to build this rich and
esoteric parable in which every element,
from the dawn's rays to the grapevines

and burgeoning ivy in the grotto, con-
tributes to the contrast between life and
death, fecundity and barrenness. Even
without an intimate familiarity with the
sources, the viewer can appreciate the
clearly expressed dichotomy between the
radiance and warm tones (as in Mercury's
red cloak) characterizing the joyous occa-
sion, and the cooler, darker hues (as in
the greying flesh and Narcissus' blue
tunic) marking the sad one.

References
Sachs Collection Catalogue, 1965, no. 92;
A. Blunt, *The Paintings of Nicolas Poussin: A
Critical Catalogue*, London, 1966, no. 132,
and idem, *Nicolas Poussin*, New York, 1967,
316–19; D. Wild, *Nicolas Poussin*, Zurich,
1980, II, no. 193.

196

THE LIBERALITY OF LOUIS XIII AND CARDINAL RICHELIEU

ca. 1637–38
Jacques Stella (1596–1657)
Oil on canvas, 177 x 147 cm
Gift in part—Lewis G. Nierman and
Charles Nierman, and Purchase in part—
Alpheus Hyatt Fund, 1972.362

References

A. Blunt, "La libéralité de Louis XIII et de
Richelieu," *Revue de l'art* no. 11 (1971), 74;
Freedberg, 1978, 397; P. Rosenberg, *France in
the Golden Age: 17th-Century French Paint-
ings in American Collections*, The Metropoli-
tan Museum of Art, New York, 1982, no. 100.

PORTRAIT OF EMMANUEL JOSEPH SIEYÈS

1817
Jacques Louis David (1748–1825)
Oil on canvas, 95.2 x 72.5 cm
Bequest—Grenville L. Winthrop,
1943.229

David painted this portrait of his friend Sieyès when they were in exile in Brussels; they were the same age, sixty-nine, and had lived through the upheavals of the Revolution, the rise and fall of Napoleon, and the restoration of the Bourbons—the last event sending them both out of France. Sieyès had a checkered but successful career. While still chancellor and vicar-general of the diocese of Chartres, he wrote the famous revolutionary pamphlet *What is the Third Estate?* and became a leader in the Constituent Assembly. Weathering the Reign of Terror, he helped bring Napoleon to power, but parted ways with the First Consul after trying in vain to procure a liberal constitution. He managed to remain enough in favor, however, to receive considerable property and honors, and even though he voted for the emperor's deposition in 1814, he became a Peer of France during the Hundred Days. David unaffectedly communicated the worldliness and acumen of his illustrious compatriot, whose response to the question of what he had done during the Revolution was "J'ai vécu" ("I survived").

References
Winthrop Retrospective, 1969, no. 83;
A. Mongan (ed.), *Harvard Honors Lafayette*,
Fogg Art Museum, Cambridge, Mass., 1975,
no. 40; A. Schnapper, *David*, New York, 1982,
283–86.

EMM. JOS. SIEYES. ÆTATIS SUÆ. 69.

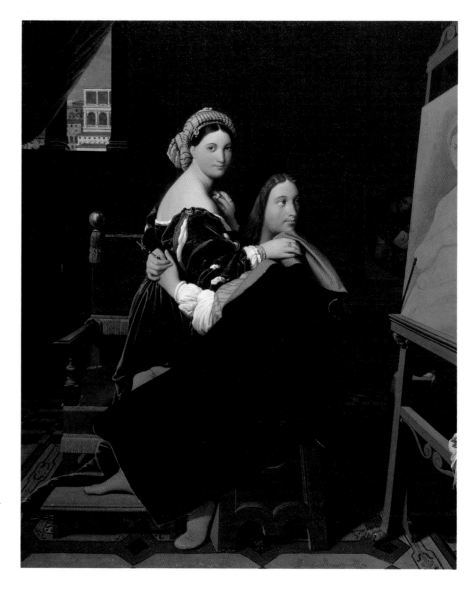

198

RAPHAEL AND THE FORNARINA

1814
Jean-Auguste-Dominique Ingres
(1780–1867)
Oil on canvas, 68 x 55 cm
Bequest—Grenville L. Winthrop,
1943.252

Through the inventiveness and under-
stated sensuousness of this painting,
Ingres extolled a concept of inspiration
for artistic genius. He depicted the Re-
naissance master, his own ideal of an
artist, embracing the beautiful but poor
Fornarina, who purportedly modeled for

the *Madonna della Sedia* (Galleria Pitti);
the finished canvas is visible in the back-
ground of Ingres' painting. Partially
obscuring that religious piece is Raphael's
work-in-progress, the semi-nude *For-
narina* (Galleria Borghese), on which he
concentrates, brush still in hand as he
clasps his lover around the waist. Shown
at the 1814 Salon, the first time Ingres
submitted paintings after his negative re-
ception in the 1806 Salon, *Raphael and
the Fornarina* was enthusiastically re-
ceived by such anti-*genre* critics as Miel
and Delpech. The latter found that "[its]
faults are amply redeemed by the inex-
pressible grace of the ensemble . . . which
I have not encountered in any of the
other [*genre*] paintings."

References
Cohn and Siegfried, 1980, no. 15; Picon,
1980, pl. 49.

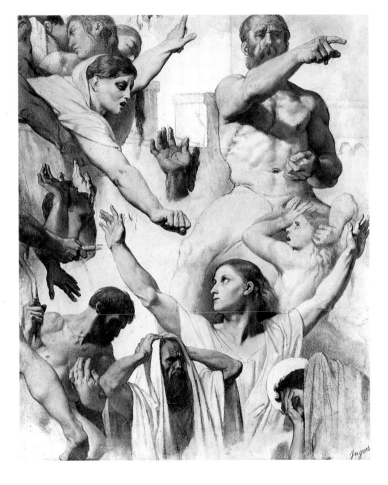

STUDIES FOR "THE MARTYRDOM OF ST. SYMPHORIEN" (SAINT, MOTHER, PROCONSUL)

1833
Jean-Auguste-Dominique Ingres
(1780–1867)
Oil over graphite and red chalk (stylus transfer), squared in graphite, on canvas, backed by a wood panel, 61.3 x 49.3 cm
Bequest—Grenville L. Winthrop, 1943.245

Ingres made at least thirteen preliminary drawings for this highly organized and finished oil sketch for *The Martyrdom of St. Symphorien*, a painting in Autun Cathedral. Using transfer grids and tracing lines, he set up a forceful configuration from his individual studies that highlights the martyr-to-be and his mother, who in the final work reaches out across the city ramparts and the crowd below to exhort her son not to relinquish his faith. The Museums hold a second oil sketch (1943.246) that contrasts the virtuous Christians shown here with the brutish pagans who prepare to slay Symphorien.

References
Cohn and Siegfried, 1980, no. 36; Picon, 1980, pl. 64.

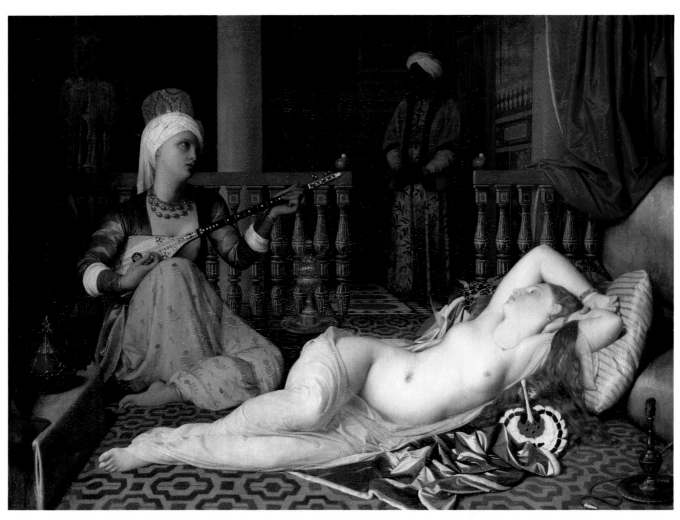

200

ODALISQUE WITH A SLAVE

1840
Jean-Auguste-Dominique Ingres
(1780–1867)
Oil on canvas mounted on panel,
72 x 100 cm
Bequest—Grenville L. Winthrop,
1943.251

The Odalisque stands as Ingres' conscious response to the success of Delacroix's *Algerian Women* and the disappointing reaction to his own *St. Symphorien* (no. 199) at the 1834 Salon. Disillusioned once again by a lack of public approbation in Paris, he returned to Rome in 1835 as Director of the French Academy. Determined to accept only private commissions, he painted this piece for his closest friend, Charles Marcotte d'Argenteuil. More thoroughly and explicitly erotic than the 1814 *Raphael and the Fornarina* (no. 198), it takes up a theme popular at the time for its exoticism. Unlike Delacroix, Ingres had no direct experience of the Moslem world (no. 205), and had to rely on a variety of second-hand sources for details like the tambour plucked by the female musician. The languid sultanne, however, whose pose reiterates that of Ingres' lost *Sleeper of Naples* of 1808, descends from a long line of sleeping Venuses from Giorgione to Le Sueur.

References
Winthrop Retrospective, 1969, no. 85; J. S. Boggs, "Variations on the Nude," *Apollo* 107/196 (1978), 487–88; Cohn and Siegfried, 1980, no. 41; Picon, 1980, pl. 68.

PORTRAIT OF MME. FRÉDÉRIC REISET

1846
Jean-Auguste-Dominique Ingres
(1780–1867)
Oil on canvas, 59.2 x 47 cm
Bequest—Grenville L. Winthrop,
1943.249

The instant appeal of this portrait must partly echo the warm friendship that existed between the artist and the sitter and her family. In the 1840's, Ingres and his wife often joined the Reisets at their summer château on the Lake of Enghien, where Ingres found time to sketch Hortense as well as her husband Marie-Frédéric (who became Director of the National Museums of France), her father, and her small daughter. Madame Reiset's frank beauty, with blond ringlets, large blue eyes, and sweetness of expression, is presented in this oil painting with seemingly spontaneous freshness and ease.

References
Winthrop Retrospective, 1969, no. 84; Cohn and Siegfried, 1980, no. 47.

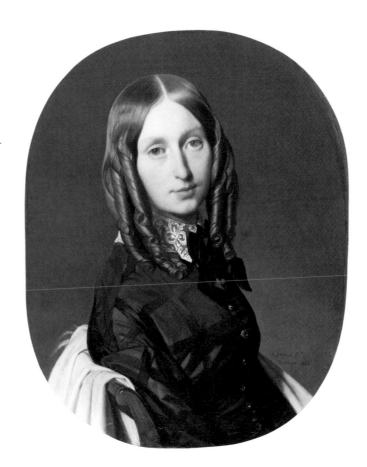

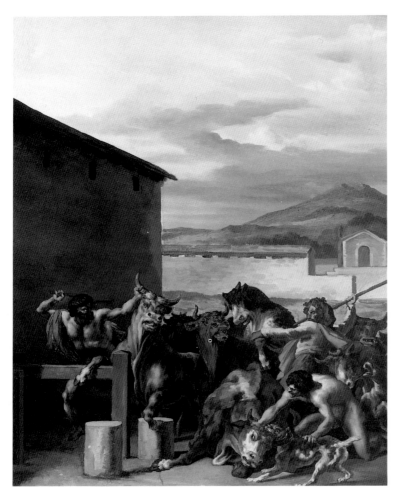

203

PORTRAIT OF A YOUNG MAN

Attributed to Théodore Géricault
(1791–1824)
Oil on canvas, 59 x 47.6 cm
Bequest—Grenville L. Winthrop,
1943.243

Reference
Winthrop Retrospective, 1969, no. 86.

202

THE BULL MARKET

1817
Théodore Géricault (1791–1824)
Oil on paper, pasted on canvas,
56.5 x 48.2 cm
Bequest—Grenville L. Winthrop,
1943.242

References
C. Clément, *Géricault*, Paris, 1973 (reprint of
orig. ed. of 1879), 299–300; Eitner, 1983,
139–42.

204

THE WHITE HORSE TAVERN

1821–22
Théodore Géricault (1791–1824)
Oil on canvas, 53.3 x 45 cm
Bequest—Grenville L. Winthrop,
1943.244

This painting is a masterful and characteristic example of Géricault's change in style from the time of his stay in England. There for the first time with a traveling exhibition of *The Raft of the Medusa* (no. 281), he found new inspiration in the work of such contemporary English artists as Constable and Landseer. *The White Horse Tavern*, in contrast to the violent, heroic action of *The Bull Market* (no. 202), recounts a common everyday event: a dispatch rider, stopping at a country inn, is offered a glass of wine by the proprietor. The mood is calm, and Géricault has concentrated on three fundamental elements: the stormy sky— with a glimpse of Paris on the horizon— that is suddenly relieved by a burst of late afternoon sunshine; the stocky, powerful bodies of the post horses with their gleaming coats; and a moment of silent communication between two men who make their livings on and by the road. By excluding superfluous detail, Géricault achieved, in spite of the canvas's small dimensions, a grand tribute to man and horse—the artist's own favorite beast—in harmony with nature.

References
Winthrop Retrospective, 1969, no. 87; Eitner, 1983, 252–53.

COMBAT OF THE GIAOUR AND THE PASHA HASSAN

1856
Eugène Delacroix (1798–1863)
Oil on canvas, 81.2 x 64.7 cm
Bequest—Grenville L. Winthrop,
1943.233

Delacroix, always fascinated by the color and exoticism of the Middle East, had read Byron's poem *The Giaour* (published in 1813). Set in late 17th-century Greece, this was a tale of rivalry over a slave-girl between a young Venetian (Giaour being a derogatory Turkish name for a non-Moslem) and a Turkish pasha named Hassan. Although Delacroix did not specifically illustrate Byron, he painted the episode of the avenger's ambush and slaying of Hassan first in 1826 and then in 1835 (canvases now respectively in the Art Institute of Chicago and the Petit Palais in Paris). During the same period, he also found stimuli in the Greek War of Independence (1821–28) and actually traveled to Morocco in 1832. Years later, when he painted the Museums' piece, he most likely would have drawn on all these sources and experiences. He even borrowed, for the position and dress of the surrendering figure, from one of his own youthful costume studies (ca. 1823, now in the Cleveland Museum of Art). And the flamboyant attire, dominated by the primary blue and red hues, allowed him full play as a colorist.

References
C. Bernard, "Some Aspects of Delacroix's Orientalism," *Cleveland Museum of Art Bulletin*, April 1971, 123–27; L. Johnson, *The Paintings of Eugène Delacroix, A Critical Catalogue 1816–31*, Oxford, 1981, 105.

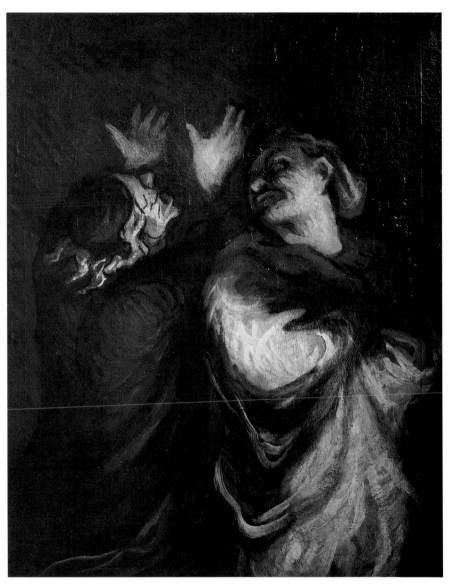

SCAPIN AND GÉRONTE

1858/62
Honoré Daumier (1808?–79)
Oil on panel, 33.6 x 25.7 cm
Bequest—Grenville L. Winthrop,
1943.225

Scapin and Géronte illustrates a scene
from *Les Fourberies de Scapin* by Mo-
lière, a playwright whom Daumier
particularly admired. Like Seurat later on
(no. 290), Daumier was attracted to the
stage and to the potential of theatrical
lighting. In his technique and his expres-
sive aims, however, he differed radically
from the Neo-Impressionist. Gradually
developing a broad painterly style, the
draftsman sought to capture in oil looks
and gestures that would characterize the
essence of both personality and action
(also no. 323). The Museums' panel de-
picts just such a moment, when Géronte
bemoans the news that his son has been
kidnapped, a story fabricated by the ras-
cal Scapin. Typically, Daumier did not
bring the painting to completion; except
for some rather clumsy touches by an un-
known painter to the head and hands of
Géronte, the work is as the master left it.

References
See C. Blanton, "An Unpublished Daumier
Panel in the Fogg Art Museum," *Burlington
Magazine* 108/763 (Oct. 1966), 511–18, in
which the author dates the panel to the late
1860's. See also K. E. Maison, *Honoré
Daumier, Catalogue Raisonné*, New York,
1968, I, no. 128.

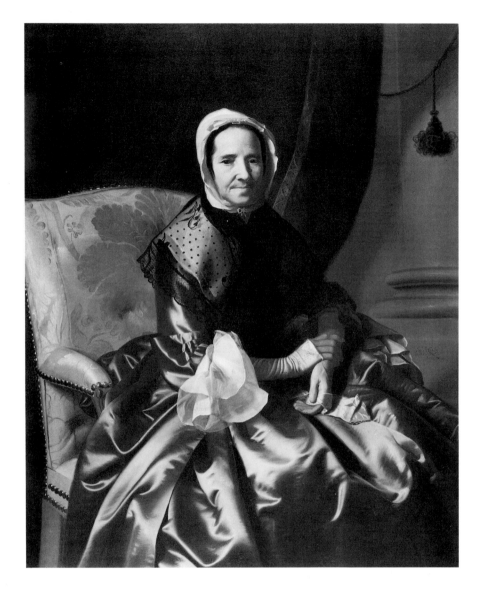

207

MRS. THOMAS BOYLSTON

1766
John Singleton Copley (1738–1815)
Signed and dated, right center: Jnº. S:
Copley/pinx 1766
Oil on canvas, 129 x 102 cm
Lent by Harvard University: Bequest—
Ward Nicholas Boylston to Harvard
College, 1828, H 16

The wife of a Boston merchant, Mrs. Thomas Boylston sat for Copley at the height of his renown as a portraitist in that city. The signs of material comfort—silk damask chair, heavy satin dress—are evident and have been scrupulously delineated, but they do not play the prominent role of the finery in portraits of Copley's English period. They merely establish, as a matter of record, the sitter's place in society, leaving the emphasis on the objectively and acutely observed character and features of the individual personality. Copley's portraits of two of her sons, as well as of her great-grandson, John Adams, also were bequeathed to Harvard by Ward Nicholas Boylston.

References
J. D. Prown, *John Singleton Copley*, Cambridge, Mass., 1966, I, 210, no. 178; *American Art at Harvard*, 1972, no. 7; Wilmerding, 1978, 493.

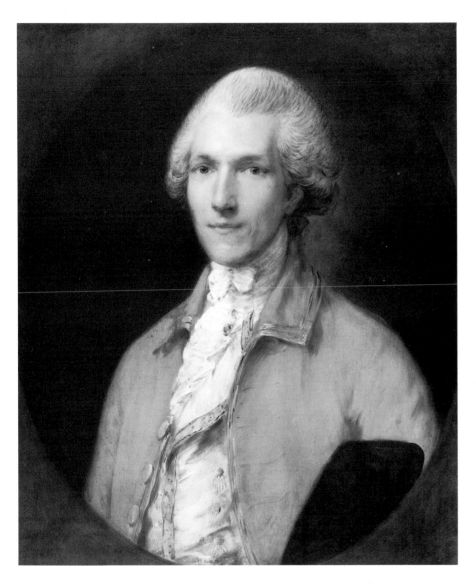

208

PORTRAIT OF SIR BENJAMIN THOMPSON, COUNT RUMFORD [1753–1814]

1783
Thomas Gainsborough (1727–88)
Oil on canvas, 75.2 x 62.5 cm
Bequest—Edmund C. Converse, 1922.1

References
L. Huntsinger, *Harvard Portraits: A Catalogue of Portrait Paintings at Harvard University*, Cambridge, Mass., 1936, no. H 284; E. Waterhouse, *Gainsborough*, London, 1958, no. 663.

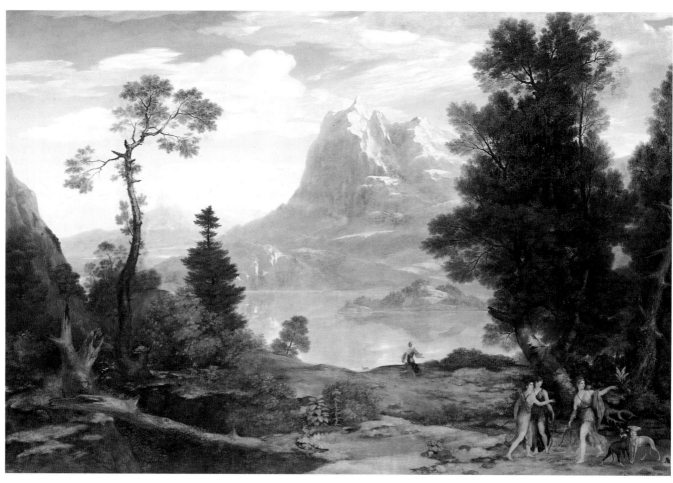

209

DIANA IN THE CHASE

1805
Washington Allston (1779–1843)
Oil on canvas, 166.7 x 248 cm
Gift—Mrs. Edward W. Moore, 1956.62

Samuel Taylor Coleridge and Washington
Irving were both with Allston in Rome
when he painted this picture in 1805.
The young artist already had worked
under Benjamin West at the Royal Acad-
emy in London, and then had traveled on
the continent and through the Swiss
Alps. Various studies, including a draw-
ing of Mt. Pilatus near Lake Lucerne,
preceded this romantic landscape, one of
Allston's first on such a monumental scale.
Demonstrating his grasp of Venetian
painting techniques and, in the dramatic
distinction between dazzling middle
ground and umbral foreground, the orga-
nizational methods of Claude Lorrain,
Diana was glowingly reviewed by Italian
critics as well as by Coleridge. Benjamin
Rowland, Jr., found it quite natural that
"the author of *Kubla Khan* should have
been spellbound by this painting . . .
[with its] air of magic solitude, together
with a wonderful feeling of luminosity
and aerial harmony."

References
The quotation is from B. Rowland, *Fogg Art
Museum Annual Report*, 1955–56, 61; see
also *American Art at Harvard*, 1972, no. 30;
Wilmerding, 1978, 493; W. H. Gerdts and
T. E. Stebbins, "*A Man of Genius*": *The Art of
Washington Allston* (1779–1843), Museum of
Fine Arts, Boston, 1979, 43–46, no. 11; B. J.
Wolf, *Romantic Re-Vision: Culture and Con-
sciousness in 19th-Century American Painting*,
Chicago, 1982, 62–64.

210

211

NOCTURNE IN GREY AND GOLD: CHELSEA SNOW

1876
James Abbott McNeill Whistler
(1834–1903)
Oil on canvas, 47.2 x 62.5 cm
Bequest—Grenville L. Winthrop,
1943.172

Whistler painted this *Nocturne* in the same year as he brought his notorious suit against the critic Ruskin, and he used the picture to explain his formalist theory of art, published as "The Red Rag" on May 22nd in *The World*: "My picture of a *Harmony in Grey and Gold* is an illustration of my meaning—a snow scene with a single black figure and a lighted tavern. I care nothing for the past, present, or future of the black figure, placed there because the black was wanted at that spot. All that I know is

that my combination of grey and gold is the basis of my picture." Clearly the detail-obscuring combination of night, snow, and mist had afforded the perfect opportunity to explore his purely artistic concerns, not only of color harmonies but also of light and dark, whereby lamps and lighted windows became iridescent abstracting shapes disposed at modulated points across the surface of the canvas.

References
D. Holden, *Whistler Landscapes and Seascapes*, New York, 1969, 46; *American Art at Harvard*, 1972, no. 93; A. M. Young, M. MacDonald, and R. Spencer, *The Paintings of James McNeill Whistler*, New Haven, 1980, I, no. 174.

THE BREAKFAST TABLE

1884
John Singer Sargent (1856–1925)
Oil on canvas, 55.2 x 46.3 cm
Bequest—Grenville L. Winthrop,
1943.150

Two surviving photographs show this canvas, which Sargent had painted while his family was staying in Nice, standing on an easel in his Paris studio. Depicting his younger sister Violet reading at breakfast, it has an appealingly intimate scale and an informality appropriate to the subject. A sense of spontaneity of execution prevails in the design as well as in the glittering array of still-life objects—glass, silver, and fine china.

References
R. Ormond, *John Singer Sargent, Paintings, Drawings, Watercolours*, London, 1970, 32, pl. 32; *American Art at Harvard*, 1972, no. 116.

212

PORTRAIT OF MISS ALICE KURTZ

1903
Thomas Eakins (1844–1916)
Oil on canvas, 60 x 48.9 cm
Gift in part—Mrs. John Whiteman (Alice Kurtz, the sitter), and Purchase in part—Funds contributed by Friends of John Coolidge. Presented to John Coolidge, Director of the Fogg Art Museum, 1948–68, 1969.1

Through the generosity of Mrs. John Whiteman (née Alice Kurtz) and of his many friends, John Coolidge was able to acquire this painting for the Fogg upon his retirement as director in 1968. Alice Kurtz was about twenty when her father, a longtime friend of Eakins, commissioned her portrait; evidently disappointed with the final results, he placed it in the attic. The harsh lighting and the uncompromising juxtaposition of suntanned face with pale neck and arms must have greatly displeased Alice's father, but to the disinterested viewer, this penetrating and objective interpretation of a strong and sensitive psyche well represents an artistic perceptiveness akin to that of the painters Eakins most admired—Velázquez, Ribera, and Rembrandt.

References
American Art at Harvard, 1972, no. 113; Wilmerding, 1978, 494; L. Goodrich, *Thomas Eakins*, Cambridge, Mass., 1982, II, 91.

THE BLESSED DAMOZEL

1871–77
Dante Gabriel Rossetti (1828–82)
Oil on canvas, 174 x 94 cm
Bequest—Grenville L. Winthrop,
1943.202

In 1847 Rossetti wrote the poem *The Blessed Damozel*, which was published three years later in the Pre-Raphaelite journal *The Germ*. It was only in 1871, however, at the request of the Liberal M. P. William Graham, that the artist finally undertook to illustrate it. The painting, based on many studies, is housed in a gold frame that Rossetti designed; he put the title on the band above the predella and four verses from the poem on the base. The predella, which he added at the prompting of Mr. Graham after completing the main panel in 1877, shows an earthbound young man in a sylvan setting gazing up at the twilight sky. Above him, three angels stand beneath the rose-strewn "gold bar of Heaven," on which the damozel leans, holding three white lilies and looking down toward her lover. Behind her, numerous couples embrace, "newly met 'mid deathless love's acclaims." From the family of William Morris, Grenville L. Winthrop acquired and then bequeathed to the Museums the first sketch for this background.

References
Paintings and Drawings of the Pre-Raphaelites, Fogg Art Museum, Cambridge, Mass., 1946, no. 83 (background sketch, no. 82); F. Spalding, *Magnificent Dreams: Burne-Jones and the Late Victorians*, Oxford, 1978, 50.

SPRING BOUQUET

1866
Pierre-Auguste Renoir (1841–1919)
Oil on canvas, 101 x 79 cm
Bequest—Grenville L. Winthrop,
1943.277

Spring Bouquet, the last painting acquired by Grenville L. Winthrop, is a ravishing early example of one of Renoir's lifelong themes. "I just let my brain rest when I paint flowers. . . . When I am painting flowers, I establish the tones, I study the values carefully, without worrying about losing the picture . . ." (as he did worry with his paintings of figures; no. 215). Here we see the young artist beginning to break from the influence of Courbet, whose use of the palette knife he occasionally had emulated. Relying instead on a brush and doubtless drawing on his earlier training in porcelain painting, Renoir clearly took pleasure in bringing to life the irradiated opulence of the bouquet's arrangement, the fragile textures and delicate colors of the decorated vase, and each unique blossom and its leafage.

References
The quotation is from W. Gaunt, *Renoir*, Oxford, 1982, no. 1. See also *Winthrop Retrospective*, 1969, no. 91.

215

SEATED BATHER

ca. 1883–84
Pierre-Auguste Renoir (1841–1919)
Oil on canvas, 119.7 x 93.5 cm
Bequest—Collection of Maurice
Wertheim, 1951.59

References
Collection Maurice Wertheim, 1949, 27–29;
F. Daulte, *Auguste Renoir. Catalogue Raisonné*, Lausanne, 1971, I (*Figures, 1860–1890*), no. 490; J. S. Boggs, "Variations on the Nude," *Apollo* 107/196 (1978), 488;
O'Brian, forthcoming, no. 9.

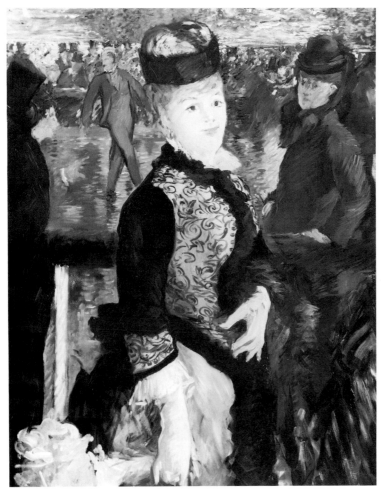

216

SKATING

1877
Edouard Manet (1832–83)
Oil on canvas, 92 x 71.6 cm
Bequest—Collection of Maurice
Wertheim, 1951.50

The interplay between the poised, styl-
ishly attired foreground figures and their
animated, colorful milieu shows Manet's
particular genius in the handling of both
paint and pictorial design. The contrast-
ing areas of detail and suggestion, dark
and light, horizontal and vertical, man-
age to capture the Parisian flair for
elegance and spontaneity that seems to

have been intrinsic to the artist's own
temperament. Although traditionally in-
terpreted as an ice skating scene, it more
probably depicts roller skating, an equally
popular pastime after the first rink had
been opened in the Cirque des Champs-
Elysées in 1875; E. Bazire, describing the
painting in 1884, referred to the shiny
skating surface as a parquet floor. If
Manet left the incidentals of sporting
equipment unclear, it was in order to
concentrate on the gyrating motion of the
skaters and the sparkling social atmo-
sphere of a fashionable, well-to-do crowd
at leisure (no. 287). He did single out one
figure, whose beautiful face is centralized
against the gay hubbub. The model,
Henriette Hauser, was an actress and the
mistress of the Prince of Orange; she had
sat for Manet's *Nana* earlier in the same
year.

References
Collection Maurice Wertheim, 1949, 17–19;
A. C. Hanson, *Manet and the Modern Tradi-
tion*, New Haven, 1977, 132, 175, 204, pl. 92;
D. Rouart and D. Wildenstein, *Edouard
Manet. Catalogue Raisonné*, Lausanne, 1975,
210, no. 260. The reference to the skating sur-
face as a parquet floor is from D. A. Gribbon,
*Edouard Manet: The Development of His Art
Between 1868 and 1876* (doctoral disserta-
tion, Harvard University), 1982, 191–94.
J. O'Brian, who kindly allowed me to read in
manuscript the entry (no. 11) for his forth-
coming catalogue of the Wertheim Collection,
made this same discovery independently.

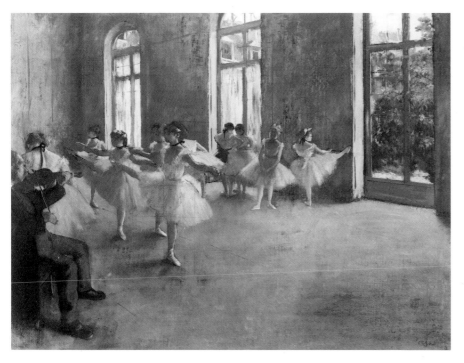

217

THE REHEARSAL

1873–74
Edgar Degas (1834–1917)
Oil on canvas, 47 x 61.7 cm
Bequest—Collection of Maurice
Wertheim, 1951.47

One is perhaps struck first by the novel viewpoint of this painting. The artist reveals, through a vast, half-empty room seen from a dramatically oblique angle, the stark environment of the ballet students rehearsing in a room of the old Paris Opera house (destroyed by fire in the autumn of 1873). The muted greys and light browns of the architecture predominate, but as one focuses in on the dancers themselves, the dainty accents of their costumes (pink ballet slippers; turquoise, red, and pink sashes and ribbons), in addition to the varying shades of their hair, take on a certain poignancy as one notes the students' oblivion to the

verdant world outside the windows. This is an early example of Degas' myriad "meditations on the dance" (the artist's own term), and no fewer than seven drawings are linked with single figures of the finished work. As usual, he relied entirely on his sketches, painting this canvas, on which transfer lines are visible, in his studio. One related painting is in the Shelburne Museum, Vermont, and another, depicting the three foremost dancers and the violinist, is in the Frick Collection, New York.

References
Collection Maurice Wertheim, 1949, 6–8. Once again I am grateful to J. O'Brian for the opportunity to read the entry (no. 2) for his forthcoming catalogue of the Wertheim Collection.

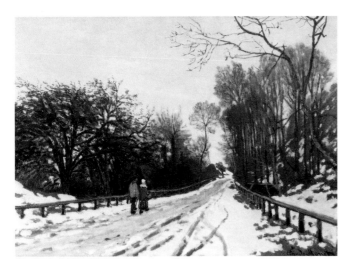

218

ROAD TOWARD THE FARM, ST. SIMEON, HONFLEUR

ca. 1867
Claude Monet (1840–1926)
Oil on canvas, 54.6 x 79.4 cm
Bequest—Grenville L. Winthrop,
1943.260

Reference
Wildenstein, 1974, 156, no. 80.

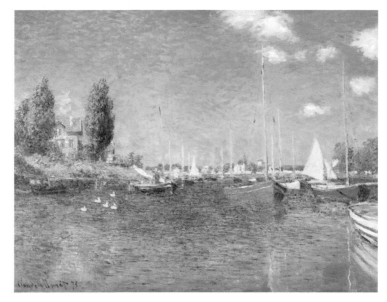

219

RED BOATS, ARGENTEUIL

1875
Claude Monet (1840–1926)
Oil on canvas, 61.9 x 82.4 cm
Bequest—Collection of Maurice
Wertheim, 1951.54

Monet lived for a number of years at Argenteuil (just outside of Paris), often painting riverscapes from a boat he had fitted up as a studio, and it was there that he made the definitive transition to a full-blown impressionistic style. Finding the setting perfectly suited to his aims, he developed both the bright palette that eliminated gloomy shadows and the abbreviated brushstrokes of apposed complementary colors that desharpened the contours of individual motifs and recorded instead the optical effects of brilliant sunshine reflected back by rippling water. This painting, one of the most significant that he did at Argenteuil, dazzles the eye with its broad, shimmering reach of river and sky, and its flotilla of sailboats bobbing nonchalantly in the light-saturated atmosphere.

References
Collection Maurice Wertheim, 1949, 9–10;
Wildenstein, 1974, 272, no. 369; P. Tucker,
Monet at Argenteuil, New Haven, 1982,
118–20, pl. XX; O'Brian, forthcoming, no. 4.

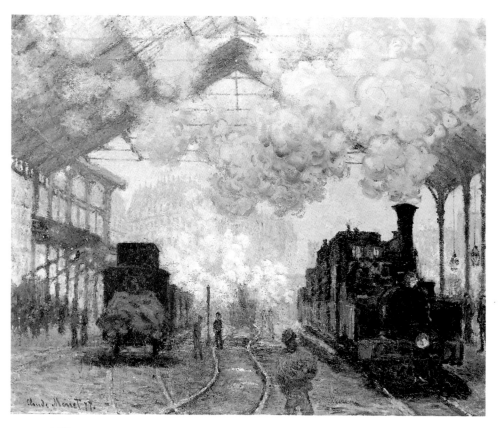

220

THE GARE ST-LAZARE, PARIS: ARRIVAL OF A TRAIN

1877
Claude Monet (1840–1926)
Oil on canvas, 83.1 x 101.5 cm
Bequest—Collection of Maurice
Wertheim, 1951.53

In high contrast to Sheeler's static and ideological depictions of machinery some fifty years later (no. 232), Monet approached his series of the Gare St-Lazare with complete objectivity, seeking to describe the ever-changing lighting and atmospheric conditions produced by steam engines moving in and out of a glass-covered station. He began the series of twelve soon after returning to Paris from Argenteuil in 1876 and exhibited eight paintings at the third Impressionist show of the following year. As has been shown by S. Levine, the Museums' painting is the largest and forms a pair with another work in the Louvre (slightly smaller but with a matching frame), the two surpassing the rest of the series in scale and epitomizing the significance of the entire sequence. The brighter colors

of the Louvre painting diverge from the muted blue-greys of its companion. Moreover, differences in vantage points and positions of the locomotives indicate both the artist's movements around the station and the movements of the trains themselves. Thus Monet explored his subject over time and from varying angles, to capture—more than the substance of the machines and their enclosing structure—the ephemeral, dusty clouds of vapor and gritty smoke that the light infiltrated and transformed.

References
Collection Maurice Wertheim, 1949, 14–16;
W. Seitz, *Claude Monet*, New York, 1960,
106; Wildenstein, 1974, 304, no. 439; S.
Levine, "Monet's 'Gare Saint-Lazare,'" *Fogg
Art Museum Newsletter* 12/4 (June 1975), 7;
P. Tucker, *Monet at Argenteuil*, New Haven,
1982, 169; O'Brian, forthcoming, no. 5.

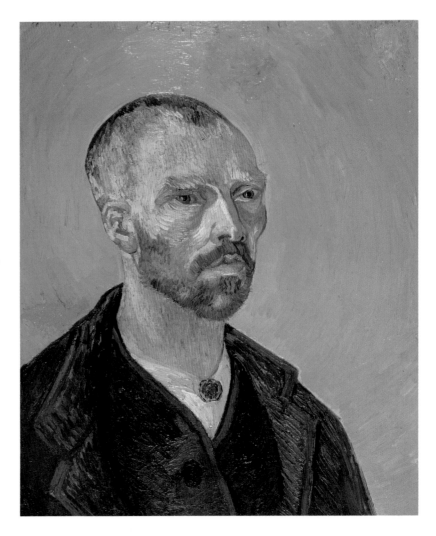

221

SELF-PORTRAIT DEDICATED TO PAUL GAUGUIN

1888
Vincent Van Gogh (1853–90)
Oil on canvas, 60.5 x 49.4 cm
Bequest—Collection of Maurice
Wertheim, 1951.65

The *Self-Portrait*, which Van Gogh dedicated and sent to his friend Gauguin (no. 223), is best described and interpreted in the artist's own words written to his brother Theo. "It is all ashen gray against pale malachite (no yellow). The clothes are this brown coat with a blue border, but I have exaggerated the brown into purple. . . . The head is modeled in light color painted in a thick impasto against the light background with hardly any shadows. Only I have made the eyes *slightly* slanting like the Japanese." He explained that he was "trying to convey in my portrait not only myself but an impressionist in general, had conceived it as the portrait of a bonze, a simple worshipper of the eternal Buddha." The feverish vigor of his portrait not only reflects a personality driven by the will to create and by the desire to probe the unknown, but also evokes Van Gogh's energetic productivity during the autumn of 1888, when he often worked on several canvases at the same time. This transfixing image certainly ranks with the very best in his oeuvre.

References
The quotations are from *The Complete Letters of Van Gogh*, London, 1958, III, no. 545. See also *Collection Maurice Wertheim*, 1949, 38–41; J. Hulsker, *The Complete Van Gogh*, New York, 1980, 360–67; V. Jirat-Wasintyński, H. Travers Newton, E. Farrell, and R. Newman, *Vincent Van Gogh's 'Self-Portrait Dedicated to Paul Gauguin': An Historical and Technical Study*, Center for Conservation and Technical Studies, Harvard University Art Museums, Cambridge, Mass., 1984; O'Brian, forthcoming, no. 19.

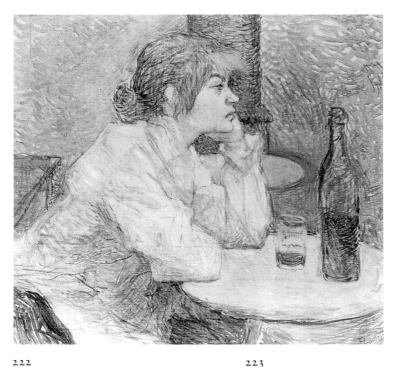

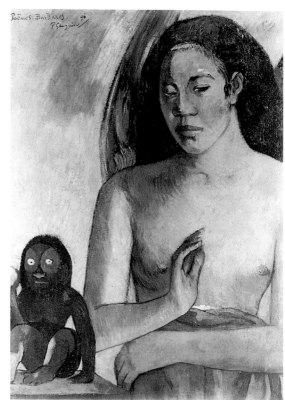

222

THE HANGOVER OR THE DRINKER

ca. 1887–89
Henri de Toulouse-Lautrec (1864–1901)
Oil and black crayon (or chalk) on
canvas, 47.1 x 55.5 cm
Bequest—Collection of Maurice
Wertheim, 1951.63

References
Collection Maurice Wertheim, 1949, 42–44;
G. Caproni and G. M. Sugana, *L'opera com-
pleta di Toulouse-Lautrec*, Milan, 1969,
no. 227; M. G. Dortu, *Toulouse-Lautrec et
son oeuvre*, New York, 1971, II, 166, pl. 340;
O'Brian, forthcoming, no. 16.

223

POÈMES BARBARES (BARBARIC POEMS)

1896
Paul Gauguin (1848–1903)
Oil on canvas, 64.6 x 48 cm
Bequest—Collection of Maurice
Wertheim, 1951.49

Dating from the time of Gauguin's second
and permanent stay in the South Seas,
Barbaric Poems creates powerful sym-
bolic imagery out of ancient Tahitian
myths. Specifically, Gauguin drew upon
the Chant of Creation, which had been
preserved orally, was written down by
A. J. Moerenhout in 1837, and was later
copied by the artist himself. Even the title
apparently relates to the Chant, by way of
Leconte de Lisle's *Poèmes barbares* (1872
and 1878), inspired by Moerenhout's
transcription. The most recent interpreta-
tion of the painting argues that the small
ape-like idol, holding a golden sphere
and emanating a golden aura, represents
Ta'aroa, the chief god in the Maori
pantheon and creator of the universe.
Expanding on the theme of the principle
of creation and universalizing the Tahi-
tian legend is the female figure; she has
the typical features of an islander, but

also makes a Buddhist "mudra" sign and
has the wings of a Christian angel. She
also may relate to the Chant's heralds of
Ta'aroa's cosmic generation. Gauguin's
close-keyed, somber but warm color
scheme seems particularly suited to this
spiritual allegory, just as the painting as a
whole seems to epitomize a vision he had
described in 1889: "A delight enhanced
by I know not what sacred horror I di-
vine in the infinite. An aroma of long-
vanished joy, that I breathe in the present.
Animal figures rigid as statues, with
something indescribably solemn and reli-
gious in the rhythm of their pose, in their
strange immobility. In eyes that dream,
the troubled surface of an unfathomable
enigma."

References
The quotation is from *Collection Maurice
Wertheim*, 1949, 45. See also G. Wildenstein,
Gauguin, Paris, 1964, I, no. 547, and O'Brian,
forthcoming, no. 20. For the interpretation of
the small idol as described above see M. L.
Zink, "Gauguin's *Poèmes barbares* and the Ta-
hitian Chant of Creation," *Art Journal* 38/1
(Fall 1978), 18–21.

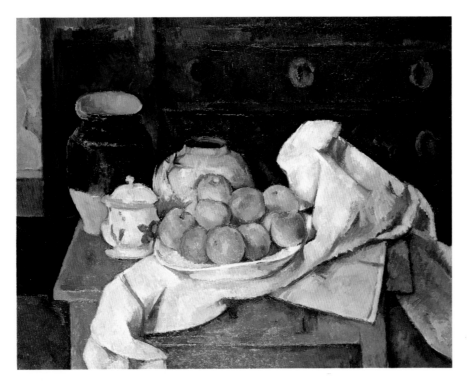

224

STILL LIFE WITH COMMODE

ca. 1885
Paul Cézanne (1839–1906)
Oil on canvas, 65.1 x 80.8 cm
Bequest—Collection of Maurice
Wertheim, 1951.46

This powerful painting is highly unusual because of its close resemblance to another work (Neue Staatsgalerie, Munich), which suggests Cézanne's particular fascination with this specific grouping. In all his many diverse still lifes, Cézanne painstakingly arranged and rearranged the same sorts of common, everyday objects, aiming to realize their full potential for the expression of structural substantiality and color harmonies. Here he calculated and synchronized his composition so as to present a bold yet subtle design. Anchoring the whole with the almost frontally disposed dark chestnut bureau, Cézanne invested the motifs on the lighter-hued table with a wealth of chromatic, textural, planar, and volumetric interrelationships. Each piece—the three jars, the plate of apples, and the tablecloth, the last suitably flattened and distorted when necessary to bring out its total plasticity—relates to the others as well as to the larger masses of the furniture. In the overall balance of light and dark tones and of curved and rectilinear shapes, the stiff, starched cloth becomes as solid as the wood and the ceramics, its complex folds taking on a special role in both steadying and enlivening the canvas.

References
Collection Maurice Wertheim, 1949, 30–32;
M. Schapiro, *Cézanne*, New York, 1952, 60;
S. Orienti, *L'opera completa di Cézanne*,
Milan, 1970, no. 471; O'Brian, forthcoming,
no. 17.

225

CUPID IN PLASTER

Paul Cézanne (1839–1906)
Oil on canvas, 43.5 x 29.2 cm
Gift—Frederick B. Deknatel, 1964.72

References
L. Venturi, *Cézanne. Son art—son oeuvre*,
Paris, 1936, I, 343, no. 1609; for a similar
work see *idem*, no. 1608; for a third painting
(Courtauld Collection, London), also with the
motif of a plaster cast of Puget's *Cupid*, see
M. Schapiro, *Cézanne*, New York, 1952, 98.

MOTHER AND CHILD

1901
Pablo Picasso (1881–1973)
Oil on canvas, 112.3 x 97.5 cm
Bequest—Collection of Maurice
Wertheim, 1951.57

This *Mother and Child*, the largest of
Picasso's series of works exploring the
theme of maternity during the Blue Pe-
riod, dates from the beginning of that
formative phase. From among the wealth
of artistic sources that the young artist
was absorbing both at home in Barcelona
and on his visits to Paris, it is the in-
fluence of El Greco and of Catalonian
Gothic sculpture that this piece perhaps
most strongly evokes, in its stylized,
gaunt, and attenuated figures. But in ad-
dition to the blue coloration, the thickly
built-up pigment, and the force of the in-
wardly directed emotionality are other
characteristics wholly distinctive to
Picasso. The heavy, tubular folds of the
mother's drapery and her position, with
shoulders hunched forward and knees
drawn up, serve to envelop the child with
as much warmth and protection as seem
possible in the stark, indifferent environ-
ment. The strength of the maternal bond
in the midst of apparent destitution and
sequestration recalls Picasso's early stud-
ies of the poor in Barcelona, while the
abstracting, almost iconic asceticism of
the heads implies an overlay of Christian
meaning.

References
Collection Maurice Wertheim, 1949, 55–57;
A. Blunt and P. Pool, *Picasso: The Formative
Years*, London, 1962, 70–71; P. Daix and G.
Boudaille, *Picasso: The Blue and Rose Peri-
ods*, Greenwich, Conn., 1967, 48 and 203,
no. VI.30; O'Brian, forthcoming, no. 24.

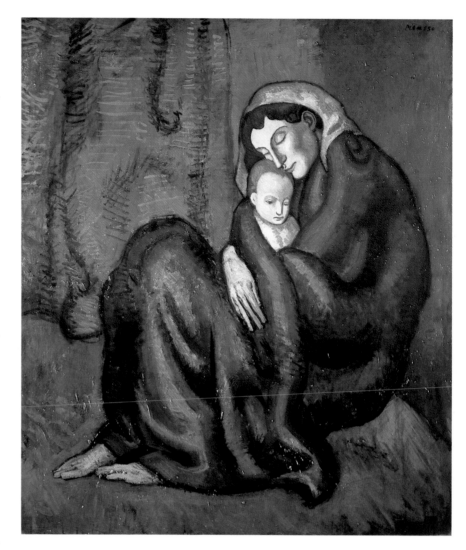

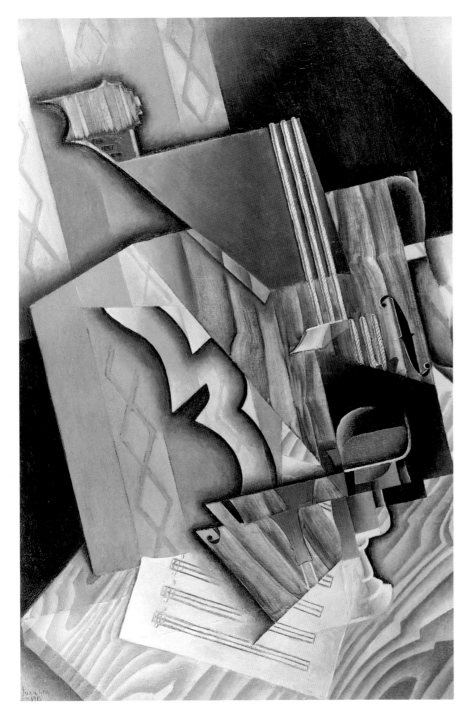

VIOLIN AND GLASS

1915
Juan Gris (1887–1927)
Oil on canvas, 92 x 60 cm
Gift—Mr. and Mrs. Joseph Pulitzer, Jr.,
1963.117

Rather than the violin of the title, this still life features what is probably a bass viol or a cello, i.e., a large instrument with sizable sound holes and thick strings. Its splintered and rearranged parts, along with the fractured pieces of the glass, constitute the central and most variegated section of the canvas. Against the grainy and vitreous textures of instrument and vessel, the broader planes of wooden table and patterned wallpaper provide a vigorous backdrop of counter-diagonals. The colors, almost garish in their intensity and appositions, contribute to the cohesive, architectonic strength of the design, in which cast shadows, even from the thin sheet of music paper, connote the protruding and receding superimposed planes. Gris' treatment of color and of tonal shading, two factors that distinguished his work from that of his slightly older associates Picasso and Braque in the years just following the analytic phase of Cubism (no. 300), are thus well demonstrated in this crisp, lucid painting.

References
Pulitzer Catalogue, III, 1971, no. 178; D. Cooper, *Juan Gris*, Paris, 1977, I, no. 122; M. Rosenthal, *Juan Gris*, New York, 1983, no. 29; Jones, 1985, 87, fig. 81.

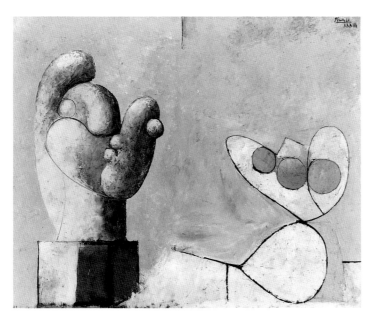

228

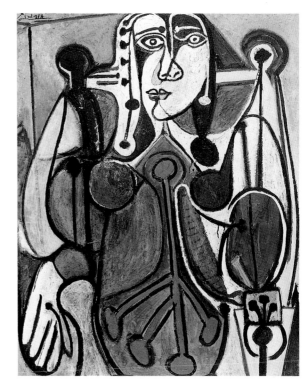

229

PLASTER HEAD AND BOWL OF FRUIT

1933
Pablo Picasso (1881–1973)
Oil on canvas, 70.8 x 92 cm
Gift—Mr. and Mrs. Joseph Pulitzer, Jr.,
1966.138

This still life is a revealing and brilliantly realized synopsis of the two discrete styles, in both sculpture and painting, that Picasso was pursuing concurrently from 1925 to 1935. The painted head, rendered with authoritative three-dimensionality, in fact derives from one of his own large-scale plaster statues of 1933, and the bowl of fruit, if following no known sculptural model, may well have been inspired by one of his works in pipe or wrought iron. Thus weighty volumetric forms and slight linear ones are made to coexist on the canvas, where despite their ostensible dissimilarities, the two modes—objects complement each other through their predominant kidney-shaped motifs and interior circular punctuations. Furthermore, as C. S. Chetham has shown, the painting is a development of the opposing themes of realism and abstraction that Picasso often juxtaposed in this same period. In a witty, multifaceted commentary on art's relation to actuality and the nature of visual imitation, Picasso placed the plaster head, an abstracting but "solid" image of his own design, on a pedestal like a real object in a gallery, to be improvised upon by the "natural" but "two-dimensional" bowl of fruit across the way.

References
Pulitzer Catalogue, I, 1957, no. 55; Jones, 1985, 83, fig. 77.

WOMAN IN BLUE

1949
Pablo Picasso (1881–1973)
Oil on canvas, 99.7 x 80.6 cm
Gift—Mr. and Mrs. Joseph Pulitzer, Jr.,
1959.151

References
Pulitzer Catalogue, I, 1957, no. 57; Jones, 1985, 84, fig. 78.

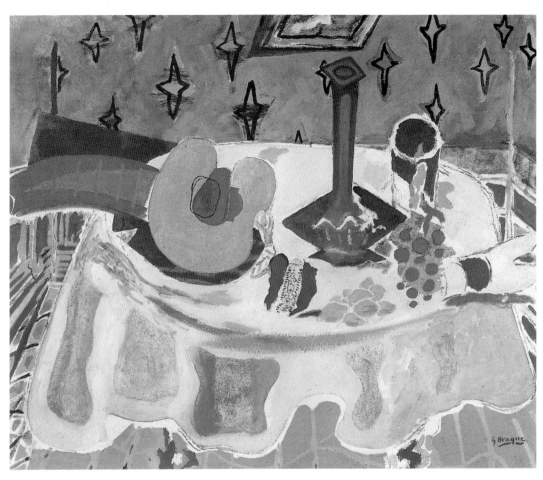

230

THE MANDOLIN

1939–40(?)
Georges Braque (1882–1963)
Oil on canvas, 88.9 x 106.7 cm
Gift—Mr. and Mrs. Joseph Pulitzer, Jr.,
1960.246

The paneled dado, tiled floor, and starred
wallpaper are just as important as the
other motifs in this painting. In fact ar-
chitectural details, still-life objects, and
intervening spaces share center stage,
with the ample, scalloped folds of the
tablecloth contributing to the rhythmi-
cally decorative whole. In this expanded
attitude toward pictorial structure,
Braque maintained the subject matter
and principles of early Cubism; he set up
the same oscillations between the three-

dimensional solidity of a mandolin or a
candlestick and the ordered flatness of
their surface designs. An analogous
painting of 1939, *Still Life with Banjo*
(Gustag Zumsteg Collection, Zurich),
presents both a narrower format and a
more tightly integrated composition.

References
Pulitzer Catalogue, I, 1957, no. 13; Jones,
1985, 85, fig. 79.

231

UNTITLED PAINTING

1953
Joan Miró (1893–1983)
Oil on canvas, 194.6 x 97.8 cm
Gift—Mr. and Mrs. Joseph Pulitzer, Jr.,
1972.361

In stark contrast to the objective, studio atmosphere of Braque's *Mandolin* (no. 230) is this untitled work by Miró, who once purportedly said of the Cubists, "I'll break their guitar." His artistic vocabulary, though not by any means devoid of external reference, strove for a visualizing of pre-conscious images; his technique, akin to that of a composer, depended on release of these signs through intuitive, spontaneous response followed by control of them through formal structure. In this painting, the temporal aspect is evoked by the bright orange crescent moon eclipsing a darker red sun, their juncture appearing as a blue patch of shadow. Below these heavenly bodies is a star, beside which a maze of sinuous black lines and resonant patches of color suggest birds and other biomorphic forms against a limitless umber ground. It is an engaging example by this remarkable individualist who explained that he did "not distinguish between poetry and painting."

References
The first quotation is from J. Dupin, *Joan Miró, Life and Work* (N. Guterman, trans.), New York, 1962, 142; see also 432 ff. and 562, no. 815. The second quotation is from G. H. Hamilton, *Painting and Sculpture in Europe 1880–1940*, Harmondsworth, 1967 (paperback ed.), 413; see also *Pulitzer Catalogue*, III, 1971, no. 197.

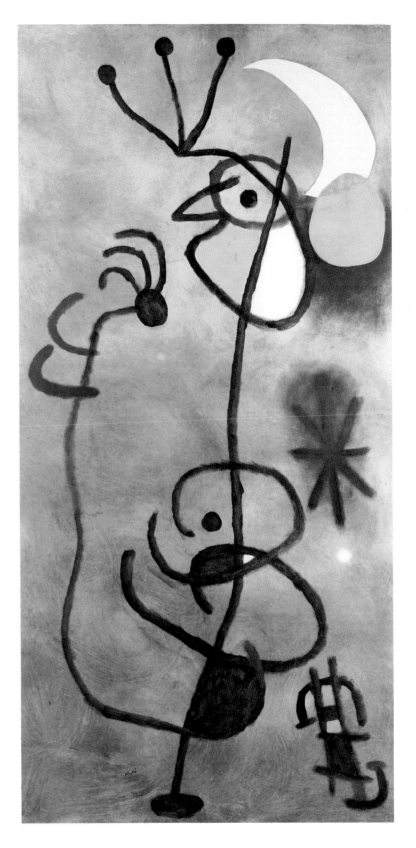

232

UPPER DECK

1929
Charles Sheeler (1883–1965)
Oil on canvas, 74 x 56.3 cm
Purchase—Louise E. Bettens Fund,
1933.97

Sheeler, who once stated that "our factories are our substitutes for religious expression," was an ardent believer in the virtue of American industrial and technological progress. As an artist, he began to turn away from Cubism in the early 1920's, searching for new means to express the age of machines; *Upper Deck* was his seminal visual manifesto. After finishing it, he explained: "This is what I have been getting ready for. I had come to feel that a picture could have incorporated in it the structural design implied in abstraction and be presented in a wholly realist manner." Behind his Precisionist style lay, in addition to a variety of contemporary influences and experiences, an appreciation of the "engineer plans" of such Italian masters as Piero della Francesca, and his own photographic work. *Upper Deck* is partly based on a photo (*Funnel*, 1927) that he took aboard the S. S. *Majestic*, the biggest steamer of its time. In the painting, he carefully positioned and balanced his subject, two electrical motors and two intake–exhaust manifolds, so as to celebrate the classical geometric beauty of their functional designs. Lacking any human reference, the canvas presents the machines' pristine whiteness and latent power. Seemingly noiseless and without emission, they gleam in the still, bright air, imperishable, intrinsically abstract and timeless testimonials to the prowess and optimistic future of industrial man.

References
For the most exhaustive discussion of the painting, including the artist's methodical practices of preparation, see S. F. Yeh, "Charles Sheeler's 'Upper Deck,'" *Arts Magazine* 53/5 (1979), 90–94. See also *American Art at Harvard*, 1972, no. 143; J. Wilmerding (ed.), *The Genius of American Painting*, New York, 1973, 251; M. Friedman, *Charles Sheeler*, New York, 1975, 62 (illus.), 72, 95; and Jones, 1985, 38, fig. 23.

233

ELEGY

1948
Robert Motherwell (1915–)
Collage, glazed, 75 x 59.5 cm
Purchase—Louise E. Bettens Fund,
1949.49

References
American Art at Harvard, 1972, no. 156;
Robert Motherwell, Städtische Kunsthalle,
Düsseldorf, 1976, 100, no. 10; H. H. Ar-
nason, *Robert Motherwell*, New York, 1982,
29–30, pl. 124; Jones, 1985, 93, fig. 88.

234

NO. 2, 1950

1950
Jackson Pollock (1912–56)
Oil, lacquer, duco, silver paint, sand and
pebbles on canvas, 287 x 91.4 cm
Gift—Mr. and Mrs. Reginald R. Isaacs
and Family, and Purchase—
Contemporary Art Fund, 1965.554

The unusual vertical format of this piece
seems suited to its particular configura-
tion. As with other paintings of this
period (1947–50), Pollock dripped,
splattered, and sometimes flung his paints
from all four sides onto the canvas,
which he had tacked to the floor. Only
when he finished this process did he crop
and orient the work. Having absorbed
the concept of automatism in the early
1940's from his friend Robert Motherwell
(no. 233), he espoused the merit of "au-
tomatic" gestures, but also exercised
conscious command of his technique and
critically examined his work as he pro-
gressed. The result in these drip paintings
was a breakthrough to an unprecedented
realm of spatial organization. Lines,
rather than defining edges or describing
contours, suddenly could compose airy
but dense latticeworks; in this example, a
thin tissue of tan, yellow, and blue seem-
ingly is overlaid with thicker threads and
swatches of black and silver, on top of
which lies a weaving of beige and white.
The sensuous interwoven surface fabric
keeps the eye roving, seeking to ap-
prehend its soaring rhythms and optical,
traceried structure.

References
American Art at Harvard, 1972, no. 157; F. V.
O'Connor and E. V. Thaw (eds.), *Jackson
Pollock, A Catalogue Raisonné of Paintings,
Drawings and Other Works*, New Haven,
1978, II (Paintings 1948–55), no. 261; Jones,
1985, iv, frontis.

COMPOSITION

1952
Franz Kline (1910–62)
Oil on canvas, 137.1 x 85.7 cm
Gift—G. David Thompson in memory of
his son, G. David Thompson, Jr.,
1959.17

Like Pollock (no. 234), Franz Kline broke
through to a revolutionary and utterly
personal abstract style that relied on
"gesture" modified by deliberate control.
Late in the 1940's he began making ab-
stract black and white brush drawings;
Elaine de Kooning reported that his mo-
ment of revelation occurred after seeing
the magnified structural details of some
of these sketches in a Bell-Opticon. From
1950, he painted amplified brushstrokes,
using cheap black enamel and a house
painter's brush. Although it might seem
that such limited materials would
produce works with a single figure–
ground relationship, a painting such as
this *Composition* reveals instead a rhyth-
mically powerful architectonic structure
animated by gradations of texture and
fluctuations of surface tone. As seen here,
the white and pinkish white rectangular
patches, sometimes built up thickly and
biting or blurring over black edges, are as
often figure as they are part of the back-
ground or void; contrasts of glossy and
matte finishes add to the vibrancy of the
interlocking construction. The aug-
mented shapes of this work, in their
edificial configuration, not only are ideo-
graphic–calligraphic abstractions, but
also are reminiscent of Kline's earlier rep-
resentational cityscapes.

References
For Elaine de Kooning's report see her intro-
duction to the *Franz Kline Memorial
Exhibition*, Washington Gallery of Modern
Art, Washington, D.C., 1962, 14–15. See also
American Art at Harvard, 1972, no. 159;
J. Wilmerding (ed.), *The Genius of American
Painting*, New York, 1973, 290–92; and
Jones, 1985, 112, fig. 109.

THE BLACK AND THE WHITE

1956
Mark Rothko (1903–70)
Oil on canvas, 238.8 x 134.6 cm
Gift—Ruth and Frank Stanton,
1981.122

Although Rothko's characteristic color
rectangles are enclosures themselves en-
closed by the perimeter of the canvas,
The Black and The White demonstrates
the expansive holistic essence of his art.
In contrast to the highly textured can-
vases of action painters such as Pollock
and Kline (nos. 234, 235), Rothko kept
the actual surface nonobtrusive; by doing
so, a misty atmosphere of light-saturated
color radiates outward. The diffusive
boundaries of the abutting rectangles
make them appear to oscillate gently
against each other and to drift before the
varied tones of the red ground. This
diffraction beyond the picture plane, en-
compassing the receptive viewer, invites
the kind of transcendental contemplation
that Rothko sought to evoke and inspire
through the "simple expression of the
complex thought."

References
The quotation is from a letter written with
Adolph Gottlieb to the *New York Times*, June
13, 1943; see P. Selz, *Mark Rothko*, Museum
of Modern Art, New York, 1961, 25 (quota-
tion on p. 11). See also *The New American
Painting*, Museum of Modern Art, New York,
1959, no. 61; and Jones, 1985, 94, fig. 90.

237

BLUE VEIL

1958–59
Morris Louis (1912–62)
Acrylic resin paint on canvas,
254 x 378.6 cm
Gift—Lois Orswell and Gifts for Special
Uses Fund, 1965.28

Morris Louis shared with Rothko (no. 236) a deep-thinking, high-principled approach to his profession; having decided toward the end of 1957 that his first veil paintings of 1953–54 surpassed his more figurative work of 1955–57, he had no qualms in destroying all the pieces he possessed of that intervening time before beginning again on the veils. Again like Rothko, he was engrossed with the expressive, optical force of pure, untextured color, but his technique of staining thinned acrylic paint into unprimed canvas yielded results independent of discrete shapes, bounded even in Rothko's undrawn manner. Since he worked in seclusion, his methods are not completely known, but it seems that after stapling the canvas to a support, he let various pigments billow downward in consecutive undulations. Evidently controlling the

flow by maneuvering both support and canvas, with the occasional supplement of a cloth wrapped around a pole, he created works in which color and fabric became inextricably united. In the *Blue Veil*, we sense the crests of the brighter underlying hues of red, orange, and yellow, the intense timbre of blue-green most apparent on the left, and the center and right-of-center seams where the large canvas probably had been folded. The waving conformation, washed over by a grainier blue tonality, presents a translucent chromatic continuum, lustrous and interfluent.

References
M. Fried, "*Blue Veil* by Morris Louis," *Fogg Art Museum Acquisitions*, 1965, 177–81; *American Art at Harvard*, 1972, no. 162; Jones, 1985, 74, fig. 68. For further discussion of technique and style (and his debt to Pollock and Frankenthaler) see M. Fried, *Morris Louis*, New York, 1971, especially 22–27.

238

BLUE RHAPSODY

1963
Hans Hofmann (1880–1966)
Oil on canvas, 213.4 x 188 cm
Gift—Rosenman, Colin, Kaye, Petschek,
Freund, and Emil, 1970.56

References
W. Seitz, *Hans Hofmann*, Museum of Modern
Art, New York, 1963, 36; Jones, 1985, 96,
fig. 92.

239

RED RIVER VALLEY

1958
Frank Stella (1936–)
Oil on canvas, 231.1 x 200.7 cm
Gift—Lawrence Rubin, 1973.135

This early, "Transitional" work was done just before Stella began his Black Paintings, that revolutionary series in which canvas-filling narrow black bands assertively paralleled the structure dictated by the framing edges of the picture support. An example of a number of pieces that Stella himself categorized as "wandering," *Red River Valley* records a moment in the artist's development when painterly handling of edges and suggestive titles still served, in however abridged a manner, as allusions to representational contexts and illusionistic space. The tonal nuances of the green ground and the brown accents of the horizontal blurred bands surrounding and adjoining the dominant red vertical still acknowledge a world outside the purely pictorial arena to which the artist soon devoted his exclusive attention.

References
C. Jones, *Frank Stella, Selected Works*, Fogg Art Museum, Cambridge, Mass., 1983; *idem*, 1985, 77, fig. 70.

240

KARMA

1964
Kenneth Noland (1924–)
Acrylic resin on canvas,
259.1 x 365.8 cm
Gift—Kenneth Noland, 1965.22

Karma is a fully developed example of Noland's *Chevron* series, begun in 1962 after the *Target* and *Lozenge* sequences. In his own continuing exploration of the involvement of the image with the perimeter of the support, Noland had reached at this stage a solution by which the upper corners of the picture edge could firmly anchor the chevrons, giving him the freedom to move them off the central axis and away from the bottom. Rigorously self-evaluating and constantly originative, he made only a few of these paintings, whose "dynamic asymmetry" so adequately answered a challenge that he moved on to yet others. Like Morris Louis (no. 237), with whom he was in close contact in the 1950's, he learned Pollock's and Frankenthaler's techniques of staining paint directly into unprimed canvas, but Noland's hard-edged bands set up a different and even more extreme dissociation from the tactile, gestural branch of Abstract Expressionism. Here the three blue tonalities, though structurally held down by their own borders and those of the frame, at the same time move outward onto the unbounded field of the raw canvas.

References
M. Fried, *Three American Painters*, Fogg Art Museum, Cambridge, Mass., 1965, 24–32, fig. 2 (quotation on p. 31); see also *American Art at Harvard*, 1972, no. 164; and Jones, 1985, 79, fig. 72.

242

241

"GREAT SALT"

London, ca. 1630
Silver, 12.1 x Diam. 16.8 cm (at base)
Marks: inside bowl, partially effaced
London hallmarks; on each scroll and on
bottom, lion passant
Lent by Harvard University: Bequest—
Richard Harris to Harvard College,
1644, 881.1927

TWO-HANDLED COVERED CUP, "THE STOUGHTON CUP"

Boston, 1701
John Coney (1655–1722)
Silver, 25.4 x Diam. 17.8 cm (at lip)
Marks: on side opposite arms, IC above a
fleur-de-lys in a heart-shaped punch
Lent by Harvard University: Gift—The
Honorable William Stoughton to
Harvard College, 1701, 877.1927

Much of Harvard University's fine collection of silver is kept at the Museums. The earliest example was made in London, probably before the College was founded. It came to these shores in 1638 with Elizabeth Glover, who married Harvard's first president, Henry Dunster. She willed it to her brother, Richard Harris, who lived at Harvard College, perhaps as a tutor, and received a master's degree in 1644. When he died in August of that year, he left the *Salt* to Harvard.

Lieutenant-Governor William Stoughton gave Harvard many generous gifts, including the original Harvard Hall—long since demolished—and this superb cup. In the baroque William and Mary style that had just reached New England, its elegant form is enlivened with wonderfully plastic fluting and gadrooning at

the base and on the cover. The contrasting, smooth midsection was engraved (with the Stoughton arms mantled with acanthus) by Coney himself, the best engraver of his time in Boston, who also incised the first paper money used in the colony and the most beautiful version of the Harvard seal. The cast caryatid handles with grotesques at the base—a highly developed version of the applied handle long in fashion—complete the strong, sculptural form.

References
For information on the "*Great Salt*" see K. C. Buhler, "Harvard College Plate," *The Connoisseur Year Book*, 1955, 49–50, and J. Fairbanks, *New England Begins: The 17th Century*, Museum of Fine Arts, Boston, 1982, III, no. 453. The scrolled knobs were meant to support a dish of fruit served after the main course. For "*The Stoughton Cup*" see Buhler, 1955, 53–54; G. Hood, *American Silver: A History of Style, 1650–1900*, London and New York, 1971, 59; *American Art at Harvard*, 1972, no. 173; and W. Cooper, *In Praise of America: American Decorative Arts 1650–1830*, New York, 1980, 89–90. Only one other vessel with this form is known, by the silversmith Edward Winslow (in the Garvan Collection, Yale University Art Gallery).

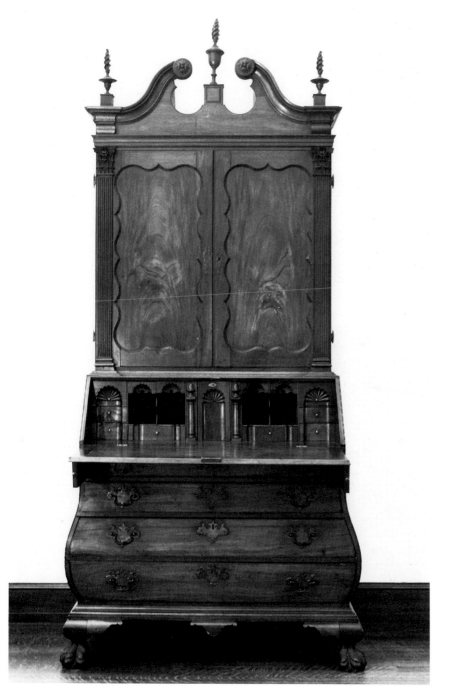

SECRETARY DESK

Boston, 1755–95
Mahogany (white pine),
289 x 125 x 63 cm
Lent by Harvard University: Donor
untraced, 205.1972

Also kept in the Museums but belonging
to Harvard University (nos. 241, 242) is
this eminent piece of American furniture
that was formerly in the President's
house. Many refinements enhance its im-
posing appearance: scroll-arched
pediment, matched-grain door panels
flanked by Corinthian pilasters, fan-
arched interior compartments, bombé or
kettle-shaped base with drawers that fol-
low its swollen "bombé" outline, paw feet
with shaped brackets. The baroque de-
signs that inspired the unusual bombé
base—found only in the vicinity of
Boston—originated on the Continent and
most likely came to America from En-
gland. Another regional feature is the
corkscrew finial, a motif typical of Mas-
sachusetts cabinetmakers.

Reference
American Art at Harvard, 1972, no. 165.

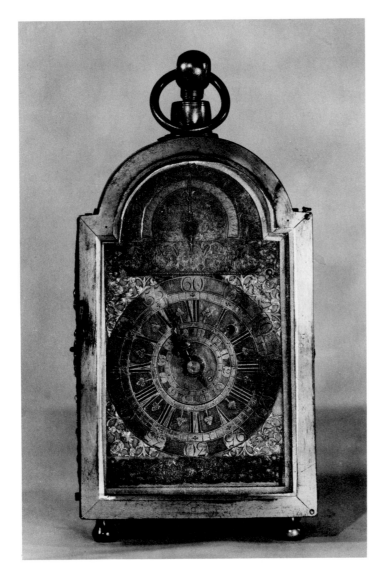

244

TRAVELING ALARM CLOCK

London, ca. 1710
John Paulet (Clockmakers' Company,
1703)
Inscribed on backplate: Paulet/London.
Silver and gilt metal, 16.5 x 9.5 cm
(without handle)
Bequest—Grenville L. Winthrop,
1943.1067

Of the forty-seven clocks that Grenville
Winthrop bequeathed to the Fogg, this is
one of the most unusual and most beauti-
ful. Although little has been ascertained
about Paulet, one surmises that he was
of French ancestry because of his name
and the handling of the scrollwork and
masks on the case. Intricate pierced deco-
ration covers all sides of the timepiece,
including the backplate, and gives it a
delicate charm that disguises its func-
tional assets to the traveler; the clock not
only has a central alarm dial but also was
built to repeat the hours and quarters
and to give the date of the month.

References
F. T. Britten, *Old Clocks and Watches and
their Makers*, London, 1922 (5th ed.), 593,
595, figs. 816–18, this clock or one identi-
cal to it; R. H. Graveson, "The Winthrop
Clocks," *The Connoisseur* CIL (1962), 216–
17; *Winthrop Retrospective*, 1969, no. 145.

PORTLAND VASE

1790–95
Wedgwood, first edition
Mark: on lip, in manganese pencil,
"9" and "J Trevor"
Blue-black jasper with polished, tinted
and undercut figures in white relief,
26 x 17.8 cm
Bequest—Grenville L. Winthrop,
1943.1181

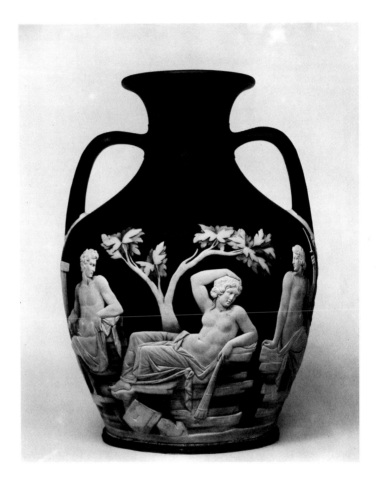

One of Grenville Winthrop's many
collecting interests was ornamental
Wedgwood, of which this is an especially
significant piece. It is a faithful copy of
the Barberini or Portland Vase, named
for the 17th- and 18th-century owners of
the Graeco-Roman amphora now in the
British Museum. In 1786 the Duke of
Portland lent the piece to Josiah Wedg-
wood to examine and reproduce. So high
were Wedgwood's standards and so diffi-
cult the problems of production that it
was four years before he was sufficiently
satisfied to place a copy on exhibition. By
that time he had succeeded in inventing
"Barberini black"—a particular mixture
of blue and black clays that he felt did
justice to the blue-black glass of the
original—and had overcome the tech-
nical impediments to imitating "those
beautiful shades to the thin and distant
parts of the figures, for which the original
artist availed himself of the semi-trans-
parency of the white glass. . . ." His
Excellency John Trevor subscribed to the
first edition, from which he received this
fine example in 1797.

References
J. Gorely and M. Wadsworth, *Exhibition of
Old Wedgwood,* Fogg Art Museum, Cam-
bridge, Mass., 1944, no. 92; W. Mankowitz,
The Portland Vase and the Wedgwood Copies,
London, 1952, 44, 47; *Winthrop Retro-
spective,* 1969, no. 137; A. Dawson,
*Masterpieces of Wedgwood in the British
Museum,* London, 1984, 149, no. 9.

WESTERN DRAWINGS

246

247

THE VISITATION (VERSO)

14th century
Anonymous Italian
Brown ink and wash with washes of
greyish purple and yellow in the archi-
tecture, on parchment, 221 x 226 mm
Recto: *Figures Related to Frescoes in the
Lower Church of San Francesco, Assisi,*
grey wash and white gouache on green
prepared parchment
Purchase—Alpheus Hyatt Fund, 1932.65

Both sides of this sheet have copies after
frescoes in the lower church of S. Fran-
cesco, Assisi. On the recto stand two
rows of figures, some taken from Simone
Martini's Chapel of St. Martin, others
from scenes by Giotto; the verso, shown

here, repeats the central part of the As-
sisi *Visitation,* also by Giotto. While
Mongan and Sachs believed the drawing
was by one of Giotto's assistants, more
recently Degenhart and Schmitt have at-
tributed it to a Sienese, possibly Niccolò
Tegliacci. In either case, the drawing di-
rectly reflects the Florentine master's
fresco style. If the drapery folds are softer
and the figures less bulky in the draw-
ing, the underpinning of solid three-
dimensional forms, both human and ar-
chitectural, remains faithful to the
ultimate source.

References
See Mongan–Sachs, 1940, no. 1, figs. 1–2;
B. Degenhart and A. Schmitt, *Corpus der Ital-
ienischen Zeichnungen,* Berlin, 1962, I, no. 52,
pl. 82.

EIGHT APOSTLES WATCHING
THE ASCENSION OF CHRIST

ca. 1464
Andrea Mantegna (1431–1506)
Brown ink and wash and white gouache
on grey-green prepared paper,
290 x 218 mm
Gift—Mrs. Jesse Isidor Straus in memory
of her husband, Jesse Isidor Straus, Class
of 1893, 1926.42.1

The *Eight Apostles* exemplifies the strong
sculptural quality of Mantegna's style. He
used white highlights to lend the craggy
masculine faces a chiseled cast and, in
order to reveal their powerful physiques,
to mold the drapery into crisp edges and

broad stretches across calves and shoulders. The drawing is a study for the *Ascension of Christ* that constitutes the left wing of the Uffizi triptych of 1464. A companion study of the Madonna and Child for the *Circumcision* making up the right wing is in the Kunsthalle at Hamburg.

References
Mongan–Sachs, 1940, no. 24, fig. 25; *Sachs Collection Catalogue*, 1965, no. 4.

248

FUNERAL PROCESSION OF THE VIRGIN

1449 or 1450
Jacopo Bellini (ca. 1400–before 1471)
Cut in three parts: upper left part is in the Louvre (Walter Gay Bequest); cut across center has destroyed upper half of the figure of the Virgin
Brown ink over black chalk on tan paper, 98 x 203 mm (l.) and 209 x 99 mm (r.)
Bequest—Charles A. Loeser, 1932.275

Sketchbooks by Jacopo in both the Louvre and the British Museum include this same scene, but only in the Harvard Museums' version does the procession move off to the right. In all three, though, St. John precedes the bier, carrying the mystical palm (a symbol of life everlasting that the angel had set on the Virgin's death bed), while the penitent converts of Jerusalem, emerging from the city gates, follow. Having probably met Alberti in Ferrara in the 1440's if not in Venice in 1437, Jacopo had absorbed the laws of perspective, but he avoided applying them scientifically in this drawing. Instead he used perspective as a device to play up the stately grandeur of the milieu and the occasion, thereby maintaining his link to the International Style. In exaggerating the recession into the distance, he distorted but monumentalized the Virgin on her huge coffin borne by the Apostles. Before the drawing was damaged, she undoubtedly made a statuesque focus in the center of the page, her body punctuated by the three great wall-turrets and her head and hands accented by the victory column of the city beyond.

References
Mongan–Sachs, 1940, no. 4, fig. 5. From the early dating it follows that the sketch was not a study for a painting in the lost *Life of the Virgin* cycle in the Scuola di S. Giovanni Evangelista in Venice, done in 1465. See also T. Pignatti, *Venetian Drawings from American Collections*, International Exhibitions Foundation, 1974, no. 4 (attributes the drawing to Giovanni Bellini); Oberhuber (ed.), 1979, no. 4. See in general B. Degenhart and A. Schmitt, *Jacopo Bellini, the Louvre Album of Drawings* (F. Mecklenberg, trans.), New York, 1984.

249

FIGHTING NUDES

ca. 1460–65
Antonio Pollaiuolo (1432?–98)
Brown ink and wash on cream paper
(extensively restored), 270 x 180 mm
Gift—Meta and Paul J. Sachs, 1940.9

This drawing, although restored and only
a fragment, remains a compelling image.
Through sparing, decisive penstrokes that
delineate muscles straining to the limit,
Pollaiuolo has evoked the fury of hand-
to-hand combat. The sureness of touch,
in which detail, except in the expressive
heads, has been kept to a minimum, no
doubt partly reflects the artist's anatomi-
cal studies and certainly gives credence
to Vasari's and Cellini's claims that
Pollaiuolo was the great draftsman of his
day. The extrinsic interest of the *Fighting
Nudes* lies in its enigmatic purpose and
meaning. Another drawing fragment (the
Prisoner Led Before a Judge in the Brit-
ish Museum) and the engraved *Battle of
Ten Nudes* by the artist (no. 319), as well
as several derived drawings and an en-
graving after a lost design, have been
associated with this one. Also, specific
antique objects—a Greek vase, an
Etruscan cinerary urn, and a Roman
sarcophagus—have been cited as sources
for individual figures. But in spite of sev-
eral ingenious reconstructions and
iconographic interpretations, which in-
clude the twelve labors of Hercules,
events from the life of Titus Manlius
Torquatus, and the martyrdom of St.
Pancrace, the subjects and the exact in-
terconnections of the pieces are still
a matter of speculation. Mongan and
Sachs proposed that the Museums' frag-
ment came from a study for a work in
metal; Vasari's reference to a bas-relief
with a Battle of Nudes supports their
suggestion.

References
Mongan–Sachs, 1940, no. 37, fig. 33; *Sachs
Collection Catalogue*, 1965, no. 3; L. Ett-
linger, *Antonio and Piero Pollaiuolo*, Oxford,
1978, 161, no. 36.

250

FOUR STANDING APOSTLES

1495–96
Pietro Vannucci, called Perugino
(1446–1523)
Black chalk, brown ink, and white
gouache on buff prepared paper,
290 x 225 mm
Gift—Mrs. Jesse Isidor Straus in memory
of her husband, Jesse Isidor Straus, Class
of 1893, 1926.42.2

This group is a study for the *Ascension
of Christ*, the subject of an altarpiece
whose central panel is now in the Lyons
Museum. Commissioned by the Benedic-
tines of S. Pietro in Perugia in 1495, the
painting proved such a success that
Perugino and his assistants copied it no
fewer than four times. Numerous repeti-
tions and variations of either the whole
or part of the design also were drawn by
Perugino's followers; none of them ap-
proaches the standard of this example,
which probably remained in the workshop and can be assigned to the master
himself. The Umbrian teacher of Raphael
demonstrated here his distinctive ability
to capture an introspective vitality of
expression and to freeze graceful, choreo-
graphic poses in movement.

References
Mongan–Sachs, 1940, no. 28, fig. 26; *Sachs
Collection Catalogue*, 1965, no. 6.

251

STUDY FOR A FRIEZE WITH SIREN AND ACANTHUS

ca. 1481
Tullio Lombardo (?) (ca. 1455–ca. 1532)
Brown ink on off-white paper,
195 x 282 mm
Bequest—Frances L. Hofer, 1979.63

Tullio and his younger brother Antonio
underwent training primarily in the
sculpting of architectural decoration. The
later term Lombardesque, from their
family name, denotes the style of marble
relief carving that first appeared in Venice
and Urbino in the late 1460's and early
1470's, and was in that early stage char-
acterized by luxuriant forms of acanthus
taken from Roman ornamental vocabu-
lary. Although the only other drawings
solidly attributed to the Lombardo broth-
ers are architectural plans, this one has
been connected to them on the grounds
of its affiliation to the carved friezes of
the triumphal arch bases of Sta. Maria
dei Miracoli in Venice (1481–89). The
elements shown here—an armless siren
with a body terminating in foliage that
sprouts into a large acanthus whorl to
her right—are consistent with the more
varied repertory of *all'antica* motifs em-
ployed by the workshop in the 1480's.
That this sheet may have been kept in a
pattern book after serving as a prelimi-
nary sketch is suggested by a Giovanni
Antonio da Brescia engraving with a very
similar design in reverse.

References
W. S. Sheard, *Antiquity in the Renaissance*,
Smith College Museum of Art, Northampton,
Mass., 1978, no. 118. For comparative mate-
rial and possible sources of the drawing as well
as its relation to Mantegna and his school see
K. Oberhuber and W. Robinson (eds.), *Master
Drawings and Watercolors. The Hofer Collec-
tion*, Cambridge, Mass., 1984, no. 1.

253

THE MADONNA AND CHILD
WITH A KNEELING ANGEL

ca. 1500—04
Fra Bartolommeo (1472—1517)
Pen and brown ink on off-white paper
(heavily foxed), 151 x 200 mm
Bequest—Meta and Paul J. Sachs,
1965.356

This charming *Madonna and Child* is
one of many such pen sketches that the
artist made in his first years at the mon-
astery of S. Marco; similar tranquil
images survive at Bayonne, Berlin, Flor-
ence, London, and Windsor. One can see
in them a definite response to Leonardo
and understand Fra Bartolommeo's own
effect on the young Raphael.

References
Mongan–Sachs, 1940, no. 57, fig. 48; *Sachs
Collection Catalogue*, 1965, no. 8.

252

THE ADORATION OF THE MAGI

ca. 1506
Vittore Carpaccio (ca. 1465—1525)
Brown ink, brown wash over black chalk
on cream paper, 222 x 315 mm
Bequest—Charles A. Loeser, 1932.281

This drawing, and a slightly earlier and
simpler version of the same composition
in the Uffizi, are probably studies for a
vanished or never-executed altarpiece.
The particularly close resemblance of the
Uffizi work to an *Adoration* of 1505 per-
mits the early dating of the Museums'
sheet. In addition to the controlled sweep
of the setting and the clearly orchestrated
groups of figures—elements that indicate
Carpaccio's developing adherence to the
principles of the High Renaissance—the
drawing's significance lies in the artist's
use of symbolism to enhance the meaning
of the biblical event. Thus the crumbling
triumphal arch and column of victory
connote the end of the pagan empire as
the Magi perform the first act of recogni-
tion of Christ's omnipotence; the verdant
tree growing through a broken wall
stands for the promise of salvation.

Reference
Oberhuber (ed.), 1979, no. 7.

254

PIETÀ WITH SAINTS AND ANGELS (RECTO)

After 1495
Filippino Lippi (1457?–1504)
Brown ink over black chalk on cream
paper, 251 x 182 mm
Verso: *Pietà with Saints and Angels*,
brown ink and wash over black chalk
Bequest—Charles A. Loeser, 1932.129

From the specific stipulations of the con-
tract that the Virgin was to hold Christ's
body on her lap and that the onlookers
were to be Sts. Anthony Abbot and Paul
the Hermit, it is apparent that the draw-
ings on both sides of this sheet (and a
third in the Louvre) were preparatory to
an altarpiece commissioned by the
monks of the Certosa of Pavia in 1495.
The work was not painted by the time of
Filippino's death, and nothing more is
known of it; the drawings, however, show
the progress of the artist's ideas. This, the
earliest, reveals a preoccupation with for-
mulating the fundamental structure and
positioning the figures. The cavernous ar-
chitecture may emulate Leonardo's 1483
Epiphany, a work that Filippino was
asked to finish in the year of the Certosa
commission. On the verso of the sheet
and then in the Louvre study, the artist
became increasingly concerned with the
dramatic possibilities of light and shade,
removing subsidiary figures and con-
textual details to focus on the principal
characters.

References
Mongan–Sachs, 1940, no. 22, figs. 21–22;
Oberhuber (ed.), 1979, no. 8.

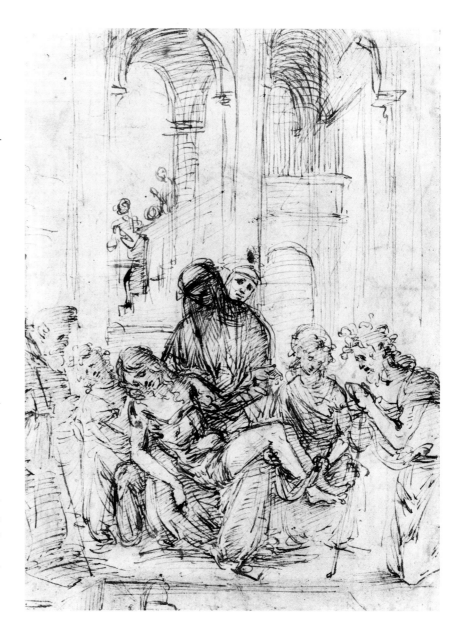

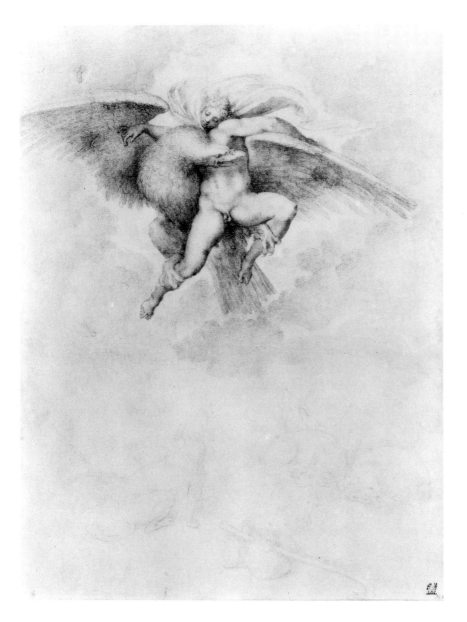

GANYMEDE

ca. 1533
Michelangelo (1475–1564)
Black chalk on off-white paper,
361 x 275 mm
Purchase—Gifts for Special Uses Fund,
1955.75

Although the authorship of this drawing often has been questioned, Hirst has argued persuasively that it is by Michelangelo himself. If in fact it is an autograph piece, it bears an important and intimate relation to a group of drawings with mythological subjects, highly esteemed at the time, that he is known to have made for his friend Tommaso Cavalieri in the year following their 1532 meeting in Rome. While three of the original four survive at Windsor Castle, the *Ganymede* seemingly was lost. The Museums' drawing is not likely to be the one finally given, but rather an exploratory sketch; many of the numerous copies, in various media, of the lost *Ganymede* eliminate the genre elements of the foreground, leaving a reduced composition that would have accorded with the *Ganymede*'s pendant *Tityus*. Charles de Tolnay has suggested that the drawings actually presented were meant not merely as keepsakes but as Platonic symbols of the artist's love for the younger man, who was celebrated for his beauty. In this sense, the Ganymede tale would represent the "ascension of the soul . . . in the mystic union of love," a theme that Michelangelo reiterated in his poems to Cavalieri.

References
M. Hirst, "A Drawing of the Rape of Ganymede by Michelangelo," *Essays Presented to Myron P. Gilmore* (S. Bertelli and G. Ramakus, eds.), Florence, 1977, II, 253–60. The quotation is from C. de Tolnay, *The Art and Thought of Michelangelo*, New York, 1964, 104–5; see also idem, *Corpus dei disegni di Michelangelo*, Novara, 1976, II, no. 344.

THE REST ON THE FLIGHT INTO EGYPT

Paolo Caliari, called Veronese (1528–88)
Black chalk, brown ink and wash, and
white gouache on blue paper,
248 x 198 mm
Bequest—Meta and Paul J. Sachs,
1965.430

References
Mongan–Sachs, 1940, no. 204, fig. 111;
Sachs Collection Catalogue, 1965, no. 16; T.
Pignatti, *Venetian Drawings from American
Collections*, International Exhibitions Foundation, 1974–75, no. 24.

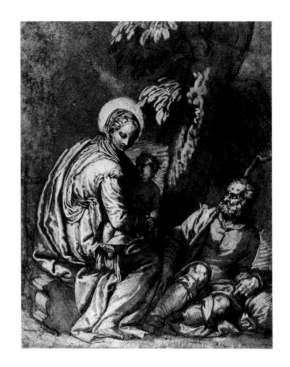

TWO SKETCHES OF A NUDE YOUTH (RECTO)

ca. 1519(?)
Jacopo da Pontormo (1494–1557)
Black and red chalks on white paper,
435 x 285 mm
Verso: *Two Profile Studies*
Bequest—Charles A. Loeser, 1932.342

One of sixty-four surviving studies for
the Vertumnus and Pomona lunette
fresco (1520–21), this sheet records the
mutation of a single figure in the third
design for that major project (the Museums' figure, holding a staff, was meant
to lean against the oculus in the center of
the lunette; in the painting he has been
supplanted by a putto). Commissioned
by the Medici for the Sala Grande of
their villa at Poggio a Caiano, the
finished work relates to the story, in
Ovid's *Metamorphoses*, of the Italian god
of husbandry and the nymph who presided over gardens and orchards, an
appropriate theme for a country residence. It also depicts other pastoral gods
and putti attending to the laurel, symbol
of the Medici, in a reference to the promise of a new Golden Age under the
family's aegis. In the painting, the young
Pontormo used the subject to depart emphatically from the principles of the High
Renaissance, exploring new and powerfully unclassical means of expression; in
this one sketch, where the figure, staring
at the viewer with unsettling eagerness, is
shifted from one audaciously foreshortened pose to another, we see the prodigious drawing talent that helped make his
departure so assuredly successful.

References
Mongan–Sachs, 1940, no. 145, fig. 83; J. C.
Rearick, *The Drawings of Pontormo*, Cambridge, Mass., 1964, no. 151 (recto), pl. 143,
and no. 139 (verso), pl. 131; Oberhuber (ed.),
1979, no. 15. The verso includes an extremely
rare pre-1530 study of a Michelangelo head in
profile.

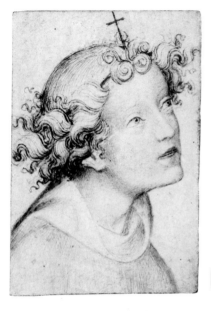

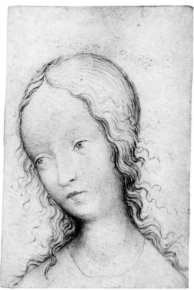

PIETÀ

Simon Marmion (ca. 1420/25–89)
Metalpoint on white prepared paper,
153 x 115 mm
Purchase—Burr, Hyatt, and Prichard
Funds, 1941.343

This is the only compositional drawing given to Simon Marmion, an artist known through documents to have worked in the north of France. Quite a number of miniatures and a few paintings, though, have been associated with him, and the *Pietà*, while not specifically linked to any one extant panel, compares closely in figure style and in the basic positioning of Christ and the Virgin to the *Crucifixion* in the Johnson Collection (Philadelphia Museum of Art) and to the *Pietà* in the Lehman Collection (The Metropolitan Museum of Art). Mongan found that in the drawing "there is, combined with a concern for absolute truth and exquisite craftsmanship which is Flemish in character, a rhythm of line and a spiritual intensity, cloaked in a grace of movement and elegance of pose, which is distinctly French."

Reference
The quotation is from Mongan (ed.),
1949, 10.

258

HEADS OF THE ANNUNCIATE ANGEL AND VIRGIN

Early 15th century
Bohemian
Black and red inks applied with a brush on parchment, 51 x 36 mm each
Purchase—Alpheus Hyatt Purchasing Fund, 1947.79, 80

These two diminutive heads ostensibly are the sole survivors of a small model book that would have been carried by a traveling artist. Luckily a rare complete book, a copy of that originally containing the Museums' drawings, has survived and is now in the Kunsthistorisches Museum in Vienna. This shows fourteen small wooden panels with four sketches each; two of the panels include heads of the Virgin and St. Gabriel that differ from the Museums' heads only in their slightly less delicate tonal gradations and finely-drawn features. Although once a matter of debate, the attribution of the Museums' heads to a Bohemian master of the International Style is now generally accepted.

References
Mongan (ed.), 1949, 4; S. M. Frinta, "The Master of the Gerona Martyrology and Bohemian Illumination," *Art Bulletin* 46 (1964), 305–6; Z. Drobna, *Gothic Drawing* (J. Layton, trans.), Prague, n.d., 46, figs. 81–82.

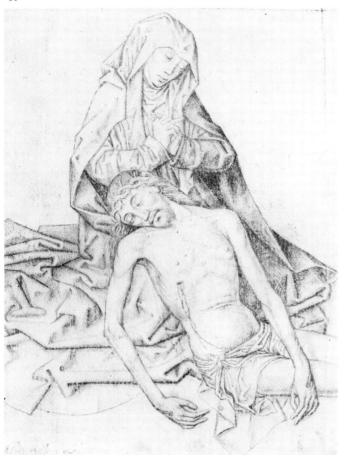

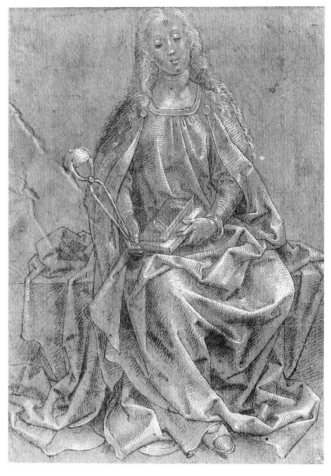

260

ST. AGATHA

ca. 1496–97
Bernhard Strigel (ca. 1460/61–1528)
Black ink and white gouache on grey-blue prepared paper, 192 x 140 mm
Gift—Meta and Paul J. Sachs, 1959.158

Of the Museums' German drawings, the finest work showing the transition from late Gothic to the Renaissance is this *St. Agatha* by the Swabian master who was one of Emperor Maximilian I's most favored portraitists. Freedberg definitively attributed and dated the piece, placing it between two other drawings, the 1491 *Holy Family* in the British Museum and the 1497–99 *Madonna and Child* in the Koenigs Collection; he found it closer to the later work on the basis of the artist's clear progression from an earlier angularity of form toward greater curvilinearity. Characteristic of all Strigel's known drawings is the chiaroscuro technique of using black and white inks on colored paper.

References
S. J. Freedberg, "A Drawing by Bernhard Strigel," *Bulletin of the Fogg Art Museum* 8/1 (1938–39), 18–24; Mongan–Sachs, 1940, no. 397, fig. 205; G. Otto, *Bernhard Strigel*, Munich, 1964, no. 92, pl. 160.

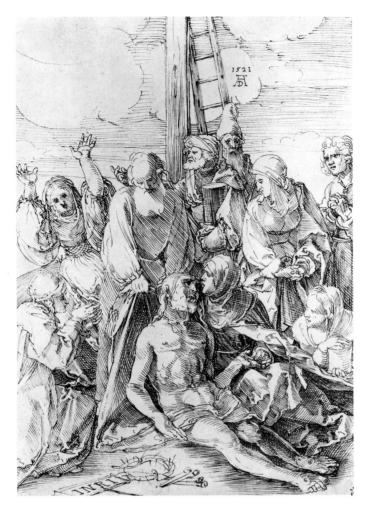

261

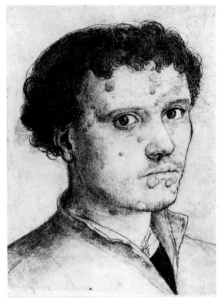

262

THE LAMENTATION

1521
Albrecht Dürer (1471–1528)
Brown ink on white paper,
290 x 210 mm
Bequest—Meta and Paul J. Sachs,
1965.339

In the authority of the hatched and cross-hatched penstrokes, we see an instance of Dürer's genius as a graphic artist; in the organic but controlled structure and the adroit handling of light and shade to build up monumental, generalized forms, we see his profound involvement with the art of Renaissance Italy. Although mono-grammed and dated by the artist, *The Lamentation* has sparked considerable scholarly debate over its precise purpose and relation to other Dürer works. The most recent assessment favors a link with the Passion scenes, the so-called *Oblong Passion*, that Dürer drew during a visit to the Netherlands in 1521. The Museums' piece thus would relate in style and con-tent, if not in format, to these designs.

References
Mongan–Sachs, 1940, no. 377, fig. 192; *Sachs Collection Catalogue*, 1965, no. 11; C. Talbot (ed.), *Dürer in America*, National Gal-lery of Art, Washington, D.C., 1971, no. XXX; W. L. Strauss, *The Complete Drawings of Albrecht Dürer*, New York, 1974, 4 (1520–28), 2120, no. 1521/69.

HEAD OF A YOUNG MAN

1523 (dated at center top)
Hans Holbein the Younger
(1497/98–1543)
Black and colored chalks, black ink, and yellow and grey wash on cream paper (heavily restored), 205 x 152 mm
Gift—Paul J. Sachs, Class of 1900, "A testimonial to my friend Felix M. Warburg," 1949.2

Traditionally called *Portrait of a Leper*, the drawing in fact depicts a young man with a disease that modern medicine di-agnoses as *impetigo contagioso*. The

263

artist, who was to become court painter to Henry VIII, already reveals in this early work his keen observational sense and his ability to temper objectivity with a subtly sympathetic response to the afflicted sitter. Inscribed by Wilhelm Koller in the 19th century on the reverse of the mount are the words "Porträt U. von Hütten in seinem Todesjahr," an identification that is not sustained by comparison with secure portraits of von Hütten. It was recently suggested that the sitter is Holbein's brother Ambrosius, whose death date is unknown, but who was last recorded in 1519. The drawing probably was remounted in the 19th century and has otherwise been tampered with.

References
Mongan–Sachs, 1940, no. 386, fig. 196; *Sachs Collection Catalogue*, 1965, no. 13. For the possible identification of the sitter see *Köpfe der Lutherzeit*, Kunsthalle, Hamburg, 1983, no. 75.

AN ALPINE LANDSCAPE

Pieter Bruegel the Elder (ca. 1525–69)
Brown ink over black chalk on cream paper, 305 x 456 mm
Bequest—Charles A. Loeser, 1932.369

That the grandeur of the Alps greatly impressed and inspired Bruegel on his journey to and from Italy (in 1551–52 and 1554 respectively) is evident from a sketch such as this; a human element is present, but it is almost subsumed by the vast surrounding distances and heights. Varying dates have been proposed for the piece, depending on interpretations of style and intent. Infrared analysis, however, has added new evidence that the drawing was executed in four successive steps, beginning with the basic chalk outlines of the peaks, moving to details in ink of the mountains and then the valley, and finishing with the foreground. Oberhuber concluded that the first three stages were executed while Bruegel was in Italy, finding their predominant concern with effects of light and atmosphere to be compatible with drawings known to date from the southward trip. Bruegel did reuse this mountain composition in a study (now in the Louvre) for his series of large engraved landscapes of about 1556, in just one of many examples of the lasting impact of his alpine experiences.

References
For discussion of execution see K. Oberhuber, "Bruegel's Early Landscape Drawings," *Master Drawings* 19/2 (1981), 146–56. See also Mongan–Sachs, 1940, no. 459, fig. 234; Oberhuber (ed.), 1979, no. 45. For a description of damage to the drawing see L. Munz, *Bruegel: The Drawings*, London, 1961, no. 18.

264

AN ALLEGORICAL GROUP REPRESENTING ASTRONOMY

Francesco Primaticcio (1504–70)
Red chalk heightened with white
gouache on pink paper, 132 x 220 mm
Gift—Meta and Paul J. Sachs, 1959.160

References
Mongan–Sachs, 1940, no. 149, fig. 285;
Sachs Collection Catalogue, 1965, no. 14.

265

PORTRAIT OF CLAUDE GOUFFIER DE BOISY

ca. 1555
François Clouet (1510?–72)
Black and red chalks on white paper,
320 x 230 mm
Gift—Meta and Paul J. Sachs, 1949.5

Clouet's virtuosity as a portraitist is demonstrated in this elegant likeness of Claude Gouffier, Master of the Horse to François I. Details of dress are accurately but summarily noted, so that attention is focused on the refined, precisely rendered physiognomy. From costume style and from comparison with an earlier drawing and painting of the same sitter, the date of the Museums' piece has been fairly narrowly established. Given Clouet's Flemish heritage, the drawing thus can speak for the significant contribution of northern realism to the art of the French court in the mid-16th century. Another notable contribution, that of Italian mannerism, is represented by the *Allegorical Group* of Primaticcio (no. 264), supervisor of the decoration of Fontainebleau and Clouet's contemporary.

References
The inscription on the upper left of this drawing is in the handwriting of a secretary to Catherine de Medici, while the number five was added by Ignatius Hungerford, an 18th-century English artist who lived in Florence and acquired several Clouets. See Mongan–Sachs, 1940, no. 569, fig. 284; and *Sachs Collection Catalogue*, 1965, no. 15.

HEAD OF A WIND GOD (RECTO)

Agostino Carracci (1557–1602)
Red chalk on buff paper, 380 x 320 mm
Verso: *Reclining Male Nude*
Purchase—Marian H. Phinney Fund and
Louise Haskell Daly Fund, 1975.91

Reference
E. Feinblatt, *Old Master Drawings from
American Collections*, Los Angeles County
Museum of Art, 1976, no. 89.

MAN READING AT A TABLE

ca. 1630's
Giovanni Francesco Barbieri, called
Il Guercino (1591–1666)
Brown ink, brown wash on beige paper,
230 x 210 mm
Bequest—Charles A. Loeser, 1932.233

Guercino, the Bolognese artist who was influenced early by the Carracci, especially Ludovico, reveals here his own effective drawing technique. Through his use of energetic, supple lines and application of washes to achieve a pronounced chiaroscuro effect, he has captured the reader's mood of pensive absorption and also created a vibrant surface pattern and texture. Highly similar studies of contemplative scholars and saints, particularly in the Princeton Art Museum and the Mahon Collection, have warranted assigning this sketch to the 1630's, that is, between Guercino's 1621–23 stay in Rome to work for Pope Gregory XV, and his permanent settlement in Bologna in 1642.

References
Mongan–Sachs, 1940, no. 263, fig. 134;
Oberhuber (ed.), 1979, no. 30.

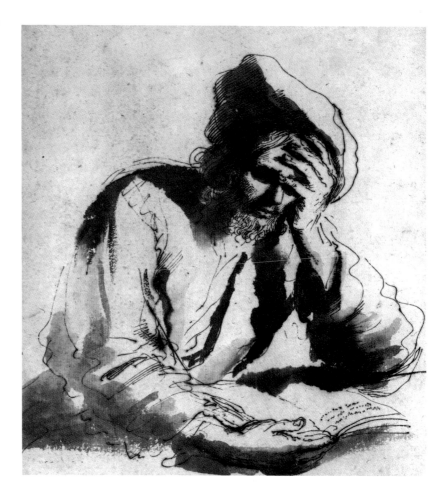

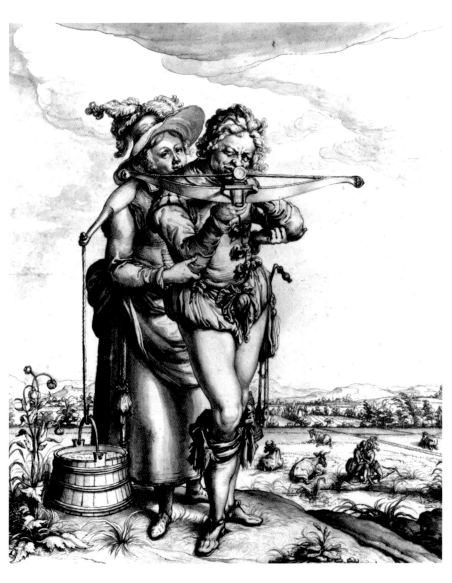

A CROSSBOWMAN ASSISTED BY A MILKMAID

ca. 1600
Jacques de Gheyn II (1565–1629)
Brown ink and grey wash over red chalk
on off-white paper, traced with a stylus,
390 x 323 mm
Gift—Meta and Paul J. Sachs, 1953.86

The Latin and Dutch verses included
with the engraving for which this draw-
ing was a study explain the moral of
the scene: aided by the young woman,
the bowman prepares to shoot at those
inflated with vanity and pomposity. The
drawing reveals a meticulous penmanship
learned from Hendrik Goltzius and cer-
tain mannerist tendencies in the elaborate
arrangement of the figures, but it also
suggests a transition toward the Baroque
in the less restricted treatment of the
landscape. Rosenberg assigned the draw-
ing to ca. 1600, that is, to a date after de
Gheyn's 1596–98 military prints, but
before his more liberated style of the fol-
lowing decades.

References
J. Rosenberg, "A Drawing by Jacques de
Gheyn," *Art Quarterly* (Summer 1954),
166–71. See also *Sachs Collection Catalogue*,
1965, no. 17, and F. W. Robinson, *17th-
Century Dutch Drawings from American Col-
lections*, National Gallery of Art, Washington,
D.C., 1977, no. 7.

269

270

A STUDY FOR THE FIGURE OF CHRIST

ca. 1609–10
Peter Paul Rubens (1577–1640)
Black chalk, charcoal, and white chalk
on buff paper, 400 x 298 mm
Gift—Meta and Paul J. Sachs, 1949.3

This chalk drawing is a study from life
for the Christ in the *Raising of the Cross*,
a triptych painted in 1610–11 for the
Church of St. Walburga in Antwerp and
now in that city's cathedral. Once about
thirty-five feet high, this painting was
stripped of its gabled top and predella
scenes in the 18th century. However, a
17th-century painting of St. Walburga's
interior preserves the original setting and
arrangement; thus the heavenward
glances of the model and of Christ are
explained by the now-lost figure of God
the Father in the niche above the central
panel. In the drawing, the sense of
upward-directed energy is predominant,
as the figure, foreshortened diagonally,
literally bursts past the edges of the page,
necessitating the separate sketch of the
left thumb. The force of the contorted
pose and the accentuated pathos may well
reflect Rubens' introduction to the
renowned Hellenistic statue of the *Lao-
coön*. The Museums have a second
drawing of the Christ figure (1943.524).

References
Mongan–Sachs, 1940, no. 483, fig. 249;
Sachs Collection Catalogue, 1965, no. 19;
J. R. Martin, *Rubens: The Antwerp Altar-
pieces*, New York, 1969, 42, fig. 14.

PORTRAIT OF DON CARLOS COLOMA

1628
Anthony van Dyck (1599–1641)
Black chalk, heightened with white
chalk on white paper faded to ivory,
242 x 187 mm
Gift—Meta and Paul J. Sachs, 1961.150

References
Mongan–Sachs, 1940, no. 466, fig. 238; H.
Vey, *Die Zeichnungen Anton van Dycks*,
Brussels, 1962, I, no. 259; L. van Puyvelde,
Van Dyck, Brussels, 1964, 215–34; *Sachs
Collection Catalogue*, 1965, no. 20.

231

271

A WINTER LANDSCAPE

ca. 1648–52
Rembrandt van Rijn (1606–69)
Pen, brush, and brown ink on cream
paper, 68 x 160 mm
Bequest—Charles A. Loeser, 1932.368

This landscape sketch, roughly contemporary with the oil *Head of Christ* (no. 191), reveals another of Rembrandt's interests in the late 1640's. Here the artist employed a specific place—a farmstead probably located along the Amstel River on the outskirts of Amsterdam—and a distilled but powerful technique, to suggest the essential atmosphere and mood of a winter day rather than mere topographical niceties of the Dutch countryside: a half dozen masterfully varied strokes to define a fence and a bare tree in the foreground, a wash through which the grain of the paper itself connotes the texture of snow, and a deft transition of thick to thin line to record the recession of the curving fence toward the tiny windmill on the far horizon. By eliminating all detail, including any human activity, the artist has captured the special qualities of vibrant light, damp air, and muted sound that only such an endlessly flat white world seemingly could engender.

References
S. Slive, "Rembrandt at Harvard," *Apollo* 107/196 (1978), 457; Oberhuber (ed.), 1979, no. 47.

VIEW OF RHENEN

ca. 1645–48
Aelbert Cuyp (1620–91)
Black chalk, yellow and brown wash, and
white gouache on off-white paper,
179 x 500 mm
Gift—John S. Newberry, Jr., in honor of
Paul J. Sachs' seventieth birthday,
1949.33

References
Mongan (ed.), 1949, 194; J. G. van Gelder
and I. Jost, in C. Baer (ed.), *17th-Century
Dutch Landscape Drawings and Selected
Prints from American Collections*, Vassar
College Art Gallery, Poughkeepsie, New York,
1976, no. 50.

273

SIX STUDIES OF HEADS

ca. 1717–18
Jean-Antoine Watteau (1684–1721)
Red, black, and white chalks on tan
(discolored) paper, 222 x 217 mm
Bequest—Meta and Paul J. Sachs,
1965.336

As a memo of fleeting expressions and
momentary attitudes, this sheet is highly
characteristic of Watteau's consummate
and prolific accomplishments on paper.
From a wealth of sketchbooks filled with
acutely observed life studies, he then
chose specific figures to include in paint-
ings; the little boy in the wide-brimmed
hat, for instance, stands behind two other
children in *Iris, c'est de bonne heure
avoir l'air à la danse*, a work purchased
by Frederick II and formerly at Potsdam.
The woman to the boy's left, seen from
four different angles, reappears on a
sheet of studies in the Louvre.

References
Mongan–Sachs, 1940, no. 641, fig. 325;
Sachs Collection Catalogue, 1965, no. 28.

274

PORTRAIT OF THE PAINTER,
BACHELIER

1773
Jean Baptiste Siméon Chardin
(1699–1779)
Pastel on paper, 544 x 442 mm
Gift—Grenville L. Winthrop, 1939.89

References
G. Wildenstein, *Chardin*, Zurich, 1963, 217,
no. 370; P. Rosenberg, *Chardin*, Cleveland
Museum of Art, 1979, 367.

275

THE INFANT BACCHUS ENTRUSTED TO THE NYMPHS

1657
Nicolas Poussin (1594–1665)
Pen and brown ink, brown wash over
traces of black chalk on off-white paper
squared in red chalk, 230 x 375 mm
Gift—Mr. and Mrs. Donald S. Stralem,
1958.290

Unknown before it appeared at auction
in 1958, this drawing is a study for the
painting of 1657, also in the Museums'
collection (no. 195). Comparing the two,
one finds that in addition to certain ad-
justments in figure positions, in the
painting the dawn's rays have replaced
Apollo in his chariot, and an ivy wreath
instead of a halo crowns Bacchus' head.
Although by this time in poor health and
unable to draw with a consistently sure
touch, Poussin nevertheless captured on
paper, partly through an efficacious use
of wash, the luminosity that suffuses the
canvas and elucidates its meaning.

References
A. Mongan, "*The Infant Bacchus Entrusted to
the Nymphs* by Poussin," *Fogg Art Museum
Annual Report*, 1958–59, 29–37; A. Blunt,
The Drawings of Poussin, New Haven, 1979,
82.

276

RECLINING FEMALE NUDE

ca. 1738
François Boucher (1703–70)
Red chalk heightened with white on tan
(discolored) paper, 315 x 415 mm
Bequest—Meta and Paul J. Sachs,
1965.235

References
Mongan–Sachs, 1940, no. 596, fig. 305;
Sachs Collection Catalogue, 1965, no. 29;
R. S. Slatkin, *François Boucher in North
American Collections: 100 Drawings*, Na-
tional Gallery of Art, Washington, D.C., 1973,
45, no. 35.

THE YOUNG GIRL ABANDONED (L'ABANDONÉE)

Jean-Honoré Fragonard (1732–1806)
Black crayon and brown wash, accented
with gum arabic varnish, on cream paper,
338 x 250 mm
Gift—Charles E. Dunlap, 1955.186

L'Abandonée corresponds closely to the
painted *Reverie*, the fifth panel and thus
one of two subsequent additions to the
original *Progress of Love*, the celebrated
series commissioned and later rejected by
Mme du Barry in 1773. The enlarged
group of six instead was installed some
seventeen years later in the home of the
artist's cousin Alexandre Maubert. Re-
cently it has been argued that the
drawing is so very similar to the painting
in particulars of composition and form
that it must be a record rather than a
preliminary study. A notably different
mood, however, is projected by the
sketch, in which the musing young
woman is both more empathetically con-
nected to the viewer and more at one
with her lush arboreal surroundings.

References
E. Williams, *Drawings by Fragonard in North
American Collections*, National Gallery of Art,
Washington, D.C., 1978, no. 61. The *Reverie*
panel is now in the Frick Collection in New
York; for discussion of it and the rest of the
series see *The Frick Collection*, New York,
1968, II (*Paintings: French, Italian and Span-
ish*), 94–120. See also E. Munhall,
"Fragonard's Studies for *The Progress of
Love*," *Apollo* 93/2 (May 1971), 407.

278

THE REST ON THE FLIGHT INTO EGYPT

Giovanni Battista Tiepolo (1699–1770)
Brown ink over traces of black chalk on white paper, 430 x 290 mm
Bequest—Meta and Paul J. Sachs, 1965.418

References
Mongan–Sachs, 1940, no. 347, fig. 172; H. Comstock, "18th-century Italian Drawings at the Fogg Art Museum," *The Connoisseur* CXXV (May 1955), 274–80; *Sachs Collection Catalogue*, 1965, no. 34.

279

A CIRCULAR CHURCH

ca. 1750
Giovanni Antonio Canal, called Il Canaletto (1697–1768)
Brown ink, grey wash on ivory paper, 197 x 329 mm
Bequest—Charles A. Loeser, 1932.327

Although the subject of this drawing is architectural, Canaletto obviously was more interested in atmospheric effects than in structure *per se*. Through modulated tones of wash and sinuous pen strokes, he emphasized the textures of masonry and sculptural details as they would look in the dazzling water-reflected Venetian light, giving the massive domed building an airy, graceful façade. The sketched edifice bears some affinity to the actual church of San Simeone Piccolo, whose appearance the artist had recorded faithfully in 1738, but here it has been transposed to a *veduta ideale*. In his later years, Canaletto increasingly created such "imagined vistas," which enjoyed great popularity with collectors in England, and in fact he probably drew this one during his own residence there. The basic design of the drawing resembles that of a painting in the Worcester Art Museum, where, however, the architectural style is more austere and the surroundings much more circumscribed.

References
Mongan–Sachs, 1940, no. 310, fig. 151; Oberhuber (ed.), 1979, no. 37.

280

PORTRAIT OF THE FAMILY OF LUCIEN BONAPARTE

1815
Jean-Auguste-Dominique Ingres
(1780–1867)
Graphite on white paper, 410 x 532 mm
Bequest—Grenville L. Winthrop,
1943.837

Ingres drew this grand group portrait of the family of Napoleon's brother Lucien in Rome around the time of the Battle of Waterloo. Lucien, in Paris when his wife, children, and stepchildren sat for the drawing, nevertheless appears, suitably elevated on a pedestal, in the form of a sculpted bust by Marin. The Bonaparte matriarch also is symbolically present, the artist having depicted Canova's bust of her as Agrippina. With all its wealth of period details—from toys to musical instruments to the ornate armchair with its winged lion protomes—one would expect to find a number of preparatory sketches; only one, however, of the Viennese fortepiano, is known to exist. Similarly Ingres' method for the final, meticulous execution of his largest portrait drawing has not been discovered, since there are none of the signs of transfer that show on other of his works.

References
Winthrop Retrospective, 1969, no. 103; Cohn and Siegfried, 1980, no. 16; Mongan, forthcoming.

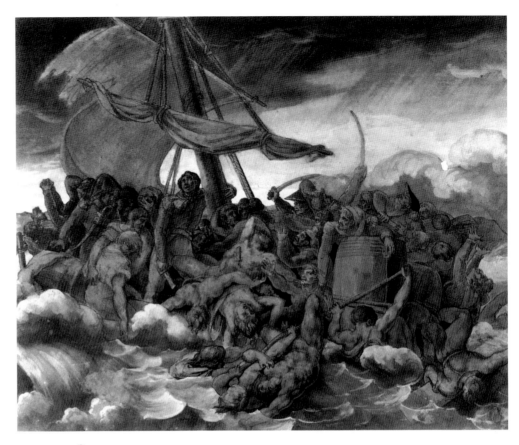

281

THE MUTINY ON THE RAFT OF THE MEDUSA

ca. 1818
Théodore Géricault (1791–1824)
Black chalk, black crayon, white chalk, watercolor, and white gouache on dark brown paper, 405 x 510 mm
Bequest—Grenville L. Winthrop, 1943.824

Géricault drew dozens of preparatory sketches for his painting of the tragic saga of the survivors of the *Medusa*, a French frigate lost off the African coast in 1816; the event had stirred great public sympathy and resulted in political scandal. From among the horrifying tales of murder, insanity, and cannibalism stemming from the thirteen-day predicament of the raft, left to drift by those lucky enough to board lifeboats, the young artist chose to concentrate on several episodes. Here he has shown the mutiny of the soldiers, directing considerable narrative force to the despairing and exhausted officer clinging to the mast,

broken saber still in hand. Executed with powerful chalk lines brushed over with dark washes, it is the most finished study of this theme known. In the final work, first exhibited in the Paris Salon of 1819 and now in the Louvre, Géricault settled on portraying the sighting of the rescue ship.

References
L. Eitner, *Géricault's Raft of the Medusa*, London, 1972, no. 35; *idem*, 1983, 166–68, fig. 155; Mongan, forthcoming. The Museums also have a study for the painting of a family group relating to the mutiny episode (1943.833); see H. Zerner, "Théodore Géricault, Artist of Man and Beast," *Apollo* 107/196 (1978), 481–83, fig. 8.

283

282

PORTRAIT OF FRÉDÉRIC VILLOT

ca. 1838
Eugène Delacroix (1798–1863)
Dark grey and black chalk with some
graphite accents and extensive stumping
accented with very soft charcoal or black
crayon on white paper, 333 x 237 mm
Gift—Meta and Paul J. Sachs, 1949.6

Writing in his journal in 1852, Delacroix
characterized Frédéric Villot (1809–75)
as "a man of merit to whom all the
graces have been denied." In earlier years,
though, the two had been friends, and
Delacroix had painted several portraits,
in addition to executing this perceptive
chalk drawing of the noted critic who be-
came Curator of Paintings at the Louvre
in 1848.

References
The quotation is from W. Pach (trans.), *The
Journal of Eugène Delacroix*, New York, 1961,
262. See also Mongan–Sachs, 1940, no. 682,
fig. 357; *Sachs Collection Catalogue*, 1965,
no. 47; and Mongan, forthcoming.

RELIGIOUS PROCESSION, STUDY
FOR "LOS DISPARATES"

Francisco José Goya y Lucientes
(1746–1828)
Sanguine chalk and wash, grey wash,
traces of black ink on off-white paper,
228 x 329 mm
Bequest—Frances L. Hofer, 1979.55

Almost abstract in its vehement render-
ing is this sketch of a riotous and
drunken religious procession, one of
Goya's favorite satirical topics. It belongs
to a set of preliminary drawings, mostly
from the early 1820's, for the twenty-two
Disparates etchings (later titled *Los
Proverbios*), which were published only
in 1864. Although this is one of several
studies from which a plate either never
was made or since has vanished, it is
evident from both configuration and ma-
terials that it is part of the *Disparates*
series. Goya gave the series this title, sig-
nifying "follies" or "absurdities"; in it
the monstrosities of life, caricatured in
Los Caprichos as specific instances of
aberrance or wickedness, have a more
thoroughly debased human existence. In
the *Procession*, a female figure with
sword raised appears to challenge the
mob; it has been suggested that she per-
sonifies Truth battling the corruption of
the Church.

References
E. Sayre, *The Changing Image: Prints by Fran-
cisco Goya*, Museum of Fine Arts, Boston,
1974, no. 230; P. Gassier, *The Drawings of
Goya*, New York, 1975, 472–73; M. Stuff-
man, *Goya: Zeichnungen und Druckgraphik*,
Städtische Galerie im Städelsches
Kunstinstitut, Frankfurt-am-Main, 1981, 192,
no. L36. About the female figure in the *Pro-
cession* see K. Oberhuber and W. Robinson
(eds.), *Master Drawings and Watercolors. The
Hofer Collection*, Cambridge, Mass., 1984,
no. 39.

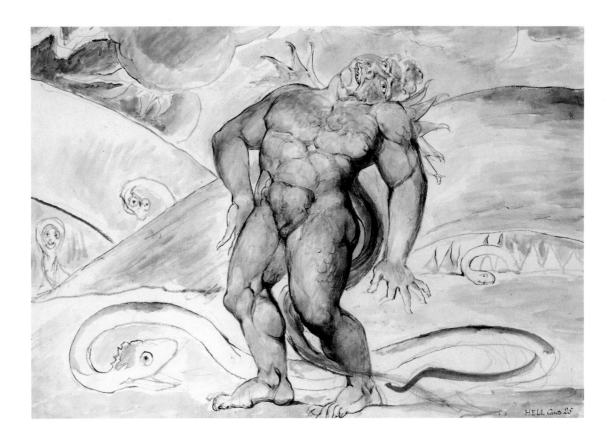

284

AGNOLO BRUNELLESCHI BEING TRANSFORMED INTO A SERPENT

ca. 1824
William Blake (1757–1827)
Watercolor and black ink over graphite
on off-white paper, 370 x 523 mm
Bequest—Grenville L. Winthrop,
1943.432

Akin to Goya (no. 283) in his visionary temperament, Blake was sixty-seven years old and in ill health when he undertook the project, proposed and financed by his young artist-friend John Linnell, to illustrate the *Divine Comedy*. First learning Italian in order to read Dante in the

original, he managed to create one hundred and two drawings—often while propped up in bed—in his three remaining years. All were auctioned in 1918 by the Linnell family, and twenty-three came to Harvard through the Winthrop bequest. The scene reproduced here is the second of four depicting the torments, in the eighth circle of hell, of five members of the Florentine nobility who had become notorious robbers. Agnolo Brunelleschi, having been attacked by a fellow thief who already had been transformed into a six-footed serpent, now suffers a similar fate. Bereft of human company, he has as witnesses only four snakes who look on ghoulishly as he sprouts the wings, tail, claws, and scales of a Satanic reptilian monster (Canto XXV, lines 33–70). The *Divine Comedy* drawings not only visualized Dante's text but also often provided a gloss by which Blake made analogies with his own writings; thus for the artist, the significance of this punishment—the bestializing of the sinner—lay in the loss of the spiritual side of man's dual nature, a theme he had himself explored.

References

For full discussion of iconography and its relation to other of Blake's works see A. S. Roe, *Blake's Illustrations to the Divine Comedy*, Princeton, 1953, 107–9; M. Klonsky, *Blake's Dante*, New York, 1980, 149, pl. 55; M. Butlin, *The Paintings and Drawings of William Blake*, New Haven, 1981, 572, no. 812/52. The drawings for the *Divine Comedy* are in varying stages of completion, and only seven engravings were made from them.

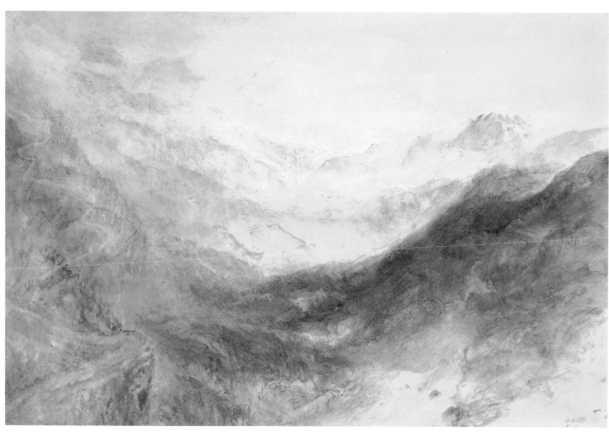

285

SIMPLON PASS

After 1841
Joseph Mallord William Turner
(1775–1851)
Watercolor and gouache on cream paper,
380 x 552 mm
Gift—Edward W. Forbes, 1954.133

References
Cohn and Rosenfield, 1977, no. 61; A.
Wilton, *J. M. W. Turner*, New York, 1979,
no. 1566.

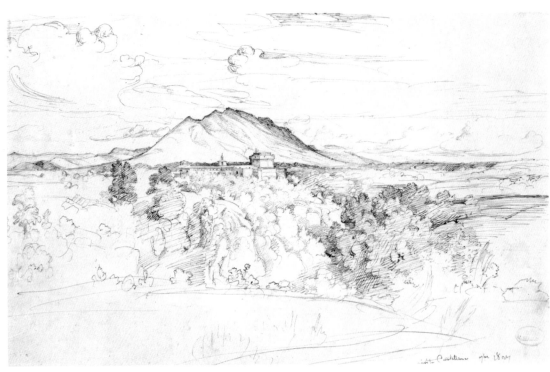

286

VIEW OF MOUNT SORACTE
FROM CIVITÀ CASTELLANA

1827
Jean Baptiste Camille Corot
(1796–1875)
Brown ink over graphite on cream paper,
280 x 415 mm
Bequest—Meta and Paul J. Sachs,
1965.247

"Le dessin est la première chose à cher-cher . . ."; this landscape drawing, in its unequivocal mapping of the particular terrain and bright, clear air of the Roman *campagna*, proves how closely Corot followed his own axiom. It is one of numerous works that the artist drew or painted in the summers of 1826 and 1827 at Cività Castellana, a town in the countryside to the north of Rome, where he was staying for the first time. The awesome silhouette of Mt. Soracte looming out of the open plain already had sparked description in verse—by Horace and Virgil and by Corot's near contemporary Byron in *Childe Harold* (1818). In the same year as he made this drawing, Corot for the first time exhibited his paintings, also Italian landscapes, at the Paris Salon.

References
Mongan–Sachs, 1940, no. 650, fig. 328; R. Shoolman and C. E. Slatkin, *Six Centuries of Master Drawings in America*, New York, 1950, 138; *Sachs Collection Catalogue*, 1965, no. 49; Mongan, forthcoming.

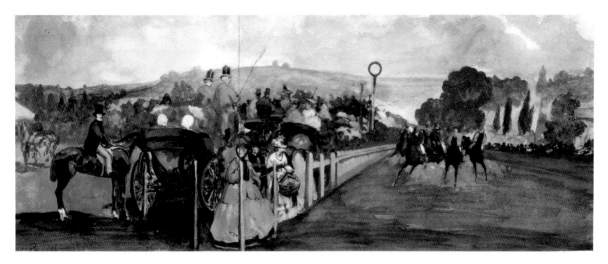

287

RACE COURSE AT LONGCHAMPS (RECTO)

1864
Edouard Manet (1832–83)
Watercolor and gouache over graphite on white paper, 221 x 564 mm
Verso: *Sketch of Grandstand Area*, graphite
Bequest—Grenville L. Winthrop, 1943.387

Like the later oil painting held by the Museums (no. 216), this watercolor shows Manet recording the latest French vogue. Horseracing, a sport imported from England, became an established facet of Parisian life only in the 1860's; at the time of the sketch, newspapers published not only racing results, but also gossip about and illustrations of the spectators, who came from all social strata and walks of life. Longchamps, in the Bois de Boulogne, was a particularly well-appointed and fashionable track, and here Manet showed it to full advantage. Departing radically from traditional grandstand viewpoints (derived from English sporting prints), it is as if he placed the observer in the middle of the course, with the horses galloping forward. By this device, he both enhanced the excitement of the event and was able to include those same details of the colorful and chic crowd that were being reported in the press. In purely formal terms, the young artist created arresting surface patterns that vie with the diagonal recession into depth, and produced a bold range of hues, particularly in the jockeys' silks, that heightens the decorative effect.

Only seven such works, of which two are fragments, are known. The Museums' watercolor, which also has a sketch of the grandstand on the verso, is the most complete version of the six pieces, including Manet's most famous lithograph, that are related in composition.

References
J. Harris, "Manet's Race-Track Paintings," *Art Bulletin* 48 (1966), 78–82; *Winthrop Retrospective*, 1969, no. 117; T. Reff, *Manet and Modern Paris*, National Gallery of Art, Washington, D.C., 1982, 129–32.

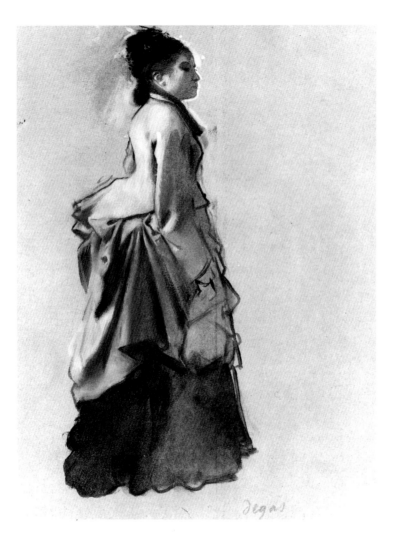

288

A YOUNG WOMAN IN STREET COSTUME

ca. 1867–72
Edgar Degas (1834–1917)
Black wash and white gouache on buff
paper, 325 x 250 mm
Bequest—Meta and Paul J. Sachs,
1965.260

References
Mongan–Sachs, 1940, no. 669, fig. 345;
Sachs Collection Catalogue, 1965, no. 58; J. S.
Boggs, *Drawings by Degas*, City Art Museum
of St. Louis, Mo., 1967, no. 62.

289

STUDY FOR PORTRAIT OF JULIE BURTEY

ca. 1863–66
Edgar Degas (1834–1917)
Graphite with touches of white chalk on
white paper, 361 x 272 mm
Bequest—Meta and Paul J. Sachs,
1965.254

This portrait study demonstrates the fruits of Degas' intense study of the Italian masters, particularly those of the 15th century, and even more of Ingres, whose sophisticated pencil technique (e.g., no. 280) he translated fluently. Executed before the emergence of Degas' fully personal style, the drawing nevertheless reveals, in its refined linear description and lucid geometric structure, the aptitude of the young draftsman. An inscription identifies the sitter as Julie Burtey (formerly read as Julia Burtin), a seamstress who lived at Rue Basse du Rempart, 2, Paris. The drawing of her is a study for the painted *Femme en robe noire*, which was listed as no. 85 in the catalogue of Degas' first sale; a separate study of her head, with the date 1863, is in the Clark Art Institute, Williamstown, and a sketchbook in the Bibliothèque Nationale in Paris has a study of her hands.

References
Mongan–Sachs, 1940, no. 663, fig. 339;
Sachs Collection Catalogue, 1965, no. 55; J. S. Boggs, *Drawings by Degas*, City Art Museum of St. Louis, St. Louis, Mo., 1967, no. 47; G. Weisberg, *The Realist Tradition*, Cleveland Museum of Art, 1981, 30. For identification of the sitter, see T. Reff, *The Notebooks of Edgar Degas*, Oxford, 1976, 111 (Notebook 22, pp. 37, 39, 41); G. Adriani, *Edgar Degas: Pastelle, Ölskizzen, Zeichnungen*, Cologne, 1984, 349, no. 55.

CAFÉ-CONCERT

ca. 1887–88
Georges Seurat (1859–91)
Black chalk and white gouache on buff
paper, 307 x 234 mm
Bequest—Grenville L. Winthrop,
1943.918

Executed by rubbing black chalk over fibrous white paper, this drawing is one of four such pieces depicting a *café-concert* that the Neo-Impressionist Seurat exhibited in the Paris Salon des Indépendants of 1888. If the subject matter is typically Impressionist, the treatment of it is not; rather than particularizing an instant of lighting and action, the artist sought to convey a sense of enduring ambience and mood through the use of theoretical, objective principles. The work may dazzle us by its lush texture and its virtuoso solution to the problem of showing an audience and orchestra in deep darkness against the brilliance of stage lights, but it is the underlying geometric harmony that Seurat himself undoubtedly valued most highly. As in his late paintings, he has used the Euclidean golden section as his basis of organization in searching for an "esthétique universelle," the major keys here being the line of footlights and the front profile of the singer. Even the angle of the conductor's baton plays a precise part in the proportional schema. As has been demonstrated cogently, the almost identical drawing in the Rhode Island School of Design's Museum of Art must be seen as a trial piece for this one, in which the compositional relationships are further perfected and to which the artist signed his name.

Reference
J. H. Rubin, "Seurat and Theory: The Near-Identical Drawings of the Café-Concert," *Gazette des Beaux-Arts* 76 (1970), 237–46.

FOUR FIGURES IN A PARK

1875
Adolph Menzel (1815–1905)
Gouache on cardboard, 195 x 147 mm
Bequest—Grenville L. Winthrop,
1943.91

Reference
See in general J. C. Jensen (*et al.*), *Adolf Men-*
zel. Gemälde, Gouachen, Aquarelle,
Zeichnungen, Druckgraphik, Schweinfurt,
1981.

292

PORTRAIT OF A MAN

1867
Wilhelm Leibl (1844–1900)
Black ink with scratch-work highlights
on brown paper, 270 x 234 mm
Bequest—Grenville L. Winthrop,
1943.530

Reference
Busch-Reisinger Museum, 1980, 140.

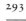

PORTRAIT OF A YOUNG GIRL

1881
William Michael Harnett (1848–92)
Black crayon and grey wash with touches
of white on grey-brown paper,
495 x 413 mm
Bequest—Meta and Paul J. Sachs,
1965.120

Known primarily as the most important
painter of *trompe-l'oeil* still life in late
19th-century America, Harnett made
very few drawings. This portrait, done in
Munich when he was in his early 30's, is
associated with only two other heads in
crayon, both of young men. Harnett him-
self stated that he finished only two
portrait sketches, and that he "attached
little value to them." The modern viewer,
however, no doubt can see in this work
the same pristine similitude, precise tex-
turing, and full tangibility that grace his
canvases.

References
American Art at Harvard, 1972, no. 90; T. E.
Stebbins, *American Master Drawings and Wa-
tercolors: A History of Works on Paper from
Colonial Times to the Present*, New York,
1976, 207–8; M. Sadik and H. F. Pfister,
American Portrait Drawings, National Portrait
Gallery, Washington, D.C., 1980, 88–89.

294

MINK POND

1891
Winslow Homer (1836–1910)
Watercolor over graphite on white paper,
352 x 508 mm
Bequest—Grenville L. Winthrop,
1943.304

Motion in this watercolor is not stopped
as in a snapshot, but merely poised. It is
as if the slightest disturbance would
cause the creatures to dive, flutter, and
leap, and thus abruptly end the still
water's magical transparent and mirror-
ing state, in which we can see not only
the lily's reflection but also its stem rising
up from the murky bottom. Sketched in
the Adirondacks where he often retreated
to hunt and fish, the work exemplifies
Homer's command of color, from the ac-
cents of the primaries in the center to the
somber, muted hues of the background. It

also reveals, in the decorative patterning
and delicacy of detail, Homer's famil-
iarity with Far Eastern art. At the time of
his 1867 trip to Paris, Japanese prints
and ceramics had found great favor fol-
lowing a major exhibition; we can detect
here their lasting imprint on this most
American of artists.

References
Winthrop Retrospective, 1969, no. 115; T. E.
Stebbins, *American Master Drawings and
Watercolors: A History of Works on Paper
from Colonial Times to the Present*, New York,
1976, 241; Wilmerding, 1978, 494; G.
Hendricks, *The Life and Work of Winslow
Homer*, New York, 1979, 297.

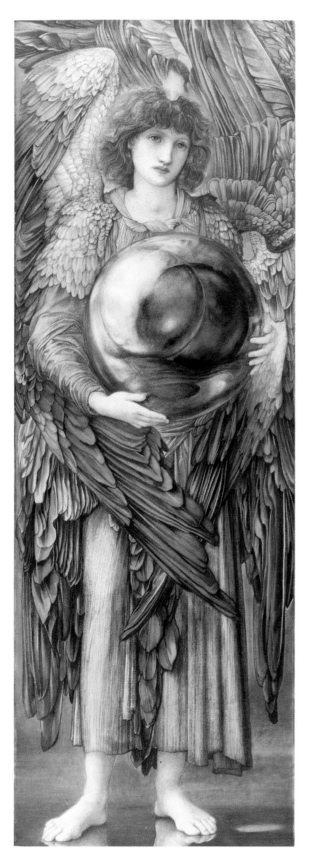

THE DAYS OF CREATION (THE FIRST)

1875–76
Edward Burne-Jones (1833–98)
Watercolor, shell gold (metallic paint),
and gouache on linen, mounted on paper,
stretched over a wood panel,
1019 x 356 mm each
Bequest—Grenville L. Winthrop,
1943.454–59

When they were first shown at the
Grosvenor Gallery in 1877, the *Days of
Creation* were hung within a single
sumptuously decorated frame of Renais-
sance style. This unifying device no
doubt amplified the narrative effect of the
six panels, in which the crystal spheres,
held by angels, consecutively disclose the
events of the first days of the world as
recounted in Genesis. Through the fifth
day, each presenting angel joins his fel-
lows; on the sixth, an extra, lyre-playing
angel completes the action by musically
praising God's work. The opalescent
colors and rich textures are similarly cu-
mulative, so that by the final day, feathers
and flowers proliferate over the entire at-
tenuated field. Burne-Jones had conceived
the design in 1870 after seeing in the
British Museum a tarot card, then be-
lieved to be by Mantegna, and already
had employed the scheme for a series of
stained-glass window panels in a North-
amptonshire church (1873).

References
*Paintings and Drawings of the Pre-
Raphaelites*, Fogg Art Museum, Cambridge,
Mass., 1946, no. 25; Cohn and Rosenfield,
1977, no. 9; F. Spalding, *Magnificent Dreams:
Burne-Jones and the Late Victorians*, Oxford,
1978, 16.

296

THE PEACOCK SKIRT

1894
Aubrey Beardsley (1872–98)
Black ink on white paper, 230 x 168 mm
Bequest—Grenville L. Winthrop,
1943.649

The commission to illustrate Oscar
Wilde's *Salomé* (1894) gave Beardsley
the perfect opportunity to explore his
own idiosyncratic obsession with wicked-
ness as well as to display his gifts as a
draftsman. From its theme of evil-doing
and its exotic setting came some of his
most remarkable inventions, of which the
Peacock Skirt (pl. II in the series) is a
particularly well-known example. The
decorative motifs derive from Whistler's
influential *Peacock Room* of 1876–77
(now in the Freer Gallery, Smithsonian
Institute), but the artist adapted them to
his own highly individual, stylized mode
of representation. Large blocks of white
and black are juxtaposed dramatically,
with stippled and hatched details and
hard, taut lines adding to the air of
impending maleficence. Through the
Winthrop bequest, the Museums came to
house a significant proportion of the
Salomé drawings.

References
B. Reade, *Aubrey Beardsley*, Victoria and Al-
bert Museum, London, 1966, pl. 17; K. Clark,
The Best of Aubrey Beardsley, New York,
1978, 80.

PEASANT OF THE CAMARGUE

ca. 1888
Vincent Van Gogh (1853–90)
Brown ink over graphite on white paper,
494 x 380 mm
Bequest—Grenville L. Winthrop,
1943.515

Van Gogh painted as well as drew Patience Escalier, whom he described in a letter to his brother Theo as "a sort of 'man with a hoe'" who strongly resembled their father but whose features were "more ordinary and bordered on a caricature." This drawing differs from the other known portrayals in that the sitter is shown facing forward and without his garden tool; its detailing and large scale imply that it was meant as a finished work. Set off by the relatively stark whiteness of the hat and jacket, the choppy, agitated strokes of the background seem to oscillate against and around the gnarled physiognomy, defined by even denser, more variegated lines. If Escalier was a lookalike for Van Gogh's father, his portrait also bears a strong family resemblance to the artist's painting of himself from the same year (no. 221), where colors and brushstrokes, particularly in the background, play an analogous psychologically intensifying role.

References
Mongan (ed.), 1949, 192; *Winthrop Retrospective*, 1969, no. 125; Jones, 1985, 52, fig. 42.

298

MONT STE-VICTOIRE (RECTO)

1889–90
Paul Cézanne (1839–1906)
Watercolor and graphite on buff paper,
309 x 467 mm
Verso: *Mont Ste-Victoire*, graphite,
1883–85
Gift—Mr. and Mrs. Joseph Pulitzer, Jr.,
in honor of Agnes Mongan, 1977.173

Cézanne drew and painted Mont Ste-
Victoire, a peak in his native Provence, all
his working life; just as in his still lifes
(nos. 224, 225), he used the actual form
as a vehicle to define and redefine pic-
torial structure. In this example, he
sketched the mountain from the same
viewpoint on both sides of the page, first
in pencil alone, then with the addition of
watercolor. The latter version, illustrated
here, relies very little on graphite. In-
stead, the artist characteristically built up

the angular shapes of the mountain and
the house at its base, and the more cur-
vilinear shapes of the trees, with daubs of
the brush that coincide only sporadically
with the lines beneath. Thus volumes
were constructed from individual facets
of color, and voids as well as solids par-
ticipate in articulating the contour of the
landscape.

References
Pulitzer Catalogue, III, 1971, no. 154; V. de
Mazia, "Expression," *The Barnes Foundation.
Journal of the Art Department* V/2 (Autumn
1974), 19–21, pl. 34.

299

HEAD OF A MAN WITH A HAT

1912
Pablo Picasso (1881–1973)
Papier collé: charcoal, graphite, grey
wash(?), laid paper and newsprint on
white laid paper, 573 x 479 mm
Gift—Anonymous, in memory of
Frederick B. Deknatel, 1979.18

Reference
G. Tinterow, *Master Drawings by Picasso*,
Fogg Art Museum, Cambridge, Mass., 1981,
no. 40.

300

MOTHER AND CHILD AND FOUR STUDIES OF HER RIGHT HAND (VERSO)

1904
Pablo Picasso (1881–1973)
Black crayon on tan paper,
338 x 267 mm
Recto: *Self-Portrait Standing*, black ink,
1903
Bequest—Meta and Paul J. Sachs,
1965.318

In this gentle, unadorned portrayal of a
mother holding her baby, we see Picasso
moving away from the angular severity of
his late Blue Period style (for an early ex-
ample, see no. 226). The tiny sketch in
the upper right corner gives his quick for-
mulation of the design: a woman, with
head lowered and turned to the right,
raises her right shoulder in a cradling
position. In the expanded version, where
the focus of her attention is included, this
latter stylized motif of the hitched shoul-
der is a key element. Used in other works
of about the same time, it serves here to
emphasize the protective tenderness—
slightly awkward and tentative—of the
young mother. The worked-up drawing
in turn was a study for a gouache of 1905
(now in a private collection in Paris); the
artist repeated the carefully shaded head,
but as these trial sketches indicate, he
found the right hand more problematic,
and fixed upon the bottom one for the
later piece.

References
Mongan–Sachs, 1940, no. 741, fig. 399;
Sachs Collection Catalogue, 1965, no. 66; G.
Tinterow, *Master Drawings by Picasso*, Fogg
Art Museum, Cambridge, Mass., 1981, no.
12b.

301

LANDSCAPE

ca. 1907–08
Piet Mondrian (1872–1944)
Charcoal, white and red chalks on brown
paper, 940 x 1390 mm (sight)
Purchase—Contemporary Art Fund, and
Gift—Allan Stone, Class of 1954,
1963.122

Mondrian wrote of his youthful work in
Toward the True Vision of Reality, "I
often sketched by moonlight—cows rest-
ing or standing immovable on flat Dutch
meadows, or houses with dead blank
windows." Here we see, through a copse
of tall, densely leaved trees, both shadowy
animals and darkened buildings against a
moonlit sky. R. Welsh of the University of
Toronto has found that Mondrian often
made large charcoal drawings like this
one in his studio, preparatory to paint-
ings and following smaller preliminary
sketches in oil made outdoors. Though
nothing is known of a final painted ver-
sion, several of these initial studies—
some including a moon and from differ-
ing vantage points—do exist. In this huge
"studio" piece, with its assiduously
rubbed charcoal surface heightened with
white and red chalk to suggest the ten-
ebrous scene, we can see links both to
Mondrian's artistic inheritance and to his
future innovations. Still rooted in the tra-
dition of Dutch landscapes, the drawing
demonstrates, by its underlying structure
of horizontals and verticals and by its
strong curvilinear forms receding into
depth, the abstract concerns that would
absorb Mondrian after his introduction
to Cubism.

References
See the notice by E. Rauh in the *Fogg Art
Museum Newsletter* I/4 (May 1964). R.
Welsh's information is from a letter in the Mu-
seums' archives.

A LADY WITH A NECKLACE

1936
Henri Matisse (1869–1954)
Black ink on white paper, 540 x 450 mm
Bequest—Meta and Paul J. Sachs,
1965.307

One is struck as much by the eloquent,
decorative flexibility of line in this draw-
ing as by its expressive ability to project
the strong personality of the sitter.
Known for her "plastic splendour, beauty
and expression of face, intelligence and
wit," the Russian Lydia Delectorskaya
modeled many times for Matisse, includ-
ing several sessions in this Balkan blouse,
the exuberant detail of which clearly de-
lighted him. If the success of this drawing
lies partially in its seemingly effortless
suggestive power, it is enlightening to
read the artist's own words of 1939: "My
line drawing is the purest and most direct
translation of my emotion. Simplification
of means allows that. But those drawings
are more complete than they appear to
some people who confuse them with a
sketch . . . the drawings are always pre-
ceded by studies made in a less vigorous
medium . . . it is not until I feel ex-
hausted by that work . . . that I can with
a clear mind give run to my pen without
hesitation."

References
Mongan–Sachs, 1940, no. 735, fig. 394;
Sachs Collection Catalogue, 1965, no. 73;
Jones, 1985, 37, fig. 22. For the quotation see
R. Escholier, *Matisse*, New York, 1960, 155.

303

THE PARADE

1954
Fernand Léger (1881–1955)
Gouache on off-white paper,
730 x 1025 mm (sight)
Gift—Professor and Mrs. Josep Lluis
Sert, 1964.61

References
On the final work in the Guggenheim Museum
and other related studies see P. de Francia,
*Peter de Francia on Léger's 'The Great Pa-
rade,'* London, 1969, 25–30; and idem,
Fernand Léger, New Haven, 1983, 246–50.

304

HIGHLAND LIGHT (NORTH TRURO)

1930
Edward Hopper (1882–1967)
Watercolor over graphite on white paper,
423 x 653 mm
Purchase—Louise E. Bettens Fund,
1930.462

References
American Art at Harvard, 1972, no. 146;
Cohn and Rosenfield, 1977, no. 25.

305

FRUIT AND SUNFLOWERS

ca. 1924
Charles Demuth (1883–1935)
Watercolor over graphite on white paper,
457 x 297 mm
Purchase—Louise E. Bettens Fund,
1925.5.3

Now also known for his topical oil paint-
ings of industrial buildings, the American
Charles Demuth had an abiding interest
in still life, in which fruits and flowers
became the transmitters of color and
form. Demuth traveled to Paris three
times, and we can see here the results of
his productive encounters with Cubist
art: in the dialogue between surface dec-
oration and spatial illusion; in the
geometric ordering of volumes; and in
the pictorial use of a single element to
perform multiple functions, in this case
the blue and white cloth that acts both as
a vase and a table covering. The Fogg was
one of the first major institutions to rec-
ognize this artist's distinctive talents
when it acquired the watercolor in 1925.

References
American Art at Harvard, 1972, no. 136; *Ten
Americans, Masters of Watercolor*, Andrew
Crispo Gallery of Art, New York, 1974, pl. 42;
Cohn and Rosenfield, 1977, no. 16.

STUDY FOR THE NORTHAMPTON MADONNA AND CHILD

1943 (misdated 1942)
Henry Moore (1898–)
Graphite, white wax crayon, grey-black watercolor or ink wash, black and orange crayon, pen and black ink on off-white paper, 225 x 176 mm
Gift—Paul J. Sachs, 1958.24

This drawing is a study for the Madonna and Child carved in green Hornton stone for the church of St. Matthew's in Northampton, England; the sculpture was commissioned by the vicar, who had been touched by Moore's drawings of mothers with children in air-raid shelters during the bombing of London in 1940–41. For the artist, the piece marked a return to a favorite subject and a brief reversal from his abstracting works of the previous decade (no. 154 is an example from the 1950's) to a representational mode. The technique of the drawing—in which strong highlights first were applied with a greasy medium that repelled the dark wash—emphasizes the plastic values that were to be translated into stone. The massive, simplified forms, from the unornamented "throne" to the mother who supports but does not cradle the child, echo Moore's own exhortation that the theme of the Madonna and Child should "have an austerity and a nobility and some touch of grandeur (even hieratic aloofness). . . ."

References
Sachs Collection Catalogue, 1965, no. 74; Wasserman, 1971, no. 24. For the sculpture see H. Read, *Henry Moore. Sculpture and Drawings*, London, 1949 (3rd ed.), I, pl. 56 j, k.

307

STUDY FOR "THE CALENDARS"

ca. 1946
Arshile Gorky (1904–48)
Charcoal and colored chalks on a ground
of rubbed charcoal heavily modeled by
erasures, on paper mounted on board
and stretched, 834 x 1024 mm
Gift—Lois Orswell, 1976.78

Arshile Gorky's complex and often pri-
vate subject matter only recently has
begun to yield up the full richness of its
meaning. Although the shapes in the de-
sign drawing, for instance, at first appear
to be almost without external reference,
they in fact represent the artist with his
family in his own house. From surviving
preliminary studies and from photo-
graphs of the final painting (destroyed by
fire in 1961), one can trace Gorky's ex-
ploration of the theme and come to
"read" his highly personal symbols. The
Museums' drawing shows the completed
composition as it was to be executed in
oil: the artist, reading a newspaper or
journal, stands on the right behind his
wife, who holds their younger daughter;
the family dog lies on a rug in the center,
in front of glowing lamps, a blazing log
fire, and possibly a baby carriage; the
older daughter sits in a large wing chair
on the left, gazing through a window at a
landscape beyond. High on the walls are
the two illustrated calendars for which
the work was named, one—a "pinup"
variety—with a graphically-depicted fe-
male torso, the other with a nature scene.
Once the semi-secret visual code has been
deciphered, one can see that the Arme-
nian artist—a refugee from his Turkish-
occupied homeland and parentless from
the age of fifteen—was not merely por-
traying a familiar domestic scene but
paying homage to a deeply-felt aspect of
his life. The title itself, along with *Mak-
ing of the Calendar* and *Days, Etc.*,
subsequent paintings continuing the
theme and vocabulary, extolls the idea of
the marking and treasuring of special
moments with loved ones.

References
H. Rand, *Arshile Gorky: The Implications of
Symbols*, Montclair, N. J., 1981, 115–38;
Jones, 1985, 92, fig. 87.

308

THE YELLOW EAR

1946
Alexander Calder (1898–1976)
Watercolor on off-white paper,
660 x 985 mm (sight)
Gift—Richard H. Solomon, 1981.120

Reference
See in general J. Lipman, *Calder's Universe*,
Whitney Museum of American Art, New York,
1976.

UNTITLED (STUDY FOR SCULPTURE "AGRICOLA I")

1951
David Smith (1906–65)
Black ink, grey gouache, and reddish-brown watercolor on off-white paper, 575 x 464 mm (sight)
Gift—Lois Orswell, 1974.148

Smith, who said that he made 300–400 large sketches a year, explained that "the need, the drive to express can be so strong that the drawing makes its own reason for being." Often his ideas remained only on paper, but this example is one of several studies for the sculpture *Agricola I* (Joseph H. Hirshhorn Collection) that was executed in painted steel and was the first of a series of over twenty (1951–59) to include bits of agricultural implements in welded constructions. Recorded at the upper right of the sheet is a first unsuccessful attempt: "illfated cast iron junked Aug. 6, 1951/remake in steel."

References
Wasserman, 1971, no. 37. For the sculpture see *David Smith 1906–1965: A Retrospective Exhibition*, Fogg Art Museum, Cambridge, Mass., 1966, fig. 25.

310

UNTITLED

1974
Richard Diebenkorn (1922–)
Acrylic on paper, 608 x 474 mm
Purchase—Funds from the National
Endowment for the Arts and the
Deknatel Purchase Fund, 1978.94

311

UNTITLED

1981
Katherine Porter (1941–)
Charcoal, gouache (or poster paint),
crayon on buff paper, 664 x 1014 mm
(sight)
Acquired through the Deknatel Purchase
Fund, 1981.84

This dynamic drawing demonstrates the
tempestuous landscape–cosmic-linked
imagery of Porter's work in recent years.
The basic abstract components—three
intersecting "targets" in black, white,
and grey with red and amber accents,
framed by a maroon semicircle above and
a large grey semicircle below—radiate
lines, wedges, and a coil that suggest
either colliding celestial bodies or cata-
clysmic natural disasters such as the
tornadoes of her native Midwest, and
topographical features such as moun-
tains. The motion-charged, light-emitting
energy of the radiating elements is
enhanced both by the corona-like emana-
tions from the central orbs and by the
way both circles and rays shoot out of the
picture edge drawn around the funda-
mentally symmetrical format of round
and jagged shapes. The artist's titled can-
vases in this mode add a significant
political and historical context (as in her
works relating to El Salvador) to the
purely painterly expressiveness. "My
paintings are about chaos, constant
changes, opposites, clashes, big move-
ments in nature. History, natural things,
short wars. I try to put everything into a
picture. What you see is what you come
up against in the world."

References
S. Westfall review in *Arts Magazine* 55/10
(June 1981), 25–26. K. Porter statement in
Art in America 70/11 (Dec. 1982), 73–74. See
also R. Storr, "Katherine Porter at David
McKee," *Art in America* 71/5 (May 1983),
165–66; and Jones, 1985, 124, fig. 124.

WESTERN PRINTS

EMPEROR AUGUSTUS AND THE TIBURTINE SIBYL

ca. 1466
Master E. S. (active ca. 1450–67)
Engraving, 219 x 146 mm
Bequest—Francis Calley Gray Collection, G2610

An elaborate, decorated arch leads into one of the rare detailed interior scenes designed by Master E. S., the first engraver to sign plates with his initials and the most significant German graphic artist of the third quarter of the 15th century. Active in the area around Lake Constance, he originated an orderly cross-hatching technique, particularly effective in this work for the texturing and shading of ashlar blocks and other architectural elements. The legibly constructed space is the setting for the story from the *Golden Legend* in which Augustus—having asked the prophetess if ever a more exalted sovereign than he would come to be—was shown a vision of the Madonna and Child in glory. In an earlier version of this theme, Master E. S. had portrayed the emperor and the sibyl alone in a landscape; here a group of courtiers attends but does not seem to witness the event directly. The sure contours, refined, sculptural drapery folds, and charming ornamental quality of the entire composition evince both his participation in goldsmiths' work and his knowledge of Netherlandish art. This particular impression, a tribute to Gray's acumen and patience as a collector, was probably the first work by Master E. S. to reach the United States.

References
R. Magurn, "The Print Collection of the Fogg Art Museum," *Harvard Library Bulletin* XII (1958), 37; A. Shestack, *Master E. S.: 500th Anniversary Exhibition*, Philadelphia Museum of Art, 1967, no. 76. See in general, idem, *15th-Century Engravings of Northern Europe*, National Gallery of Art, Washington, D.C., 1967, nos. 4–16.

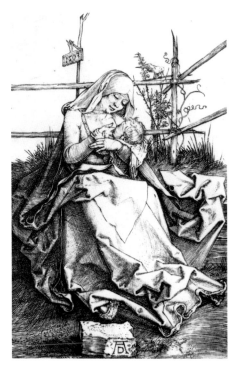

313

314

ST. JOHN ON PATMOS

ca. 1475–80
Martin Schongauer (ca. 1450–91)
Engraving, 161 x 115 mm
Purchase—Dr. Arnold Knapp Bequest
Fund and by Exchange, M13646

Schongauer, a painter of paramount importance (although few of his paintings remain), was also the principal engraver of the generation following Master E. S. His work, like that of his predecessor, indicates knowledge of the goldsmiths' craft, and also reveals his receptiveness to Flemish art. In fact, his close familiarity with Netherlandish panels, especially those of Rogier van der Weyden, suggests that he actually traveled to that region, as well as to Burgundy. This image of St. John, writing the Apocalypse while entranced by a vision of the Madonna (Revelations 12:1), illustrates both Schongauer's absorption of Flemish painting and his advancements in the technique of engraving. In the saint's noble, monumental form, made tangible by the expert control of the burin and the resulting suppleness of the hatching, we can readily comprehend Schongauer's profound influence on the early Dürer (no. 314), and, as his prints were disseminated throughout Germany and Europe, on numerous other artists from Riemenschneider (no. 349) to Michelangelo.

Reference
A. Shestack, *15th-Century Engravings of Northern Europe*, National Gallery of Art, Washington, D.C., 1967, no. 45.

THE MADONNA ON A GRASSY BANK

1503
Albrecht Dürer (1471–1528)
Engraving, 115 x 71 mm
Purchase—Francis H. Burr Memorial, William M. Prichard, Francis Calley Gray, and George R. Nutter Funds, M12972

References
C. W. Talbot (ed.), *Dürer in America: His Graphic Work*, National Gallery of Art, Washington, D.C., 1971, no. 26; *Albrecht Dürer, Master Printmaker*, Museum of Fine Arts, Boston, 1971, no. 61; W. L. Strauss, *The Intaglio Prints of Albrecht Dürer*, New York, 1977, no. 39.

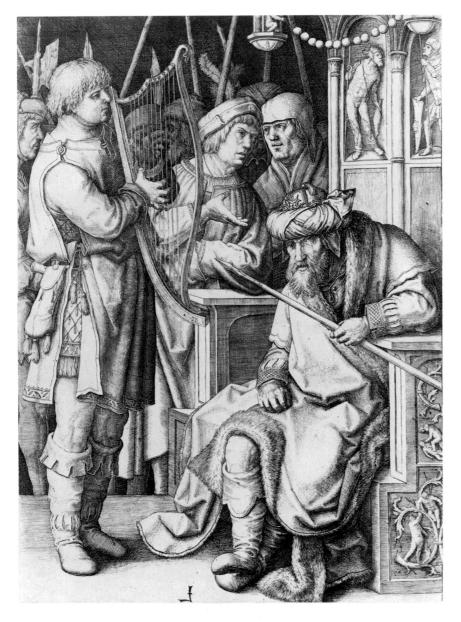

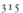

315

DAVID PLAYING BEFORE SAUL

Lucas van Leyden (1494–1533)
Engraving, Bartsch 27, first state,
254 x 183 mm
Purchase—Francis H. Burr Memorial,
M12150

By situating the viewer on the dais, practically next to the ornate throne, Lucas typically magnified the dramatic impact of the scene in which David plays to Saul. By subtly combining signs of the king's tension—clenched teeth and right hand, rigidly crossed feet, unfocused but intense eyes—with hints of relaxation in the slumping shoulders and relatively loose grip on the deadly weapon, he brilliantly conveyed Saul's madness, and pinpointed the climactic moment of the story. Like the anxious courtiers and guardsmen behind the throne, we are left to await the precarious power of David's attempt to assuage the king's murderous *melancholia*. In this exceptionally good impression of an early engraving, it is apparent how Lucas' painterly technique (no. 365), highlighting the two key figures and modulating the tones to the darkness of the background, matches and reinforces his psychological insight.

Reference
E. S. Jacobwitz and S. L. Stepanek, *The Prints of Lucas van Leyden and His Contemporaries*, National Gallery of Art, Washington, D.C., 1983, no. 13, especially for discussion of possible sources in Dürer.

JAN SIX

1647
Rembrandt van Rijn (1606–69)
Etching, drypoint, and burin on Japanese
paper, second state, 242 x 186 mm
Bequest—Francis Calley Gray Collection,
G3284

In the Museums' extensive holdings of
Rembrandt's etchings few are as rare or
as evocative as the portrait of the young
Jan Six, an Amsterdam merchant, hu-
manist, and, later, Burgomaster. The
sitter's nonchalance and the intimate set-
ting befit this friend and regular patron of
the artist. They are also characteristic of
both a deepening grasp of psychology
and an acute observation of reality that
became pronounced in Rembrandt's
works of this period. No less typical is an
increasing formal and technical mastery
of the print medium. The Gray Collec-
tion's impression not only preserves
Rembrandt's line and surface in their in-
tended variety but also renders his fine-
grained atmosphere warm and envelop-
ing. A masterpiece on a small scale, it
portends all that is treasured in the late
Rembrandt.

References
L. Münz, *Rembrandt's Etchings*, London,
1952, no. 70; *Rembrandt: Experimental
Etcher*, Museum of Fine Arts, Boston, and The
Pierpont Morgan Library, New York, 1969,
no. II.

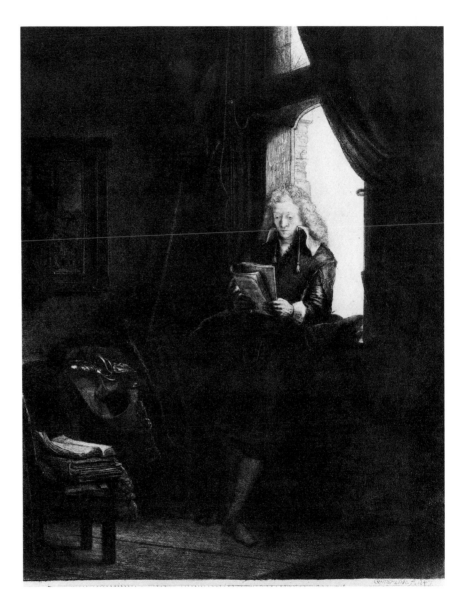

317

318

YOUTH AND GIRL EACH OFFERING THE OTHER AN APPLE

ca. 1470–80
Baccio Baldini (?) (ca. 1436–87)
Engraving, fine manner, brown ink
added, Diam. 119 mm
Bequest—Francis Calley Gray Collection,
G2936

Extant in only one impression, this extraordinarily prescient acquisition by Gray belongs to a group of twenty-four kindred pieces, known as the "Otto" prints after the name of an 18th-century owner.

The prints, mostly with amatory themes such as the one shown here, were intended to decorate the lids of small boxes that young ladies received as love tokens from their admirers. Often a space was left for the addition of a coat of arms; in this example, the six *palle* (balls) of the Medici were added by a contemporaneous hand, also responsible for the inscriptions at the top. The ornamental quality of the design and the elegant forms of the stylish couple demonstrate the "fine manner" of printing characterizing one of two distinctive techniques employed by early Florentine graphic artists.

References
A. M. Hind, *Early Italian Engraving*, New York, 1938, I, no. 10, II, pl. 134; R. Magurn, "The Print Collection of the Fogg Art Museum," *Harvard Library Bulletin* XII (1958), 37; B. L. Brown, *Prints and Drawings of the Quattrocento*, Fogg Art Museum, Cambridge, Mass., 1981, no. 46.

THE DESCENT FROM THE CROSS (AFTER RAPHAEL)

ca. 1521–22
Ugo da Carpi (ca. 1479–1532)
Chiaroscuro woodcut, first state,
355 x 281 mm
Purchase—William M. Prichard Fund,
M657

Reference
Rome and Venice: Prints of the High Renaissance, Fogg Art Museum, Cambridge, Mass., 1974, no. 37.

319

BATTLE OF THE TEN NUDES

ca. 1470–75
Antonio Pollaiuolo (1432–98)
Engraving, second state, 393 x 580 mm
Bequest—Francis Bullard in memory of
his uncle, Charles Eliot Norton, M377

Leaving aside the complex and unre-
solved questions regarding icono-
graphical interpretation, possible
prototypes, and relations to other of
Pollaiuolo's works (no. 249), we can focus
on the image and its singular place in
evolving Quattrocento graphic art. Ex-
ceptional in its monumental scale, it is
the only print known by the versatile
Pollaiuolo, and the earliest known to be
executed and signed by a major Italian

artist. In spite of its gruesome theme, it is
a beautifully structured design of
counterpoised figures set against a deco-
rative background of plants and vines,
while the individuals represent a tour de
force of modeling the human form in
movement. If it is true that the *Battle*
belongs in part to the long tradition of
pattern-sheets, it is also true that it is
markedly innovative in technique, con-
tent, composition, and expressivity. No
doubt Pollaiuolo's experience as a niellist
and draftsman contributed to his inge-
nuity with the burin; no doubt his direct
study of anatomy and antique works and,
as has been suggested, his possible aware-
ness of Alberti's *Treatise on Sculpture*,
contributed to his unsurpassed ability to
display tensed musculature. With his
skills and understanding, Pollaiuolo's use
of reversed and complementary poses af-
forded the opportunity to demonstrate
every inch of the warriors' straining

bodies, and it is hardly surprising that the
piece had an immediate and long-lasting
effect on other artists.

References
For iconography and prototypes see especially
L. S. Fusco in J. A. Levenson, K. Oberhuber,
and J. L. Sheehan, *Early Italian Engravings
from the National Gallery of Art*, Washington,
D.C., 1973, no. 13. The engraving is, generally
speaking, in the "broad" as opposed to the
"fine manner" (no. 317), but the various kinds
of strokes and their combinations are distinc-
tive to the artist. For technique, style, and
context, see also L. D. Ettlinger, *Antonio and
Piero Pollaiuolo*, Oxford, 1978, 31–35, and
no. 15.

320

IMAGINARY VIEW OF PADUA
(ALSO CALLED MURANO)

Giovanni Antonio Canal, called Il
Canaletto (1697–1768)
Etching, first state, 297 x 432 mm
Gift—Belinda L. Randall (from the John
Witt Randall Collection), R2968

The *Imaginary View of Padua* is from a
series of etchings—"some representing
actual sites, others imaginary," as Ca-
naletto described on the title plate—of
Venice and the mainland environs. Dedi-
cated to the British Consul Joseph Smith,
Canaletto's greatest benefactor, the series
was the artist's first venture in print-

making, and most likely occupied him
during the eleven years before he left
for England in 1746. As in his draw-
ings (no. 279), he concentrated on at-
mospheric effects, using the etching
needle as well as the white areas of the
paper to portray tonal contrasts and gra-
dations produced by sun, clouds, and
water. In this bustling city scene, the wide
road to the bridge provides a dazzling
foil both to the densely worked foliage
and mill of the foreground, and to the
rich textures of the buildings and walls
silhouetted against the hazy sky beyond.
This vivid impression is also representa-
tive of the Museums' fine group of
Canalettos and, in general, of 18th-
century Italian etchings.

Reference
R. Bromberg, *Canaletto's Etchings*, London,
1974, no. 11.

321

THE BLACKSMITH'S SHOP
(AFTER JOSEPH WRIGHT OF
DERBY)

1771
Richard Earlom (1743–1822)
Mezzotint, first state, 606 x 433 mm
Bequest—Francis Calley Gray Collection,
G1162

Reference
J. E. Wesseley, *Richard Earlom*, Hamburg,
1866, no. 122.

322

JUNCTION OF THE SEVERN AND THE WYE (PL. 28 [EP] FROM THE LIBER STUDIORUM)

1811
J. M. W. Turner (1775–1851)
Etching and mezzotint, first state,
208 x 289 mm
Purchase—Francis Calley Gray Fund,
G5044

This riverscape comes from part six, published on the first of January 1811, of Turner's *Liber Studiorum*. An ambitious graphic project—seventy out of a planned one hundred prints were issued in sets of five from 1807 to 1819—it was modeled after Claude Lorrain's *Liber Veritatis*, which was in the collection of the Duke of Devonshire as of 1720 and was made accessible in Richard Earlom's (no. 321) printed version of 1777 (supplemented from 1803 on). Claude, whom Turner revered, may have provided the inspiration, but the purposes of the two *Liber*s differed radically, the earlier one being a sketched record of paintings that the French master made for himself and his heirs. Turner, on the other hand, declared his intent in the subtitle: "Illustrative of Landscape Compositions, viz. Historical, Mountainous, Pastoral, Marine, and Architectural." That is, he undertook to demonstrate publicly the broadest possible scope of his talents as a landscape artist (each plate being initialed according to its category). Like Claude, he drew on his own previous works for the series, but for the majority he made fresh sketches of both imaginary and real scenes in preparation for the plates, more in the spirit, for instance, of his predecessor Canaletto (no. 279). Eighty-three preparatory drawings for the *Liber Studiorum* are kept in the British Museum as part of the Turner bequest; the print illustrated here is ultimately based on a watercolor of ca. 1798.

The *Junction of the Severn and the Wye*, an example of an "Epic" or "Elevated Pastoral," the artist's sixth actual category, was the first plate on which Turner did all the mezzotinting as well as the basic etched structure. It reveals an acuity with graphic techniques—thoroughly in keeping with his abilities in pen and sepia—in rendering both subtle modulations and dramatic contrasts of light on the cliffs and the banks of the Wye as it bends sharply toward the vast expanse of the Severn estuary and the distant hills.

References
A. Wilton, *The Life and Work of J. M. W. Turner*, London, 1979, 87–89; G. Wilkinson, *Turner on Landscape. The 'Liber Studiorum,'* London, 1982, 67–70.

323

RUE TRANSONAIN, LE 15 AVRIL 1834

Honoré Daumier (1808–79)
Lithograph, 357 x 512 mm
Museum Purchase, M13712

The *Rue Transonain* appeared in the July issue of *Association Mensuelle Lithographique*, published by the fervent republican Charles Philipon. One of Daumier's most trenchant political condemnations, it recounts the ruthless massacre by government troops of "insurgents" on the night of April 14th, 1834. Far from exploiting the sensational potential of the event, Daumier chose to portray, completely without rhetoric, the awful silence of the aftermath: the dawning light reveals, beyond the disarrayed bed and overturned chair, the slain, bare-legged but dignified figure of a robust young man, a symbolic citizen victimized by the inept constitutional monarchy of Louis-Philippe; underneath and to either side of the corpse lie a child and other innocent casualties. The simplicity of design and the mastery of execution, in which all incidentals to the one dreadful revelation of senseless slaughter have been suppressed, testify to the twenty-six-year-old artist's mature control of the lithographic medium as well as to his sagacity as a social commentator.

References
R. Rey, *Honoré Daumier*, New York, 1966, 15–17; R. Passeron, *Daumier, Témoin de son temps*, Paris, 1979, 104–7.

324

THE BALLOON

1862
Edouard Manet (1832–83)
Lithograph, trial proof, 395 x 510 mm
Museum Purchase, M13710

References
T. Reff, *Manet and Modern Paris*, National
Gallery of Art, Washington, D.C., 1982,
no. 98; *Manet*, Galeries nationales du Grand
Palais, Paris, 1983, 133–36, no. 44.

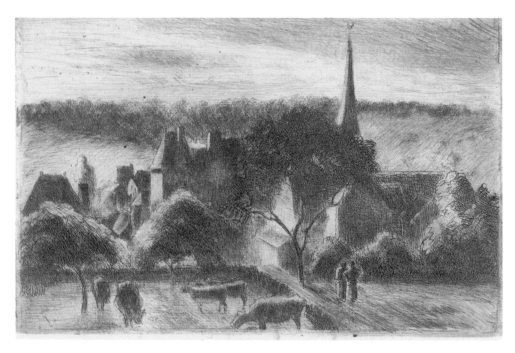

325

CHURCH AND FARM AT ERAGNY

1894–95
Camille Pissarro (1830–1903)
Color etching, sixth state, fifth color
state, no. 3, 158 x 245 mm
Gift—Robert Walker in honor of Jakob
Rosenberg, M19867

Pissarro, beyond any other Impressionist
painter, was drawn to the possibilities of
the graphic arts; more than two hundred
lithographs, monotypes, and etched
plates attest to his activity in these media.
Particularly during the several years of his
collaboration with Degas (beginning in
1879), he experimented with a multitude
of new and unorthodox intaglio tech-
niques, achieving markedly innovative
effects of painterly textures and im-
pressionistic opticality. This landscape
scene, which recently has been dated to
1894–95 on the bases both of its close
relation to a painting of 1895 (now in the
Louvre) and of Pissarro's concentration
on color etching after he had acquired his
own press in 1894, is representative of

the artist's method of working in series.
The Museums' impression is the third of
four constituting the fifth color state of
an image that already had evolved
through six states in black and white. In
the color series, Pissarro varied the use of
red, blue, and yellow plates over one of
three key plates ranging from grey to
black, exploring permutable conditions
of atmosphere and light. The fifth state,
with its emphasis on rose, lemon-yellow,
and blue-green, evokes the quiet time
of sunset in the village, after a fresh,
lucid day.

References
B. Shapiro, *Camille Pissarro. The Impression-
ist Printmaker*, Museum of Fine Arts, Boston,
1973, illus. (frontis.); *Pissarro*, Hayward Gal-
lery, London, 1980, no. 185.

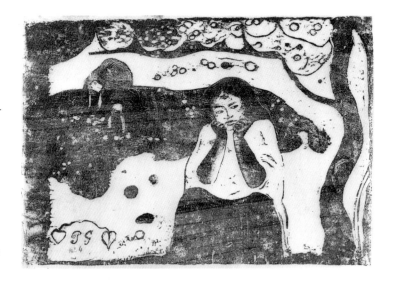

MISÈRES HUMAINES (SOUVENIR DE BRETAGNE)

Paul Gauguin (1848–1903)
Woodcut, 205 x 290 mm
Museum Exchange, M12045

Reference
M. Guérin, *L'Oeuvre gravé de Gauguin*, Paris, 1927, no. 69.

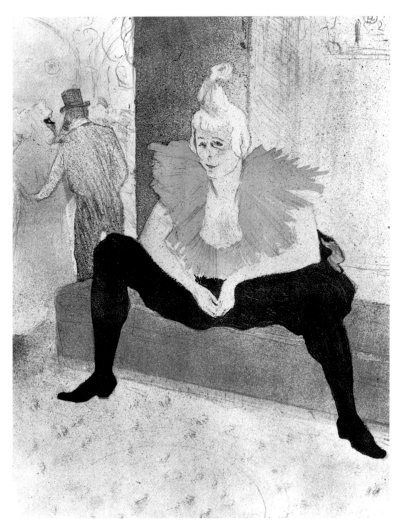

326

327

LA CLOWNESSE ASSISE (FROM ELLES)

1896
Henri de Toulouse-Lautrec (1864–1901)
Lithograph, 528 x 400 mm
Museum Purchase, M13499

One of eleven lithographs published in 1896 in the suite titled *Elles*, *La Clownesse assise* exemplifies Toulouse-Lautrec's command of that medium as well as his lifelong interest in the novel characters and stylish ambience of the theater, circus, and cabaret (also no. 222). The bold composition, graceful contours, and succinctly captured features of Mlle. Cha-u-ka-o immediately draw the spectator into this apparent moment of interlude during a performance.

Reference
L. Delteil, *Le Peintre-Graveur Illustré*, Paris, 1920, XI, no. 180.

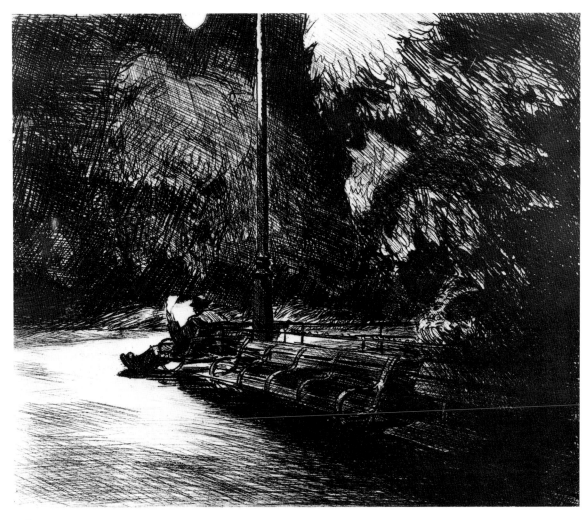

328

NIGHT IN THE PARK

1921
Edward Hopper (1882–1967)
Etching, 174 x 210 mm
Gift—George J. Dyer, M10100

Except for two drypoints of 1928, Hopper executed all his prints, both drypoints and etchings, between 1915 and 1923. Particular in method and materials, he did most of his own printing, and limited (with one exception) each plate to a maximum of one hundred impressions; he believed that "the best prints were done on an Italian paper called 'Umbria' . . . the whitest paper I could get. The ink was an intense black that I sent for . . . in London. . . ." In *Night in the Park*, he used these opposing values of heavy inking against clearly wiped portions—i.e., the densely worked and overhanging foliage and receding plane of the empty foreground benches versus the hard glare from the lamppost on the deserted path and the lone man's newspaper—to create the essence of isolation and potential danger in the urban night. Like Rembrandt (no. 271), the artist he most esteemed, Hopper showed himself in this piece to be a master of the art of omission and suggestiveness.

References
G. Levin, *Edward Hopper: The Complete Prints*, New York, 1979, 21, pl. 80; F. Carey and A. Griffiths, *American Prints 1879–1979*, British Museum, London, 1980, no. 62; B. Wallen (ed.), *The Gloria and Donald B. Marran Collection of American Prints*, Santa Barbara Museum of Art, 1981, no. 38; E. S. Jacobowitz and G. H. Marcus, *American Graphics 1860–1940*, Philadelphia Museum of Art, 1982, no. 52.

329

RUE DES RATS

1928
Stuart Davis (1894–1964)
Lithograph, 342 x 546 mm
Transfer—Graphic Rental Program,
M15568

While in Paris for more than a year,
Stuart Davis executed his first prints, a
dozen black and white lithographs all
linked to later paintings of Parisian street
views; the example shown here has its
equivalent in *Rue des Rats, No. 2*
(1929), a canvas in a private collection.
These works demonstrate a temporary re-
turn to a more representational mode,
but as in *Rue des Rats*, the planar styl-
ized structures and their configuration
are still related to his earlier abstractions

founded in Cubist collage. Also, the simi-
larly roughened textures of sky, street,
and right-hand wall serve to animate the
surface and add to the two-dimensional
effect generated by this artist who be-
came possibly the principal American
modernist in the 1930's. The Museums
received from the estate of Stuart Davis
his daily journal covering over twenty
years of his mature activity. This vast
body of written comment on art theory
and political and social issues is an im-
portant primary source for scholarship
on Davis' role in the modern movement
in America.

References
America in Print, Hirschl and Adler Galleries,
New York, 1981, no. 111; E. S. Jacobowitz
and G. H. Marcus, *American Graphics
1860–1940*, Philadelphia Museum of Art,
1982, no. 79. In general see J. R. Lane, *Stuart
Davis. Art and Art Theory*, Brooklyn
Museum, 1978.

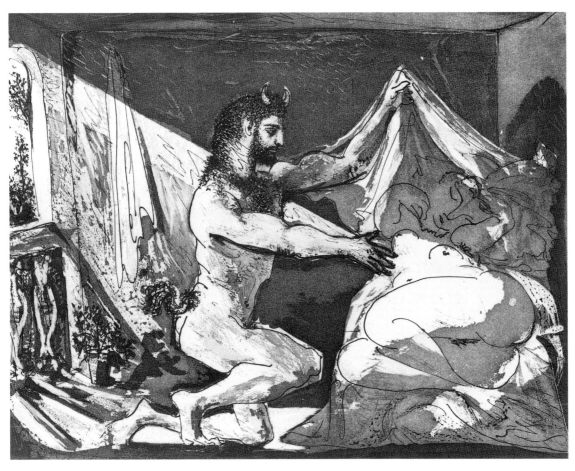

330

SATYR DÉVOILANT UNE FEMME
(VOLLARD SUITE 27)

1936
Pablo Picasso (1881–1973)
Etching and aquatint, 317 x 418 mm
Gift—Meta and Paul J. Sachs, M13164

Done during the year that Picasso became director of the Prado in Madrid, and the year before he painted *Guernica*, this is a particularly fine example from the one hundred prints of the *Vollard Suite* (1930–37), named for the renowned art dealer and publisher (1867–1939) who commissioned it. The last of the twenty-seven discrete sheets (the rest being grouped according to specific themes, i.e., the Battle of Love [5], The Sculptor's Studio [46], Rembrandt [4], The Minotaur [15], and portraits of Ambroise Vollard [3]), it is representative of the neoclassical mode that predominates in the series. At the same time, it is one of only three in which Picasso explored the technique of the sugar or lift-ground aquatint, introduced to him in 1936; here he used the method to create a stunning image of curbed lust. A ray of bright light streams through the window, illuminating and enframing the satyr's posture and eager gesture, and apexing on the torso and thighs of his quarry.

This directed triangle cuts the design diagonally, the upper dark half then setting off the highlighted head and concentrated gaze of the intruder as he lifts the veil from the utterly vulnerable, shadowed face of the sleeping woman. The intensity of these formal and expressive contrasts is softened by the subtlety of the intermediate greys that lend a poetic aura to the otherwise disturbing scene.

References
H. Bolliger, *Picasso's Vollard Suite*, London, 1956, no. 27; *Sachs Collection Catalogue*, 1965, no. 100.

331

ETCHING, NO. 1

1969
Barnett Newman (1905–70)
Etching, 376 x 603 mm
Gift—Annalee Newman, M20186

Reference
H. Rosenberg, *Barnett Newman*, New York, 1978, no. 228.

332

BARCELONA SERIES (PROOF OF NO. 6)

1944
Joan Miró (1893–1984)
Lithograph, 699 x 522 mm
Gift—Joan Miró, M15233

Through the mediation of the architect Josep Lluis Sert, the Museums were most fortunate in receiving one of the two intact *Barcelona Series*, the other three sets intended for sale having been divided up. This example from the total group of fifty lithographs typifies the fanciful, often wittily erotic imagery characteristic of the suite, finished in Barcelona during a period when Miró felt the need to work more freely. Here he has spotlighted a large male anthropoid accompanied by a

small female; the two are surrounded by a floating barrage of other small figural and anatomical bits, as well as by characteristic Miró shapes suggesting a celestial context (no. 231). The play of textures—for example, "hairy" and "atmospheric"—against the varied linear improvisations has a lively and engaging sensuousness, the whole hinting at the artist's aim to "discover the sources of human feeling" through his own idiosyncratic sign language.

References
In general see S. Hunter, *Joan Miró: His Graphic Works*, New York, 1958, XXVI–XXX; and M. Leiris and F. Mourlot, *Joan Miró, Lithographe*, Paris, 1972, I, 37–45, 54 (illus.).

333

FLAG I

1960
Jasper Johns (1930–)
Lithograph, 440 x 674 mm
Purchase—in memory of Tatyana
Grosman with funds provided by Agnes
Gund Saalfield, Dr. and Mrs. Mark
Mills, and the William Hayes Fogg Art
Museum Fund for the Director, M20192

Although perfectly capable of standing
on its own as an image, *Flag I* ideally
should be viewed with its companions
Flags II and *III* of the same year, a cru-
cial one in the artist's career. The three
lithographs not only represent Johns'
continuing commitment to working in a
series of deliberately restricted motifs but
also show a stylistic turning point when
he moved from the seminal *Flag*, *Target*,
and *Number* paintings of the late 50's to
work in lithography. The human catalyst,
who presented Johns with a lithographic
stone in 1960, was Tatyana Grosman,
founder of the Universal Limited Art
Editions (ULAE), the atelier that she es-
tablished expressly to interest painters in

the art of lithography. For Johns, who
based his prints on his previous works
(the black and white *Flags* are all directly
related to drawings), the new medium
provided an evolutionary opportunity.
Where the earlier encaustic paintings had
virtually broken down the distinction be-
tween real objects and their pictorial
surrogates, the printed transformations
allowed him at the same time to be ges-
tural in the manner of the Abstract
Expressionists and to declare more
clearly than ever the literal flatness of his
work. Thus the heavy crayon strokes al-
most obliterate the predetermined stars
and stripes of the American flag, but the
utter fusion of ink with paper denies the
textural quality inherent in painting on
canvas.

References
R. S. Field, *Jasper Johns: Prints 1960–70*,
Philadelphia Museum of Art, 1970, no. 5;
B. Rose, "The Graphic Work of Jasper Johns,
Part I," *Artforum* 8/6 (Feb. 1970), 39–45.

PHOTOGRAPHS

334

BRIDGE OF SIGHS, ST. JOHN'S COLLEGE, CAMBRIDGE

1844
W. H. Fox Talbot (1800–77)
Calotype, 16.5 x 21 cm
Gift—Margaret W. Weston in honor of
Ansel Adams, P1981.7

"Those who have visited Oxford and Cambridge in vacation time in the summer must have been struck with the silence and tranquility which pervade those venerable abodes of learning. Those ancient courts and quadrangles and cloisters look so beautiful so tranquil so solemn at the close of summer's evening, that the spectator almost thinks he gazes upon a city of former ages, deserted but not in ruins. . . ." Thus Fox Talbot described an Oxford view in *The Pencil of Nature*, a book of photographs with accompanying text that he published in 1844–46. His words apply equally well to this seemingly uninhabited Cambridge from the same period. A contemporary of Daguerre, Fox Talbot began making "photogenic drawings" in 1835 and went on to discover paper negatives and the negative-positive principle, by which prints could be mass produced. A member of Parliament and substantial landowner as well as savant and inventor, this pioneer of the medium photographed art works, "still lives," and people as well as architecture, from details of his home at Lacock Abbey to vistas of Paris, London, and other French and English cities.

References
H. J. P. Arnold, *William Henry Fox Talbot*, London, 1977, pl. 53. The quotation is from G. Buckland, *Fox Talbot and the Invention of Photography*, Boston, 1980, 83.

335

COAL MINERS, PA.

ca. 1908
Lewis W. Hine (1874–1940)
Silver print, 12 x 17 cm
Gift—Walter Rosenblum, P1975.38

Lewis Hine, acclaimed for his records of immigrant families arriving at Ellis Island and for his heroic efforts from 1908 to 1918 to publicize the widespread exploitation of child labor, took an early interest in the adult worker as well. The image of these three men testifies to his fascination with coal miners in particular ("Other workers are just as human, but so much less wonderful . . .") and demonstrates his frank approach to the medium as a means of social commentary. The three miners stand close to the camera, facing the lens, and us, directly. Before the blurred background of their working environment, they are timeless, individualized symbols of the strength and dignity of the common man. As a teacher of photography (ca. 1903–8) at the Ethical Culture School in New York, Hine had a profound influence on the young Paul Strand (no. 336); as a committed participant in the social reform movement of the early twentieth century, he had a concrete effect in heightening public awareness of the deplorable conditions of industrial and farm labor.

References
The quotation is from J. M. Gutman, *Lewis W. Hine and the American Social Consciousness*, New York, 1967, 13. See in general *America and Lewis Hine: Photographs 1904–40*, Millerton, New York (Aperture), 1977.

336

WOMAN, NEW YORK, 1916

Paul Strand (1890–1976)
Silver print, 33 x 25.4 cm
Purchase—National Endowment for the Arts Grant, P1972.175

References
Paul Strand: A Retrospective Monograph, Millerton, New York (Aperture), I (*The Years 1915–1946*), 1972, 15; *Paul Strand: Sixty Years of Photographs*, Millerton, New York (Aperture), 1976, no. 37.

FEMME

1930
Man Ray (1890–1976)
Print from a solarized negative,
29.5 x 22 cm
Purchase—Robert M. Sedgwick II Fund,
P1977.20

The Dadaist–Surrealist painter Man Ray turned to photography, apparently to bolster his income, after moving to Paris in 1921. He became a successful portrait and fashion photographer, but it is his creative works, in which portraiture remained a dominant theme, that allowed him full exercise of his fertile imagination. For Man Ray, the medium was "a marvelous explorer of aspects that our retina will never register"; his image of a friend, Mary Gill, demonstrates his ability to extend our vision. The print from a solarized negative resulted in heavy black outlines and tonal reversals at the edges, creating a dreamlike effect. The sitter, with hand (depicted as if emerging through a balustrade), face, and neck highlighted and set off by the dark contours, is seen against the aura of her own "galvanized" hair; the ambiguous foreground and background planes seem to box her in and hold her away from the real world. In his photograms— cameraless works analogous to Fox Talbot's "photogenic drawings" of a hundred years earlier (no. 334)—as well as in his solarizations, Man Ray sought to visualize the poet Breton's confidence "in the superior reality of certain forms of association hitherto neglected."

References
The quotations are from *Man Ray*, Millerton, New York (Aperture), 1979, 7, 10. See also A. D. Coleman (intro.), *Man Ray: Photographs*, New York, 1975; D. Pratt, "Photography in a Teaching Museum," *Apollo* 107/196 (1978), 499; and Jones, 1985, 132, fig. 136.

BLACK AND WHITE

ca. 1930
Gertrude Käsebier (1852–1934)
Gum bichromate print, 21.5 x 17 cm
Gift—Jean and Julien Levy, P1978.1

Gertrude Käsebier is remembered principally as one of the founders, along with Alfred Stieglitz, of the Photo-Secession group and as a master of pictorialist photography (as opposed to "straight" photography epitomized by, e.g., Paul Strand). However, as this late image of a black washerwoman hanging laundry shows, she was capable of a sensibility dramatically different from that evinced by her earlier romanticized portraits of mothers and children.

Reference
Unpublished prior to its reproduction in D. Pratt, "Photography in a Teaching Museum," *Apollo* 107/196 (1978), 498.

339

WOODEN HOUSES, SOUTH BOSTON

1930
Walker Evans (1903–75)
Silver print, 11.5 x 17.2 cm
Gift—Mr. John McAndrew, P1971.30

Part of a project instigated by Lincoln Kirstein to photograph Victorian domestic buildings in and around Boston, this image is an archetypal example of Evans' pristine treatment of a subject. The hard contrasts brought out by bright sunlight emphasize the ornamental neogothic detail, and the vitality of the cityscape is perhaps best described by a passage in Kirstein's essay for the exhibition of Evans' work at the Museum of Modern Art in 1938: "the power . . . lies in the fact that he so details the effect of circumstances on familiar specimens that the single face, the single house, the single street, strikes with the strength of overwhelming numbers, the terrible cumulative force of thousands of faces, houses and streets." Determinedly independent, Evans met with Stieglitz only once, and of all the images published in *Camera Work*, only Strand's *Woman, New York, 1916* (no. 336) truly inspired him. He did live for a time with his friend Ben Shahn, however, and along with the latter (no. 340) participated in the monumental photographic survey of Depression America sponsored by the Farm Security Administration. In *Wooden Houses*, he already had disclosed his unique stature, again in Kirstein's words, as "a conspirator against time and its hammers."

References
The quotations are from L. Kirstein's essay in *Walker Evans: American Photographs*, Museum of Modern Art, New York, 1938, 196, 197 and see pl. 27. See also J. Szarkowski, *Walker Evans*, Museum of Modern Art, New York, 1971.

340

SHERIFF DURING STRIKE, MORGANTOWN, W. VA.

1935
Ben Shahn (1898–1969)
Silver print, 20.3 x 25.4 cm
Gift—Mrs. Bernarda B. Shahn, P1970.1225

Reference
D. Pratt (ed.), *The Photographic Eye of Ben Shahn*, Cambridge, Mass., 1975, 93.

341

RITUAL BRANCH

1958
Minor White (1908–76)
Silver print, 29 x 23.5 cm
Purchase—National Endowment for the
Arts Grant, P1972.181

References
M. White, *Mirrors, Messages, Manifestations,*
Millerton, New York (Aperture), 1969, 64
(illus.); Jones, 1985, 131, fig. 134.

342

FEET, 133

1958
Aaron Siskind (1903–)
Silver print, 35.2 x 27.9 cm
Gift—Mrs. Phyllis Lambert, P1972.50

Reference
C. Chiarenza, *Aaron Siskind: Pleasures and
Terrors,* New York, 1982, 147–49, pl. 160.

![Portrait of Alexander Liberman, Tatiana Liberman, and Francine du Plessix Gray by Irving Penn, 1954]

343

PORTRAIT OF ALEXANDER LIBERMAN, TATIANA LIBERMAN, AND FRANCINE DU PLESSIX GRAY

1954
Irving Penn (1917–)
Silver print, 23.5 x 18.5 cm
Gift—Alexander Liberman, P1981.22.6

When Alexander Liberman, the newly appointed art director of *Vogue*, hired Irving Penn as his assistant in 1943, he launched both Penn's independent photographic career and a long period of originative work together. As this image of Liberman, his wife, and Francine du Plessix Gray reveals, Penn has captured the world of fashion and the concept of celebrity with a stylized candor that continues to be distinctly his own. Typically, Penn has isolated his subjects in a deceptively neutral studio environment, giving full play to the contrast between the tatty, bare, controlled setting and the cool chic of the sitters; their detached intensity has an eerie power to discomfit and intrigue the viewer. At the same time classicizing and mannered, the image has distilled the essence of individual poise and confidence. Penn has sought the extraordinary in the full range of man's formalized beauty, from French pastry chefs to the Asaro Mud Men of New Guinea, as well as to these sophisticates from the realm of *haute couture*.

References
See in general A. Liberman (intro.), *Moments Preserved. Irving Penn*, New York, 1960, and J. Szarkowski, *Irving Penn*, Museum of Modern Art, New York, 1984.

344

ROOTS, FOSTER GARDEN, HONOLULU

Portfolio I, 1948
Ansel Adams (1902–84)
Silver print, 19.2 x 15.5 cm
Gift—Malcolm S. Millard in memory of his father, Everett L. Millard '98, P1980.154

This image from Portfolio I of 1948 leaves little doubt as to Ansel Adams' imprint on the work of the slightly younger Minor White (no. 341), just as Adams' own acknowledged debt to Paul Strand (no. 336) and the influence of Eugène Atget are manifest. Although one may be drawn first to his stunning, crystalline visions of the American west, Adams' close-up shots display the same sensitivity to light and its role in revealing the subtleties of texture and form at a given moment. Here the sinuous, turgid roots contrast with but seem to shelter the delicate, dense foliage growing amidst them. The photographer's precision of technique and purity of approach to the subject have succeeded in capturing the sublime power and inexhaustible mystery of nature seen afresh.

Reference
J. Szarkowski, *The Portfolios of Ansel Adams*, Boston, 1981, Portfolio I, 8.

CAL, WISCONSIN

1965
Danny Lyon (1942–)
Silver print, 21.6 x 31.8 cm
Purchase—National Endowment for the
Arts Grant, P1972.204

Rather than completely segregate his subjects from their milieu as Penn (no. 343) has done, even with the Hell's Angels, Danny Lyon has photographed them from within it. This print from his book *The Bikeriders* shows Lyon's involvement with motorcycle groups of the mid-60's. He not only followed them from track to track, but actually joined one of the "rebel" gangs, the Chicago Outlaws, and rode with them in 1965–66. Lyon's work thus belongs in the tradition of photography as social documentary, personalized by his own engrossed participation. Lyon also plays up the peripheral status of his subjects; as with the Texas prisoners he subsequently portrayed, the motorcyclists stand on the fringes of society, and his records of them force us to rethink our notions of reality. To Lyon, "these people might live more on the edge of existence, more extreme lives

than others, but they also have more feelings and more reality about them. . . . Why are they 'out' and your society 'in'? . . . Where I live everyone is 'out,' but that is the norm here and therefore they are not out at all!"

References
D. Lyon, *The Bikeriders*, New York, 1968, pl. on p. 44. The quotation is from T. H. Garver (intro.), *Danny Lyon: Ten Years of Photography*, Newport Harbor Art Museum, 1973.

UNTITLED

1983
Lorie Novak (1954–)
C print, 36 x 36 cm
Gift of the Artist, P1983.15

Lorie Novak, who has stated an interest "in everyday environments, and ordinary places that I can turn into something different," also has said that the most vivid images remaining from her childhood in southern California are of domestic interiors. This large color print demonstrates her imaginative photographic translation of such an ordinary interior space. A bed, viewed obliquely from the foot, dominates the room, while projected transparencies made from old snapshots (one of a crowded stadium) add a vibrant touch of nostalgic animation to the strange, quiescent genre scene.

Reference
See in general *American Photographer* 6/2 (Feb. 1981), 48.

BUSCH-REISINGER
MUSEUM

SCULPTURE

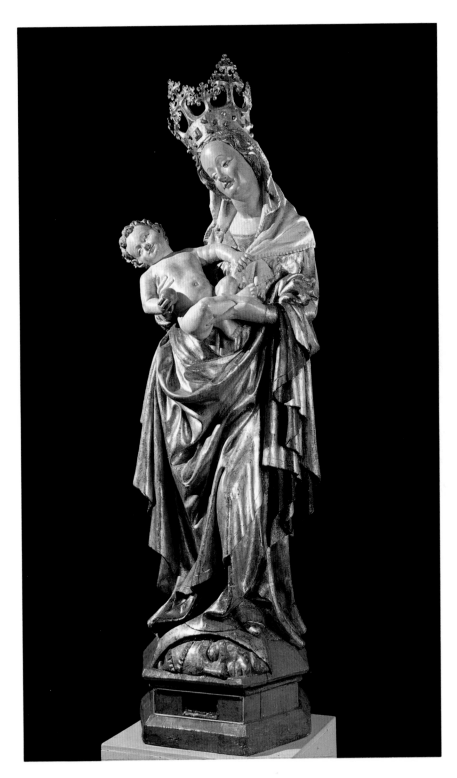

347

THE MADONNA AND CHILD

ca. 1430
Austrian, Tyrolean
Polychromed poplar, 155 cm (including pedestal)
Museum Purchase—Anonymous Funds, BR 1963.2

This devotional image, whose pedestal functioned as a reliquary, is an excellently preserved example of a *schöne* (beautiful) *Madonna*, a figural type that attained great popularity in central Europe in the late 14th and early 15th centuries. From the deep, heavy folds of her precious gold and silver garments, to her rounded facial forms and sweet expression, to details such as the way her fingers gently press into the pliant baby flesh, she is representative of the *weiche Stil* (soft style), the German name given to the sculptural equivalent of the International Style in painting and drawing (e.g., no. 258). Her attributes specifically define her as the Virgin described in the Apocalypse: "a woman clothed in the sun (gold) and the moon under her feet, and on her head a crown." The face within the crescent moon has been identified as that of Adam in Limbo awaiting the redemption promised by the second coming of Christ; his original sin is called to mind by the apple that the Child holds.

References
Kuhn, 1965, no. 9; *Busch-Reisinger Museum*, 1980, 104–5.

ST. JOHN THE EVANGELIST

ca. 1490–1500
German, Lower Swabian
Lindenwood, 126.5 cm (without
baseboards, which are later additions)
Gift—Mrs. Solomon R. Guggenheim,
BR 1964.5

The fervent emotion projected by this fig-
ure of St. John, which most likely once
belonged to a Crucifixion group, is ac-
cented by the central fluted drapery folds
leading to the large uplifted head, whose
curling tresses frame the grief-stricken
face. In both style and expressiveness the
St. John can be compared to the prints of
Master E. S. (no. 312), as well as to the
sculpture of such artists as Conrad Sifer
and Hans Seyfer. The lindenwood piece
originally was polychromed; parts of the
chalk ground remain in crevices of the
drapery.

References
Kuhn, 1965, no. 16 (especially for com-
parisons with other sculpted works); *Busch-
Reisinger Museum*, 1980, 100–1.

349

ST. ANTHONY ABBOT

ca. 1510
Attributed to Tilman Riemenschneider
(ca. 1450–1531)
Lindenwood, 117.5 cm
Purchase—Anonymous and Special Gifts
from the Friends of Charles L. Kuhn,
BR 1969.214

Reference
Busch-Reisinger Museum, 1980, 102–3.

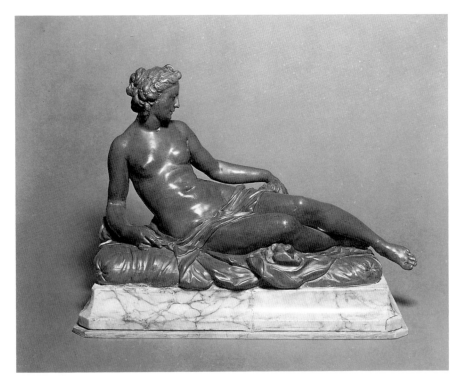

350

RECLINING NYMPH

ca. 1739
Georg Raphael Donner (1693–1741)
Lead statuette on marble base, 28 cm
(including base) x 40.5 cm (figure alone)
Purchase—Museum Association Fund,
BR 1964.7

In contrast to the early Baroque exuberance of the Guggenbichler group (no. 352) is this relaxed, coolly classicizing *Reclining Nymph*. It is closely related to two of the four river personifications that Donner, the preeminent Austrian sculptor of the early 18th century, made for his most notable undertaking, the decoration of the fountain in Vienna's Neuer Markt. Since the lead fountain figures became so badly damaged that they eventually had to be replaced by copies (the originals, along with one other cast of the statuette, are in the Baroque Museum of Vienna), the Museums' almost intact cabinet piece is an invaluable example of Donner's influential and refined style. For the *Nymph*, the artist drew in part on Cellini's celebrated *Nymph of Fontainebleau* (now in the Louvre) of the 16th century (see, e.g., no. 264 for Italian influence at the French Court), transforming it into his own conception of ideal feminine beauty, enhanced by the courtly attributes of luxurious cushions and pampered lap dog.

References
Kuhn, 1965, no. 78; *Busch-Reisinger Museum*, 1980, 82–83.

351

TRIUMPH OF A SEA-GODDESS

1530's
Peter Flötner (1485–1546)
Steatite, Diam. 17.5 cm
Purchase—Museum Association Fund,
BR 1951.213

This fine, elaborately decorated steatite relief, portraying a widely used classical subject, shows the strong impact of Renaissance Italy on the northern sculptor. The lively procession of eighteen putti around the circular field in all probability was the model for the base of an ornate vessel in metalwork. It is a particularly valuable survivor of Flötner's carving, since his major monumental works, the Hirschvogel House of Nuremberg and the Fugger Burial Chapel of Augsburg, were demolished in the Second World War, and only a few other of his pieces are known. For this relief, both a preparatory drawing (Herzog Anton Ulrich-Museum, Braunschweig), and a bronze cast (Musée des Arts Décoratifs, Paris) also are extant.

References
Kuhn, 1965, no. 33; *Busch-Reisinger Museum*, 1980, 93.

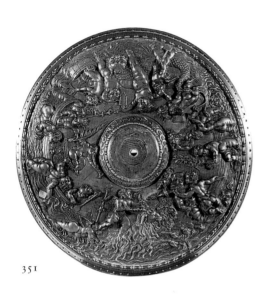

351

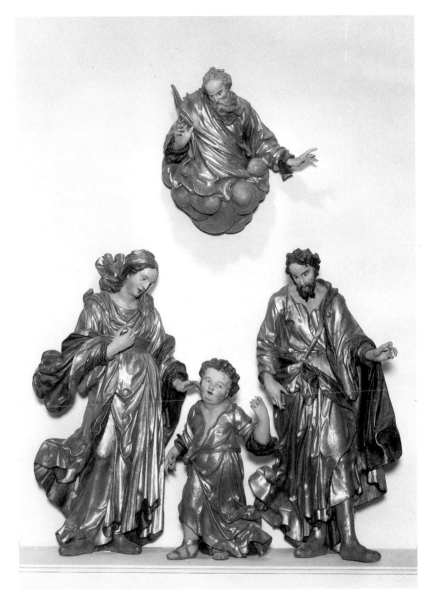

352

**THE RETURN OF THE HOLY
FAMILY FROM EGYPT**

ca. 1690
Meinrad Guggenbichler (traced
1649–1723)
Polychromed lindenwood, Madonna
77 cm, St. Joseph 76 cm, Christ Child
49 cm, God the Father 44.5 cm
Purchase—Museum Association Fund,
BR 1956.275

References
Kuhn, 1965, no. 64; *Busch-Reisinger
Museum*, 1980, 91.

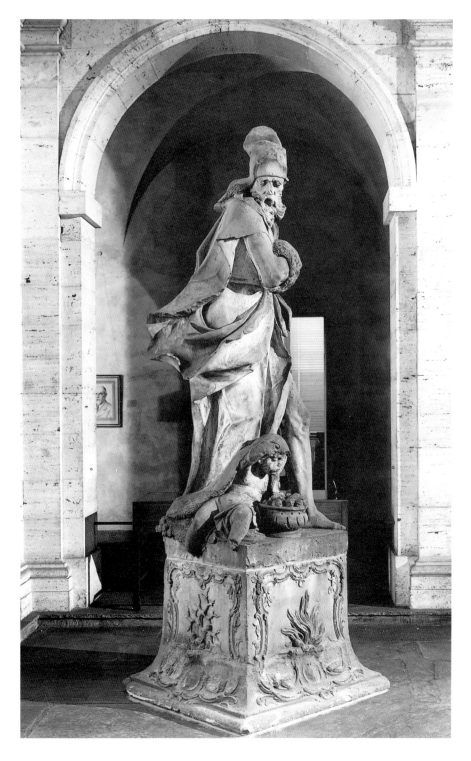

THE FOUR SEASONS (WINTER)

ca. 1760–65
Workshop of Johann Joachim Günther
(1717–89)
Sandstone, 330 cm (including pedestals),
236 cm (figures alone)
Purchase—Alpheus Hyatt Fund,
1952.11a–d

The Four Seasons once graced the gardens of the Palace of Bruchsal, the grand 18th-century residence in Baden of the Prince–Bishops of Speyer. Two other series—*Four Halberdiers* and *The Four Elements*—also assigned to Günther's workshop, remain *in situ* and complete the original group of twelve. In the first rank of German Rococo garden sculpture, *The Seasons*, in spite of losses and weather damage, retain their monumentality and captivating spontaneity. Spring and Summer are personified as elegant, lightly robed young women, while Autumn appears as a mischievous Bacchanalian young man. *Winter*, illustrated here, is an elderly but vigorous figure, who turns away from the blustery weather, his beard and heavy cloak buffeted by the wind. His muscular arms are exposed, but his hands are shoved into a fur muff, as a putto at his feet tries to kindle a coal fire. Carved from full-scale clay models, *The Seasons* must attest to the exceptional level of stonecutting achieved by Günther's assistants.

References
Kuhn, 1965, no. 91; J. Coolidge, "Masterpieces of the German Rococo," *Apollo* (the conflated volume published for the Fogg Art Museum), 1978, 74–75; *Busch-Reisinger Museum*, 1980, 81.

LARGE DAPHNE

1930
Renée Sintenis (1888–1965)
Bronze, 144.8 cm
Gift—Mrs. Charles L. Kuhn,
BR 1959.49

Like Georg Kolbe, Renée Sintenis was
influenced by the sculpture of Rodin. In
this work, we see the attenuated, still-
angular frame of the adolescent nymph
just at the instant in the myth when she
changes into a laurel tree. The meta-
morphosis is emphasized by the trunklike
position of her legs, the uplifted branch-
ing of her arms, and the locks of hair that
already have become leaves. The Busch-
Reisinger also has a smaller cast of the
Large Daphne, which the artist executed
for the garden of the Lübeck Museum in
1930.

References
Kuhn, 1957, 71, 145; *Busch-Reisinger Mu-
seum*, 1980, 80.

DANCER

1914
Georg Kolbe (1877–1947)
Bronze, 63.5 cm
Gift—Anonymous in memory of Minnie
S. Kuhn, BR 1932.64

Prompted by seeing Nijinsky perform,
the Berlin-based artist captured not just a
graceful choreographic pose, but the
inner creative concentration of the fa-
mous Russian ballet dancer in this
bronze statuette. Kolbe began sculpting
in 1903, inspired particularly by the
work of Rodin (no. 148), and we can see
here a similar drive to model light-reflect-
ing surface textures and to animate the
human figure.

References
Kuhn, 1957, 69, 138; *Busch-Reisinger
Museum*, 1980, 76–79.

CONSTRUCTION IN SPACE WITH BALANCE ON TWO POINTS

1925
Naum Gabo (1890–1977)
Black, white, and transparent plastics,
25.6 x 34.9 x Diam. 16.5 cm
Gift—Lydia Dorner in memory of Dr.
Alexander Dorner, BR 1958.46

The thin, interlocking planes and "lines" of this sculpture are entirely in keeping with the ideals of Constructivist art as conceived by Naum Gabo and other creators of the movement in Russia in the second decade of this century. As set forth by Gabo and his brother Antoine Pevsner in their "Realistic Manifesto" of 1920: " . . . art must be based upon two fundamental elements: space and time. Volume is not the only concept of space. Kinetic and dynamic elements must be used to express the true nature of time. The static rhythms are no longer sufficient. . . ." Influenced by developments in physics and making use of man-made substances, they sought "new [nonimitative] forms." The simple geometric shapes cut out of both opaque and transparent plastics conjoin in an intricate and mobile fashion in this *Construction*; the materials, rather than emphasizing mass, have the innovative consequence of incorporating space into the very essence of the design.

References
H. Read and L. Martin, *Gabo: Constructions, Sculpture, Paintings, Drawings, Engravings,* Cambridge, Mass., and London, 1957, no. 36; Kuhn, 1957, 13; *Busch-Reisinger Museum,* 1980, 64–65; *Deutsche Kunst,* 1983, 175–76; Jones, 1985, 104, fig. 99.

LIGHT-SPACE MODULATOR

1923–30
László Moholy-Nagy (1895–1946)
Mobile construction of steel, plastics,
wood, and other materials with an
electric motor, 151.1 cm
Gift—Sibyl Moholy-Nagy, BR 1956.5

Like Gabo (no. 356), Moholy-Nagy was
a singularly innovative sculptor. The
Light-Space Modulator, or *Light Prop
for an Electric Stage* as the artist titled it,
was one of the earliest kinetic and light-
articulated constructions, built during
Moholy's years at the Bauhaus. Elec-
trically powered, the complex of aper-
tured and meshed reflective metal,
plastic, and wood components was meant
to revolve in a dark space against a cy-
clical, alternating flashing of multicolored
lights. The artist's wife Sibyl described
her husband's concept: "Light beams
overlap as they cross through dense air;
they're blocked, defracted, condensed.
The different angles of the entering light
indicate time. The rotation of light from
east to west modulates the visible world.
Shadows and reflexes register a con-
stantly changing relationship of solids
and perforations." In such a way the
Modulator was conceived not only as an
autonomous work of art, but also and
more importantly as a machine for gener-
ating an "architecture of light."

References
The quotation is from S. Moholy-Nagy,
Moholy-Nagy: Experiment in Totality, New
York, 1950, 69. For the background of the
Modulator, for its original plywood box en-
vironment, and for later modifications made
by the artist to keep the fragile mechanism
working see N. R. Piene, "László Moholy-
Nagy's Light-Space Modulator," Howard Wise
Gallery, New York, 1970. See also Kuhn,
1957, 70, 141; *Busch-Reisinger Museum*,
1980, 60–63; and *Deutsche Kunst*, 1983,
186–90.

358

ADAM AND EVE

1936
Max Beckmann (1884–1950)
Bronze, one of an edition of five cast
1958/59, 83.3 cm
Gift—Mr. and Mrs. Irving Rabb,
BR 1976.5

Beckmann, who took up sculpture only
in his last years in Germany, gave to the
Adam and Eve theme his own unique
construction, in which a mammoth,
somnambulent Adam, entwined by the
serpent, holds a diminutive Eve in his
right palm. The artist's sculptural output
was small; this is one of his eight remain-
ing pieces.

References
Busch-Reisinger Museum, 1980, 68–69;
Deutsche Kunst, 1983, 220.

359

CRIPPLED BEGGAR

1930
Ernst Barlach (1870–1938)
Terracotta, 221 cm
Museum Purchase, BR 1931.5

Commissioned to do sixteen figures for
niches in the façade of St. Catherine,
Lübeck, Barlach finished just three before
the National Socialists halted the project.
The series, called *The Community of
Saints*, was finished and installed by
Gerhard Marcks in 1947. Of Barlach's
work, the *Crippled Beggar* came first and
was the sole figure to be cast twice. Ac-
quiring one of these in 1931 (the other
remains in Lübeck), Charles L. Kuhn
made the Busch-Reisinger the first Ameri-
can museum to have a superior example
of the German artist's sculpture. Inspired
by both the medieval objects of his home-
land and the folk art of Russia (where he
had traveled in 1906), Barlach created in
this figure a spare, archetypal image of
earthly suffering and pious hope in divine
recompense.

References
Kuhn, 1957, 67–68, 129–130; *Busch-
Reisinger Museum*, 1980, 70–73; *Deutsche
Kunst*, 1983, 79–80.

360

CUP, SAUCER AND TRAY

1904
Otto Eduard Gottfried Voigt
(1870–1949)
Porcelain, Meissen, cup: 8.3 x Diam. 5.7
cm (at mouth); saucer: Diam. 13.3 cm;
tray: 47.6 x 31 cm
Gift—Mr. J. Jonathan Joseph,
BR 1970.10a–c

Reference
See in general *Meissner Porzellan von 1710 bis
zur Gegenwart*, Österreichisches Museum für
angewandte Kunst, Vienna, 1983.

PAINTINGS

THE MADONNA AND CHILD

ca. 1460's
Dirck Bouts (ca. 1420–75, Flemish
School)
Oil on panel, 29.7 x 21.7 cm
Gift—Mrs. Jesse Isador Straus in
memory of her husband, Jesse Isador
Straus, Class of 1893, 1959.186

Of Dutch background, Dirck Bouts be-
came the official painter of Louvain.
Apparently he executed only a few half-
length Madonnas, and Friedländer as-
signed just four to the artist's hand; in
addition to the one illustrated here, they
are at the Bargello in Florence, the Na-
tional Gallery in London, and the Staedel
Institut in Frankfurt. Intended as a devo-
tional image, the Museums' scrupulously
lighted, refined example is intimate in
scale and follows a type made popular by
the workshop of Rogier van der Weyden
and ultimately, if only indirectly, relating
to that master's famous work *St. Luke
Painting the Virgin* (Museum of Fine
Arts, Boston). Of further interest is an
underdrawing (revealed by infrared ex-
amination) outlining a sole full-length
female nude, the only such motif found
in Bouts' oeuvre.

References
M. J. Friedländer, *Early Netherlandish Paint-
ing*, Leyden, 1968, III, 28–29, pl. 19, no. 11.
Other scholars, however, have questioned the
attribution to Bouts; see C. T. Eisler, *Les
Primitifs Flamands. New England Museums*,
Brussels, 1961, I, pt. 4, no. 69, who attributes
the piece to Bouts' circle and dates it ca. 1475.
For information about the underdrawing see P.
Schubaker, "Jan van Eyck's 'Woman at her
Toilet,'" *Fogg Art Museum Annual Report*,
1974–76, 67; the author links the pose of
Bouts' figure to that of van Eyck's *Judith*. See
also *Busch-Reisinger Museum*, 1980, 56–57.

THE MADONNA AND CHILD
(FOLLOWER OF ROGIER VAN DER
WEYDEN) AND **PORTRAIT OF JOOS
VAN DER BURCH PRESENTED BY A
BISHOP** (FOLLOWER OF GERARD
DAVID)

ca. 1475–1525
Flemish School
Oil on panel, each panel 54.8 x 34.7 cm
Bequest—G. W. Harris in memory of
John A. Harris, BR 1965.22

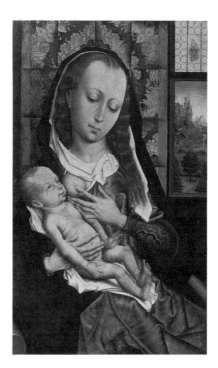
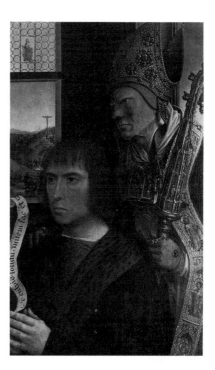

The left-hand panel of this diptych, like
the Bouts painting (no. 361), derives
from the nursing Madonna type of
Rogier van der Weyden. Here, however,
the anonymous follower has included a
charming landscape with allusions to the
Meeting at the Golden Door (the figures
in front of the city gate) and to the purity
of the Virgin (the enclosed garden). The
right-hand panel, undoubtedly painted
later by another hand from the circle of
Gerard David to match the left, also has a
symbolic vista, with a glimpse of the
Road to Calvary and the Crucifixion. In
its present state, the donor portrait of
Joos van der Burch (d. 1496) most likely
is posthumous, made when the panel was
changed from an earlier devotional image
with a likeness apparently of one of Joos'
sons, Simon (d. 1518), to a funerary
monument in honor of the father.

References
For discussion of changes on the right-hand
panel, including those of the coats of arms and
inscriptions on the reverse, and the possibility
that the bishop was painted by yet another
16th-century (?) hand see C. T. Eisler, *Les
Primitifs Flamands. New England Museums*,
Brussels, 1961, I, pt. 4, no. 64. See also *Busch-
Reisinger Museum*, 1980, 55.

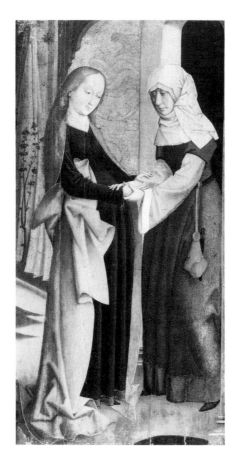

THE VISITATION

ca. 1495
Rueland Frueauf the Elder (active
1470–1507, German School)
Oil on panel, 69.2 x 40.6 cm
Museum Purchase, BR 1965.52

Reference
Busch-Reisinger Museum, 1980, 51.

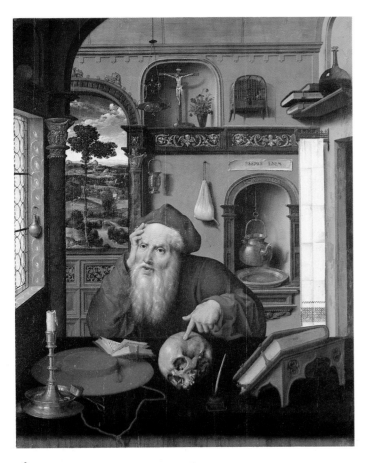

364

365

ST. JEROME IN HIS STUDY

ca. 1521
Attributed to Joos van Cleve the Elder
(ca. 1490–1540, Flemish School)
Oil on panel, 99.7 x 83.8 cm
Gift—Howland Warren, Richard Warren,
and Mrs. Grayson M.-P. Murphy,
BR 1965.17

It is difficult to imagine a more dramatic
contrast to Ribera's penitent *St. Jerome*
(no. 184) than this representation of the
scholarly saint in a comfortable, well-
appointed contemporary northern inte-
rior. A painting of extraordinarily high
quality, it is one of many versions made in
the Netherlands after Dürer's *St. Jerome
in his Study* (now in Lisbon), which was
painted in Antwerp in 1521. The details
of Jerome's surroundings, sharpened and
accentuated by direct and reflected light,
include a wealth of disguised religious
references (as in the snuffed candle allud-
ing to life's impermanence) and also

inform us of the growing Flemish attrac-
tion to Italian classicizing ornament (as
in the cornices and the marble columns
with their gilded capitals) in the early
16th century. The focus, however, re-
mains on the contemplative Jerome, that
model prototype for the humanists of
Erasmus' era and an exemplar for those
caught up in the issues of the
Reformation.

References
C. W. Haxthausen, "The Busch-Reisinger
Museum, Harvard: the Germanic Tradition,"
Apollo 107/195 (1978), 411; *Busch-Reisinger
Museum*, 1980, 46–47. For other versions of
Dürer's model see M. J. Friedländer, *Early
Netherlandish Painting*, Leyden, 1972, IX, no.
39. See also J. Hand, *Joos van Cleve and the
St. Jerome in the Norton Gallery and School
of Art*, West Palm Beach, Fla., 1972, fig. 4.

ANGEL

ca. 1530
Follower of Lucas van Leyden (Dutch
School)
Oil on panel, 35.6 x 27.3 cm
Bequest—Grenville L. Winthrop,
BR 1965.24

Because this painting is only a fragment,
we can focus on the delicate atmospheric
coloration of the distant landscape and
the glowing, ethereal lighting of the sky
and of the heavenly being on the hill-
top—features that proclaim the hand of a
gifted follower of Lucas van Leyden. The
piece probably belonged to an Annuncia-
tion to the Shepherds or a Nativity; the
scene must have been completed by the
upper right-hand and entire lower por-
tion of the original piece.

References
J. Rosenberg, "Early Flemish Painting," *Fogg
Art Museum Bulletin* X/2 (Nov. 1943),
47–49; *Busch-Reisinger Museum*, 1980, 54.

366

PORTRAIT OF A BEARDED MAN AND **PORTRAIT OF A LADY HOLDING A FLOWER**

ca. 1535–40
Barthel Bruyn the Elder (1493–1555, German School)
A. Oil on canvas (transferred from panel), 48.9 x 36.8 cm
B. Oil on panel, 47 x 34.9 cm
Gift—Charles E. Dunlap,
BR 1966.36, 37

Active in Cologne, Barthel Bruyn became the foremost portrait painter in that city. This richly clad and bejewelled pair holds objects referring both to their position in society and to their time of life. The man grasps a script most likely indicating a successful career in commerce, while the woman stands behind a railing on which

is displayed a carnation, a symbol of affiance. Since she also holds a sprig of night-shade, an allusion to death, we can surmise that they were husband and wife, and that the man's likeness is posthumous. The rather severe lighting and vitrified elegance of the works reveal the influence of the Italian mannerists Bronzino and Pontormo.

Reference
Busch-Reisinger Museum, 1980, 48–49.

367

FOREST IDYLL

ca. 1870
Hans von Marées (1837–87)
Oil on canvas, 60 x 76.2 cm
Gift—Erich O. and Kurt H. Grunebaum,
BR 1960.31

Forest Idyll and *Landscape with Women*
(also in the Busch-Reisinger Museum) are
the only paintings in this country by
Hans von Marées. Not yet well known
here, he was a significant 19th-century
German artist whose main sources were
the art of the Renaissance and of antiq-
uity, and who influenced later painters
such as Beckmann (no. 381). *Forest Idyll*,
which demonstrates his classicizing style,
is thought to be the first of several studies
for *Evening Forest Scene* (formerly in the
Nationalgalerie, Berlin). Cut down con-
siderably from its original dimensions,
the sketch in its present state only par-
tially covers over an earlier composition
that had a frontal male nude and a differ-
ent landscape.

References
Busch-Reisinger Museum, 1980, 43; U.
Gerlach-Laxner, *Hans von Marées: Katalog
seiner Gemälde*, Munich, 1980, no. 101.

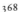

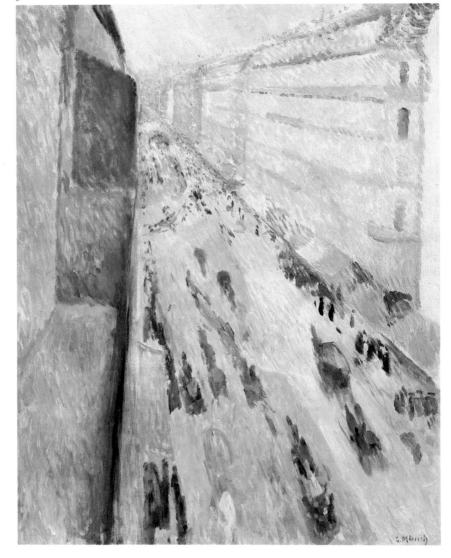

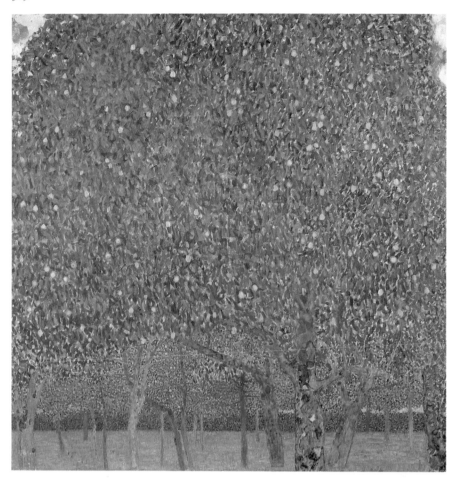

368

RUE DE RIVOLI

1891
Edvard Munch (1863−1944)
Oil on canvas, 79.7 x 64.5 cm
Gift—Rudolf Serkin, 1963.153

Rue de Rivoli dates from the time of
Munch's visits to Paris, where he ab-
sorbed various current styles, including,
as is evident here, those of Impressionism
and Neo-Impressionism. Despite its city-
scape theme, its light color tonality, and
its broken-up brushstrokes, however, the
Norwegian's painting bears little resem-
blance to comparable settings depicted
by Monet and Pissarro. Pissarro's gay,
stately expanse of a similar broad avenue
(*Mardi Gras on the Boulevards*, acc. no.
1951.58), for instance, has been distorted
here into a steep, narrow chute; the
viewer, presumably looking out from a
high balcony, is overwhelmed by the rush
of city traffic and hordes of pedestrians,
and is closed in by the high buildings that
permit only a glimpse of the sky. The jar-
ring combination of violets and yellows
adds to the effect of pessimism and claus-
trophobia, and hints at the darker
interpretations of man's lot that typify
Munch's artistic development.

References
Busch-Reisinger Museum, 1980, 42; *Deutsche
Kunst*, 1983, 44−46.

369

PEAR TREE

1903
Gustav Klimt (1862−1918)
Oil and casein on canvas, 101 x 101 cm
Gift—Otto Kallir, BR 1966.4

References
Busch-Reisinger Museum, 1980, 40; *Deutsche
Kunst*, 1983, 57−59.

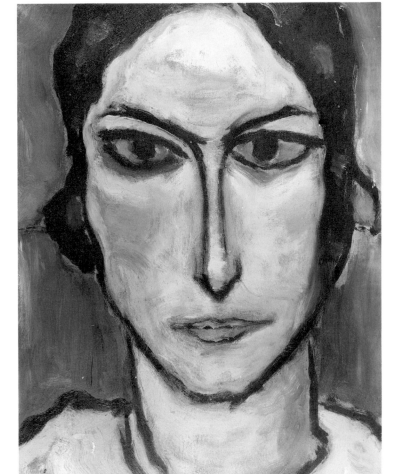

370

HEAD OF A WOMAN

ca. 1911
Alexei von Jawlensky (1864–1941)
Oil on cardboard, 45 x 34 cm
Gift—Charles L. Kuhn, BR 1951.267

Jawlensky, Kandinsky's long-time friend and associate, painted the female head throughout his career. In this particular *Head of a Woman*, done before his later, more abstracting style, we can note both the striking analogies to Fauvist works and the impact of the folk art and religious icons of his native Russia. The vivid primary colors in the horizontal bands of blouse and background are all reflected in the flesh tones and features of the face, which is further emphasized by heavy black contours. Chromatic dissonances, especially in the reds, and details such as the blue whites of the enormous mesmerizing eyes, join with the basic design to set up a formidable, reverberating confrontation with the viewer.

References
Kuhn, 1957, 50, 136; *Busch-Reisinger Museum*, 1980, 38; *Deutsche Kunst*, 1983, 128 (illus.).

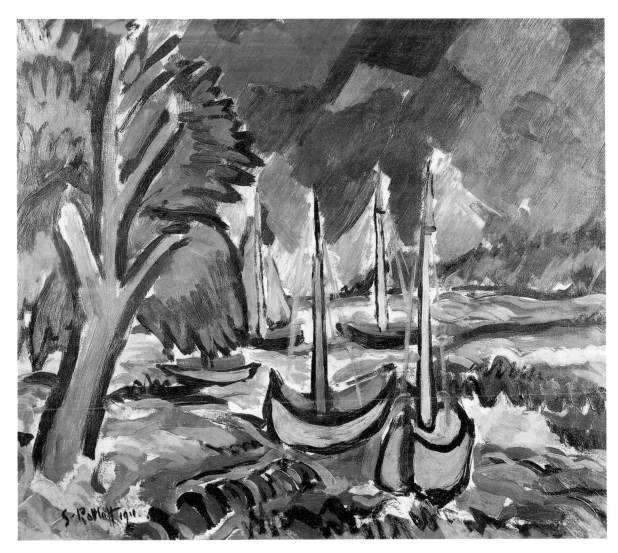

371

HARBOR SCENE

1911
Karl Schmidt-Rottluff (1884–1976)
Oil on canvas, 57.2 x 66.7 cm
Purchase—Museum Association and Eda
K. Loeb Funds, BR 1954.115

References
Kuhn, 1957, 64, 144; *Busch-Reisinger Museum*, 1980, 34 (illus.); *Deutsche Kunst*, 1983, 92–93.

372

TRIPTYCH: TO THE CONVALESCENT WOMAN

1912–13
Erich Heckel (1883–1970)
Oil on canvas, each panel 81.3 x 70.8 cm
Purchase—Edmee Busch Greenough
Fund, BR 1950.415a–c

This imposing triptych is about three years later than the vivacious line drawing *Brother and Sister* (no. 384) and was executed after Heckel had moved to Berlin from Dresden. Not only is it one of his most noteworthy achievements, but also it epitomizes, along with the Nolde painting (no. 373), the strong attraction of the Brücke artists to primitive art as a source for the expression of inner emotion. The subject is a personal one, Heckel having depicted his ailing wife Siddi propped up against pillows, in domestic surroundings. Although the panels are of equal size and the composition is continuous, the wasted body and gaunt face of the center panel is the primary focus of attention. The bouquet of large sunflowers on the right and the chrysanthemums on the left bend toward the sick woman, and the overtly primitivizing objects (most likely Heckel's own works)—the statuette on the left and the carved flowerstand on the opposite side—also face inward as well as echo her own jagged, cult-object-like form. Behind her is an orange patterned Ashanti hanging, an African gift from the artist's brother; it is yet another domestic decoration whose fiery tones enhance the exotic, emotionally charged ambience. Both Heckel and his fellow Brücke artist Kirchner (no. 375) made woodcuts after the central panel.

References

Kuhn, 1957, 49, 135; *Busch-Reisinger Museum*, 1980, 36–37; *Deutsche Kunst*, 1983, 101–3; Jones, 1985, 47, fig. 35.

THE MULATTO

1913
Emil Nolde (1867–1956)
Oil on canvas, 77.5 x 73 cm
Museum Purchase, BR 1954.117

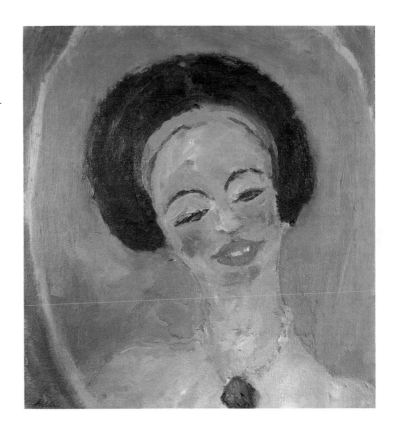

Whereas Heckel (no. 372) based his primitivism on objects to be seen in the ethnographic collections of Dresden, Nolde had the benefit of first-hand experience as well. As a member of an expedition to German New Guinea in 1913, he had ample opportunity to study the cultures of Russia, the Far East, and the South Seas, recording what he saw in a great number of watercolors and pencil drawings. When he came back to Germany the following year, he began turning his sketches into oils. As though set against the blazing aura of a tropical sun, the woman's face itself is aglow with florid pink and scarlet tones; the tactile surface of the heavily and furiously applied paint intensifies the immediate and enigmatic sensuous appeal of the unknown islander.

References
Kuhn, 1957, 60, 142; *Busch-Reisinger Museum*, 1980, 32–33; *Deutsche Kunst*, 1983, 104–6.

374

SUPREMATIST PAINTING, RECTANGLE AND CIRCLE

ca. 1915
Kasimir Malevich (1878–1935)
Oil on canvas, 43.1 x 30.7 cm
Alexander Dorner Trust, BR 1957.128

References
Busch-Reisinger Museum, 1980, 22; *Deutsche Kunst*, 1983, 173–74.

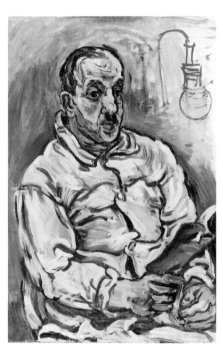

375

SELF-PORTRAIT WITH A CAT

1920
Ernst Ludwig Kirchner (1880–1938)
Oil on canvas, 120.6 x 80 cm
Museum Purchase, BR 1950.12

Kirchner, a founder of Die Brücke along with Heckel and Schmidt-Rottluff (nos. 372, 371), suffered terribly in the First World War, and following a total collapse, went to Switzerland to recuperate in 1917. He remained there for the rest of his lifetime. By the time he painted this *Self-Portrait* in the spring of 1920, he obviously felt a new lease on life. Although the wary expression hints at an inner struggle of will, he showed himself facing the viewer, holding a bunch of flowers—a sign, as in Heckel's triptych (no. 372), of hopeful recovery—and accompanied by his cat Boby. Through the window, the Alpine landscape glistens in the sunlight. The large, simplified forms and the brilliant color scheme, with orange and red prevailing, both add to the sense of renewed spirits and differentiate the work from his earlier, more line-dominated manner and disquieting themes. Kirchner did only a few more self-portraits in the 20's, ending with *Melancholy of the Mountains*, a woodcut of ca. 1928.

References
Kuhn, 1957, 51, 137; D. Gordon, *Ernst Ludwig Kirchner*, Cambridge, Mass., 1968, no. 621; *Busch-Reisinger Museum*, 1980, 31; *Deutsche Kunst*, 1983, 106–9.

376

PORTRAIT OF DR. HEINRICH VON NEUMANN

1916
Oskar Kokoschka (1886–1980)
Oil on canvas, 90.1 x 59.9 cm
Purchase—Museum Association Fund, BR 1952.21

References
Kuhn, 1957, 55, 138; *Busch-Reisinger Museum*, 1980, 29; *Deutsche Kunst*, 1983, 64 (illus.).

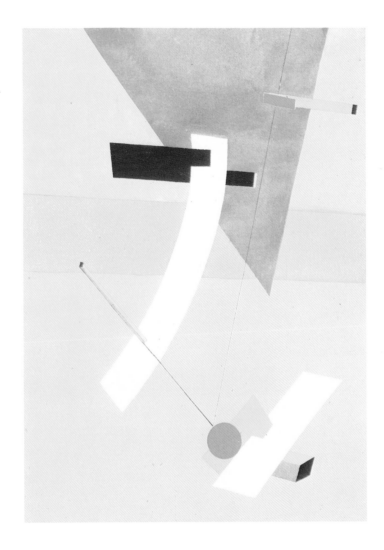

PROUN 12E

ca. 1920–22
El (Lasar Markovitch) Lissitzky
(1890–1941)
Oil on canvas, 57.1 x 42.5 cm
Purchase—Museum Association Fund,
BR 1949.303

Influenced both by Malevich's Su-
prematism (no. 374) and by the work of
the Constructivists, Lissitzky's *Prouns*
also reflect his architectural training,
more directly discernible in his drawn
*Design for a Children's Book, Of Two
Squares* (no. 388). In manifestos of the
1920's, he described Prouns—the term is
an acronym for the Russian abbreviation
Pro Unovis, or "for the affirmation of
what is new in art"—as an "interchange
station between painting and architec-
ture." An advocate of Communism,
Lissitzky was intentionally seeking to
initiate a style that would represent the
post-Revolutionary society. *Proun 12E*,
an intriguing, seemingly weightless spa-
tial interaction of varying textures and
geometric- "architectural" forms (lines,
planes and solids, angles and curves),
aptly embodies his artistic ideals.

References
Kuhn, 1957, 57, 140; *Busch-Reisinger Mu-
seum*, 1980, 26; *Deutsche Kunst*, 1983,
176–79; Jones, 1985, 105, fig. 100.

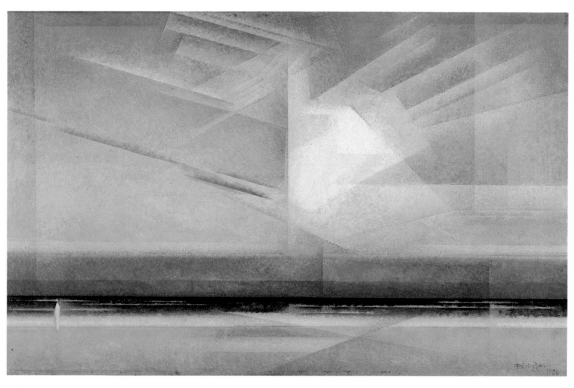

378

BIRD CLOUD

1926
Lyonel Feininger (1871–1956)
Oil on canvas, 43.8 x 71.1 cm
Purchase—Museum Fund in memory of
Eda K. Loeb, BR 1950.414

The title of this painting, one of the art-
ist's most celebrated oils, derives from the
translucent, light-radiating and reflecting
planes of the cloud that fans out, bird-
like, over the sky. The motif's disciplined
and prismatic but magically expansive
geometry is echoed by the patterns on the
wide beach; the low, dark, distant hori-
zon line anchors the sea–skyscape,
observed by a single tiny figure on the

shore. In spite of Feininger's associa-
tions with the Blaue Reiter, the Bauhaus
(no. 391), and the Blaue Vier, he re-
mained nonpartisan in both style and
subject matter; nature, rather than ab-
stract forms or human actions, more
often provided the substance from which
he materialized his personal visions. In
relation to a cloud that he already had
conceptualized, he wrote: "Last night on
the beach there was a mirrorlike smooth-
ness and strange cloud formation. I see
colors here at the sea, indescribable. . . .
The day before yesterday, all the colors of
the rainbow were present in an incredible
purity, a menacing sky, foreboding yester-
day's thunderstorm! Last night I suddenly
experienced *my* cloud . . . in exactly the
same colors! And it is always like that. I
can paint what I like—nature herself
always confirms it." Through his individ-
ualistic, ethereal but architectonic

representations of form and color in the
material world, he created works, akin to
those of Cézanne (no. 298), that tran-
scribed the momentary into the
immutable.

References
Kuhn, 1957, 45, 133; H. Hess, *Lyonel
Feininger*, New York, 1961, 101–3; *Busch-
Reisinger Museum*, 1980, 24; *Deutsche Kunst*,
1983, 136–37; Jones, 1985, 60, fig. 51. The
Busch-Reisinger's Feininger Archive includes
drawings as well as two watercolors related to
Bird Cloud.

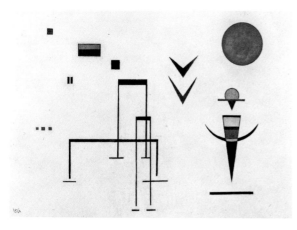

379

JOCULAR SOUNDS

1929
Wassily Kandinsky (1866–1944)
Oil on cardboard, 34.9 x 48.9 cm
Purchase—Museum Association Fund
and in memory of Eda K. Loeb,
BR 1956.54

Painted during his years at the Bauhaus
(1922–33), *Jocular Sounds* illustrates
Kandinsky's new, more disciplined and
geometric style of that period. It also
manifests some of the theoretical tenets
of *Punkt und Linie zu Fläche (Point and
Line to Plane;* 1926), for as the artist
once stated: "Form is for me only a
means to an end, and I spend much time
and intensive effort on the theory of form
because I want to penetrate its inner mys-
teries." In this painting, for instance, the
design gravitates to the right, a feature in
accord with his written theory; likewise
the "jocular" aspect derives in part from
the fusion of the color red with the right
angle, a "warm" synaesthesia also in
keeping with his principles. That he must
have enjoyed composing this piece is evi-
dent in the delightful combinations and

relationships of red and blue forms
against the light background. Rectangles
and circles emanate slight coronas of
color that make them appear to levitate
in the radiant, unconfined space; flat
arches span each other and seem to re-
gress despite the overall separation and
weightlessness of the elements. The whole
succeeds in confirming Kandinsky's early
precept of "inner necessity," as ordered in
nature, dictating the harmony of the for-
mal outcome.

References
Kuhn, 1957, 51, 136–37; *Busch-Reisinger
Museum,* 1980, 25; *Deutsche Kunst,* 1983,
123.

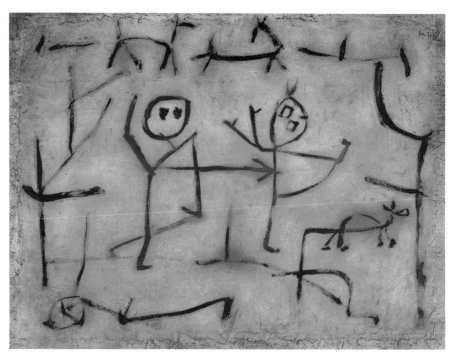

380

HOT PURSUIT

1939
Paul Klee (1879–1940)
Colored paste and oil on paper on jute,
48.3 x 64.8 cm
Gift—Mr. and Mrs. Alfred Jaretzki, Jr.,
1955.66

References
Kuhn, 1957, 52, 137; *Busch-Reisinger
Museum,* 1980, 21; *Deutsche Kunst,* 1983,
153–54; Jones, 1985, 65, fig. 57.

SELF-PORTRAIT IN TUXEDO

1927
Max Beckmann (1884–1950)
Oil on canvas, 138.4 x 95.9 cm
Museum Purchase, BR 1941.37

One of the Expressionist paintings exhibited as "Degenerate Art" by the Nazis in 1937, Beckmann's *Self-Portrait in Tuxedo* previously had been highly acclaimed; it also was the first of his works to come to the Busch-Reisinger, Curator Charles Kuhn acquiring it for six hundred dollars in 1941. Like Kirchner, Beckmann had a breakdown during World War I (in which he served in the medical corps), but unlike the guarded convalescent self-image that Kirchner produced (no. 375), Beckmann projected in this piece a formidable and complete sense of assurance (also no. 392). The relaxed but uninviting pose, the formal attire, and the air of sophisticated if somewhat blasé elegance not only record the tenor of Weimar society in the 1920's but also reflect Beckmann's idealistic views of the artist's role in that society. In an essay of 1927 related to the *Self-Portrait*, he wrote of a utopian "aristocratic Bolshevism" that should be established by artists as high priests of the new culture. The bold, geometrically ordered forms and the muted colors of this painting make his point clearly and succinctly.

References
Kuhn, 1957, 41, 130–31; *Busch-Reisinger Museum*, 1980, 19; *Deutsche Kunst*, 1983, 213–14; Jones, 1985, 46, fig. 34.

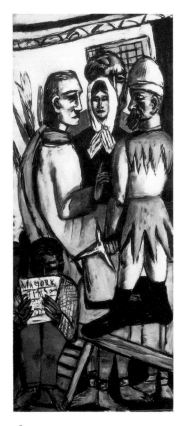
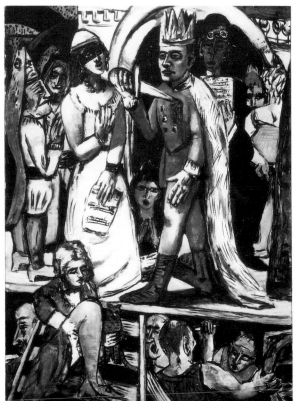

382

THE ACTORS

1941–42
Max Beckmann (1884–1950)
Oil on canvas, center 199.4 x 150 cm,
wings 199.4 x 83.7 cm
Gift—Lois Orswell, 1955.174a–c

Beckmann presented a very different self-image from the portrait of 1927 (no. 381) in this triptych, dating from the time of his exile in Amsterdam during World War II. As the lead in a three-part drama, he wears the costume of a king, and strides solemnly forward as he plunges a knife into his heart. The main supporting roles, visualized in the left and right side panels, are played by a figure who "could be Christ today" (Beckmann's words) confronted by a brutish soldier, and a prostitute, gazing into a looking-glass and sitting in a room with a large classicizing Janus head whose highlighted side has the profile of a

philosopher. Below stage, various more or less directly related activities enlarge and reinforce the main themes, all of which have to do with aspects of good and evil, taken partly from Beckmann's own experiences, partly from contemporary events. The fifth out of ten triptychs by the artist, *The Actors* personifies his desire "to get hold of the magic of reality and to transfer this reality into painting—to make the invisible visible through reality." The triptych form, which he may have derived from von Marées (no. 367), takes on a special significance in this example. In its complex, trancelike, "sacrificial" iconography, *The Actors* is not just a moral theatrical but also seems specifically to allude to traditional Christian representations—the "pit" scene, for instance, evoking the predella panels of an altarpiece. The cryptic, monumental forms, brought to life vividly through the use of throbbing colors, jagged volumes, and inflections of black, both invade our world and mirror it, demonstrating Beckmann's belief that "it is in fact reality which forms the mystery of our existence."

References
C. Chetham, "*The Actors* by Max Beckmann," *Fogg Art Museum Annual Report*, 1955–56, 54, 62–64; C. S. Kessler, *Max Beckmann's Triptychs*, Cambridge, Mass., 1970, 51–62; *Busch-Reisinger Museum*, 1980, 20; *Deutsche Kunst*, 1983, 216–20; Jones, 1985, 102, fig. 97.

DRAWINGS

PORTRAIT OF HERWARTH WALDEN

1910
Oskar Kokoschka (1886–1980)
Pen and ink and graphite on squared
paper, 36.2 x 22.2 cm
Purchase—Friends of Art and Music at
Harvard, 1949.137

As in his later painting of Dr. Neumann
(no. 376), Kokoschka displayed in this
sketch his greatest forte, the psychologi-
cal portrait. His drawing of Herwarth
Walden, whom the artist called "Ein
Fanatiker des Expressionismus," dates
from the time of their collaboration on
Der Sturm, a politically progressive,
chiefly literary–critical periodical for
which Kokoschka drew title-page por-
traits each week. Walden was an
extraordinarily influential figure in the
realm of the avant-garde, and under the
name of *Der Sturm* he also operated a
school, theater, publishing establishment,
and, most importantly, a gallery.
Kokoschka sketched him for the last July
issue of *Der Sturm* in 1910, capturing
with his frenetic and diversified pencil
and pen strokes the physical oddities, the
intellectual spirit, and the sense of un-
bounded energy and keen discernment
that made Walden, and his organization,
such a driving force in the art world of
early 20th-century Berlin.

References
Kuhn, 1957, 55, 138; P. Selz, "Der Sturm: The
Modern Movement Unfolds," *Art Interna-
tional* VI/9 (Nov. 1962), 20–21; *Busch-
Reisinger Museum*, 1980, 136 (illus.);
Deutsche Kunst, 1983, 60–61.

384

BROTHER AND SISTER

1910
Erich Heckel (1883–1970)
Black chalk on cream paper, 27.5 x 34.6
cm
Purchase—Loeb Fund and Friends of the
Busch-Reisinger Museum, BR 1978.5

References
Busch-Reisinger Museum, 1980, 129 (illus.);
Deutsche Kunst, 1983, 87–89.

385

CAFÉ

ca. 1919
George Grosz (1893–1959)
Ink on grey paper, 35.5 x 29.2 cm
Museum Purchase, BR 1934.195

George Grosz was yet another nervous
casualty (nos. 375, 381) of the First
World War. After his recovery, he became
a member of the Berlin Dada group,
which he described in his *Autobiogra-
phy*: "We Dadaists had meetings . . . in
which, for a small admission fee, we did
nothing but tell people the truth—i.e.,
insulted them. . . ." Grosz further ob-
served: "Dada rose as a reaction to the
cloud wandering tendencies of [an] art
which found meaning in cubes and
'Gotik.' . . ." In Germany, Dada also had
strong socialist ties, and *Café* chronicles

these political concerns in Grosz' typi-
cally harsh yet versatile graphic vo-
cabulary. A cynical commentary on the
ultraconservative, complacent elements of
the post-war bourgeoisie, the drawing, as
indicated by the legible section of the
folded newspaper, may also allude to a
specific event, the defeat of the radically
left-wing Munich Räterepublik.

References
Kuhn, 1957, 47, 134; *Busch-Reisinger
Museum*, 1980, 124; G. Grosz, *An Autobiog-
raphy* (N. Hodges, trans.), New York, 1983,
134; second quotation from *Deutsche Kunst*,
1983, 194–95.

386

COSTUME DESIGNS FOR THE "TRIADIC BALLET"

ca. 1922
Oskar Schlemmer (1888–1943)
Ink, gouache, metallic powder, graphite,
and collage, 38.1 x 53.3 cm
Museum Purchase, BR 1950.428

This drawing, a delightful design and one of only a few such works to survive, comprises costume studies for the "Triadic Ballet." Schlemmer's most important undertaking in choreography, it was staged in Stuttgart the year before he took over the Bauhaus theater in 1923. Highly inventive in both detail and overall effect, the costumes, derived from basic geometric forms such as spirals, cylinders, cones, spheres, and disks, illustrate the artist's desire to create a realm in which man could move in complete harmony with space. The ballet consisted of three parts calling for yellow, rose, and black stage sets; two men and one woman, instructed to move "ideally" like marionettes, performed twelve dances and wore eighteen different outfits.
" . . . [The] dance is independent and predestined to gently drive into the senses whatever is new. . . . The triadic ballet, dance of triplicity, change from the one, two, and three in form, color, and movement, shall also establish the planimetry of the dance area and the stereometry of bodies in motion, that dimension of space which must necessarily evolve by tracing elementary forms such as the straight line, the diagonal, the circle, the ellipse, and their interconnections. Thus, the dance, according to its origin, becomes Dionysian and pure feeling, symbol for the balancing of polarities." In the evolution of his ideas, the costumes came first, followed by the music and the actual dance steps, or "floor-geometry."

References
Kuhn, 1957, 64, 144; the quotation is from a diary entry (Sept. 1922) published in H. M. Wingler, *The Bauhaus*, Cambridge, Mass., 1962, 360–62; *Busch-Reisinger Museum*, 1980, 119; *Deutsche Kunst*, 1983, 112–14.

387

LANDSCAPE WAGON NO. 14

1930
Paul Klee (1879–1940)
Watercolor on grey silk mounted on
white card, 47 x 61.6 cm
Museum Purchase, BR 1951.46

The ragged piece of silk on which Klee
drew this watercolor apparently was torn
from a handkerchief he used as a chin-
rest for his violin. Serving as a reminder
of the artist's profound involvement with
music and the theoretical correlations he
made between music and painting, it also
illustrates his inventive openness to new
techniques and media. The sportive
vehicle takes its basic form from a com-
bination of interconnected solid and
variously meshed planes, and this "chas-
sis" carries landscape motifs along with
it—green and yellow knolls topped by
trees on the right, a simple domestic
structure on the upper left. Seeming to
bounce along gently on its two wheels,
the featherweight *Landscape Wagon No.
14* manifests Klee's fertile, synthesizing,
procedural imagination, from the actual
support to the fabricated image to the
title he gave it.

References
Kuhn, 1957, 53, 137; *Busch-Reisinger
Museum*, 1980, 111; *Deutsche Kunst*, 1983,
150–54.

388

DESIGN FOR A CHILDREN'S BOOK, OF TWO SQUARES

ca. 1920–22
El (Lasar Markovitch) Lissitzky
(1890–1941)
Pen and ink over graphite on cream
machine-made laid paper, 25.4 x 20.3 cm
Gift—Mrs. Lydia Dorner in memory of
Alexander Dorner, BR 1961.38

Reference
Deutsche Kunst, 1983, 176–77.

DESIGN FOR THE CHICAGO TRIBUNE COMPETITION

1922
Walter Gropius (1883–1969)
Ink rendering: elevation, 152.4 x 76.2 cm
Gift—Walter Gropius, BR 1969.59b

The *Design for the Chicago Tribune Competition* demonstrates clearly Gropius' total rejection of *a priori* notions of architecture and his constant aspiration "to a new space conception . . . away from the static wall enclosure toward a flowing spatial continuity in keeping with the dynamic trend of our period. . . ." Consonant with these principles is the skin of glass—a motif that he introduced as early as 1911 in the Fagus Works in Germany—stretched across the façade proposed for the Chicago building. Done during his years as director of the Bauhaus (1919–28), the forward-looking scheme lost out in this instance to a neo-Gothic skyscraper. The Chicago design is but a single example from the Busch-Reisinger's Gropius Archive, a collection of about 5,000 photographs, prints, drawings, models, and books by this most consequential 20th-century architect.

References
The quotation is from a statement written by Gropius for the *Encyclopedia of World Art*, London, 1963, VII, 180. See also *Busch-Reisinger Museum*, 1980, 138; *Deutsche Kunst*, 1983, 160–61.

SIDE ELEVATION AUSTIN AVE.

PRINTS

390

MADONNA

1895
Edvard Munch (1863–1944)
Lithograph with crayon, tusche, and
needle on grey-blue wove paper,
60.3 x 44.2 cm
Purchase—through the generosity of
Philip Straus, Class of 1937, and Lynn
Straus, M20227

Reference
E. Prelinger, *Edvard Munch: Master
Printmaker*, New York, 1983, 141 (illus.).

391

BAUHAUS PROCLAMATION (CATHEDRAL OF SOCIALISM)

1919
Lyonel Feininger (1871–1956)
Woodcut on brown paper, third state
(trial proof), 12
32.1 x 19.4 cm
Gift—Mr. and Mrs. Lyonel Feininger,
BR 1949.198

In addition to visionary seascapes
(no. 378) Feininger created analogous in-
terpretations of Gothic architecture,
another favorite theme in both his paint-
ings and graphic work. He began making
woodcuts only in 1918, but was imme-
diately prolific in the medium, producing
more than 100 blocks in six months.
This is a rare trial proof (with text) of the
Cathedral of Socialism, printed on the
cover of the Bauhaus Manifesto in the
spring of 1919, soon after Gropius had
become director and called on Feininger
to be his first Master of Form and to lead
the graphic workshop. The title as well as
the star-beamed, bird's-eye view reflect
the high-minded artistic and political
principles of the Weimar institution.

References
Kuhn, 1957, 85; H. Hess, *Lyonel Feininger*,
New York, 1961, 88–89; L. E. Prasse,
*Feininger: A Definitive Catalogue of his
Graphic Work*, Cleveland Museum of Art,
1972, no. W143, III B; *Concepts of the
Bauhaus: The Busch-Reisinger Museum Col-
lection*, Cambridge, Mass., 1971, no. 37.

392

SELF-PORTRAIT WITH HAT

1921
Max Beckmann (1884–1950)
Drypoint, second state, 32.5 x 24.8 cm
Purchase—Francis H. Burr Memorial,
M12208

References
Kuhn, 1957, 76; *Deutsche Kunst*, 1983,
209–10.

393

COMPOSITION WITH HEAD IN PROFILE

1921
Kurt Schwitters (1887–1948)
Lithograph (print eleven of Bauhaus
Portfolio III 'Neue Europäische
Graphik'), 24 x 20 cm
Gift—Mrs. Walter Gropius, BR 1974.17

Schwitters, who introduced Dada in the
city of Hanover in 1919, is most re-
nowned for his collages (one of which,
including the word fragment "merz,"
from Kommerz, instantly and fortui-
tously provided the name he applied to
all his subsequent art). This lithograph,
which was published in the third
Bauhaus Portfolio, is his earliest print.
Rather than integrate letters and words
(though numbers are incorporated) with
the composition as do other of his works,
the main element here is a profile head, to
which various abstracting, geometric,
and even anatomical forms (the heart),
have been whimsically appended. The in-
terplay of arcs and arrows both enlivens
and gives coherence to the design.

References
See in general W. Schmalenbach, *Kurt Schwit-
ters*, Cologne, 1967, and *The Modern Art of
the Print: Selections from the Collection of
Lois and Michael Torf*, Williams College
Museum of Art, Williamstown, Mass., and
Museum of Fine Arts, Boston, 1984, 75.

op. 1

Gabo

For Alex Dorner January 19th 1953
with best wishes Gabo

394

OPUS 1

1950
Naum Gabo (1890–1977)
Wood engraving, 20.3 x 14 cm (sheet size)
Inscribed to Alexander Dorner, January 19, 1953
Gift—Mrs. Lydia Dorner in memory of Dr. Alexander Dorner, 1961.37

This print, inscribed to Alexander Dorner in 1953, is one of a limited number from Gabo's series of twelve wood engravings (1950–73) that he sold or gave away. The majority of the monoprints and their variants were reserved for portfolios that he intended to assemble himself, but that plan was carried out only after his death. Although the title numbers refer to the images' planned order in the portfolios rather than to their order of execution, *Opus 1* in fact was the first of the lot, and the first graphic work ever undertaken by the Constructivist sculptor. Done at the prompting of his friend William Ivins, former curator of prints at The Metropolitan Museum of Art, *Opus 1* represents the beginning of a fascination with the unfamiliar medium that gripped the artist for the rest of his life. He applied the same concepts to his prints as he had to his sculptures (no. 356), seeking to materialize the element of time and stressing the space-encompassing quality of translucency (the prints, mostly on thin Japanese papers, were meant to be held up to the light). Experimenting with diverse tools, inks, and papers, he created a multitude of effects with his dozen designs, most of which were concretely, as well as conceptually, related to his three-dimensional pieces.

References
See in general H. Read and L. Martin, *Gabo: Constructions, Sculpture, Paintings, Drawings, Engravings*, Cambridge, Mass., and London, 1957, no. 132; M. Mazur, "The Monoprints of Naum Gabo," *Print Collector's Newsletter* 9/5 (Nov.–Dec. 1978), 148–51 (in which the author notes the connection between *Opus 1* and *Bas-Relief on a Circular Surface—Semi-Spheric* of 1937); and *The Modern Art of the Print: Selections from the Collection of Lois and Michael Torf*, Williams College Museum of Art, Williamstown, Mass., and Museum of Fine Arts, Boston, 1984, 81.

KEY TO ABBREVIATED CITATIONS

Abbreviated citations listed here are those that occur three or more times in the text; other references are cited in full in the individual entries.

American Art at Harvard, 1972

American Art at Harvard. Cambridge, Mass.: Fogg Art Museum, 1972.

Bergman, 1978

Bergman, R. P. "Varieties of Romanesque Sculpture." *Apollo* 107/195 (1978): 370–76.

Busch-Reisinger Museum, 1980

Busch-Reisinger Museum, Harvard University. New York: Abbeville, 1980.

Cahn and Seidel, 1979, I

Cahn, W., and L. Seidel. *Romanesque Sculpture in American Collections*. New York: B. Franklin, 1979, I (New England Museums).

Cohn and Rosenfield, 1977

Cohn, M. B., and R. Rosenfield. *Wash and Gouache: A Study of the Development of the Materials of Watercolor*. Cambridge, Mass.: Fogg Art Museum, 1977.

Cohn and Siegfried, 1980

Cohn, M. B., and S. L. Siegfried. *Works of J.-A.-D. Ingres in the Collection of the Fogg Art Museum*. Fogg Art Museum Handbooks, vol. 3. Cambridge, Mass., 1980.

Collection Maurice Wertheim, 1949

La peinture française depuis 1870: collection Maurice Wertheim. Québec: Musée de la province de Québec, 1949.

Deutsche Kunst, 1983

Deutsche Kunst des 20. Jahrhunderts aus dem Busch-Reisinger Museum, Harvard University, Cambridge, U.S.A. Frankfurt-am-Main: Städtische Galerie im Städelschen Kunstinstitut, 1983.

Eight Dynasties of Chinese Painting, 1980

Eight Dynasties of Chinese Painting: The Collections of the Nelson Gallery-Atkins Museum, Kansas City and The Cleveland Museum of Art. Cleveland: Cleveland Museum of Art, 1980.

Eitner, 1983

Eitner, L. *Géricault, His Life and Work*. London: Orbis, 1983.

Fahy, 1978

Fahy, E. "Italian Painting Before 1500." *Apollo* 107/195 (1978): 377–88.

Fong (ed.), 1980

Fong, W. (ed.). *The Great Bronze Age of China*. New York: The Metropolitan Museum of Art, 1980.

Forbes Catalogue, 1971

Edward Waldo Forbes, Yankee Visionary. Cambridge, Mass.: Fogg Art Museum, 1971.

Freedberg, 1978

Freedberg, S. J. "Lorenzo Lotto to Nicolas Poussin." *Apollo* 107/195 (1978): 389–97.

Hanfmann and Mitten, 1978

Hanfmann, G. M. A., and D. G. Mitten. "The Art of Classical Antiquity." *Apollo* 107/195 (1978): 362–69.

Hanfmann and Rowland, 1954

Hanfmann, G. M. A., and B. Rowland, Jr. "Ancient Arts in the Fogg Museum." *Archaeology* 7/3 (1954): 130–37.

Jones, 1985

Jones, C. A. *Modern Art at Harvard*. New York: Abbeville, 1985.

Kuhn, 1957

Kuhn, C. L. *German Expressionism and Abstract Art: The Harvard Collections*. Cambridge, Mass.: Harvard University Press, 1957.

Kuhn, 1965

Kuhn, C. L. *German and Netherlandish Sculpture, 1280–1800: The Harvard Collections*. Cambridge, Mass.: Harvard University Press, 1965.

Lion-Goldschmidt, 1978

Lion-Goldschmidt, D. *Ming Porcelain*, translated by K. Watson. New York: Rizzoli, 1978.

Loehr, 1968

Loehr, M. *Ritual Vessels of Bronze Age China*. New York: Asia Society, 1968.

Loehr, 1975

Loehr, M., assisted by L. G. Fitzgerald Huber. *Ancient Chinese Jades from the Grenville L. Winthrop Collection*. Cambridge, Mass.: Fogg Art Museum, 1975.

Loehr, 1978

Loehr, M. "Aesthetic Delight: An Anthology of Far Eastern Art." *Apollo* 107/195 (1978): 414–21.

Medley, 1976

Medley, M. *The Chinese Potter*. Oxford: Phaidon, 1976.

Mitten and Doeringer, 1967

Mitten, D. G., and S. F. Doeringer. *Master Bronzes from the Classical World*. Cambridge, Mass.: Fogg Art Museum, 1967.

Mongan–Sachs, 1940

Mongan, A., and P. J. Sachs. *Drawings in the Fogg Museum of Art*. 3 vols. Cambridge, Mass.: Harvard University Press, 1940.

Mongan (ed.), 1949

Mongan, A. (ed.). *One Hundred Master Drawings*. Cambridge, Mass.: Harvard University Press, 1949.

Mongan, forthcoming

Mongan, A. *French Drawings of the First Half of the Nineteenth Century*. Forthcoming.

Oberhuber (ed.), 1979

Oberhuber, K. (ed.). *Old Master Drawings: Selections from the Charles A. Loeser Bequest*. Fogg Art Museum Handbooks, vol. 1. Cambridge, Mass.: 1979.

O'Brian, forthcoming

O'Brian, J. *The Maurice Wertheim Collection of Late 19th and 20th Century European Art*. Forthcoming.

Picon, 1980

Picon, G. *Jean-Auguste-Dominique Ingres*, translated by S. Gilbert. New York: Rizzoli; Geneva: Skira, 1980.

Pulitzer Catalogue, I, 1957

Modern Painting, Drawing and Sculpture Collected by Louise and Joseph Pulitzer, Jr., 1957–71, 3 vols. Cambridge, Mass.: Fogg Art Museum, 1957.

Pulitzer Catalogue, III, 1971

Modern Painting, Drawing and Sculpture Collected by Louise and Joseph Pulitzer, Jr., 1957–71, 3 vols. Cambridge, Mass.: Fogg Art Museum, 1971.

Rosenfield, Cranston and Cranston, 1973

Rosenfield, J. M., F. Cranston, and E. A. Cranston. *The Courtly Tradition in Japanese Art and Literature: Selections from the Hofer and Hyde Collections*. Cambridge, Mass.: Fogg Art Museum, 1973.

Sachs Collection Catalogue, 1965

Memorial Exhibition: Works of Art from the Collection of Paul J. Sachs (1879–1965) Given and Bequeathed to the Fogg Art Museum. Cambridge, Mass.: Fogg Art Museum, 1965.

Sams, 1976

Sams, G. K. *Small Sculptures in Bronze from the Classical World: An Exhibit in Honor of Emeline Hill Richardson, William Hayes Ackland Memorial Art Center and the Department of Classics of the University of North Carolina at Chapel Hill*. Chapel Hill, N.C.: The Center, 1976.

Sickman and Soper, 1956

Sickman, L., and A. Soper. *The Art and Architecture of China*. Harmondsworth, England: Penguin Books, 1956.

Simpson, 1980 Simpson, M. S. *Arab and Persian Painting in the Fogg Art Museum*. Fogg Art Museum Handbooks, vol. 2. Cambridge, Mass., 1980.

Sirén, 1956–58 Sirén, O. *Chinese Painting: Leading Masters and Principles*. 7 vols. New York: Ronald Press, 1956–58.

Sutherland, 1974 Sutherland, C. H. V. *Roman Coins*. London: Barrie and Jenkins, 1974.

Suzuki, 1982 Suzuki, K., comp. *Comprehensive Illustrated Catalogue of Chinese Paintings*. vol. 1. *American and Canadian Collections*. Tokyo: Tokyo, daigaku shuppan-kai, 1982.

Vermeule, forthcoming Vermeule, C. C. *Stone Sculptures: The Greek, Roman, and Etruscan Collections of the Harvard University Art Museums*. Forthcoming.

Wasserman, 1971 Wasserman, J. L., assisted by M. Perry. *Six Sculptors and their Drawings*. Cambridge, Mass.: Fogg Art Museum, 1971.

Watkins Collection, 1973 *The Frederick M. Watkins Collection*. Cambridge, Mass.: Fogg Art Museum, 1973.

A. Welch, 1979 Welch, A. *Calligraphy in the Arts of the Muslim World*. Austin: University of Texas Press, 1979.

S. C. Welch and Beach, 1965 Welch, S. C., and M. C. Beach. *Gods, Thrones, and Peacocks; Northern Indian Painting from Two Traditions, Fifteenth to Nineteenth Centuries*. New York: Asia House Gallery, 1965.

Wildenstein, 1974 Wildenstein, D. *Claude Monet: biographie et catalogue raisonné*. Lausanne-Paris: La Bibliothèque des Arts, 1974.

Wilmerding, 1978 Wilmerding, J. "Harvard and American Art." *Apollo* 107/196 (1978): 490–95.

Winthrop Retrospective, 1969 *Grenville L. Winthrop: Retrospective for a Collector*. Cambridge, Mass.: Fogg Art Museum, 1969.

INDEX

Item numbers appear in boldface; page numbers in roman type.